"ONE CANNOT BE PESSIMISTIC ABOUT THE WEST. THIS IS THE NATIVE HOME OF HOPE. WHEN IT FULLY LEARNS THAT COOPERATION, NOT RUGGED INDIVIDUALISM, IS THE QUALITY THAT MOST CHARACTERIZES AND PRESERVES IT, THEN IT WILL HAVE ACHIEVED ITSELF AND OUTLIVED ITS ORIGINS. THEN IT HAS A CHANCE TO CREATE A SOCIETY TO MATCH ITS SCENERY."

— WALLACE STEGNER, 1969

NEW WEST

HIRMER

Wolfgang Wagener & Leslie Erganian

INNOVATION

LANDSCAPE

INFRASTRUCTURE

ARCHITECTURE

ENTERTAINMENT

MCM MEDIUM

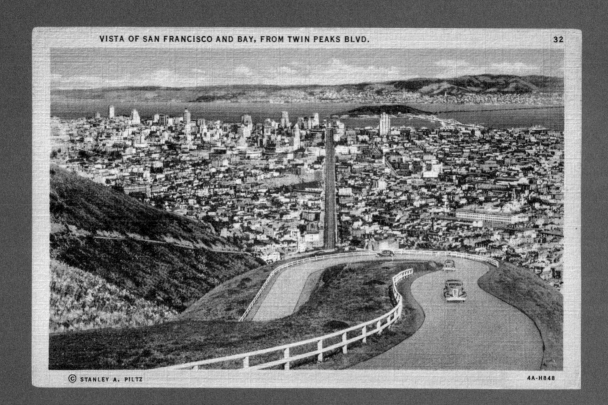

VISTA OF SAN FRANCISCO AND BAY, FROM TWIN PEAKS BLVD. 32

© STANLEY A. PILTZ 4A-H848

INTRODUCTION

The idea for *NEW WEST* began to percolate one sunny Saturday morning during the spring of 2014 with the singular find of a mid-century linen post card at a flea market in Palo Alto. The aesthetic quality of the image was the initial draw to this "Vista of San Francisco and Bay, from Twin Peaks Blvd." The precise printing on textured cardboard and resultant hyperreal colors in this hybrid art form and early example of social media, which brought together crisply focused black-and-white photography, artist-driven hand-coloring techniques, and the highest standard of lithographic printing, made it look more like a miniature piece of contemporary art than a historic image taken during the days before mid-century linen post cards yielded to slick and glossy photochromes.

Upon closer scrutiny, the historic value of this image began to reveal itself beneath the aesthetic beauty of this color-saturated card. The more closely we examined this snapshot of history, the more our knowledge and understanding of the last seventy-five years of urban growth began to lift off and expose the organizing patterns and principles of design and development for the City and County of San Francisco. This image clearly captured and communicated the city layout and resulting skyline of the time, forged by the economic and political forces of the American West.

These powerful twin forces, materialized by a mix of market-driven real estate development and publicly planned urban development, are manifested in the

VISTA OF SAN FRANCISCO AND BAY
San Francisco, California, 1934
A sight never to be forgotten is seeing San Francisco spread out before you from Twin Peaks, a centrally located urban mountain rising 1,000 feet above the city. You behold the broad Pacific, the Golden Gate, the bay, cities, mountains, temples, citadels, and fleets.

physical structures located throughout the city. These forces are written in the historic 1898 San Francisco Ferry Building, located where the straight shot of Market Street cuts a central axis to the water line of the Bay to make a welcoming and efficient gateway to the city for 50,000 daily commuters during the height of the age of steam. These forces are written in the 1925 skyscraper of the Pacific Telephone & Telegraph Company Building, which rises boldly to the right of Market Street in the South of Market district. At 440 feet in height, it was the second-tallest building in the American West at the maturity of the age of steel. These forces are written in the 1930s foreground ribbon of highway, which bends the linear axis of Market Street into a figure eight around the top of Twin Peaks, expanding the City by the Bay into the emerging suburbs during a youthful growth spurt enabled by the age of oil. These forces are also written in the 1940s Lawrence Berkeley National Laboratory, visible out beyond the terminus of Market Street at the San Francisco Ferry Building, past Yerba Buena Island on the opposite side of the Bay, nestled in the Berkeley Hills and overlooking the Berkeley campus of the University of California at the introduction of the age of information. This radiation lab, funded by one of the earliest federal research and development programs in the American West, became the cradle of the atom bomb.

This single image also represents the extraordinary population growth of the City and County of San Francisco: from a one-thousand-person town circumscribed by a wild and barren geography in 1850, to the principal urban center of the American West for the coming century, until the City of Los Angeles took over the reins in 1950, one short century later.

The raising of the first American flag in the West in the year 1846 occurred in San Francisco's Portsmouth Square, which can be pinpointed halfway between Market Street at mid-ground and Telegraph Hill to the left. The grand American strategy and revolutionary experiment of the nineteenth century had been the continental expansion across the West and the development of national American interests during a period of relative global peace. The United States enjoyed the protection of its own shore-to-shore continental geography and British dominance in seas throughout the world. This dominance and relative calm presented a period that was ideal for establishing the foundational network of public institutions in the West. These institutions included state capitols, courthouses, post offices, civic centers, and university campuses, through which the democratic ideals of the founding fathers, who believed that the government should secure the rights of individuals and advance their shared interests, were expressed.

By the twentieth century, this national focus and muscle for forging a framework broadened to include international affairs. The United States had by now grown strong enough to dominate the Western Hemisphere. America controlled the Pacific and Atlantic Oceans, drove the integration of the global economy, and facilitated the international strategy of Pax Americana, which heralded an extraordinary period of peace and prosperity in the Western world, based upon a network of autonomous countries cooperating for mutual benefit. Two significant San Francisco manifestations, both traceable through our mid-century linen post card, express this ambitious international American vision, which was defined, refined, and delivered by

U.S. Presidents Franklin D. Roosevelt and Harry S. Truman during and after World War II.

The first major western expression of an inward-facing nation to an outward-facing one was America's World's Fair on San Francisco Bay in 1939, for which construction had just begun north of Yerba Buena Island when this photograph was taken. U.S. President Franklin D. Roosevelt, via one of his live radio addresses to the American public called "fireside chats," summarized his international aspirations during the opening ceremonies: "As the boundaries of human intercourse are widened by giant strides of trade and travel, it is of vital import that the bonds of human understanding be maintained, enlarged and strengthened rapidly. Unity of the Pacific nations is America's concern and responsibility; their onward progress deserves now a recognition that will be a stimulus as well. Washington is remote from the Pacific. San Francisco stands at the doorway to the sea that roars upon the shores of all these nations, and so to the Golden Gate International Exposition I gladly entrust a solemn duty. May this, America's World's Fair on the Pacific in 1939, truly serve all nations in symbolizing their destinies, one with every other, through the ages to come."

A marker of the second major expression of an inward-facing nation to an outward-facing one can be seen in San Francisco's monumental Beaux-Arts Civic Center, to the left of Market Street in mid-ground, topped by the majestic golden dome of City Hall. It became the site for the 1945 international peace conference, which formalized Pax Americana. This event was also facilitated by U.S. President Franklin D. Roosevelt. In 1941, having devised the name United

Nations (UN) for the Allied nations, he proposed to then British Prime Minister Winston Churchill that the name be continued, and that the allegiances formed during war times continue to stay strong during peace times. Immediately following the end of World War II, these nations met in San Francisco for the UN Conference on International Organization, which was attended by fifty governments as well as a number of non-governmental organizations involved in authoring the framework for the United Nations.

Through close observation of, and inquiry into, this single image of the "Vista of San Francisco and Bay, from Twin Peaks Blvd.," the mid-century linen post card offers not only a visual record of the development of one specific city and county in the West, but also a record of the patterns of the evolution of the American West as a whole. Multiply this embedded knowledge by the more than 10,000 views that were photographed, printed, and shared by millions across the United States between 1931 and 1959, and one can begin to have a sense of the mother lode of history that these broadly replicated and distributed artifacts have as a collection, if visually read with the attention they deserve.

We, as both observers and collectors, have chosen to examine these curated Western views through the lenses of landscape, infrastructure, architecture, and entertainment. These four areas of rapid transformation most shaped the quality of life throughout the American West through which the producers, photographers, artists, and printers celebrated the preexisting geography of the landscape, as well as its high-speed transformation to suit man's need for growth, commerce, mobility, arts, education, and public life.

While looking through this prism, we have also chosen to focus on the ways in which four distinct waves of innovation—steam, steel, oil, and information— have driven the development of the American West and etched their history into each city and structure built upon it. What makes this evolution at mid-century so fascinating is that, while steam was the foundational layer of transformation, the three ensuing ages overlapped and built cumulatively upon each other's strengths.

Finally, through the lessons learned throughout our creation of this book, and from our deep examination of the collection, we have recognized that we are at present on the threshold of the next transformative wave of innovation. The opening decades of the twenty-first century find Pax Americana in crisis after seventy-five years of influence, the age of oil at maturity, the age of information in accelerating growth but with the brakes of public regulation already beginning to be applied, and the next innovation wave, the age of symbiosis, poised to crest.

At this moment of change, it is worth exploring and understanding the true heroism, innovation, and beauty inherent and captured with these remarkable historic artifacts of the *NEW WEST*, also known as post cards.

Wolfgang Wagener & Leslie Erganian

NEW WEST

THE LONGITUDE OF THE 100TH MERIDIAN WEST has been recognized as the passage from the eastern to the western United States since the year 1878. It marks the geographic and climatic transformation from the flat and humid continental East, to the mountainous and semiarid West, as well as the starting line from which uniquely western population and development patterns began to emerge in the nineteenth century.

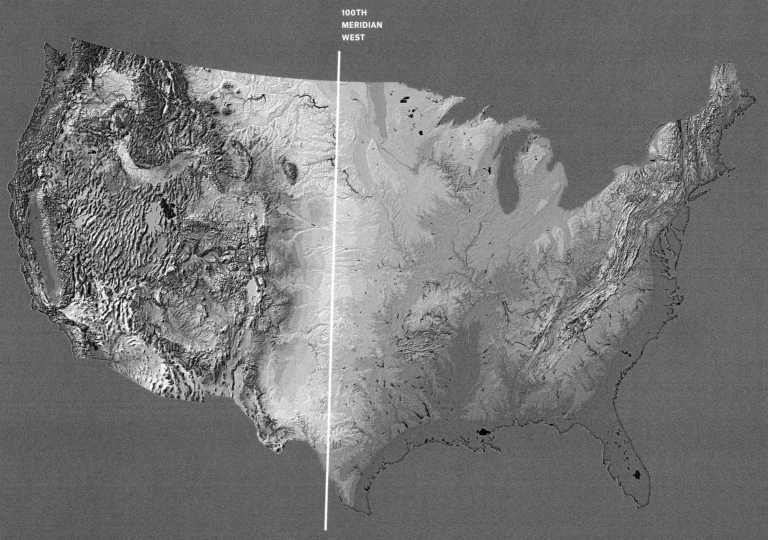

100TH
MERIDIAN
WEST

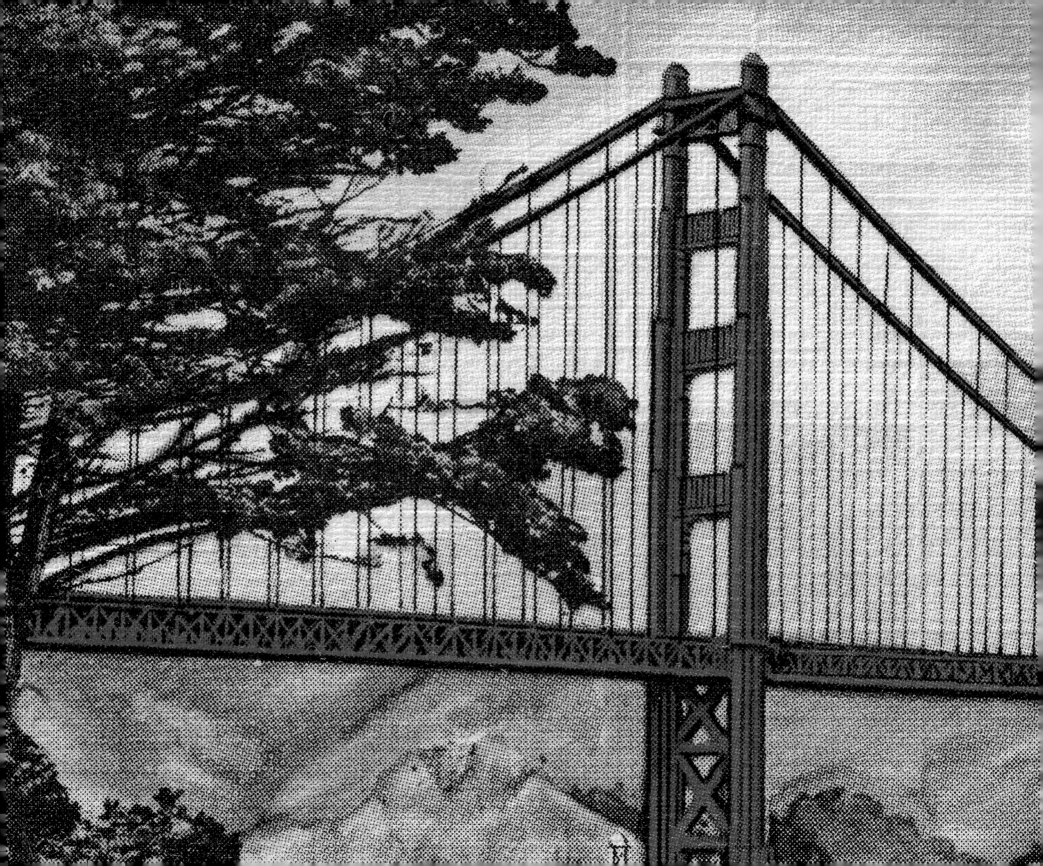

INNOVATION

STEAM, STEEL, OIL, AND INFORMATION

by Wolfgang Wagener

"OUR GOAL IS TO STAND AT THE INTERSECTION OF TECHNOLOGY AND THE HUMANITIES."

— STEVE JOBS, 2005

GOLDEN GATE BRIDGE
San Francisco, California, 1937
The imposing and artistic setting of the Golden Gate Bridge across the Golden Gate can only be appreciated by those who have viewed the sight. This 4,200-foot single-span structure, built at a cost of $35,000,000, is the connecting link between San Francisco and the Redwood Highway Scenic Wonderland. It brings the rich northern counties of California closer to the Metropolitan markets of the San Francisco Bay area by direct rapid automotive transportation. The bridge accommodates six lanes of vehicular traffic and two ten-foot sidewalks.
[previous spread]

IN MAY 2017, THE WEEKLY MAGAZINE *The Economist* reported that the world's most valuable resource was no longer oil, but data. Data, they claimed, was the "the oil of the digital era." Data now drives a growing, highly profitable economy, comparable in scale to that which oil had throughout the past century.

Local oil discoveries in Pennsylvania in the second half of the nineteenth century, followed by the ubiquitous application of oil with the introduction of kerosene and oil lamps, together triggered the commencement of the age of oil. The subsequent mass adoption of the internal combustion engine made oil a major national commodity, with oil booms in California, Texas, and Ohio in the early twentieth century. Oil, a portable, dense energy source, has been the main driver throughout an international era of automobiles, airplanes, and mass production, and has facilitated the vast spread of urban development. Oil has facilitated the cost-effective production and distribution of people, goods, and services throughout the world. The maturation of the age of oil in the second half of the twentieth century heralded the energy crisis, environmental pollution, and other externalities. From this time onward, private companies and the public sector began to introduce new

ways to reduce, replace, and regulate the extraction and consumption of oil. Examples can be found in the exploration of renewable energy sources, the improvement of energy efficiency, the rollout of electro-mobility, and smart growth for cities, concentrating urban development into compact walkable centers.

The contemporary data industry has been evolving with a similar cycle of introduction, mass adoption, and maturation. The introduction of local, digital computers in the 1940s for the calculating needs of military defense and social security for governments in Germany and the U.S. marked the commencement of the age of information. Over a fifty years period, local stand-alone computers evolved into a global system of interconnected computer networks. Today's rapid mass adoption of cloud computing, personal smartphones, and the Internet of Things has made data abundant and ubiquitous. Artificial intelligence is making data more and more valuable. At the inflection point of the current wave of innovation, private companies and the public sector are still at the beginning of fully grasping the unintended consequences of the digital transformations for the economic, social, and physical context in which they operate, including the impact on further urban development at the intersection of cities and nature.

FOUR WAVES OF INNOVATION

THE DEVELOPMENT OF THE NEW WEST has been propelled by four waves of innovation: steam, steel, oil, and information. This timeline illustrates the innovation adoption stages of each wave, from introduction to mass adoption and finally to maturation.

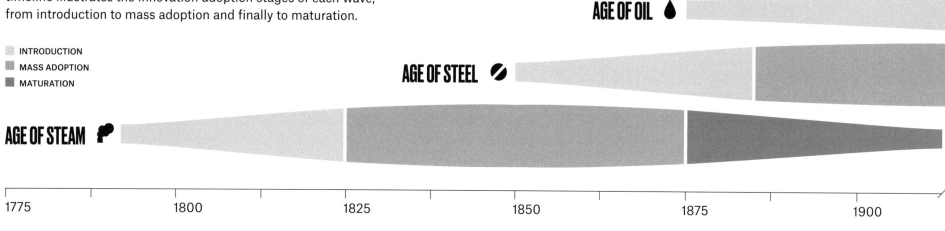

INTRODUCTION
MASS ADOPTION
MATURATION

AGE OF OIL

AGE OF STEEL

AGE OF STEAM

1775 1800 1825 1850 1875 1900

AGE OF STEAM

INTRODUCTION

1776 Declaration of
 Independence
1781 Steam Engine
1785 Land Ordinance
1800 Library of Congress
· 1804 Lewis and Clark
 Expedition
1807 Steam Boat
1811 Street Grid
1814 Steam Locomotive
· 1823 Mission Trail Completion,
 Sonoma
1848 Treaty of Guadalupe
 Hidalgo

MASS ADOPTION

1825 Erie Canal
1830 Baltimore & Ohio Railroad
1833 Telegraph
· 1840 Oregon Trail
1846 Smithsonian Institution
· 1847 Agricultural Irrigation,
 Utah
· 1848 Gold Discovery, California
· 1850 California Statehood,
 Sacramento
· 1850 University of Utah,
 Salt Lake City
1851 Crystal Palace, London
1853 Steam Elevator
1853 Haussmann's Paris
· 1853 Hydraulic Mining,
 California
1860 Water Supply and
 Sanitation
1862 Homestead Act
1862 Morrill Act—Land Grant
 Universities
1868 Vienna Ring Road
· 1869 Transcontinental Railroad,
 Utah
· 1872 Yellowstone National Park,
 Wyoming

MATURATION

· 1874 California State Capitol,
 Sacramento
· 1880 Hotel Del Monte Resort,
 Monterey
1888 Freight Car Refrigeration
· 1889 Pikes Peak Cog Railway,
 Colorado
· 1890 Yosemite National Park,
 California
1898 Ferry Building,
 San Francisco
1899 Rivers and Harbors Act
· 1912 Arizona Statehood
1914 Panama Canal
· 1915 Panama–Pacific Expo,
 San Francisco

AGE OF STEEL

INTRODUCTION

1856 Bessemer Steel
1858 New York Central Park
· 1873 Cable Car, San Francisco
1876 Telephone
1879 Electric Light
1879 Electric Streetcar
1880 Electric Elevator
1881 Sprinkler
1883 Electric Thermostat
1884 Bicycle

MASS ADOPTION

· 1885 Reinforced Concrete
 Building, San Francisco
1885 Steel High-Rise, Chicago
1885 Department Store
1889 Eiffel Tower
· 1889 Reinforced Concrete
 Bridge, San Francisco
· 1889 Power Transmission,
 Portland
1890 Electric Subway
1893 Chicago World's Fair
1903 Concrete High-Rise,
 Cincinnati
· 1904 Land Use Ordinance,
 Los Angeles
· 1913 Los Angeles Aqueduct
· 1914 Smith Tower, Seattle
1915 Equitable Building,
 New York
1916 Zoning Ordinance,
 New York
· 1918 Curtain Wall,
 San Francisco
· 1927 Russ Building,
 San Francisco
· 1928 City Hall, Los Angeles
1931 Empire State Building,
 New York

MATURATION

1934 Federal Housing
 Administration
· 1935 Hoover Dam, Nevada/
 Arizona
1935 Social Security
 Administration
1935 Works Progress
 Administration
1937 National Gallery of Art
· 1937 Golden Gate Bridge,
 San Francisco
· 1939 San Francisco World's Fair
1939 New York World's Fair
· 1942 Grand Coulee Dam,
 Washington
· 1945 Shasta Dam, California

· New West Innovation

AGE OF INFORMATION

1925 1950 1975 2000 2025 2050

AGE OF OIL

INTRODUCTION

1859 Oil Creek Pennsylvania
· 1879 Internal Combustion
 Engine
1896 Marconi Radio
1900 Brownie Camera
1901 Spindletop Gusher
1902 Air-Conditioning
1903 Wright Brothers Plane
1908 Ford Model T
· 1912 Movie Studio, Hollywood
· 1912 Transcontinental
 Highway, San Francisco
· 1923 Transcontinental Flight,
 San Diego

MASS ADOPTION

1926 NBC, Radio
· 1928 Lindbergh Field,
 San Diego
· 1929 Academy Awards,
 Hollywood
· 1932 Summer Olympics,
 Los Angeles
· 1935 China Clipper,
 San Francisco
1939 NBC, Television
· 1939 Gone with the Wind,
 Hollywood
· 1940 Freeway, Pasadena
1941 Pearl Harbor, Hawaii
· 1941 Blackout Plant,
 Long Beach
1944 G.I. Bill
· 1945 Case Study House
 Program, Los Angeles
· 1946 Equitable Building,
 Portland
· 1955 Disneyland, Anaheim
1955 Shipping Container
· 1956 Shopping Center, San Jose
1956 Seagram Building
1956 GM Technology Center
1956 Federal Highway Act
· 1958 Jet Airliner, Seattle

MATURATION

1961 Death and Life of Great
 American Cities
1962 Silent Spring
1963 Clean Air Act
· 1965 Sea Ranch, California
1965 National Endowment
 of the Arts
1966 National Historic
 Preservation Act
1970 National Environmental
 Policy Act
1974 Housing and Community
 Development Act
1987 Sustainable Development
1993 Leadership in Energy and
 Environmental Design,
 LEED

AGE OF INFORMATION

INTRODUCTION

· 1939 Audio Oscillator, Palo Alto
1941 Z3 Computer
1944 Harvard Mark I
1945 Electronic Numerical
 Integrator and Computer,
 ENIAC
· 1945 Atomic Bomb, Nevada
· 1957 Digital Image, Portland
1958 National Aeronautics and
 Space Administration,
 NASA
· 1968 Whole Earth Catalog,
 Menlo Park
· 1969 Advanced Research
 Projects Agency Network,
 ARPANET, California/
 Utah
· 1971 Microchip, Santa Clara

MASS ADOPTION

· 1976 Personal Computer,
 Cupertino
1977 Intelligent Building
· 1983 Public Global Positioning
 System, GPS
1989 Fall of Berlin Wall
1990 World Wide Web
1990 Electric Vehicle 1, Detroit
1991 High Performance
 Computing Act
1992 Telepresence
· 1992 Streaming Media,
 Mountain View
· 1994 Online Shopping, Seattle
1999 Airport City
2000 Ecosystem Services
2003 Smart Grid
· 2004 Social Networking,
 Menlo Park
· 2007 Mobile Internet, Cupertino
· 2007 Cloud Computing,
 San Francisco
· 2007 Shared Mobility,
 San Francisco
2010 Smart City
2013 Resilient City
· 2018 Apple Park, Cupertino

MATURATION

Internet of Things
5G Wireless
Immersive Experiences
Digital Twin
Artificial Intelligence
Logistics Technology
Autonomous Things
Low-Earth-Orbit Satellites
City and Nature Symbiosis
Digital Privacy and Ethics

FOUR WAVES OF INNOVATION

These two examples illustrate innovation as a driver for long-term economic growth. Economist Joseph A. Schumpeter described the growth trajectory of these waves in 1942 as "creative destruction": "The history of a productive apparatus … is a history of revolutions. So is the history … of transportation from the mail coach to the airplane. The opening up of new markets, foreign or domestic, and the organizational development from the craft shop and factory to such concerns as U.S. Steel illustrate the same process of industrial mutation—if I may use this biological term—that incessantly revolutionizes the economic structure from within, incessantly destroying the old one, incessantly creating a new one. This process of Creative Destruction is the essential fact about capitalism."

Building on Schumpeter's analysis, Carlota Perez, Centennial Professor at the London School of Economics, has made significant contributions to the current understanding of the relationship between innovation, economic development, and public institutions. Her influential 2002 book *Technological Revolutions and Financial Capital* defined five technological revolutions that shaped the modern Western world over the past 250 years, the first being the industrial revolution in Great Britain. The westward expansion of the U.S., beginning in the first half of the nineteenth century, evolved in parallel to this industrial revolution. In the undeveloped and sparsely populated American West, still an unknown territory at the time, nothing old had to make way for the new. These transformative industrial technologies had no roadblocks to overcome and could adapt and evolve rapidly. The westward expansion was the physical platform for the four waves of innovation that followed the industrial revolution. The ages of steam, steel, oil, and information propelled the naturally and uniquely beautiful American West into one of the most innovative and successful regions of the global economy.

Steam, Railway, and Mechanization

The industrial revolution erupted around 1776 in Great Britain, just as the U.S. was declaring its independence from the kingdom. This age of steam, railways, and mechanization led to machinery and automation that dramatically increased the production output. Steam-powered factories were no longer tethered to the naturally available energy sources of waterwheels and windmills. They could be located adjacent to the extraction sites of the raw materials needed for manufacturing. This paradigm shift established the need for a national transportation system. The emerging steamship, railway, and telegraph networks accelerated the westward expansion of the U.S., as well as ushering in an era of trans-continental and transoceanic connection for the rest of the world.

Steel, Electricity, and Heavy Engineering

The second wave of innovation was the age of steel, electricity, and heavy engineering. It materialized in the U.S. and Germany around 1850. As a consequence, industry expanded beyond railways to all national manufacturing sectors and led to the development of the energy grid and telephone networks. This forged the dynamic development of the architectural landscape of the American West through massive water and electricity infrastructure projects that powered industry, agriculture, transportation, and construction, as well as cities, which became magnets for a rapidly growing population. More than fifty percent of the Western population already lived in cities

DRIVING THE LAST SPIKE
Promontory, Utah, 1935
At Promontory, Utah, May 10, 1869, the first transcontinental railroad was a reality. Here the Golden Spike was driven, celebrating the successful completion of this most difficult undertaking.

STEEL MILL
Pueblo, Colorado, 1942
The Colorado Fuel and Iron Company steel mills are the largest west of the Mississippi River. They give employment to many thousands of men, including the steel mills and their supporting mines and railroads.

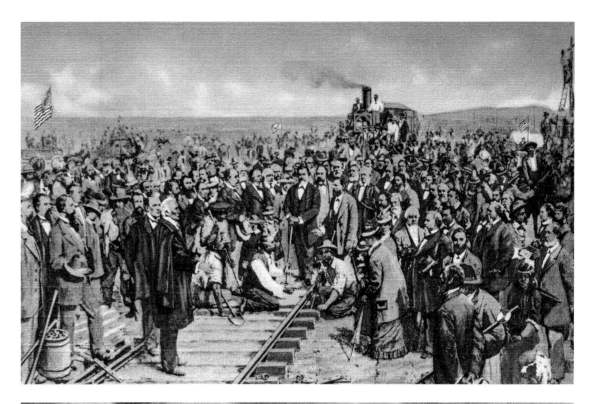

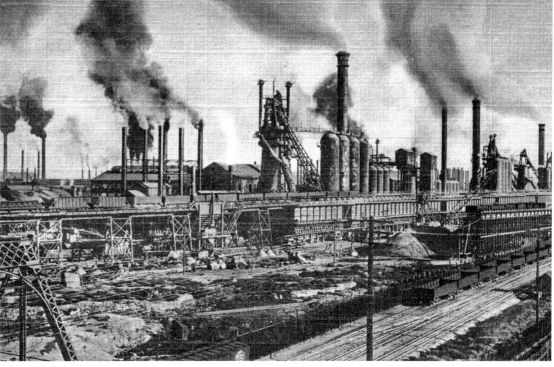

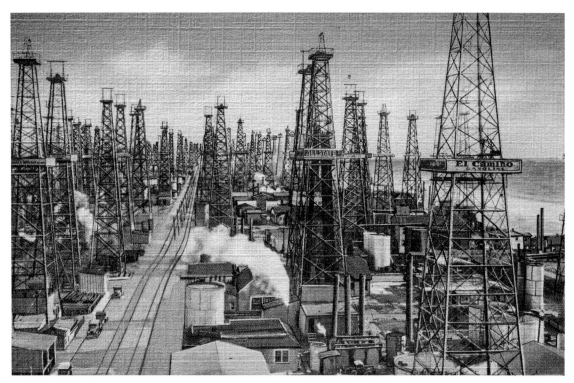

OIL WELLS
Venice, California, 1943
"Venice of America" is a residential section in Los Angeles commonly know for its oil industry. Venice oil field is the 4th most productive field in California with 340 wells in use.*

CONTROL BOARDS
Grand Coulee Dam, Washington, 1942
Looking down the Governor Gallery in one of the two powerhouses at the Grand Coulee Dam, Washington. Dial readings indicate how the world's most powerful generators and other equipment are functioning. Visitors are guided through this gallery.

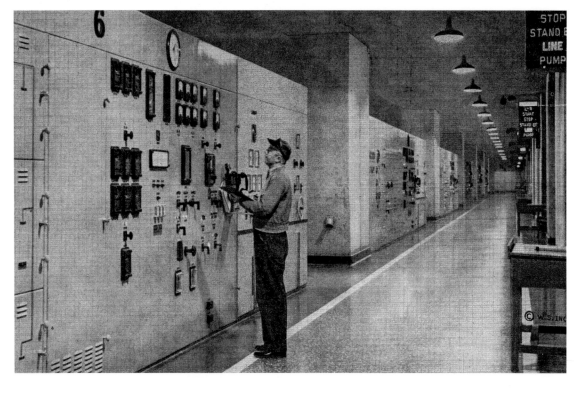

by 1920, while more than ninety percent were inhabiting five megapolitan geographies in the American West by 2000.

Oil, Automobile, and Mass Production
The third wave of innovation was the age of oil, automobile, and mass production. It surfaced in the U.S. at the turn of the twentieth century in the American West and propelled the nation into global economic and political leadership during the period of Pax Americana in the second half of the twentieth century. The age of oil ultimately facilitated radio and television networks, along with the cost-effective production and distribution of civilian and military goods and services on an international scale. The standardization of land, water, and air transportation via intermodal containerization fueled an explosion in international commerce, consumption, and travel that still continues today.

Information, Communication, and Big Data
The fourth wave of innovation is the age of information, communication, and big data. It emerged and evolved quickly in the 1940s in Germany and the U.S. driven by the computing needs of World War II. Since the attack on Pearl Harbor, the American West has been driving the age of information through huge military research and development programs on the Pacific Coast. The 1971 invention of the microprocessor in California's "Valley of Heart's Delight," aka Silicon Valley, advanced the digital transformations quickly and enabled computers to become more and more powerful, compact, and linked together. The ability to create digitally and disseminate and manage massive amounts of data led to the rise of cloud computing, personal smartphones, and artificial intelligence. The digital platform of the information era has been transforming the way that goods, services, and information are created and distributed from producer to user, resulting in the reshaping of the urban geographies of where and how people work, live, learn, and play.

INNOVATION ADOPTION
Technological innovations are intrinsically tied to the economic, social, and physical context in which they take place. The evolution of the American West reveals a consistent S-curve pattern that maps the market acceptance trajectory over time. Introduction, mass adoption, and maturation represent the three typical innovation stages across an approximately hundred-year life cycle. While acceleration characterizes the mass adoption stage, and deceleration characterizes the maturity stage, it is interesting to note that when increased market saturation and regulation begin to flatten the S-curve, it also begins to disperse and direct the grown energy into the next transformative wave of innovation.

Introduction
The introduction stage is the eruption of unique technologies. This phase features inventions, new products, new industries, explosive growth fueled by intense financial capital, and a dislike for the status quo. During this early period, the paradigm for a new technology takes its initial shape. The first practical steam engine by Scottish inventor James Watt ushered in the age of steam, railway, and mechanization in 1775. The twin inventions of the first inexpensive industrial process for the mass production of steel, patented by English inventor Sir Henry Bessemer in 1856, and the mechanical production of electrical power by American inventor Thomas Alva Edison and Serbian-American inventor Nikola Tesla in 1870, forged the age of steel, electricity, and heavy

engineering. The first affordable automobile for the mass market, developed and manufactured in 1908 by American industrialist and founder of the Ford Motor Company, Henry Ford, drove the age of oil, automobile, and mass production. And the invention of Z3, the first operational modern computer by German inventor Konrad Zuse in 1941, in parallel with the first general-purpose computers designed in the U.S.—Mark 1, a collaboration between IBM and Harvard University in 1944, and the Electronic Numerical Integrator and Computer (ENIAC) by American computer pioneers John William Mauchly and J. Presper Eckert of the University of Pennsylvania in 1945—turned on the age of information, communication, and big data.

Mass Adoption

Mass adoption marks the transformation stage of every new technology. At the inflection point of this era, integrated infrastructure platforms take hold and begin to shape the economic, social, and physical context. This leads to the realization of the full market potential of innovation. Ecosystems develop around the new technology platform, creating entirely new markets and business models. The platform in the age of steam was the national transportation system; in the age of steel it was the national energy grid; in the age of oil it was the international distribution system; and in the age of information, it is the global system of interconnected computers. Each new infrastructure platform layers on top of the previous ones and interacts with them.

The celebrations and cultural acceptance of innovations by the general public through experiences in entertainment, arts, and architecture during this period of mass adoption and broad prosperity can be called a golden age. Examples are the Victorian era of the age of steam, the Belle Epoque and Roaring Twenties of the age of steel, the American Way of Life during the age of oil, and today's age of information, which has yet to acquire a title.

Maturation

Because of the rapid market expansions during the introduction and mass adoption stages, the public sector steps in during the maturation period with regulations and, when needed, significant investments. It takes a more realistic view of the potential of technology innovation and its unintended consequences for the economy, society, and the natural environment. Examples for the governance of public health, safety, and welfare in urban development are the nuisance laws during the age of steam, zoning and land-use regulations during the age of steel, environmental impact assessments and comprehensive urban planning in the age of oil, and the emerging data privacy and smart city regulations in today's age of information.

Towards the end of each wave, markets get saturated, returns from technological innovations start to decline, and financial capital looks for new areas, sectors, and regions. At this point, the S-curved evolution begins again with the next wave of innovation.

SPATIAL ORGANIZATION

Each wave of innovation in the American West has created essential transportation and communication capabilities that shape the way people, organizations, and industries distribute their activities in time and space. The availability, reach, and quality of transportation and communication infrastructures define the human activity range and determine where businesses produce and sell, where employers locate jobs, and where

families choose to live, work, learn, and play. All human behavior is impacted by spatial distance, or more to the point, by the human inventiveness to overcome it. There are two ways to reduce spatial distance: density and distribution. Density avoids distance by the colocation of human activities. Distribution overcomes distance by the mobilization of people, goods, services, and information. All urban form can be seen as a balance of the twin forces of density and distribution.

Urban development in the age of steam distributed human activities through railway networks, telegraph communications, and land subdivisions; urban development in the age of steel maximized the use of land through vertical density and connections to water, sanitation, electricity, transportation, and telephone infrastructures; urban development in the age of oil expanded the action radius of human activities through automobility, intermodal logistics, air transportation, television, and residential subdivisions; and today, urban development in the age of information reaches even further through the extended activity range of ubiquitous, global digital data networks, telepresence, and artificial intelligence, which creates resilient and responsive combinations in the way people, organizations, and industries distribute and mix their activities in space and land use.

ARCHITECTURAL EVOLUTION

Land is an immobile asset. "Location, location, location" is the number one rule in real estate. Landowners thrive and prosper when they can increase the usability of a plot of land. Technological innovation augments land use in two ways: by stacking and through the connection of space. Stacking increases the usable site area by multiplying it. Connecting adds utility to floor space: through access

(connection to transportation networks), health (connection to water and sanitation networks), productivity (connection to electricity networks that power lighting, air-conditioning, and equipment), and intelligence (connection to digital networks for data creation, sharing, and management).

Each wave of innovation in the American West has created distinct buildings with floor plans and utilities that express the way people, organizations, and industries use floor space. The buildings in the age of steam provided shelter through skeleton and skin; the buildings in the age of steel stacked floor plates and added the artificial physiology of pipes, wires, ducts, and vertical transportation; the buildings in the age of oil expanded the size of floor plates horizontally through indoor environmental control and fluorescent lighting; and today, the buildings in the age of information become more resilient and responsive through the central nervous system of ubiquitous digital data networks and artificial intelligence.

Every step along this architectural evolution has yielded higher economic value for landowners through improved asset utilization by accommodating more activity in less space and over longer periods of time. The American West has had a unique place in this architectural development. At mid-nineteenth century, there was no marketplace for building materials, no building trades, no building design and construction industry, let alone the means to connect to transportation, water, sanitation, power, and information networks. In just one hundred years, however, this region evolved from working with imported materials and construction methods to being one of the most innovative real estate, design, and construction markets by mid-twentieth century.

POPULATION GROWTH

1800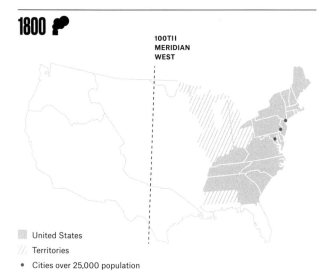

100TII MERIDIAN WEST

- [] United States
- [/] Territories
- • Cities over 25,000 population

	WEST	U.S.
POPULATION	<10,000	5 million
URBANIZATION	<1%	5%

1850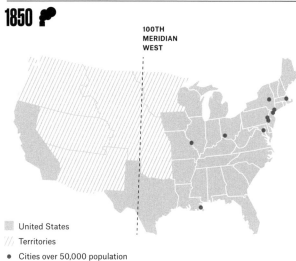

100TH MERIDIAN WEST

- [] United States
- [/] Territories
- • Cities over 50,000 population

	WEST	U.S.
POPULATION	300,000	25 million
URBANIZATION	5%	15%

1900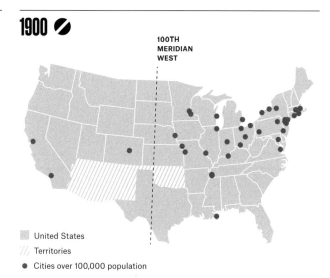

100TH MERIDIAN WEST

- [] United States
- [/] Territories
- • Cities over 100,000 population

	WEST	U.S.
POPULATION	5 million	70 million
URBANIZATION	40%	40%

INFRASTRUCTURE EVOLUTION

WATERWAYS

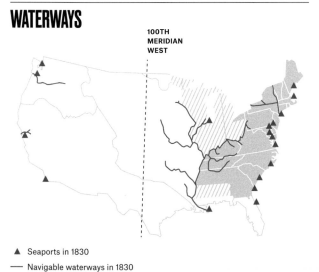

100TH MERIDIAN WEST

- ▲ Seaports in 1830
- — Navigable waterways in 1830

RAILWAYS

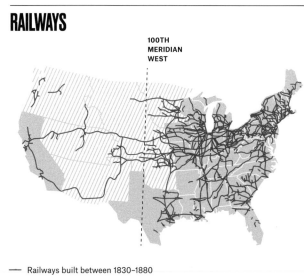

100TH MERIDIAN WEST

- — Railways built between 1830–1880

DAMS

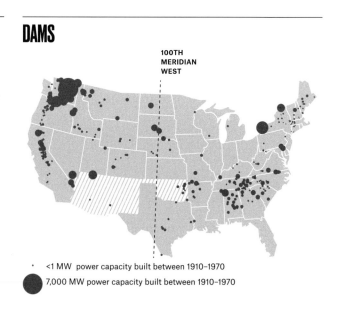

100TH MERIDIAN WEST

- • <1 MW power capacity built between 1910–1970
- ● 7,000 MW power capacity built between 1910–1970

1950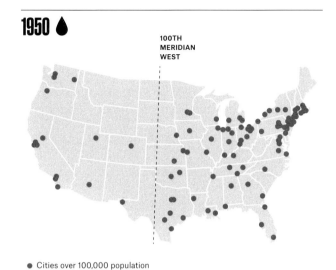

100TH
MERIDIAN
WEST

● Cities over 100,000 population

	WEST	U.S.
POPULATION	20 million	150 million
URBANIZATION	70%	65%

2000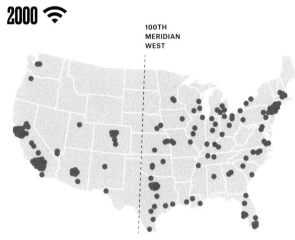

100TH
MERIDIAN
WEST

● Cities over 100,000 population

	WEST	U.S.
POPULATION	65 million	280 million
URBANIZATION	90%	80%

2050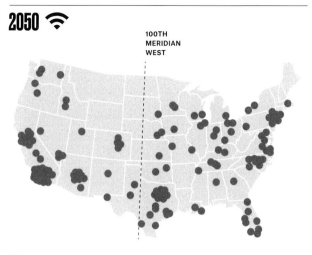

100TH
MERIDIAN
WEST

● Cities over 200,000 population

	WEST	U.S.
POPULATION	135 million	400 million
URBANIZATION	95%	85%

HIGHWAYS

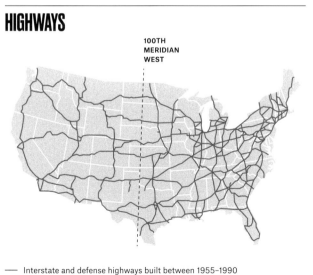

100TH
MERIDIAN
WEST

—— Interstate and defense highways built between 1955–1990

AIRPORTS

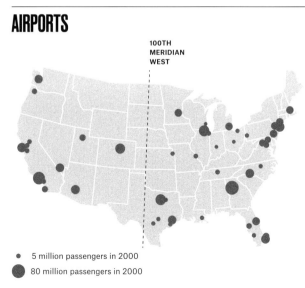

100TH
MERIDIAN
WEST

● 5 million passengers in 2000
⬤ 80 million passengers in 2000

INTERNET

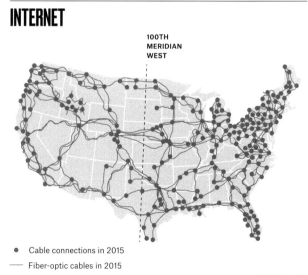

100TH
MERIDIAN
WEST

● Cable connections in 2015
—— Fiber-optic cables in 2015

SOURCES: page 301

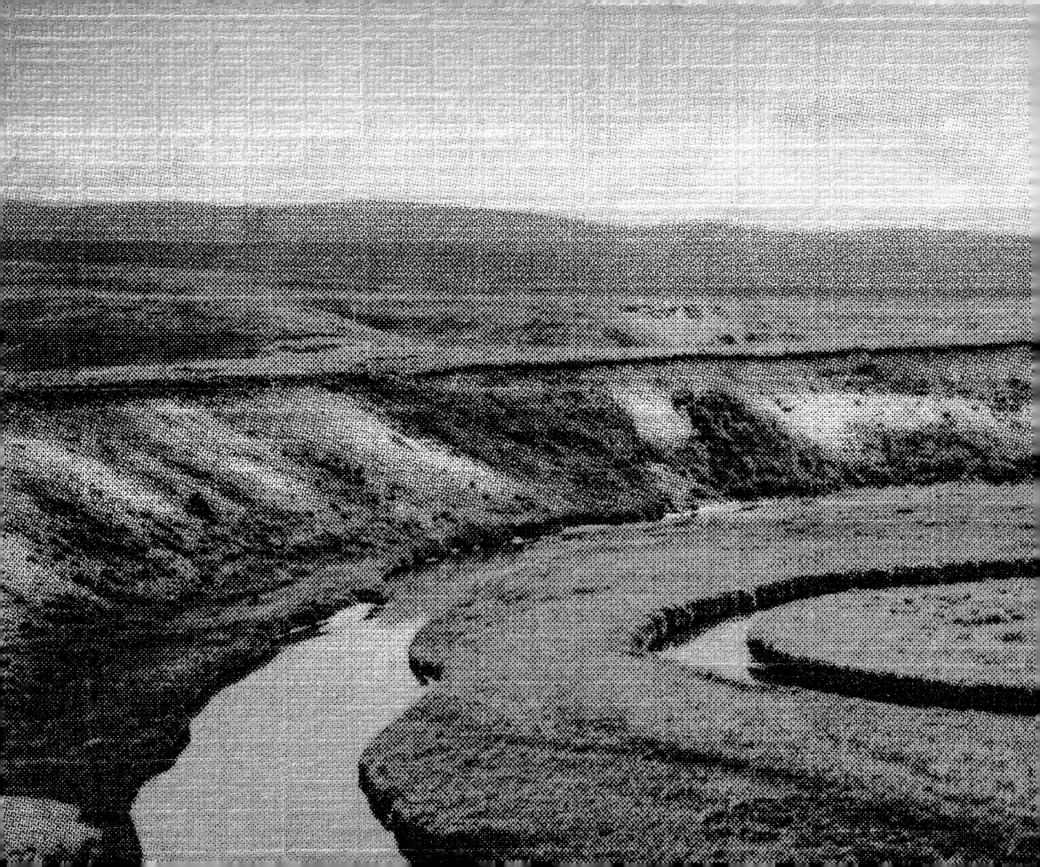

LANDSCAPE

OUT OF
THE WILD

by Leslie Erganian

"OH BEAUTIFUL FOR SPACIOUS SKIES, FOR AMBER WAVES OF GRAIN, FOR PURPLE MOUNTAIN MAJESTIES ABOVE THE FRUITED PLAIN!"

— KATHARINE LEE BATES, 1893

TROUT CREEK
Yellowstone National Park,
Wyoming, 1935
Trout Creek, with perfect symmetry,
has cut through meadowland
to form the design of the ancient
Chinese monad (the trademark of
the Northern Pacific Railway).
[previous spread]

THE STORY OF LANDSCAPE IS OF NECESSITY a story about how man affects it. Be his footstep light upon the earth, as it was with the Native American cultures, or heavy, as it has been throughout the most recent two centuries in the American West, the landscape is altered by what man does to it, in how he either exploits or preserves, hinders or enables our blue planet's natural processes, for better or for worse.

The need for growth and expansion has dictated the better part of what changes we, as a society, have wrought upon our terrestrial home. This has occurred throughout what we think of as modern and intelligent times, but which, inevitably, will seem outdated and ill-considered to future generations. However, there are increasing murmurs from more forward-thinking individuals and institutions that a balance between the earth's own need not only to survive but to thrive and mankind's desire for the same must be explored, defined, designed, and manifested to ensure a healthy, sustainable, and symbiotic future for us both. As Chief Seattle observed in 1854, "Humankind has not woven the web of life. We are but one thread within it. … All things are bound together. All things connect."

The West is the perfect place to explore in order to understand the promise and the limitations of human-driven land transformation. It has only been through the four innovation waves of the industrial revolution—steam, steel, oil, and information—that the natural limits of its ability to sustain both human and plant life have been overcome by incredible advances in transportation, civil engineering, architecture, and agriculture. This has allowed for the redistribution of water to once arid and infertile geological provinces, the conveyance of goods and services to once remote and uncivilized outposts, and the preservation and enjoyment of the natural beauties of this unique place.

In 1878, explorer and geologist John Wesley Powell defined the dividing line between the North American East and West as the 100th meridian. Observing that this virtual line, cutting up through Texas, Oklahoma, Kansas, Nebraska, South then North Dakota, and on into Manitoba, Canada, marked a distinct separation between moist and arid climate regions, Powell presciently recognized the need to implement different land and water district management policies to respond to the naturally divergent constraints and capabilities of the land on either side of it. He used the concept of the 100th meridian to attempt to convince Congress to agree to enact policies tailored to support the natural limitations of land development. Legislators, however,

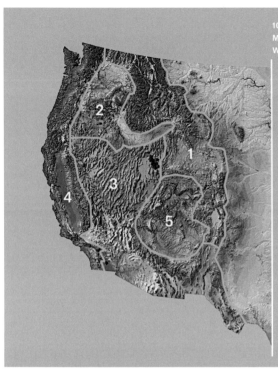

Geological Provinces of the West

1. Rocky Mountain Province
2. Columbia Plateau Province
3. Basin and Range Province
4. Pacific Province
5. Colorado Plateau Province

valuing growth above all things for their young and vigorous states and constituents, did not pay proper heed to his recommendations.

While that decision has given us the New West as we know it today, with all its wonders and its marvels, its cities and structures, its national parks and preserves, it has also given us an increasingly precarious and potentially perilous environmental situation. Twenty-first-century scientists agree that the dividing line between the moist East and arid West has advanced 140 miles to the east, to the 98th meridian, since Powell's original designation. This places untenable demands on an already overburdened western water supply system and puts the land and populace that falls between that two-degree shift at peril. Nature's bill must always be paid eventually, and never without interest for the delay.

WESTERN GEOLOGY AND HYDROLOGY
The American West is composed of five geological provinces, each with its own unique geological and hydrological characteristics: the Rocky Mountain Province, Columbia Plateau Province, Basin and Range Province, Pacific Province, and the Colorado Plateau Province.

Above ground, weather is all, conducting the story of the movement and availability of moisture it all its forms, which, in turn, dictates the viability, diversity, and growth of plant life, the migration patterns of birds, beasts, and humans, and the agricultural potency of each distinct geographical region. Weather also directs the force of erosion, the blasting and etching of the earth's soil, sediment, and rock surface by wind and water. Underneath the earth's crust, shifting tectonic plates conduct a different story.

MOUNT SNEFFELS
Rocky Mountains, Colorado, 1937
Mount Sneffels, altitude 14,143 feet, from the Uncompahgre River as seen from the Million Dollar Highway (U.S. 550) between Montrose, Ridgway, and Ouray.

CRATERS OF THE MOON
Arco, Idaho, 1937
Craters of the Moon National Monument is a vast ocean of lava flows with scattered islands of cinder cones and sagebrush. View from Big Crater Rim.

The massive scale and ruggedness of the Rockies, located at an unusually far inland distance from the ocean as compared with the rest of the world's western-edged mountain ranges, make it abundantly clear that the forces that shaped the West were of a uniquely different nature and are still at work. From a precipitation perspective, the Rocky Mountain range has the highest snowfall on earth.

Rocky Mountain Province
Where the Pacific plate subducts beneath the North American plate is where the West begins. The Rocky Mountain range erupts along the line of collision, marking a clear divide between the Interior Plains Province of the great Midwest, a region with five hundred million years of tectonic stability, and the Rocky Mountain Province, a region of geological youth, activity, and instability.

Columbia Plateau Province
The semi-arid Columbia Plateau Province, extending throughout Eastern Washington, North Central Oregon, and spilling over slightly into Northern Idaho, is covered with the world's largest accumulation of young basaltic lava, the majority of which flowed throughout a brief but productive 1.5 million years of violent volcanic eruptions that began 17 million years ago. Across nearly 15 million years of erupting and retreating, a thickness of more than

DEVIL'S CACTUS GARDEN
Palm Springs, California, 1937
"The Devil's Cactus Garden," covering thousands of acres on a sandy mesa, contains the largest variety of cacti found in any natural garden. Mount San Jacinto in background. Elevation 10,805 feet.

6,000 feet accumulated to form this igneous province that extends a massive 63,000 square miles.

Basin and Range Province

The Basin and Range Province covers much of the inland western United States and Northwestern Mexico. As the name suggests, the Basin and Range Province has twin aspects. The first region, known as the Great Basin, is an area of 200,000 square miles, characterized by having only internal water drainage, water that cannot run to the sea, and, as a consequence, either evaporates into the atmosphere or percolates down into the ground. The second region, whose topography geologist Clarence Dutton described during the late 1800s as "an army of caterpillars marching towards Mexico," consists of many small parallel north-south mountain ranges rising 8,000 to 10,000 feet above sea level and divided by small basins with a floor

elevation that varies between 3,000 and 5,000 feet. Precipitation that falls either as rain or snow melts in the spring throughout this geological and hydrological region.

Pacific Province

The Pacific Province is the geological province that extends the length of the Pacific coast of North America. It is the youngest and most tectonically active of all the western geological provinces, and, as such, is still engaged in ongoing mountain building. It is also part of the eastern edge of the Pacific Ring of Fire. The Sierra Nevada Range, which only began to rise five million years ago, is a tilted fault block, sharper and taller at the eastern edge, and sloping gently to the sea. It marks the eastern edge of the province, which includes other smaller parallel ranges with agriculturally productive valleys between. This geologically diverse region is also home to many of America's great national parks,

CATHEDRAL ROCKS
*Yosemite National Park,
California, 1934*
On entering Yosemite Valley, one is
impressed by the massive granite walls
which form the Gateway. El Capitan
on one side and the Cathedral Rocks
on the other, towering 3,000 feet
above. This is the narrowest part of
the valley proper.

including Muir Woods, Yosemite, King's
Canyon, and Olympic National Park, as well
as a varied and beautiful coastline.

Colorado Plateau Province

Once covered with tropical seas, the
Colorado Plateau Province is characterized
by sedimentary rock layers. Mesas, canyons,
and rocks formed deep inside the earth
were expelled to the surface by continental
collisions. Massive mountain ranges erupted
in due course, while the elemental forces
of wind and water sculpted their surfaces.
Weathering and erosion in this region created
such staggering delights as the Grand
Canyon, Zion Canyon, and Bryce Canyon.
These three canyons, once part of the same
structure that the Colorado River carved out
over the course of seventeen million years,
were broken and shifted into three distinct
layers, with the shared rock units between
them, creating a supersequence of formations
that geologists call the Grand Staircase. The
bottom layer, the Grand Canyon, considered
one of the seven natural wonders of the
world, is a vast and glorious chasm that the
Colorado River still etches through today
to expose deeper and deeper layers of rock,
sand, and volcanic sediment, and to reveal
the underlying layers of the earth's history
through erosion. The middle layer, Zion, is
a collection of narrow canyons that used to
sit atop the smaller finger tributaries of the
river. Bryce, a collection of odd-shaped pillars
called hoodoos, used to sit at top. The colors
throughout this region are stunning and
represent a rich variety of mineral deposits,
including copper, silver, zinc, and uranium.
By the time these minerals proved too difficult
to extract, word of the unique beauty of the
region had spread far and wide, and tourism
itself proved to be by far the most valuable
by-product of the area, thus ensuring its
preservation for generations to come.

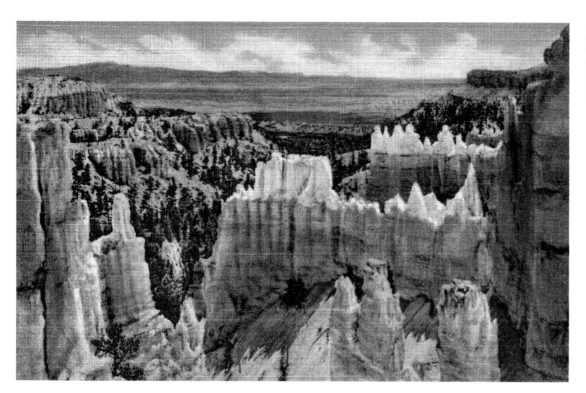

SCULPTOR'S STUDIO
Bryce Canyon National Park, Utah, 1937
This "close-up" of the Sculptor's Studio from Sunset Point shows the "Happy Family" posing for all who care to let their imagination carry them into Fairyland.

PERCOLATION AND EVAPORATION

With precipitation scarce throughout the Western United States, water was a valuable commodity, and in order to unlock the region's potential for supporting growth, it had to be collected, transported, conserved, and distributed. Huge swaths of undesirable land were transformed throughout the nineteenth and twentieth centuries by a network of dams, reservoirs, and aqueducts. Irrigation was the key that unlocked the land's potential in places such as California's Central Valley. Today, more than fifty percent of the nation's fruits, vegetables, and nuts come from California, including ninety-nine percent of artichokes, ninety-nine percent of walnuts, ninety-seven percent of plums, and ninety-five percent of garlic.

The construction of infrastructure to support water delivery was critical to the transformation of urban centers as well. Imported water elevated Los Angeles from a desert into a county that today supports over ten million inhabitants. No writer has ever captured this moment in history better than Robert Towne, the screenwriter of the 1974 film *Chinatown*. Set in 1937, the film was inspired by the California Water Wars, a progressive set of skirmishes over water rights in the Owens Valley of Southern California.

In real life, William Mulholland, first superintendent and chief engineer of the Los Angeles Department of Water and Power, transformed the city with a 233-mile aqueduct that brought water from the Owens River in the Eastern Sierra Nevada Mountains all the way to Los Angeles. In the film, two opposing characters were based on Mulholland, water tycoon Noah Cross, played by John Huston, and Hollis Mulwray, head of the Water

DANTE'S VIEW
*Death Valley National Monument,
California, 1931*
"Dante's View" of the lowest and the
highest points in the United States,
less than 100 miles apart and both
in Inyo County, California. Badwater,
Death Valley, 279 feet below sea
level, and Mount Whitney, 14,496 feet
elevation.

Department. Detective Jake Gittes, played by
Jack Nicholson, finds the eyeglasses of the
murdered Mulwray in the backyard saltwater
tidal pool belonging to Cross. Having already
discovered saltwater in Mulwray's lungs,
despite the corpse turning up in a fresh-
water reservoir, Gittes finally has Cross in his
crosshairs.

Cross, unflinching, waxes rhapsodically.
"Hollis was always fond of tide pools. You
know what he used to say about them?—
That's where life begins … marshes, sloughs,
tide-pools … he was fascinated by them …
you know when we first came out here, he
figured that if you dumped water onto desert
sand it would percolate down into the bedrock
and stay there, instead of evaporating the
way it does in most reservoirs. You'd lose only
twenty percent instead of seventy or eighty.
He made this city."

TIME

There is something of the western wilderness
that declares itself so strongly that it compels
awe and a recognition of one's place in the
world. Only when we recognize our human
smallness compared to the height of a
mountain, the breadth of a desert, or the
expanse of an ocean, or accept the shortness
of our lives in contrast to the 4.5 billion-
year lifespan of the earth, can we begin to
understand what we owe to that landscape
as its temporary stewards. In the words of
Lyndon B. Johnson in 1964, "If future
generations are to remember us with gratitude
rather than contempt, we must leave them
more than the miracles of technology. We
must leave them a glimpse of the world as
it was in the beginning, not just after we got
through with it." We must ensure that while
we are intent on coming out of the wild, we
preserve enough places to return to it.

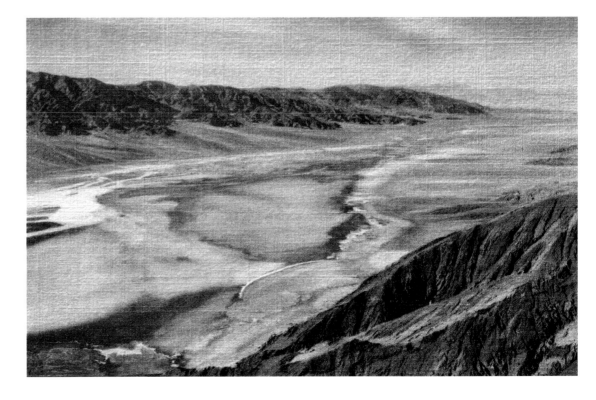

EXPLORATION

LANDSCAPE IN THE AGE OF STEAM

Extraction was a mighty force behind the shape-shifting of the western wilderness throughout the nineteenth century. The discovery of a few suspicious yellow flakes floating in the American River at Sutter's Mill in 1848 seduced a mass migration of men to go west and carve out their fortunes with a pickax in the California Sierras.

A vast material and human infrastructure arose within the span of six years to help them do it. Supplies and merchants, housing and laborers, banks and bars erupted in rapid order, tripling the new state's population. Without the lure of gold, aided and abetted by the steam engine, neither word nor worker would have traveled so far so fast. The salt of Salt Lake City, borax of Death Valley, and cinnabar of Almaden on the Bay of San Francisco, necessary for gold refinement, were just as ready for plucking. This trammeling age of industry left toxic by-products and scars that are still visible today.

Looting the landscape always comes first to a virgin territory, and it included large-scale logging in the Pacific Northwest and fishing up and down the Pacific coast. The softer pursuits of agriculture followed, requiring more skill, a longer time horizon, interdependence with the land, and water delivery across great distances. The natural riches of the West were bountiful, and the appetite of this wave of explorers and settlers was ravenous.

"THE MEEK SHALL INHERIT THE EARTH,
BUT NOT ITS MINERAL RIGHTS."

— J. PAUL GETTY, 1965

GOLD DREDGE
Marysville, California, 1943
These gold dredgers working on the Yuba River are the mechanical replacement of the "49-er", who panned the gravel for gold nuggets and gold particles lying in the stream courses. The process of drawing the gravel from as deep as 100 feet to bedrock, washing, and amalgamating, is all done in one continuous operation within these dredges.
[previous spread]

COAL MINING
Rock Springs, Wyoming, 1936
Rock Springs is one of the great coal mining centers of the West and coal mining areas are dotted all about it.

SALT BEDS
Great Salt Lake, Utah, 1934
This great salt sea, located 15 miles west of Salt Lake City, is the largest of its character in the world. The water is about 22% solids and one may float upon its surface without effort. Thousands of tons of salt obtained by solar evaporation are shipped from the shores of this lake annually.

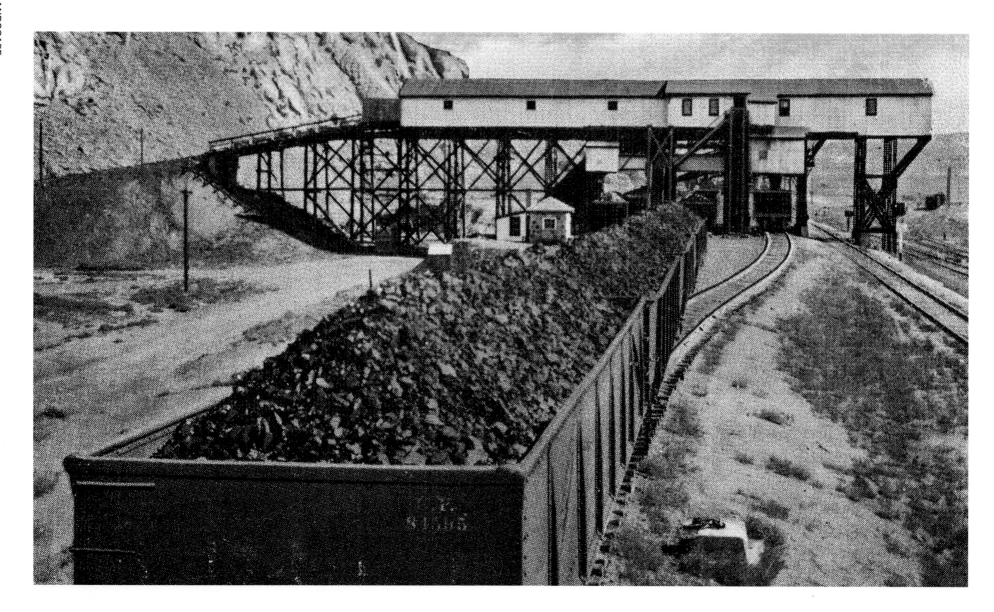

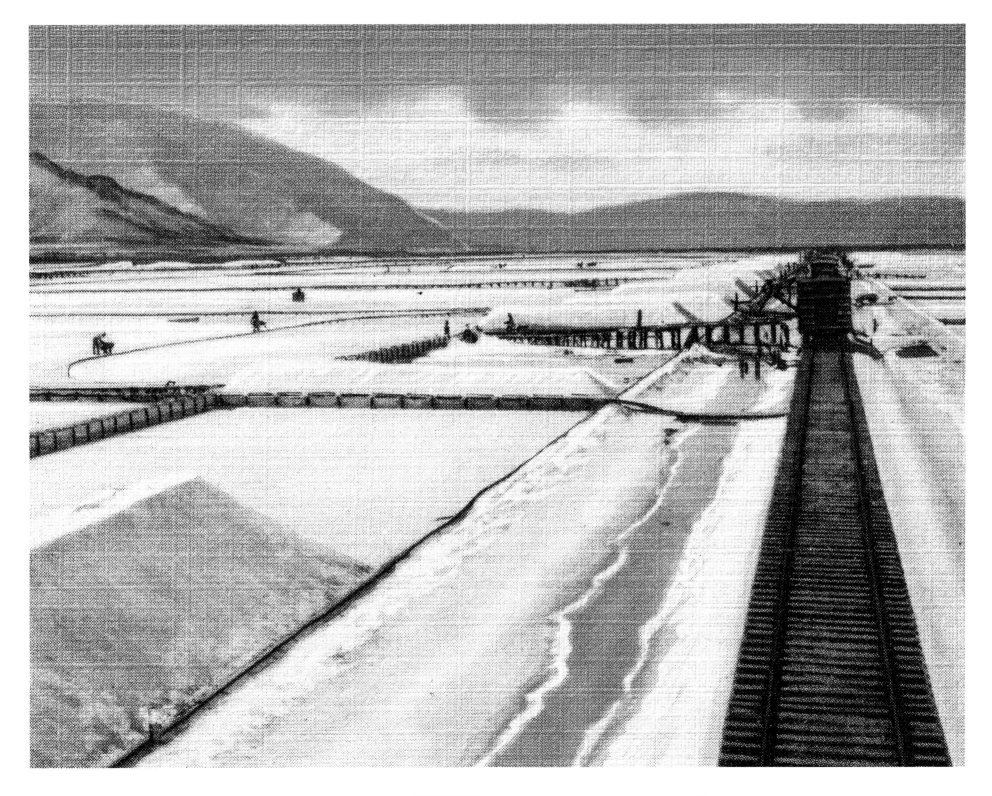

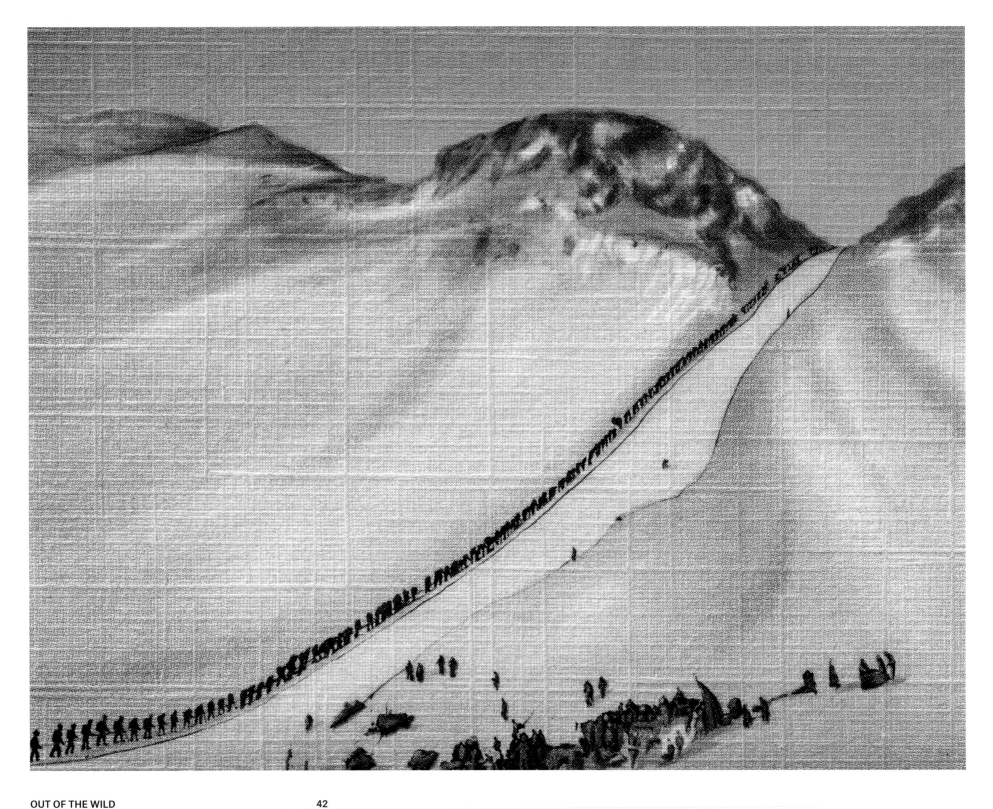

GOLD RUSH
Skagway, Alaska, 1937
News of the sensational discoveries of gold in Alaska in 1896–98, startled the world. Fifty thousand gold hunters from far and wide stampeded into Alaska. Distance and inaccessibility of the field, the hardships and vicissitudes only tended to make the diggings more attractive. To cross the divide over back-breaking, hazardous Chilkoot Pass, a climb of 11 miles, is one of the outstanding memories of a glamorous past.

UNDERGROUND DRILLING
Butte, Montana, 1938
Copper mine, 3,000 feet underground. As copper mining ramped up, it attracted workers from all over the world, creating a cosmopolitan setting for the city against the backdrop of the Continental Divide.*

COPPER MINE
Bingham Canyon, Utah, 1941
Utah Copper Mine is located at Bingham Canyon, Utah, about 30 miles southwest of Salt Lake City. The magnitude of current daily production at Bingham can be visualized in the following figures on a recent single day's operation: Tons of ore moved, 105,000. This means 50 cars per hour or nearly one car per minute.

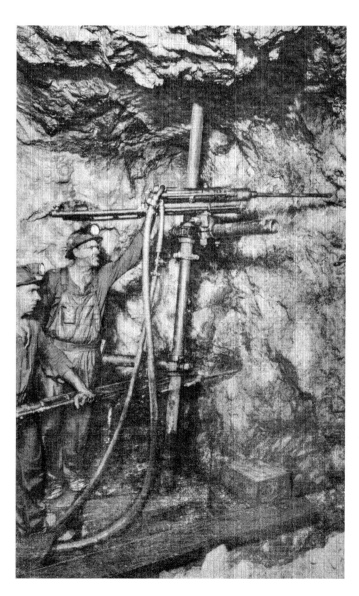

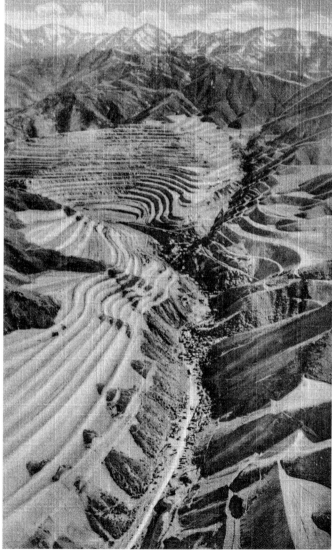

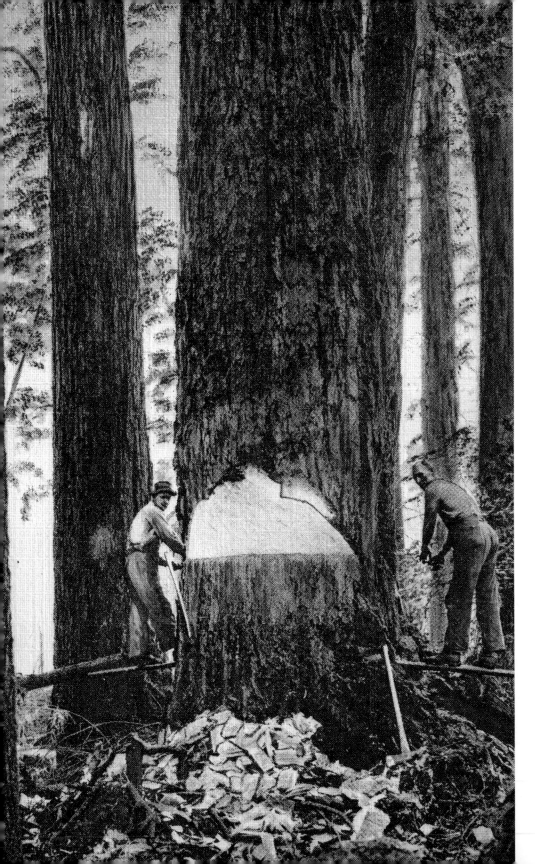

CUTTING A GIANT FIR
Tacoma, Washington, 1944
Lumber is one of Washington's leading industries. Men are shown cutting down a giant of the forest, a Douglas fir. Working on springboards, they are starting a back cut after finishing an undercut. Wedges are used to keep saws from binding and also to throw the tree.

LOGGING
Northwest Forest, Oregon, 1942
Giant timbers, 100 feet or more in length and six to eight feet square, are being cut from tall spruce growing in sections along the coasts of Oregon and Washington. Trees from which they are sawed are frequently 200 to 300 feet high.

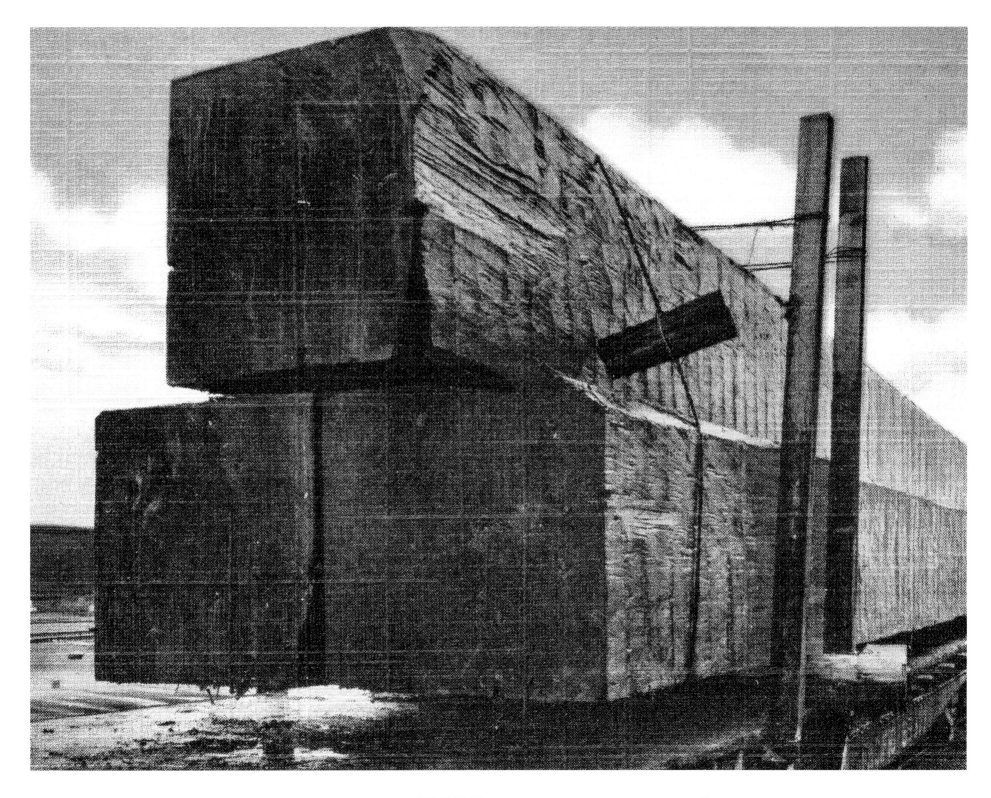

VALLEY OF HEART'S DELIGHT
San Jose, California, 1943
When it's Blossomtime in California. While the agricultural and horticultural production of the valley was limited before American statehood, by 1890 the valley had a total of 4,454,945 fruit trees, a doubling in only a decade. In 1915, the tally stood at some 7,829,677, a healthy 57% increase.

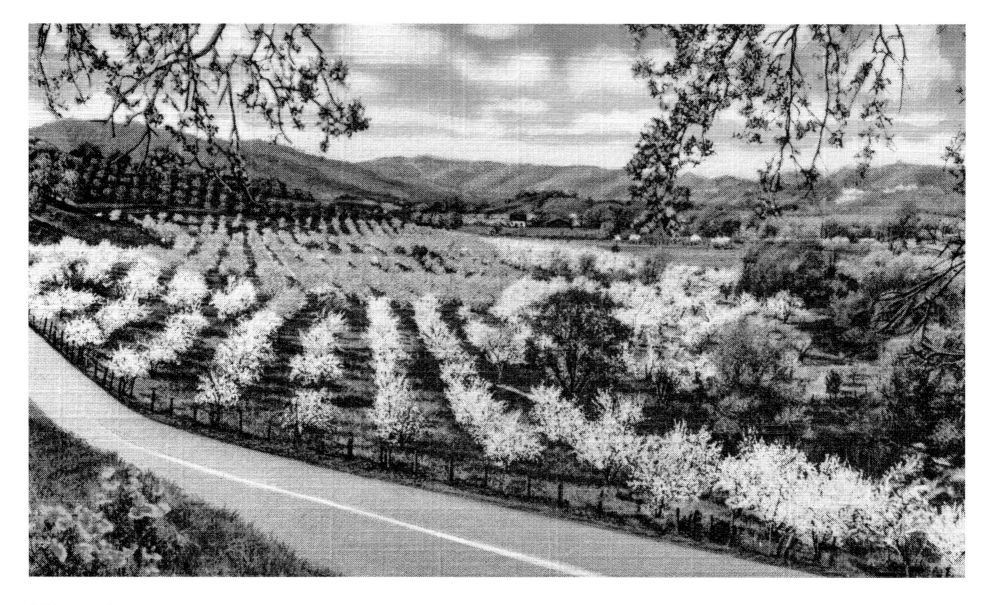

BLOSSOM TIME
San Jose, California, 1938
Blossom Time in California draws thousands of visitors to the country areas. Fiestas and festivals are held in celebration of nature's abundance and beauty.

SUTTER BUTTES ORCHARDS
Yuba City, California, 1943
Sutter Buttes are a remarkable range of volcanic peaks thrusting abruptly up from the floor of the valley. Here, some of the finest ranches, farms, and orchards in California are to be found surrounding this complete "Smallest of Mountain Ranges."

LANDSCAPE

PEN-FEEDING SYSTEM
Phoenix, Arizona, 1942
Tovrea's operates the world's largest individually owned pen-feeding system for fattening beef cattle. Over 30,000 head of cattle can be fed at one time in this gigantic operation. Tovrea's grain-tender beef is shipped to all parts of the United States and many foreign countries.

WALRUS KILL
King Island, Alaska, 1942
Explorers' experiences in the Arctic region have been noted to detail the capture of a walrus which saved the party from starvation. This was sometimes referred to as a "fortunate kill."*

ROUNDUP
Denver, Colorado, 1941
A roundup on the range, located out on the western prairies in the Rocky Mountains.*

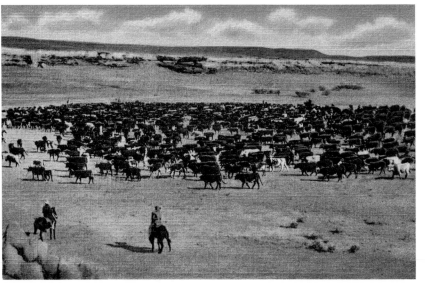

TUNA PACKING
San Pedro, California, 1942
The tuna brought to the bustling fish
markets and canneries of San Pedro
and Terminal Island became the
lifeblood of a diverse and thriving
immigrant fishing community.

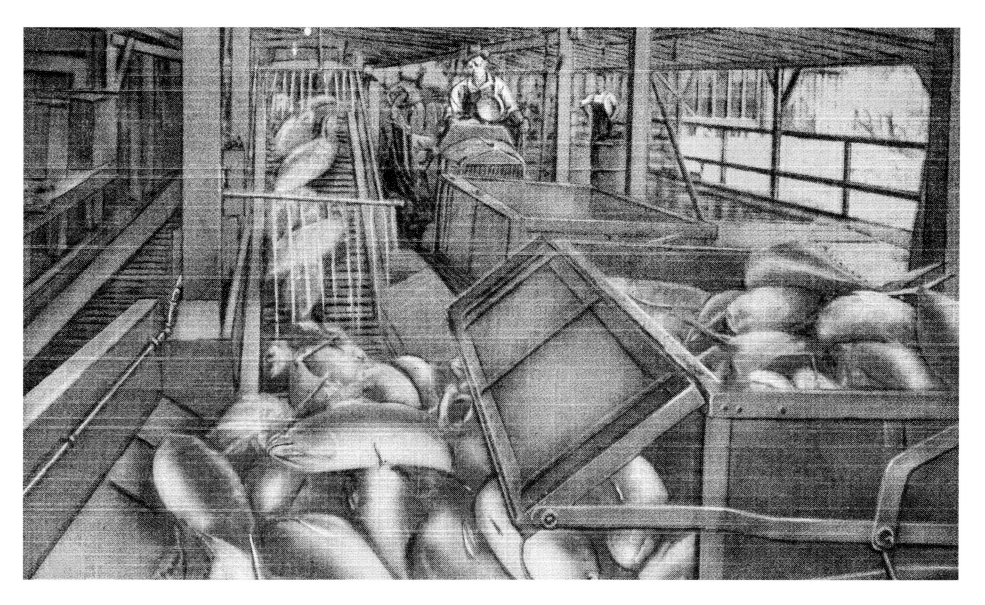

DATE GARDENS
Indio, California, 1943
Dates are harvested in Coachella Valley during the early fall months, and the men work from tall ladders, mobile steel towers, and sometimes from platforms built out from the palm's trunk. Date clusters do not ripen at the same time, and each palm is picked about eight different times.
[top left]

OLD BALDY
Upland, California, 1931
Midwinter in California combines the sight of snowcapped mountain ranges and the sight of ever bountiful valley orchards. Pictured here is a Naval orange grove.*
[bottom left]

PICKING ORANGES
Riverside, California, 1933
Navel oranges, juicy and thin-skinned, are enjoying an ever-growing demand.
[middle]

CITRUS PACKING
Riverside, California, 1943
An up-to-date California orange-packing house.*
[top right]

ORANGE BELT
Riverside, California, 1935
Southern California's Orange Belt counties of Riverside and San Bernardino were historically agricultural, with vast areas of farmable land, warm temperatures, and access to mountain water.*
[bottom right]

ORANGE GROVE IRRIGATION
Riverside, California, 1933
Navel orange trees stretch into the distance of this irrigated orchard. Parallel to the orange trees are irrigation canals, fed from the main irrigation channel pictured in the foreground, which is releasing the water to flow into the canals.*
[opposite page]

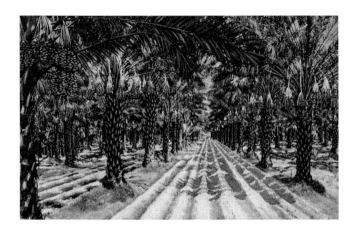

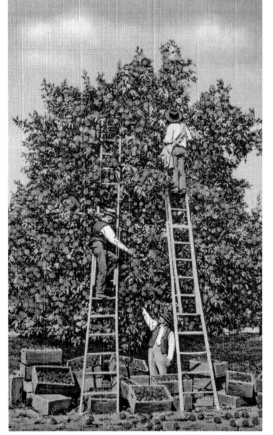

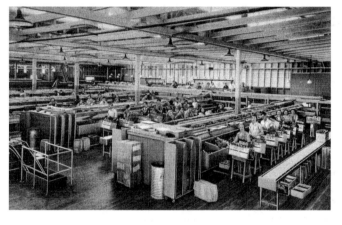

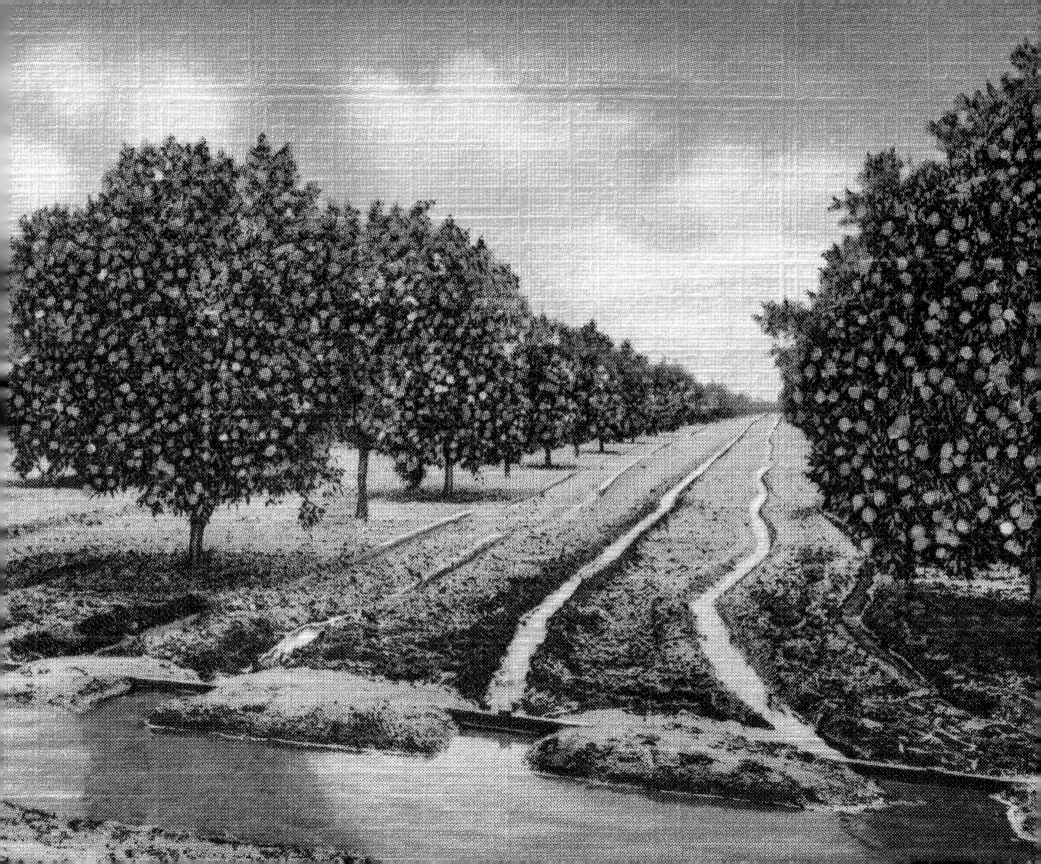

CULTIVATION

LANDSCAPE IN THE AGE OF STEEL
The rapid rise of buildings and the attendant thrum of urban activities in the age of steal, electricity, and heavy engineering throughout the American West created a concomitant need for city spaces in which to retreat and find respite. Distinctly different types of city parks emerged in response to this need, owing to the unique western topography and broad availability of undeveloped land. Dramatic site lines towards ocean and mountains, a temperate climate capable of supporting a remarkable diversity of vegetation, and an experimental attitude by landscape designers combined to produce outdoor urban spaces that transcended tradition.

Created for egalitarian access and edification, these spaces often included libraries and museums of science and art and took advantage of the scale and siting available to them. Griffith Observatory, situated inside Griffith Park, is a Los Angeles icon and a quintessential example of the best qualities and capabilities of the cultivated western landscape. Perched atop a dry, shaved mountaintop, with big-city views below and starry skies above, it makes the most of both ends of the spectrum from raw to polished nature. Irrigation delivered through 233 miles of aqueduct all the way from the eastern Sierra Nevada Mountains ensure its lawns stay lush right up to the edge where they drop off. Where else but in the West?

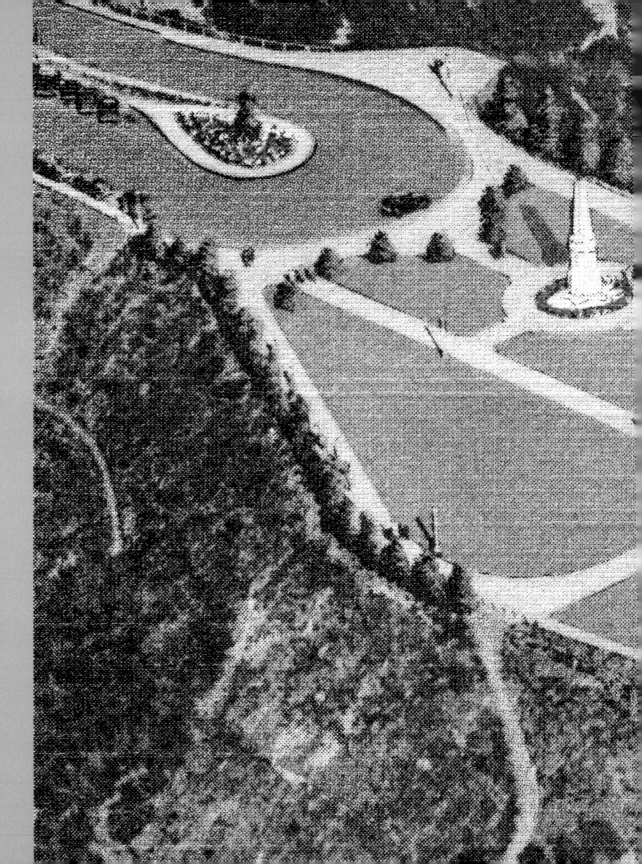

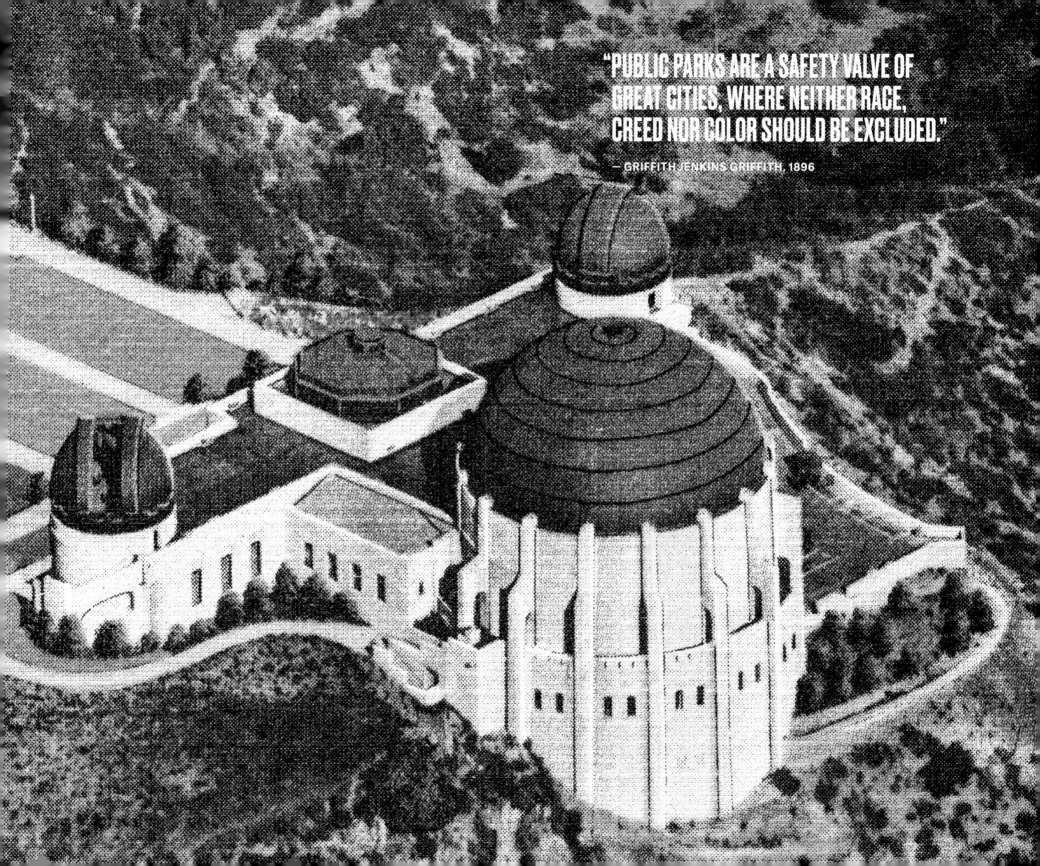

"PUBLIC PARKS ARE A SAFETY VALVE OF
GREAT CITIES, WHERE NEITHER RACE,
CREED NOR COLOR SHOULD BE EXCLUDED."
— GRIFFITH JENKINS GRIFFITH, 1896

PLANETARIUM
Griffith Park, Los Angeles, California, 1938
Griffith Park Observatory and Planetarium is one of the newest and finest planetariums in the United States. It is situated on a high peak in a setting of natural beauty with a commanding view of Los Angeles, Hollywood, and the blue Pacific.
[previous spread]

ECHO PARK
Los Angeles, California, 1938
Echo Park, situated near the heart of Downtown Los Angeles, affords a restful haven. Canoeing and motorboating are popular sports on its beautiful lake.

ELYSIAN PARK
Los Angeles, California, 1933
The park is the second-largest park in Los Angeles at 600 acres. It is also the city's oldest park, founded in 1886 by the Elysian Park Enabling Ordinance.

WESTLAKE PARK
Los Angeles, California, 1936
Beautiful Westlake Park is situated at 7th and Alvarado Streets and consists of 35 acres, two of which cover the lake. Concerts are held here every Sunday afternoon.*

LAKESIDE PARK
Oakland, California, 1935
Beautiful Lakeside Park is one of the world's largest wild game sanctuaries. Thousands of all variety of wild ducks and geese and other game birds have their mating grounds here, fully protected by the City of Oakland, and are fed twice daily at the expense of the municipality.

ORIENTAL GARDENS
Santa Monica, California, 1938
Bernheimer's Oriental Gardens, in Pacific Palisades, showcase eight acres of rare and beautiful plants and flowers, and one studded with priceless bronze statuary. Housed within the interesting buildings is a unique collection of oriental art, antiques, tapestries, and furnishings.*

MACARTHUR PARK
Los Angeles, California, 1936
MacArthur Park, named after General Douglas MacArthur, is located on Wilshire Boulevard between Alvarado and Parkview. The Elks Club is featured in the background.*

JAPANESE TEA GARDEN
San Francisco, California, 1932
The Japanese Tea Garden in Golden Gate Park, San Francisco, is a replica of old Nippon. Here are humpback bridges, stone gardens, tiny streams, bamboo trees, temples, and cherry blossoms. In cozy nooks about the grounds, visitors are served tea and delicious rice cakes by dainty Japanese maidens.

WESTLAKE PARK
Los Angeles, California, 1936
Wilshire Boulevard is one of the principal thoroughfares of Los Angeles, passing thru the exclusive Wilshire district to Beverly Hills and the beaches west of downtown.

ENCANTO PARK
Phoenix, Arizona, 1940
Encanto Municipal Park is 227 acres in extent and lies wholly within the city of Phoenix. This picture is taken from a sundeck of the clubhouse, which faces an excellent 18-hole golf course to the north, and to the east and south the lake, with its two-mile system of lagoons, where boating is enjoyed the year round.

LA FAYETTE PARK
Los Angeles, California, 1941
Clara R. Shatto donated 35 acres of land to the City of Los Angeles in 1899. The land consisted of tar seeps and oil wells, and Shatto requested that it be developed into a public park. The name was changed to commemorate Marquis de La Fayette, a military officer of the American Revolutionary War, in 1918. A statue of him was erected in 1937.

LINCOLN PARK
Long Beach, California, 1941
Restful Lincoln Park, at Pacific Avenue and Ocean Boulevard in downtown Long Beach, features an array of beautiful plants and flowers. The public library is visible in the distance.*

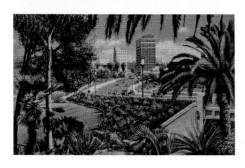

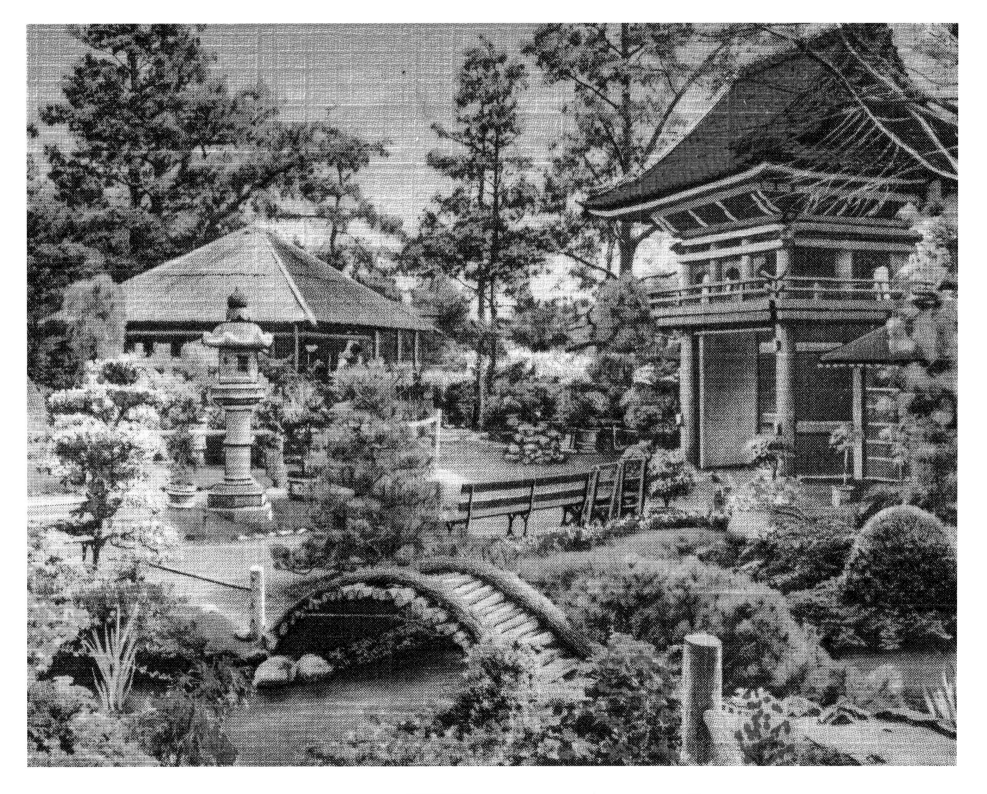

PAPAGO PARK
Phoenix, Arizona, 1936
Papago Park is an area of unspoiled desert, displaying a wide variety of cactus and desert growth. Rough, red rock, butte-like hills create a vivid scar in this park. Deeply eroded, these rocks form themselves into fantastic shapes and figures—the most famous of which is "Hole in the Rock."

MEMORIAL PARK
Provo, Utah, 1937
Mount Timpanogos stands as a guardian over the valley of Utah County. The highest mountain in the Wasatch Range, it is capped with a perpetual glacier.

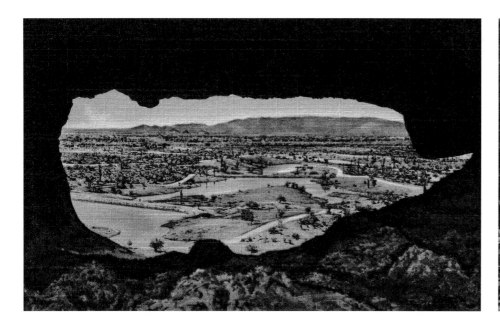

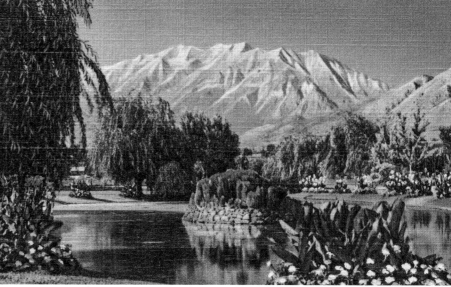

NATIONAL CEMETERY
Los Angeles, California, 1945
The Los Angeles National Cemetery,
a United States Veterans
Administration Cemetery in
West Los Angeles, has grown to
more than 114 acres since its late
19th-century origins.*

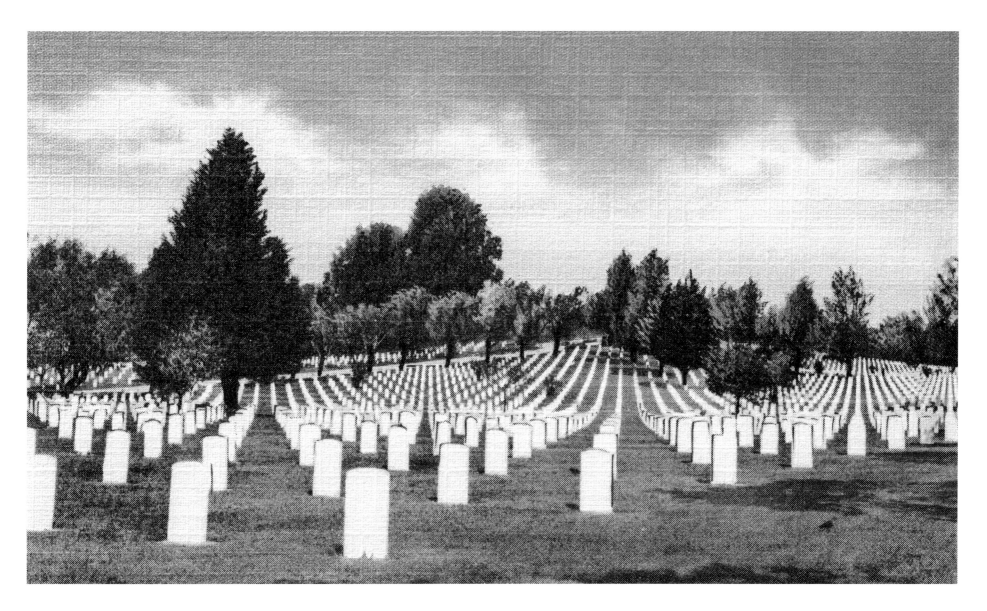

CONSERVATORY OF FLOWERS
Golden Gate Park, San Francisco, California, 1932
In this great glass-enclosed building, all manner of plants and flowers are grown, many of them for the purpose of transplanting in the park. The shrubs and delicate plants of practically every country are here on display. In front of the structure, great beds of colored flowers form continuous greetings to San Francisco visitors.

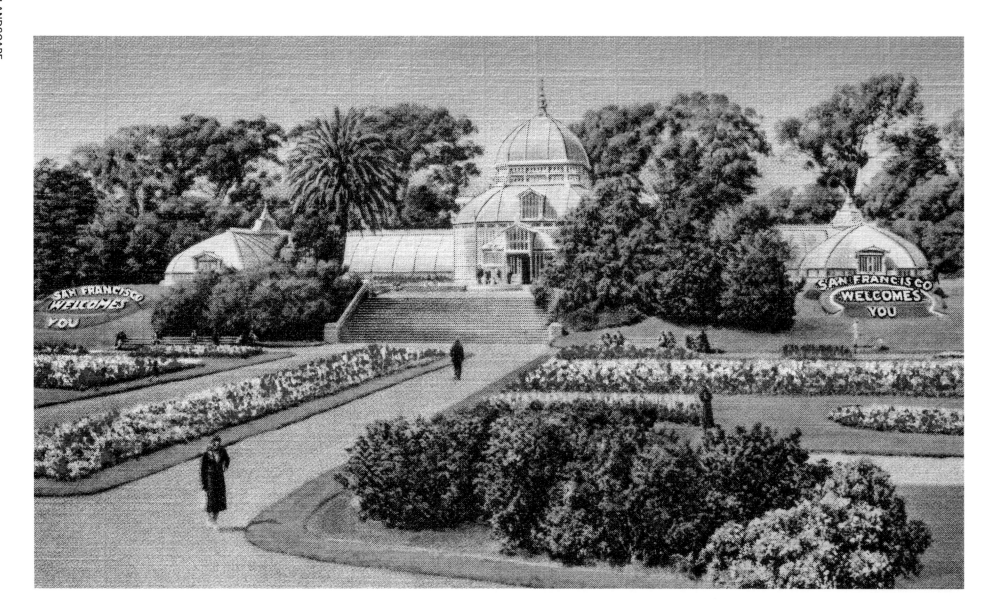

BAND STAND
Golden Gate Park, San Francisco, California, 1932
The Golden Gate Park Band Stand and elm-shaded concourse, trained to form a natural pergola, provide an all-year-round outdoor Temple of Music, where San Francisco residents may spend Sundays and holidays listening to the band concerts.

EGYPTIAN SHRINE
Rosicrucian Park, San Jose, California, 1937
This is a replica of the original shrine built in early history in the Temple of Karnak in Egypt. The shrine shown is located in Rosicrucian (Amorc) Park, San Jose.

BOTANICAL BUILDING
Balboa Park, San Diego, California, 1933
The Botanical Building and lagoon in front of it constitute a perennial beauty spot. The lagoon in season is massed with lotus and pond lilies of many hues.

STEINHART AQUARIUM
Golden Gate Park, San Francisco, California, 1932
One of the finest collections of fish in the world is housed in this building of the California Academy of Sciences in Golden Gate Park, San Francisco. In great glass cages, excellently lighted, the fish found in all parts of the earth are assembled.

DE YOUNG MEMORIAL MUSEUM
Golden Gate Park, San Francisco, California, 1934
The de Young Memorial Museum, in Golden Gate Park, is the best possible monument of the public spirit of the people of San Francisco. Much of this success was possible because of the personal interest and gifts of the late M. H. de Young.

ELECTRIC FOUNTAIN
San Diego, California, 1938
Plaza Park, with U.S. Grant Hotel in background, features a fountain in the middle of the plaza designed by Irving Gill, modeled after the Choragic Monument of Lysicrates. Louis J. Wilde, banker and part-owner of the U.S. Grant Hotel, donated $10,000 to help build the Electric Fountain, completed in 1910.*

PORTAL OF THE PAST
Golden Gate Park, San Francisco, California, 1932
When the fire of 1906 destroyed much of San Francisco, all that remained of one of the Nob Hill mansions was the portals before the building. These "Portals of the Past" were presented to the Golden Gate Park, and there placed on the shore of a picturesque lake.

**THE HUNTINGTON LIBRARY
AND ART GALLERY**
Huntington Botanical Gardens, San Marino, California, 1936
Adjoining Pasadena, on the Henry E. Huntington Estate in San Marino, is the Henry E. Huntington Library and Art Gallery, containing a vast collection of art treasures, priceless books, and historic manuscripts and letters. This ranks among the world's greatest museums.

**MUSEUM OF HISTORY,
SCIENCE AND ART**
Exposition Park, Los Angeles, California, 1932
The Museum of History, Science and Art is the largest natural and historical museum in the western United States. The moving force behind it was a museum association founded in 1910.*

MUNICIPAL AUDITORIUM
Rainbow Pier, Long Beach, California, 1933
Located on a filled-in beach, within the shelter of the famous Rainbow Pier, the building contains three meeting halls with a seating capacity of over 7,500.

PERSHING SQUARE
Los Angeles, California, 1936
Pershing Square is a picturesque oasis in the heart of the downtown business district, Los Angeles, California.

CENTRAL LIBRARY
Los Angeles, California, 1931
The central library, built in 1926, is located near the heart of the shopping district of Los Angeles. It contains seventeen reading rooms, a music room, art room, and lecture hall, each devoted to specialized service to the public. One of the most beautiful and complete public libraries in America.*

OUTDOOR ORGAN
Balboa Park, San Diego, California, 1933
The world's largest outdoor pipe organ, facing the plaza with a seating area to accommodate 3,000 people—and daily the scene of outdoor pageants and musical events.

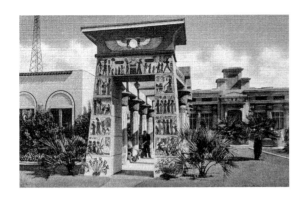
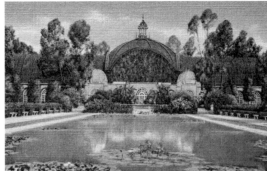
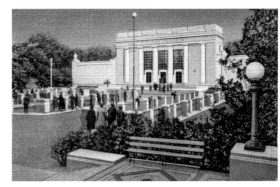
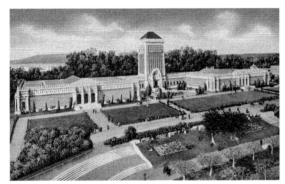
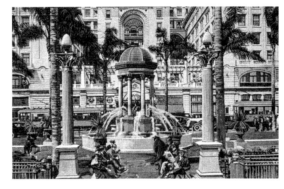

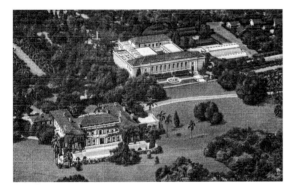

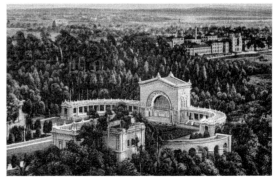

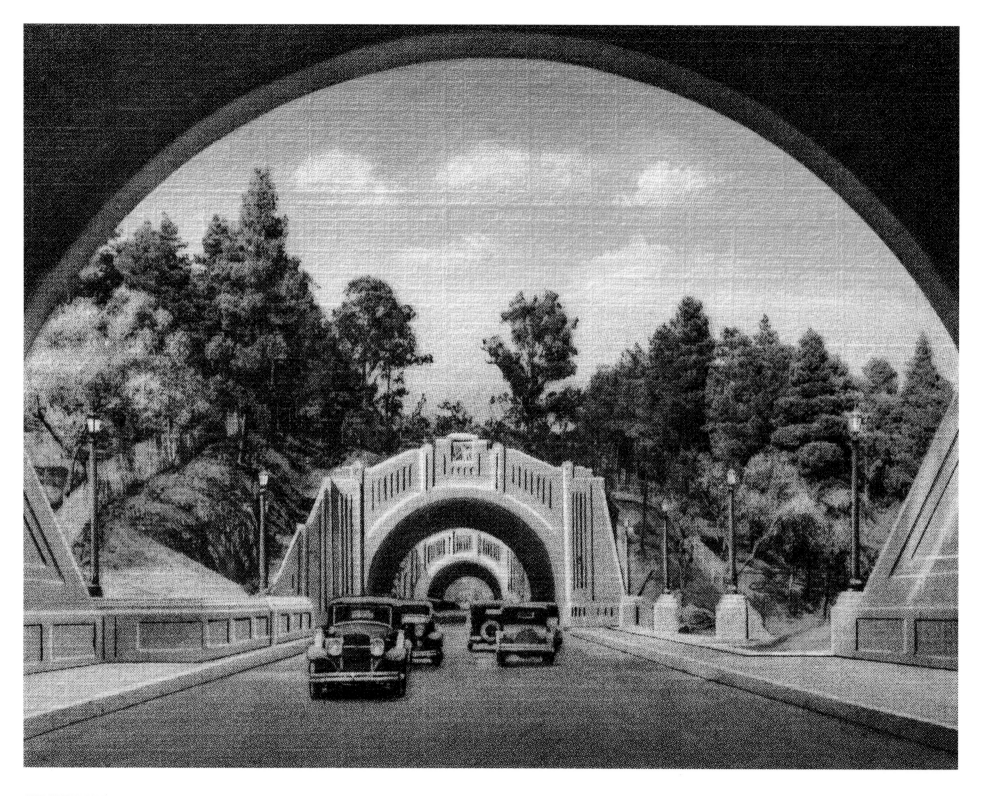

FIGUEROA STREET TUNNEL
Elysian Park, Los Angeles,
California, 1931
The Figueroa Street Tunnels opened
in 1931. A set of four tunnels carry
traffic on the Arroyo Seco Parkway.
From south to north, the four tunnels
measure 755, 461, 130, and 405 feet
in length, 46 feet in width, and 28 feet
in height.*

PLANETARIUM
Griffith Park, Los Angeles,
California, 1935
The Griffith Observatory includes
a planetarium, hall of science, and
12-inch refracting telescope. It is
the gift of Griffith J. Griffith to the
City of Los Angeles. Opened on
May 15, 1935, it is located at an
elevation of 1,135 feet on the slope
of Mount Hollywood.*

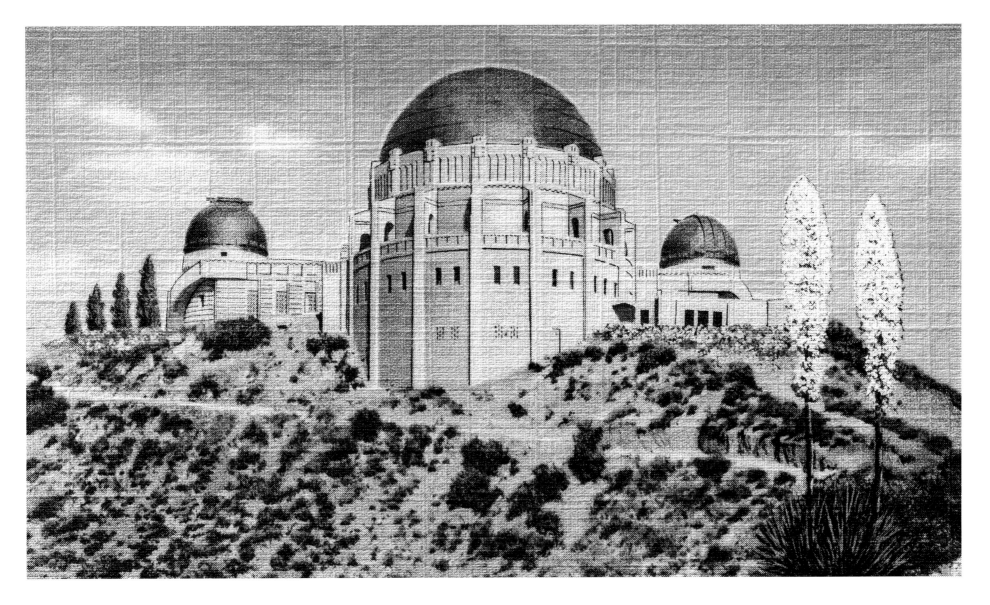

RECREATION

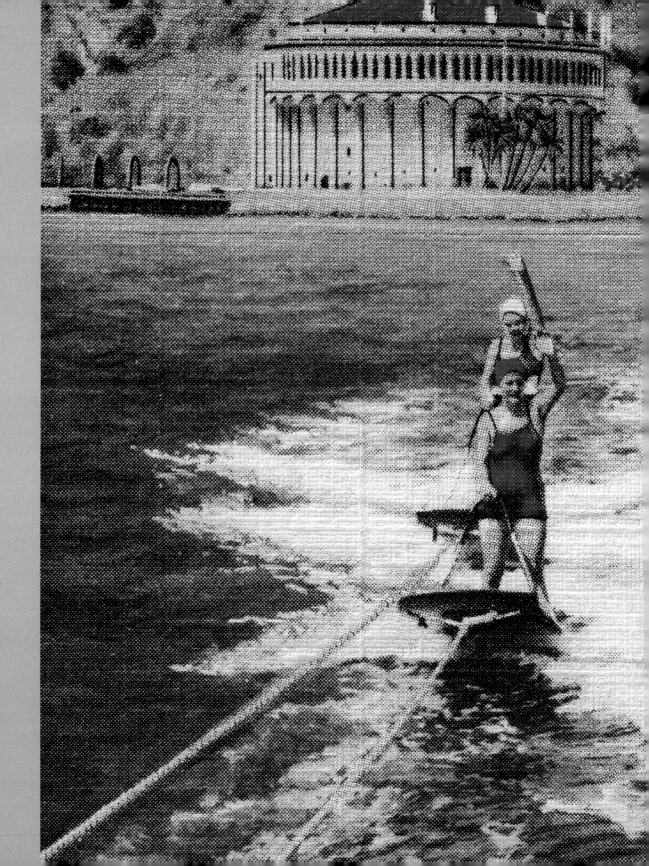

LANDSCAPE IN THE AGE OF OIL

Personal transportation not only transformed the western landscape but almost every citizen's ability to enjoy it. With car and oil affordability and availability, and a vast developed network of highways crisscrossing the states, it was possible for a person of ordinary means to experience the breadth of natural beauty offered throughout the West. From driving to camping, sunning to swimming, surfing to skiing, and hiking to chilling, Americans took to the road in droves to explore the mother lode of natural beauty that is the West.

Day-trippers who already lived in the West had easy access to breathtaking natural wonders, often with the capacity to be up a mountain or in the ocean within hours. Citizens living on the other side of the 100th meridian made family sojourns across the continent to witness the eroded spectacle of Arizona's Grand Canyon in all its multicolored glory, or to pay homage to the tallest living plant specimens on earth, the Redwoods, in such urban-adjacent locations as Muir Woods, sixteen miles north of San Francisco.

Landscape in the age of oil was also transformed by the ability to quickly, easily, and affordably transport the agricultural bounty that water redistribution, through public works built during the prior age of steel, enabled. The broad availability of the freshest produce and meat in the country made fresh-eating itself a western pastime, and in decades to come a transformative regional cuisine.

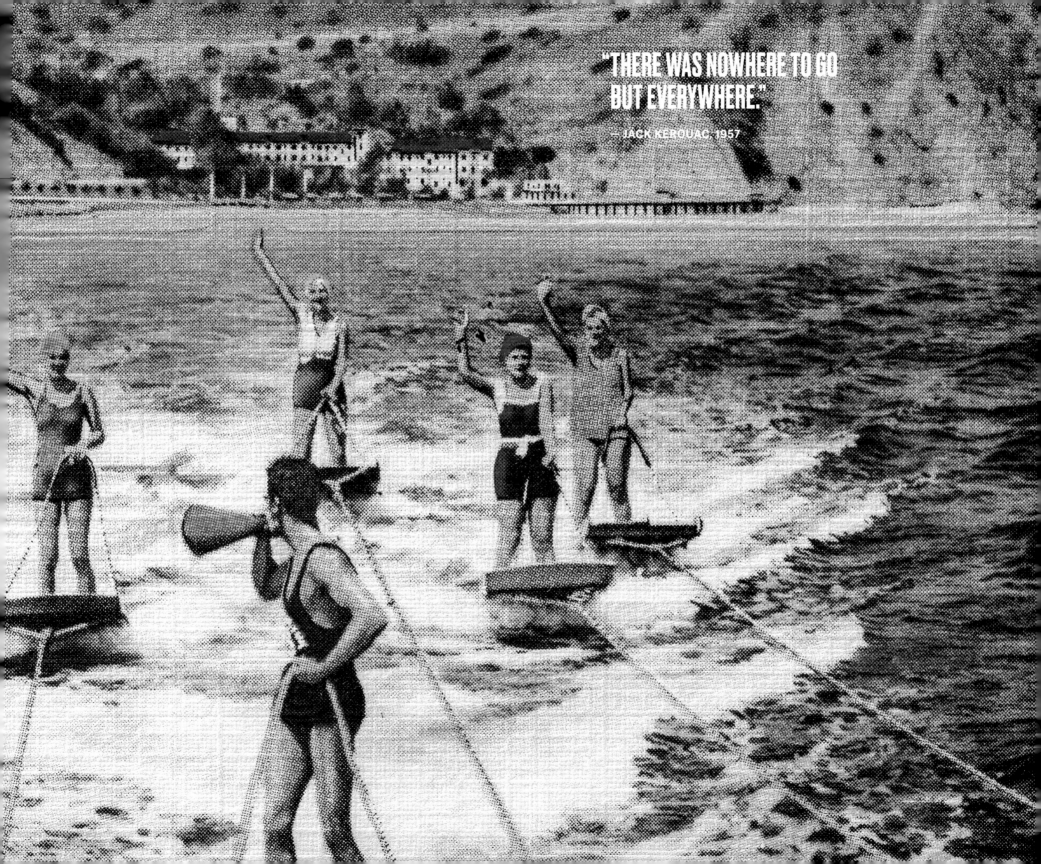

"THERE WAS NOWHERE TO GO
BUT EVERYWHERE."

— JACK KEROUAC, 1957

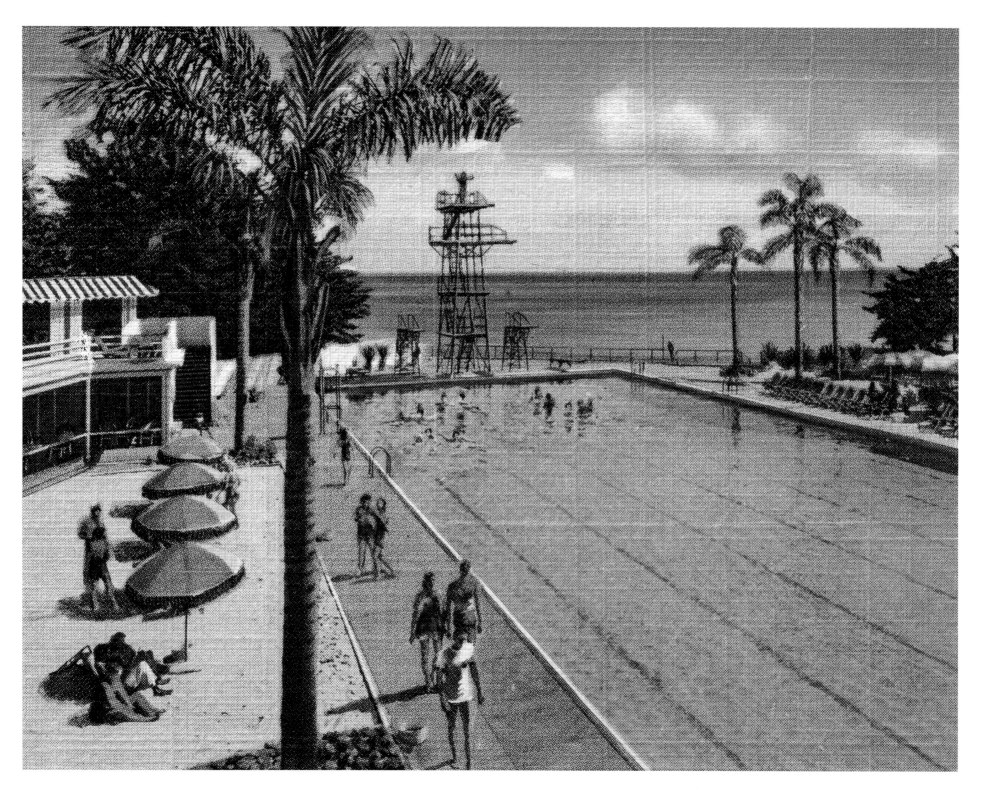

AQUAPLANING
Santa Catalina Island, California, 1935
Water sports at Santa Catalina
Island are a never-ending delight.
Speedboating and aquaplaning around
Avalon Bay and along the shores of the
sheltered crystal clear waters afford
a thrill that will live long in memory.
[previous spread]

CORAL CASINO
Santa Barbara, California, 1940
Every facility for entertainment and
enjoyment surround the magnificent
swimming pool at the Santa Barbara
Biltmore's smart beach club—"Coral
Casino." There is a beautiful dining
and dancing salon, an open patio,
a distinctive cocktail lounge, and
cabanas that represent the ultimate
in semiprivate beach lounges.

WELCOMING CROWDS
*Avalon, Santa Catalina Island,
California, 1940*
Welcoming crowds gather to greet
the daily arrivals of the steamer from
the mainland with cheerful songs and
laughter. Avalon's gaily tiled Fountain
Plaza, with its bowers of palm and
olive trees, and the soft music of
troubadours, is a place where the
realism of everyday life becomes
suddenly unimportant. It is a place
to play, to dream, to let the rest of the
world go by.

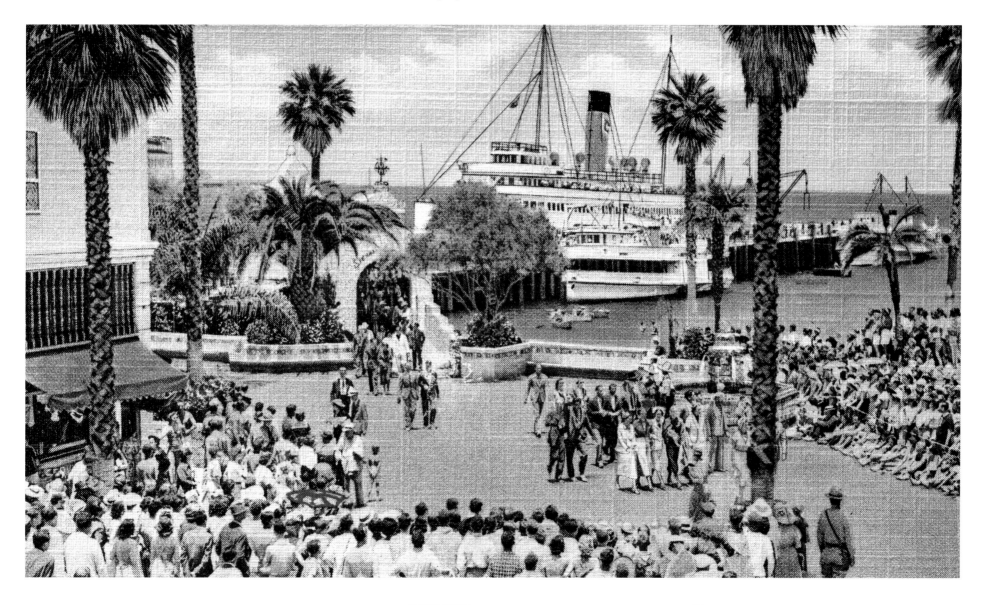

CROWDS ON THE BEACH
Santa Cruz, California, 1938
During the summer months, hundreds of thousands of people vacation on the beaches here in front of the casino.

FLEISHHACKER SWIMMING POOL
San Francisco, California, 1932
The world's largest outdoor heated swimming pool is located at the southwestern end of San Francisco—at Fleishhacker's Playground. The tank is one thousand feet in length and is filled with six million gallons of seawater. Aquatic events are regularly held in the huge tank.

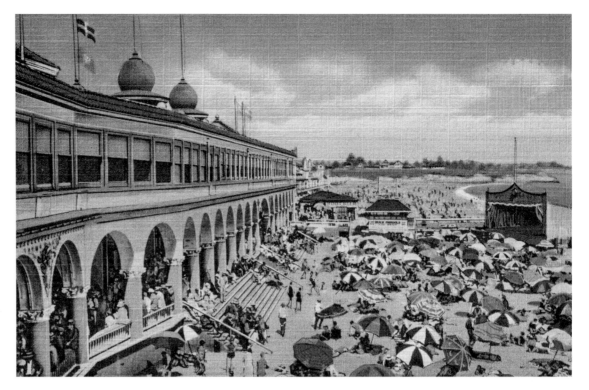

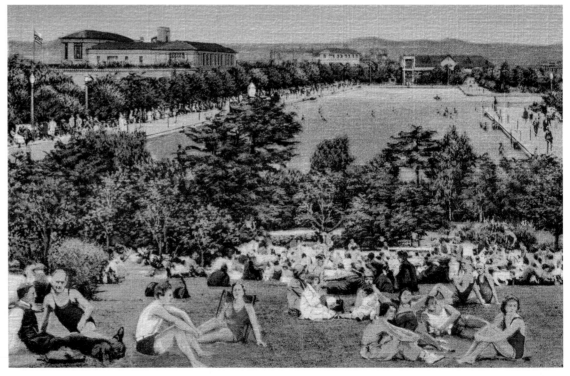

LOS ANGELES COUNTY BEACH
Santa Monica, California, 1931
Overlooking the beach and Roosevelt Highway, one glimpses the blue Pacific.*

BEACH ESPLANADE
San Francisco, California, 1932
The San Francisco ocean beach stretches southward for several miles. In the foreground is a miniature Coney Island with various concessions. A wide esplanade extends south to Fleishhacker Playground, affording an unexcelled view of the breakers and the Pacific.

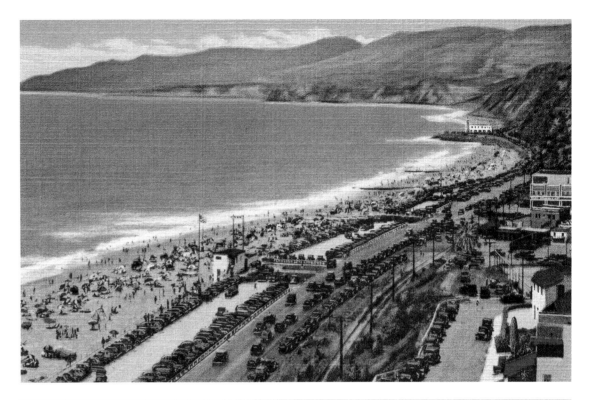

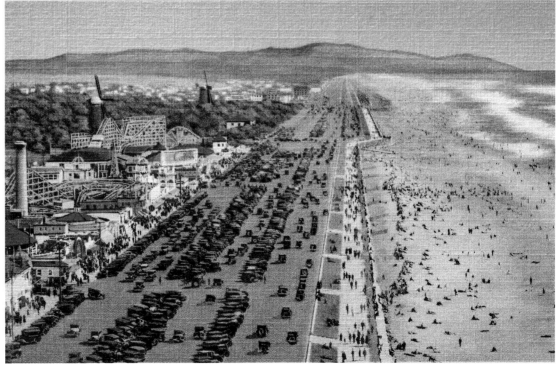

CRUISER "DESCANSO"
Santa Catalina Island, California, 1949
New, fast oceangoing cruiser, plying between Avalon and the mainland. During the summer, it makes regular trips to the isthmus and other points of interest along the shores of Catalina. The "Descanso" is shown leaving Avalon with the Tower of Chimes on the hillside and the famous casino to the right.

FLIGHT OF THE SNOWBIRDS
Newport Beach, California, 1953
The world's largest yachting event is participated in each year by yachtsmen from 6 to 96. The Flight of the Snowbirds is the most outstanding event of its kind and often as many as 200 of the little catboats will be a-sail on the bay at one time.

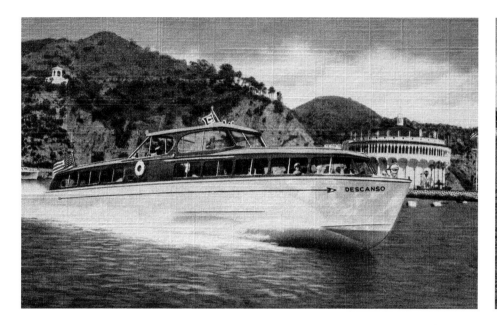

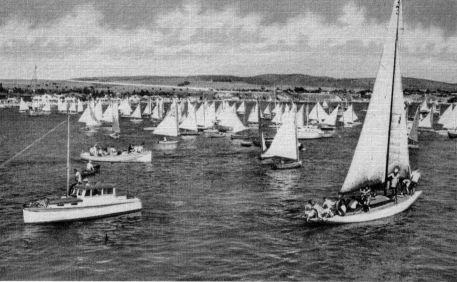

PRESIDIO GOLF COURSE
San Francisco, California, 1938
Founded in 1895 by the private
San Francisco Golf and Country
Club, the original 9-hole Presidio
Golf Course was one of the earliest
courses on the west coast. During the
Spanish-American War, the course
remained open, but was extensively
used for training and drill. After the
1906 earthquake, a refuge camp was
established here. In 1910, the course
was expanded to 18 holes.*

VENICE ATHLETIC BEACH
Venice, California, 1952
This spacious beach playground offers
recreational facilities and activities for
all ages. A separate enclosed children
area, a convenient public parking
lot, and ideal swimming behind the
breakwater add to the comfort of the
public. These facilities help make
the Los Angeles city beach at Venice
the world's best equipped.

HORSEBACK RIDERS
Palm Springs, California, 1940
Riding through the smoke trees and wildflowers is an experience long to be remembered.

ORIGINAL FARMERS MARKET
Hollywood, California, 1948
Scene in the Original Farmers Market, West 3rd Street at Fairfax–Hollywood's unique outdoor food market, where motion picture stars and Hollywood housewives shop. The world's largest, most colorful permanent food fair patronized daily by more than 15,000 Southern Californians.

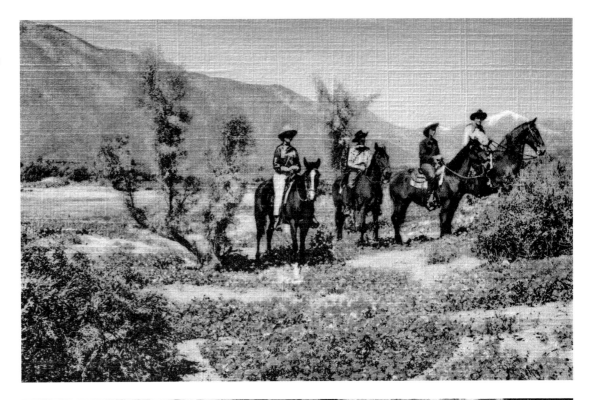

PALM CANYON DRIVE
Palm Springs, California, 1941
This beautiful palm-lined main thoroughfare is noted for its many unusual and fascinating shops.*

FISHING FROM THE PIER
Newport Beach, California, 1953
Every kind of sportfishing is to be found at Newport Harbor. Many find pleasure in fishing from the piers, others from live-bait and trolling boats. Tuna, albacore, sea bass, yellowtail, barracuda, halibut, and many others are caught in these waters. The world's record striped marlin, weighing 692 pounds, was caught just off the entrance to New Harbor.

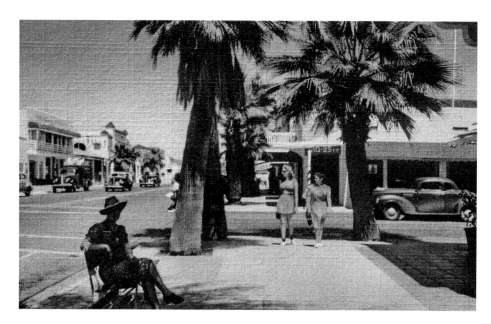

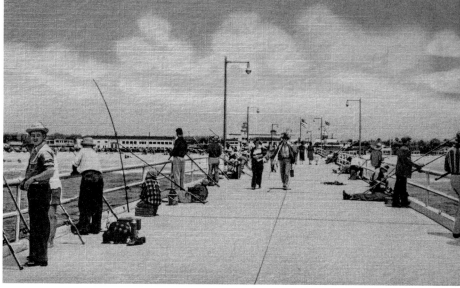

TROPICAL ICE GARDEN
Los Angeles, California, 1941

Tropical Ice Garden is the world's first year-round open-air ice-skating rink, seating 10,000 spectators and accommodating 2,000 ice skaters on its outdoor rink. The endeavor aims to "bring to Westwood Village a corner of St. Moritz, with buildings creating an exact replica of an Alpine village, set in surroundings of stately palm trees and hibiscus." The arena opened in November 1938.*

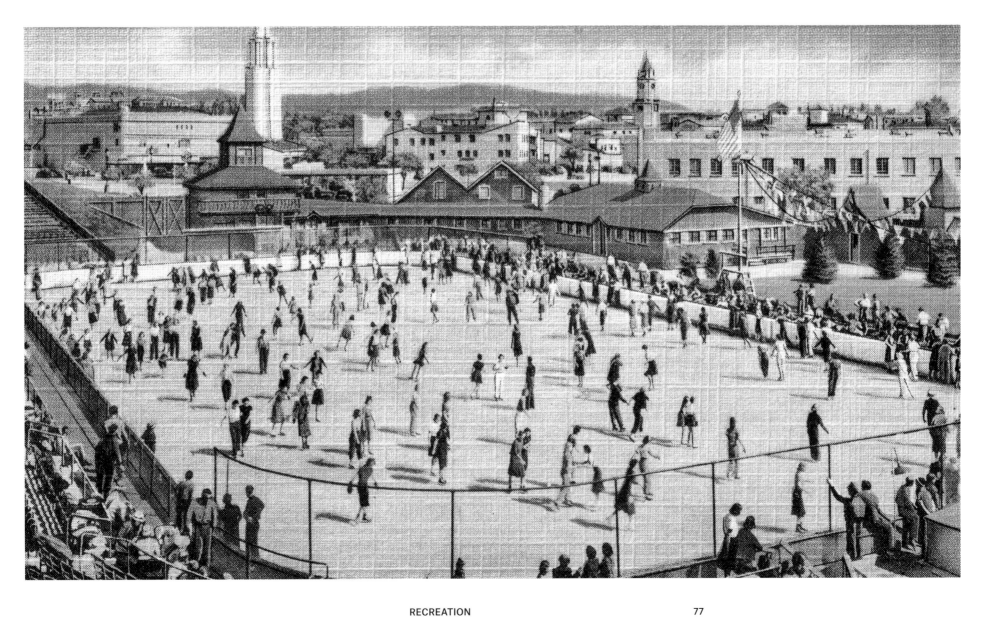

SKIING ON MAZAMA RIDGE
Rainier National Park,
Washington, 1938
America's greatest ski terrain is to be found in Paradise Valley. This mountain glacier wonderland offers a wealth of ski trails over an immense area of hills and valleys to points of outstanding scenic beauty.

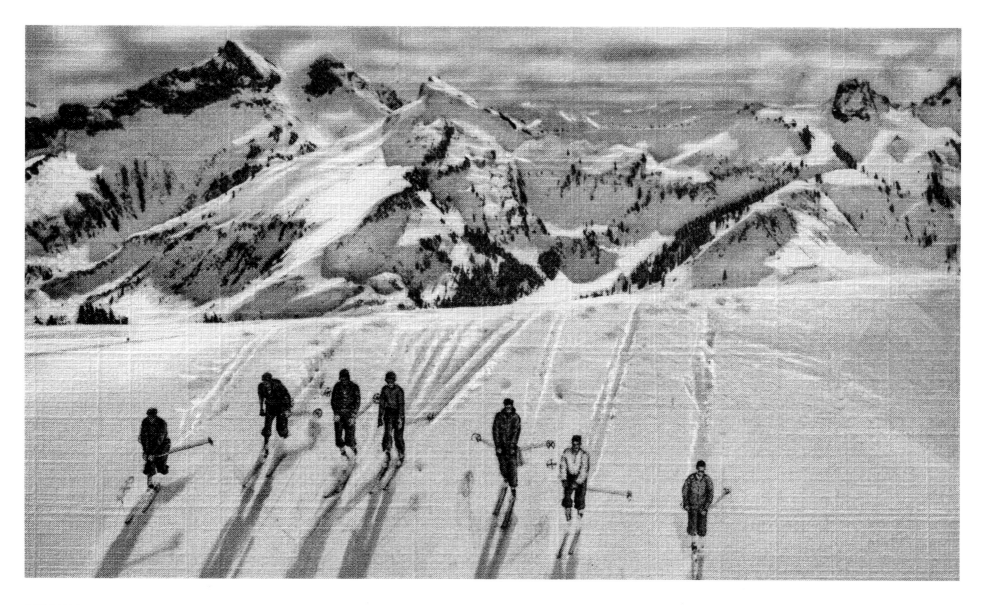

ICE CAVE
Rainier National Park,
Washington, 1938
A party under the direction of guides
entering an ice cave in Paradise
Glacier. The walls of these caves are of
crystal clear ice and in places the light
of day filters through in beautiful blue
and green colors.

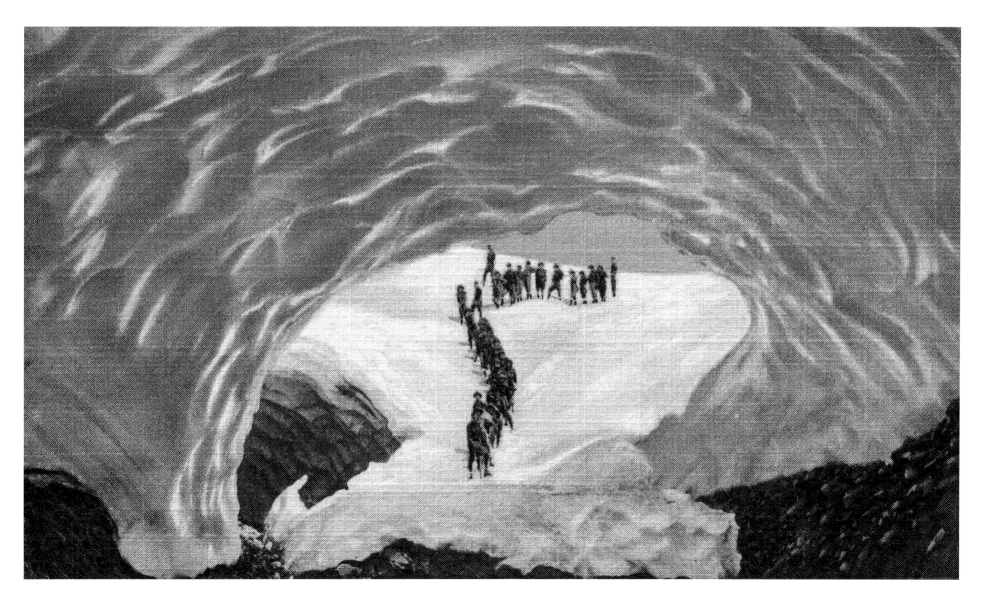

OPEN SPACE

LANDSCAPE IN THE AGE OF INFORMATION

Innovation in the age of information had the remarkable effect of lengthening the tether of life. With good roads, affordable cars, and a vibrant and vital information network from television and radio to two-way communication such as telephone and eventually the Internet, people not only felt freer to venture farther and farther out from city centers for their personal holidays but could begin to live and work at what would have once been considered the extremities of civilized society. One could be just as connected in the underdeveloped landscape as in the heart of the city. Decentralization did not have to equate to being disconnected from the pulse of the world at large. Not only could one conduct all the basics of living and working away from the more populous and vertical city centers, but one could enjoy an easier and more personal access to nature.

This ability reformed and reoriented the patterns of daily living and allowed for the transcendence of the normative. With suburban outposts farther from cities, and remote destinations closer to suburbs, the very idea of remoteness began to contract and soften, placing pristine nature in all her glory within easy reach of the everyman. This shift literally brought home the supplications of the West's original spiritual steward John Muir, and encouraged an individual mindfulness, as well as a give-and-take, with the land.

"EVERYBODY NEEDS BEAUTY AS WELL
AS BREAD, PLACES TO PLAY IN AND PRAY IN."

— JOHN MUIR, 1912

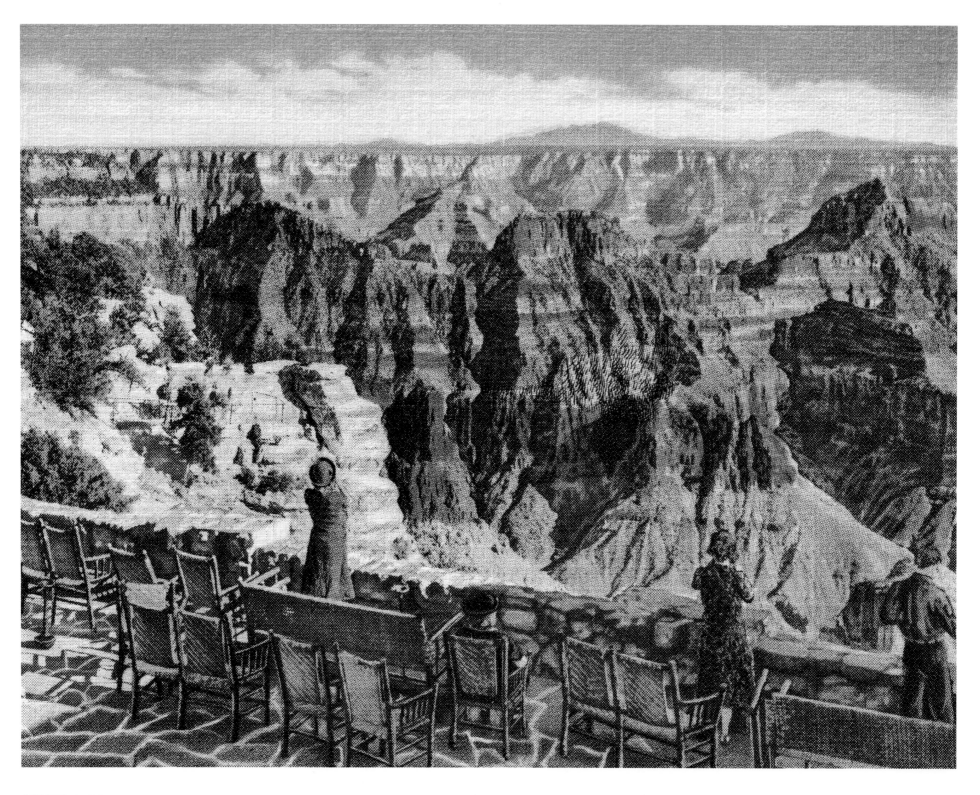

RAINBOW BRIDGE
Rainbow Natural Bridge National Monument, Utah, 1943
Rainbow Bridge is the greatest among the known natural bridges of the world and is unique in that it is not only a symmetrical arch below but presents a curved surface above, thus roughly imitating the arch of the rainbow for which it is named. Its dimension is 309 feet in the clear from the bottom of the gorge.
[previous spread]

NORTH RIM VIEW
Grand Canyon National Park, Arizona, 1938
This panoramic view presents itself to visitors to the North Rim of the Grand Canyon from the terrace of the beautiful new Grand Canyon Lodge. The canyon at this point averages twelve miles in width and is over a mile in depth. Mountains, the peaks of which are on a level with the eye, rise from the floor in all their flaming colors that defy description.

LEAP FOR LIFE
Grand Canyon National Park, Arizona, 1941
This spectacular leap was performed by a park ranger at a point known as Douglas Fairbanks Rock, about five minutes' walk east of El Tovar. The jump is 12 feet from rock to rock as indicated, with a 2,000-feet drop below, tho the Colorado River flows a mile below the Canyon's rim.

HOPI POINT
Grand Canyon National Park, Arizona, 1937
A considerable extent of the Colorado River is seen from Hopi Point, an important stop on the famous Grand Canyon Rim Drive. Even though it is several miles away, the muddiness of the river is plainly visible as it flows its swift and tumultuous course.

HIGH GEAR ROAD
San Bernardino Mountains,
California, 1937
The glorious scenic drive over the
high-gear state highway leads quickly
and easily to the beautiful land of the
sky-blue waters at Lake Arrowhead.
Wide panoramas of the whole country-
side below in colorful splendors, and
in the distance, snow-clad peaks of
Mount San Bernardino, Greyback, and
Mount San Jacinto rise 11,000 feet
above sea level.

SUMMIT HOUSE
Mount Evans, Colorado, 1941
A fine oiled highway now leads to the
top of Mount Evans, 14,260 feet above
the sea, making it the highest peak
reached by auto. A wonderful series of
panoramas and views, looking down to
different lakes, is seen from this road.

EDWIN NATURAL BRIDGE
San Juan County, Utah, 1940
Height 104 feet. Thickness, top of arch 10 feet. Width of top of arch 35 feet. Width of span 194 feet. Height of span, 88 feet.

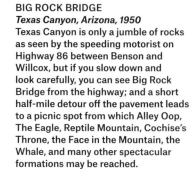

BIG ROCK BRIDGE
Texas Canyon, Arizona, 1950
Texas Canyon is only a jumble of rocks as seen by the speeding motorist on Highway 86 between Benson and Willcox, but if you slow down and look carefully, you can see Big Rock Bridge from the highway; and a short half-mile detour off the pavement leads to a picnic spot from which Alley Oop, The Eagle, Reptile Mountain, Cochise's Throne, the Face in the Mountain, the Whale, and many other spectacular formations may be reached.

VICTORIAN ARCH
Bryce National Park, Utah, 1934
Among the hundreds of gorgeously
colored imaginary cities and castles
in Bryce Canyon, one of the most
celebrated designs carved by the
winds and storms of ages in this region
is the Victorian Arch.

DRIVE THRU THE SHRINE TREE
Redwood Highway, California, 1936
The giant redwoods are thousands of years old and reach a maximum height of 375 feet and a diameter of 25 feet. To drive thru one of these monarchs creates a lasting impression of their greatness.

OLD FAITHFUL GEYSER
Yellowstone National Park, Wyoming, 1934
This is America's most famous geyser, which entertains its audience regularly every 60 to 65 minutes, erupting for approximately four-minutes duration. With 150 feet, this is also one of the world's highest and most spectacular eruptions.

FIRE FALL
Yosemite National Park, California, 1933
Each night during the summer season, a huge bonfire is built on Glacier Point, 3,200 feet directly above Camp Curry. At the conclusion of the nightly campfire entertainment, the burning embers are pushed from the point above, and this cataract of fire and sparks makes a sheer drop of over 2,000 feet before striking any obstacles, a sight long to be remembered.

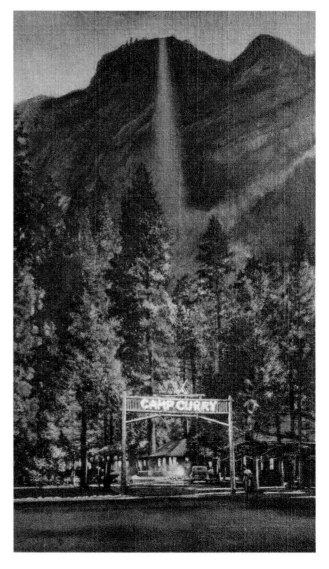

ARCHED ROCK
Yosemite National Park, California, 1940
An oddity on the El Portal Road where the highway passes through a natural formation of granite.

BOY SCOUT TREE
Redwood Highway, California, 1935
A typical redwood giant in the Redwood Empire. The "Boy Scout Tree" near Crescent City contains over 147,000 feet of lumber and is 31 feet in diameter at the base.

GLACIER POINT
Yosemite National Park, California, 1933
Glacier Point rises 3,234 feet above the floor of the valley, at which point were an object dropped, it would touch nothing for 3,000 feet. An excellent view of the valley and mountains around is to be had from this point.

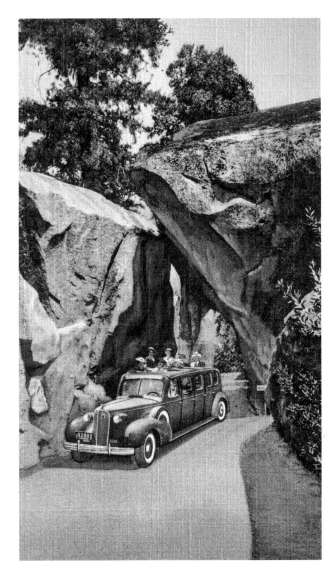

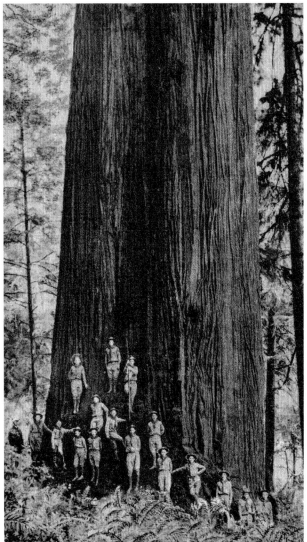

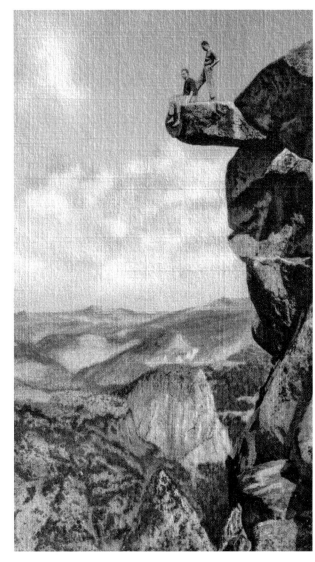

OBSERVATION POINT
Yosemite National Park, California, 1938
Daily crowds gather at this designated parking area to view one of the most commanding panoramas of the scenic grandeur of Yosemite. Auto caravans that daily tour the valley are under the guidance of a ranger naturalist, who lectures and explains the interesting features of Yosemite.

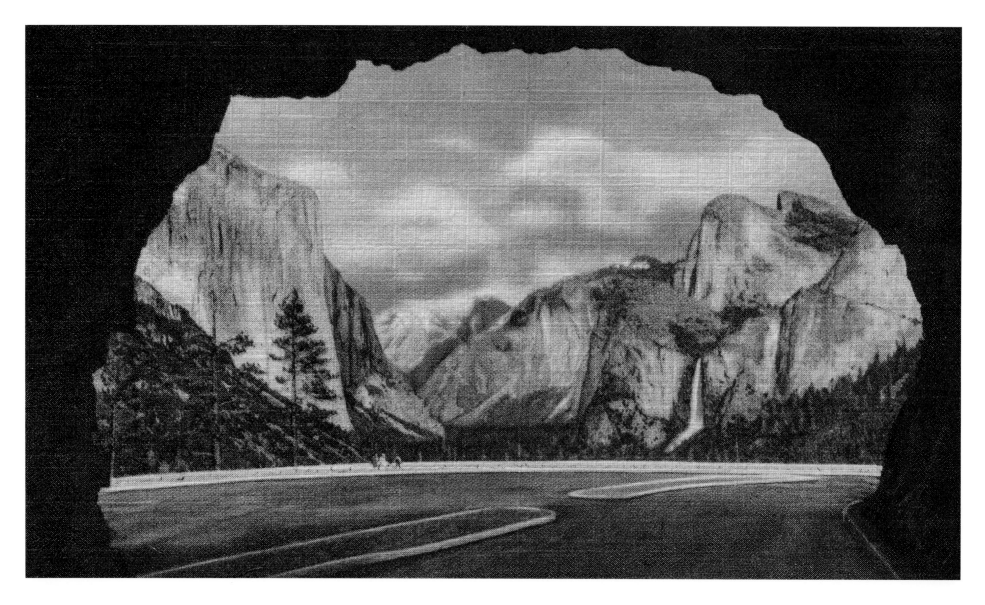

TEMPLE OF SINAWAVA
Zion National Park, Utah, 1937
As the traveler stands on the floor of Zion Canyon surrounded by towering mountains, the tops of which reach into the blue sky thousands of feet above, he feels the stillness and is led to contemplate his own smallness in the presence of these mighty, majestic monuments wrought by the Hands of Deity.
[top left]

17 MILE DRIVE
Carmel, California, 1940
The continuation of the famous 17 Mile Drive extends along the shore of beautiful Carmel Bay. Many attractive homes banked by gardens of flowers face the beach of snow-white sand.
[top right]

CRATER LAKE
Crater Lake National Park, Oregon, 1937
The blue of the lake is broken by the forest-covered Wizard Island, a miniature volcanic cinder cone, which rises 850 feet above the surface of the lake, itself 6,000 feet above sea level.
[bottom left]

CLIFF GALLERY
Zion National Park, Utah, 1933
The Mount Carmel Highway was built at a cost of over $2,000,000. The tunnel is over a mile long, 22 feet wide, and 16 feet high; cut through the mountain just inside the face of the cliff. At a few points, the tunnel approaches close enough to the surface of the cliff for galleries to be cut through, affording gorgeous views of the east and west canyon walls.
[bottom right]

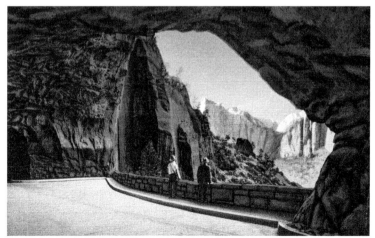

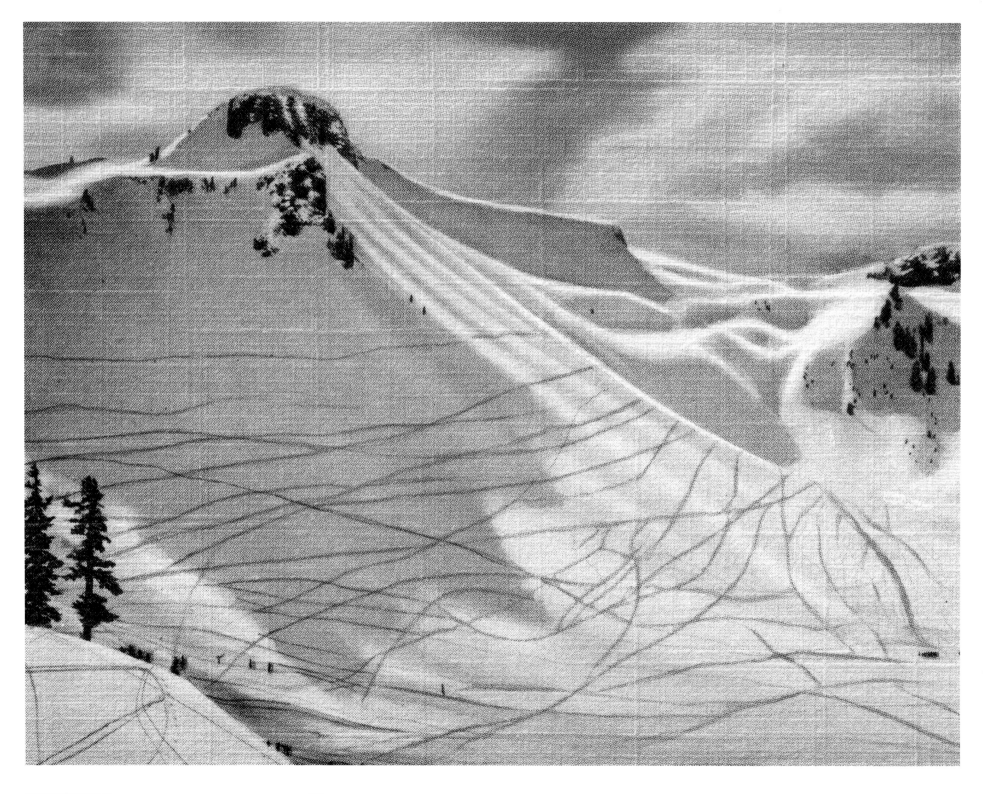

SKI COURSE
Mount Baker, Washington, 1938
The Mount Baker ski terrain is favorably comparable with the best that Europe has to offer. There is every kind of skiing one could desire, from the gentlest slopes for beginners to the most exciting runs and jumps for the veterans. The area is accessible by an improved highway throughout the winter and is just a two-hour drive from Bellingham, Washington.

THREE ARCH BAY
Laguna Beach, California, 1932
Located on the coast highway fifty miles from Los Angeles and seventy miles from San Diego lies the mecca of Southern California—Three Arch Bay near the quaint, beautiful Artist Colony of Laguna Beach.

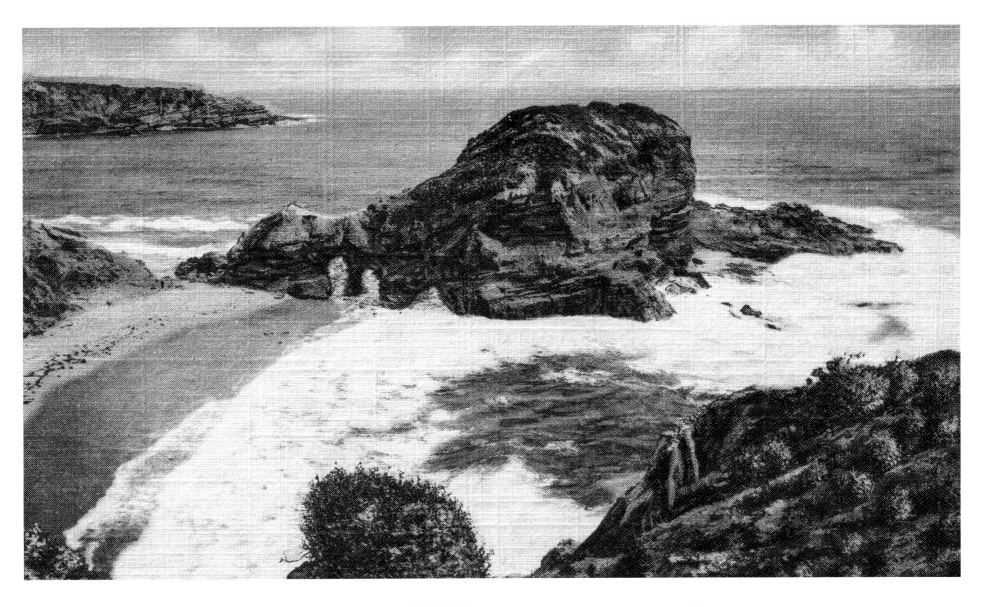

INFRASTRUCTURE

FORGING A FRAMEWORK

by Wolfgang Wagener

"THE WEST BEGINS WHERE THE AVERAGE ANNUAL RAINFALL DROPS BELOW TWENTY INCHES. WATER IS IMPORTANT TO PEOPLE WHO DO NOT HAVE IT, AND THE SAME IS TRUE OF CONTROL."

— JOAN DIDION, 1977

ARIZONA SPILLWAY AND
HIGHWAY BRIDGE
Boulder Dam, Arizona/Nevada, 1936
Two great concrete spillways, each big
enough to float the largest battleship
in the world, are molded into the rock
walls of Black Canyon. Each spillway
is of sufficient capacity to receive the
entire flow of the Colorado River at its
greatest record flood. Over the Arizona
spillway passes the surfaced highway
on a graceful concrete arch bridge.
[previous spread]

AT THE COMMENCEMENT OF THE TWENTY-
first century, Neil deGrasse Tyson, astro-
physicist and the Frederick P. Rose Director
of the Hayden Planetarium at the Rose
Center for Earth and Space in New York
City, conducted a study of the major funded
projects in the history of the world. The short
list of the top five programs ever developed
includes the Egyptian pyramids, the Great
Wall of China, the great Spanish explorations,
such as the voyages of Columbus and
Magellan, and the American Manhattan
Project and Apollo Program. Tyson also
imagined that going to Mars or anywhere
other than low-Earth orbit might constitute
a similarly significant effort in modern times.

According to Tyson's inquiry, only three
drivers have been sufficient enough to
justify the spending of such an exceptionally
large portion of a nation's gross domestic
product on major projects throughout world
history: one, in praise of powerful ideas (the
pyramids, the Taj Mahal, the Vatican); two,
the promise of economic returns (the great
explorations, the interstate highways); and
three, the security of nation-states (the Great
Wall of China, the Manhattan Project, the
Apollo Program). If a major project satisfies
one or more of these three criteria, it prompts
a population to agree to spend significant
amounts of money more willingly.

The New West is the result of an extraordinary
modern-times combination of these three drivers
in concert. The magnitude of vision, capital, and
skill needed to develop the American West's
political, economic, and military infrastructures
over the past 200 years required public policies
and funding that only the federal government
could provide. The collective imprint of forging
this framework can be seen everywhere: in the
state capitols and civic institutions that govern
American ideas, in the public land surveys
that have shaped land use and city building,
and in the dams that distribute water and
produce energy. Extensive highway, airport,
and communication networks bind people
and commerce together. Massive defense
installations and research and development
clusters provide national security and innovation,
while the land itself, still significantly more than
half publicly owned, is utilized most notably for
nature preservation, recreation, and tourism.
In just two centuries, the New West arrived at
the zenith for publicly funded, history-altering
projects throughout the world.

AMERICAN IDEA
The foundational New West driver is the
praise of a powerful American idea: that the
national identity is built on the rule of law,
and that the law applies equally to all. This
political framework has formed and held the
United States together. During the westward

INFRASTRUCTURE

Founding of the West

STATEHOOD	PUBLIC UNIVERSITY
1. 1850 California	1. 1850 Utah
2. 1859 Oregon	2. 1861 Washington
3. 1864 Nevada	3. 1866 Oregon
4. 1876 Colorado	4. 1868 California
5. 1889 Washington	5. 1874 Nevada
6. 1889 Montana	6. 1876 Colorado
7. 1890 Idaho	7. 1885 Arizona
8. 1890 Wyoming	8. 1886 Wyoming
9. 1896 Utah	9. 1889 New Mexico
10. 1912 Arizona	10. 1889 Idaho
11. 1912 New Mexico	11. 1893 Montana

expansion, it gave diverse groups of pioneers, settlers, and spiritual leaders a sense of shared mission, a common vocabulary, and a context within which to participate in the democratic process.

Rule of Law and Equality

With the founding of the United States of America in 1776, the society entered into a social contract in which we the people created the laws by which we would be governed. This was an exceptional step, since the rest of the world had been defining countries through territorial principles, such as blood, soil, language, and history. Building an enlightened social order rooted in reason and requiring the consent of the governed has been a uniquely American idea from the outset. Popularized by Theodore Parker in the 1850s, it has been comprised of three principles: "That all people are created equal, that all possess unalienable rights, and that all should have the opportunity to develop and enjoy those rights." Securing those rights requires a government of the people, by the people, and for the people.

Public Discourse and Education

As important as the unifying top-down rule of law has been in America, there has been a concomitant bottom-up vision for reasoned public discourse, public education, and social mobility—a framework of decency within which people have been able to participate in the democratic process. When states were admitted into the Union, the 1855 Supreme Court of the United States ruled that every township of the public lands should grant a section of the land to the state for the use of public schools: "Plant in the heart of every community the same sentiments of grateful reverence for the wisdom, forecast, and magnanimous statesmanship of those

CALIFORNIA STATE CAPITOL
Sacramento, California, 1932
Inspired by the U.S. Capitol in
Washington, D.C., the State Capitol
reflects the Greek and Roman
influences of the U.S. Democracy.

who framed the institutions of these new States." The westward expansion was a grand socializing experiment to introduce the pioneers and settlers to democratic ideals. The goal was that local citizens would absorb the democratic values crucial to the nation's success if they engaged in the civic process of local governance, public education, and public safety.

Public Land Survey and Private Property Rights
When the federal government assumed control of nearly all of the land west of the Mississippi River (from the Louisiana Purchase from France in 1803, the Texas Annexation in 1845, the Oregon Territory Treaty with the United Kingdom in 1846, the Mexican Cession in 1848, and the Gadsden Purchase from Mexico in 1853), questions of private ownership and government monopoly were constantly raised. The federal government embarked on what may have been the biggest real estate sale in world history, primarily in response to the need to obtain revenue to pay its national debts and the belief in a strong local government in a mainly agrarian national economy, as symbolized by the myth of the American yeoman farmer.

Before the transfer of federal land to private citizens and corporations could happen, however, publicly owned real estate had to be surveyed—a massive but enduring public investment. Thomas Jefferson proposed a Public Land Survey System, which made the United States different from the rest of the world. It resulted in the Land Ordinance of 1785, which provided the systematic survey and monumentation of public lands, and the Northwest Ordinance of 1787, which established a rectangular survey system. Almost all of the public land of the West was divided up into squares that measured six miles per side. These "townships" were then divided into square-mile "sections," and further into acreage-size subsections. As a result, land across the West was given away in a checkerboard pattern. The great advantage of this grid system was that it made land easily saleable. This meant that a single party, individual, family, business, or land developer, could buy or sell land. Fee-simple ownership was one of America's main attractions for European immigrants. The European legacy of centuries of feudalism made clear-title real estate ownership the exception, not the rule.

In addition to the sale of land, the federal government granted approximately twenty

percent of the public land to homesteaders who wanted to own and operate their own farms (1862 Homestead Act), to states providing colleges for the benefit of agriculture and the mechanic arts (1862 Morrill Act), and to private railroad companies for the development of the transcontinental railroads (1862 Pacific Railroad Act).

At the beginning of the twenty-first century, approximately sixty-five percent of the land in the American West remains publicly owned for national and state parks, forests, wildlife refuges, Indian reservations, military installations, and set aside for resource extraction, grazing, and recreation.

ECONOMIC RETURN

After establishing the political framework, the second New West driver is the economy. Nobody had more foresight to recognize this potential better than Mark Twain in his 1866 *Letters from Hawaii*, which he wrote as the special correspondent for the *Sacramento Union* newspaper: "California has got the world where it must pay tribute to her. She is about to be appointed to preside over almost the exclusive trade of 450,000,000 people … The gateway of this path is the Golden Gate of San Francisco; its depot, its distributing house, is California; her customers are the nations of the earth; her transportation wagons will be the freight cars of the Pacific Railroad."

In 1900, the American West was still struggling to develop, despite being a supplier of raw materials for the booming industrial areas in the American Northeast: "It was rich in agriculture, minerals, and timber, but its transportation system was not fully developed, and its financial institutions were weak and small. The West desperately required more capital investment if it was to develop.

It was beholden to Wall Street and to foreign investors," historian Gerald D. Nash observed in his economic history of the twentieth-century West. Private banks, fearing that private enterprises would need a long time to pay off their debts, were reluctant to loan money. Given the challenging geographical and hydrological features of the West and the expense of overcoming them, it seemed unlikely that private enterprise would be able to develop the region.

Water and Power

The most limiting factor for the development of the arid West had for some time been water. Federal institutions, such as the United States Bureau of Reclamation and the United States Army Corps of Engineers, were set up to finance, create, and manage what private enterprise had not been able to accomplish: develop, store, and distribute water to meet the growing needs of agriculture, industry, and cities. The Newlands Reclamation Act of 1902 began a flood of federal funds into the West. This continued throughout the following decades until the Central Arizona Project in 1968, which became the last major water infrastructure scheme approved by the United States Congress.

Dams are at the core of this vast federal water infrastructure network. Hundreds were built throughout a sixty-year period. Conceived as multipurpose projects, they generated renewable hydropower, reclaimed agricultural land, provided utilities for industry and cities, improved river navigation, and created recreation areas for fishing and water sports. Developed in the public interest, each dam was tailored to the economic needs of a specific region. The revenue generated from the water and power consumers was returned to the Federal Treasury to repay the cost of constructing, operating, and

VALLEY OF HEART'S DELIGHT
San Jose, California, 1929
The valley, named after the Spanish Mission Santa Clara, is known as the Valley of Heart's Delight for its high concentration of orchards, flowering trees, and plants. It is the largest fruit production and packing region in the world. Canned and preserved foods account for two-thirds of the total quantity of United States manufactured goods.*

rural regions to move people and goods needed to be improved, and on a global level, the direct link of the Atlantic and Pacific Oceans through the Panama Canal was essential. Both projects were too big for private enterprise, so the federal government provided the capital and managerial expertise to develop them.

While the Panama Canal was getting completed in 1914, two transportation revolutions were taking place—the motorization of land and air transportation. Henry Ford and others created a mass market for automobiles in the first three decades of the twentieth century. This triggered a consumer demand for better roads. The American Automobile Association lobbied for better highways to increase trade, commerce, and travel. At the same time, the United States Army was becoming concerned with the need for a national highway network, as it started to replace horses with motorized equipment and to move vehicles across longer distances. President Woodrow Wilson made road building a key element of his platform: "The happiness, comfort and prosperity of rural life, and the development of the city, are alike conserved by the construction of public highways. We, therefore, favor national aid in the construction of post roads and roads for military purposes." The United States Congress responded with the Highway Act of 1916, under which the federal government assumed half of the cost of road building, with the states paying for the other half. This was the first in a series of federal highway investments over a forty-year period, which culminated in the National Interstate and Defense Highways Act of 1956.

The emerging national highway network was complemented with municipal airfields and terminals beginning in the late 1920s, which reduced national and international travel times

maintaining each project. Dam development faded during the 1960s due to growing environmental concerns and the shift toward the development of the West into a more urban region, which consumes less water per capita than agriculture.

Land and Air Transportation
By 1900, most of the western railroads had been built. However, to integrate the American West into the industrializing national and global markets, and to facilitate growth, the transportation infrastructure had to be further developed to overcome significantly greater travel distances than those in the East. On a national level, the connections of cities and

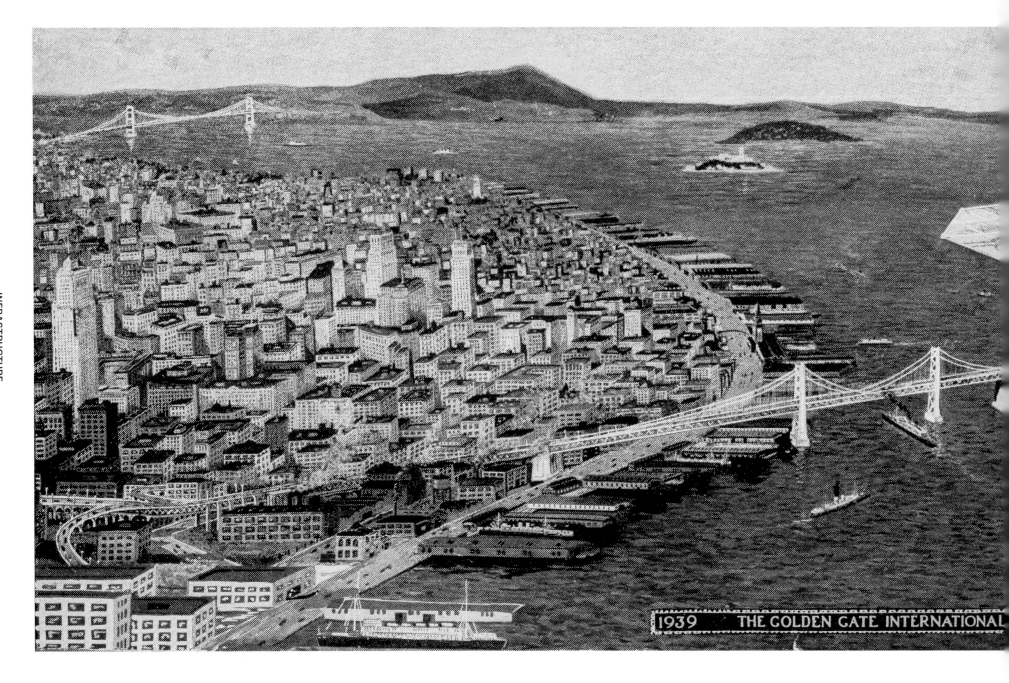

1939 THE GOLDEN GATE INTERNATIONAL

GOLDEN GATE INTERNATIONAL EXPOSITION
San Francisco, California, 1936
In 1939, San Francisco, Oakland, and the cities around the Golden Gate invite the world to join with them in celebrating the completion of the world's two largest bridges, spanning San Francisco Bay, at the Golden Gate International Exposition. On a magic man-made Exposition Isle, over a mile long and two-thirds of a mile wide, America's World's Fair will open its gates February 18, 1939, and run to December 3, of the same year. Dedicated to the giant Trans-Bay Bridges, the Exposition will also present "A Pageant of the Pacific," depicting the nations of the Pacific on spectacular parade.

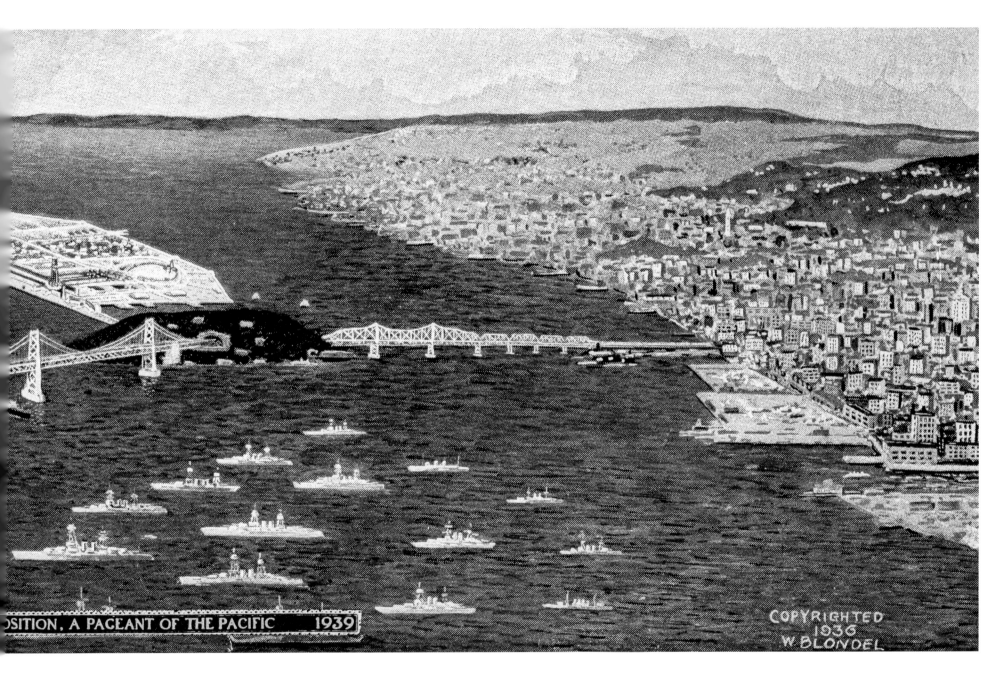

OSITION, A PAGEANT OF THE PACIFIC 1939

COPYRIGHTED 1936 W. BLONDEL

THE WORLD'S LARGEST BRIDGES SPANNING SAN FRANCISCO BAY: the San Francisco-Oakland Bay Bridge, costing $77,000,000, is the longest and largest span ever built, linking metropolitan San Francisco with the Eastbay Empire. A double-deck structure with six traffic lanes, the giant Trans-Bay Bridge is 8¼ miles long. It includes the world's largest vehicular bore, passing through mid-Bay Yerba Buena Island, and the world's largest cantilever span, on the Eastbay bridge sector.

The majestic Golden Gate Bridge—costing $35,000,000—is the largest single-span suspension bridge in the world—is the first bridge ever built across a major harbor entrance. Its 746-foot towers (191 feet higher than Washington Monument) and 4,200-foot span, supported by two 36½-inch cables (containing 80,000 miles of steel wire) create the key link in the proposed All-Pacific Coast Highway System.

even further. Inspired by Charles Lindbergh's transcontinental flight and excited that his plane, *Spirit of St. Louis*, had been designed, built, and tested in Southern California, the city of San Diego passed a bond issued in 1928 for the construction of a two-runway municipal airport, which opened the same year and was the first federally certified airfield to serve all aircraft types, including seaplanes. One year earlier, the city of Oakland opened an airport in Northern California with a 7,020-foot-long runway that was the longest in the world at the time, making it the departing point for many historic flights. While airports were and are for the most part owned and operated by local municipalities, the federal government played an important role by funding the development.

In combination, water, power, and transportation infrastructures helped to overcome the geographical and hydrological challenges of the American West, facilitating the growth of this region's population and cities. In only half a century, federal investments helped transform what began as a colonial economy into a modern, technologically advanced global economy.

NATIONAL SECURITY
The third and most recent New West driver has been the military framework of the Pacific Coast defense of the United States. Up to the beginning of the twentieth century there had been no significant military presence in the American West. Triggered by the demands of two world wars, the entire West Coast transformed in just fifty years from a collection of military outposts to a regional powerhouse, ensuring Pax Americana throughout the Asia-Pacific region. For the first time in its history, the United States maintained a large peacetime military presence. Major permanent

military installations started about 1940 and have continued well into the twenty-first century. For every single western state, military expenditures have been a major source of income, providing the economic well-being for many western cities. In Los Angeles, for instance, one in three employed persons worked in the military-industrial aerospace complex. In San Diego, about a third of the annual city income came from expenditures of the United States Navy.

Land
The United States Army operated small training centers in repurposed nineteenth-century forts that had served as early trading posts between Native Americans, trappers, and traders during the westward expansion of the United States. The catalyst for massive army investments, however, were two world wars. The United States mobilized millions of soldiers who needed to be trained. Many of these trainings took place in the West. The West offered not only vast, remote, and government-owned land, it also offered a great diversity of topography and ecosystems within which one could prepare for conditions similar to those which might be encountered overseas. Major General George S. Patton, for instance, chose the Desert Training Center in Southern California and Western Arizona as the key training facility to prepare for combat during the 1942–1943 North African campaign.

Water
At the turn of the twentieth century, the United States Navy operated small installations in the three principal natural harbor cities—Seattle, San Francisco, and San Diego, including a small shipyard on Mare Island at the northern end of the San Francisco Bay. Following World War I, however, the United States Navy

became the first line of defense and grew rapidly. The completion of the Panama Canal in 1914 offered new flexibility, and by 1918, United States foreign policy expanded the balance of power into the Asia-Pacific region, including the defense of Hawaii and the Philippines. These developments resulted in the relocation of half of the United States Navy fleet to the West Coast in 1919, with San Diego emerging as the main center for the Pacific fleet.

Air

The United States Air Force was established after World War II, when air power became the major component of national security. The air force established dozens of airfields in the West, which it favored not only for good flying weather but also because of the availability of vast stretches of empty land suitable for training pilots and testing aircraft, including the Edwards Air Force Base in California and the White Sands Missile Range in New Mexico.

The groundwork for the air force military installations in the West had been triggered by World War I. To protect the West Coast, the United States Navy established airfields to support the operation of the Pacific Fleet during the 1930s, including Moffett Field, a Naval Air Station in Sunnyvale, which is home to one of the world's largest dirigible hangars. In addition, both the army and the navy during World War I signed significant contracts with airplane manufacturers in Southern California, such as Douglas Aircraft Company, and with Boeing in Seattle helping to start a brand-new industry.

Research and Development

As military weapons became more sophisticated, they also became more expensive. Nuclear weapons, missiles, space flights, and electronic equipment didn't cost millions of dollars to create, but billions. Military expenditures to fuel western economic growth increased significantly during the second half of the twentieth century. The first surge came with the Korean War, 1950–1953, and it grew during the Cold War with the Soviet Union in the 1950s and 1960s.

In the second half of the twentieth century, federal funding was not just for the development and operation of military installations, but for the entire military ecosystem of national research labs, research universities, and private companies engaged in Cold War research and development, such as the Jet Propulsion Laboratory in Pasadena, the Ames Research Center in Sunnyvale, the Lawrence Livermore National Laboratory in Berkeley, the Los Alamos National Laboratory in New Mexico, and the Nevada National Security Site near Las Vegas for testing of nuclear devices.

By the 1960s, large-scale federal funding went to the aerospace complex in Southern California, nuclear testing in Nevada, space flight in Northern California, and to electronics and information technology companies in California, Utah, and Colorado, incubating what is now known as Silicon Valley.

As the youngest region of the United States, the West lagged in terms of development behind the rest of the nation until the mid-twentieth century. But the modern framework that the federal government forged made it not only one of the most funded in world history, it transformed the West into one of the most successful regions of the United States. As the egalitarian template of American life, the New West flourished into one of the largest economies in the world and became a stronghold for the Pax Americana.

FOUNDING

INFRASTRUCTURE IN THE AGE OF STEAM
The foundation of the United States triggered three major federal infrastructure investments in the nineteenth-century West. First, the United States acquired the majority of its land from France, Great Britain, and Mexico between 1803 and 1853, and, subsequently, surveyed it according to the Public Land Survey System grid. Second, it introduced the rule of law by admitting the eleven Western states into the Union between 1850–1912, starting with California. Third, with the 1862 Pacific Railroad Act, it promoted the integration of the West into the national and global markets for trade, commerce, and travel through transcontinental railroads, with the first construction being completed in 1869.

These activities took place within a uniquely American context—one that asserts that the national identity of the United States is built on the rule of law, that the law applies equally to all, and that education should be more democratic. To provide social orientation for these abstract ideas, the western states created concrete physical expressions: majestic state capitols, modeled after the neoclassical Capitol Building in Washington, DC, nesteled within a tightly-knit network of courthouses in each of the more than four hundred newly established counties, and a new type of egalitarian American university campus that was less elitist than the traditional colleges of the East.

"AN EDIFICE SHOULD BE CONSTRUCTED
THAT WILL BE SATISFACTORY OF
THE GRANDEUR OF THE COMING TIME."

— GOVERNOR LELAND STANFORD, 1863

WASHINGTON STATE CAPITOL
Olympia, Washington, 1942
Third building to house the state legislature since Washington was admitted to the Union in 1889. The capitol is one of the most beautiful in the country. The Senate and House Chambers are especially impressive, the former being entirely of marble from famous quarries of Europe.
[previous spread]

UTAH STATE CAPITOL
Salt Lake City, Utah, 1940
Salt Lake City is located between the Wasatch and Oquirrh Mountains. Its altitude is 4,330 feet. Its population, 153,000. It covers an area of 53 square miles. The major portion of the city is divided into 10-acre blocks divided by straight streets 132 feet wide. The street running south from the entrance of the State Capitol building is said to be the longest straight street in the world.

UTAH STATE CAPITOL
Salt Lake City, Utah, 1934
Utah may justly be proud of its state capitol. The building was finished and formally opened to the public October 9, 1916. From its commanding location, a wonderful view of the whole of Salt Lake Valley may be had. The capitol proper is 240 feet wide, 404 feet long, and 285 feet high. The diameter of the dome is 64 feet. Total cost $2,739,528.

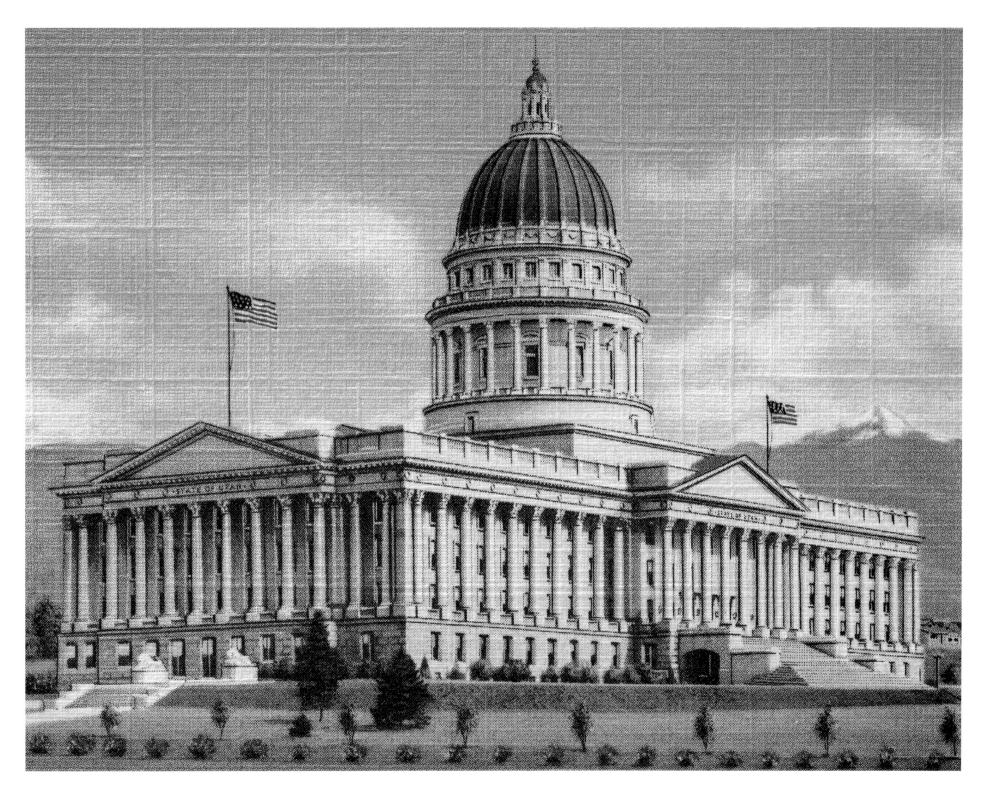

CALIFORNIA STATE CAPITOL
Sacramento, California, 1943
The state capitol, with its majestic
beauty, is surrounded by a beautiful
park of matchless shrubbery and trees,
symbolic of Nature's gifts to California,
and commands the admiration and
praise of thousands of visitors annually.

INFRASTRUCTURE

FRESNO COUNTY COURT HOUSE
Fresno, California, 1939
Fresno, the county seat of Fresno County, is located in the center of California in the great San Joaquin Valley. It is in the heart of, and the distributing point for the great farming empire of Central California. Population in excess of 60,000.

OREGON STATE CAPITOL
Salem, Oregon, 1940
This new $3,000,000 building is 395 feet long, 162 feet wide, and 168 feet high. Erected on same grounds as old state capitol and faces Capitol Boulevard North.

IDAHO STATE CAPITOL
Boise, Idaho, 1937
The original state capitol at Boise was built in 1885. In 1905 the capitol building was authorized for legislative, executive, and judicial purposes at a cost of one million dollars. Building continued from 1906–1912. The east and west wings were erected 1919–1920, at a cost of $2,290,000.

MARICOPA COUNTY COURT HOUSE
Phoenix, Arizona, 1939
The Maricopa County Court House and Phoenix City Hall is located on West Washington Street between First and Second Avenues. Cost $2,225,000 to build.
[top left]

KERN COUNTY COURT HOUSE
Bakersfield, California, 1943
The City of Bakersfield was first incorporated in 1873, the same year that the county seat was moved from the booming little town of Havilah to Bakersfield. This county court house was built in 1912.*
[bottom left]

SANTA CLARA COUNTY COURT HOUSE
San Jose, California, 1936
This splendid structure is in the heart of downtown San Jose, opposite St. James Park; adjoining buildings are the new post office and hall of records.
[top right]

CLARK COUNTY COURT HOUSE
Las Vegas, Nevada, 1937
Located in Las Vegas, Nevada, the second-largest city in the state, the Clark County Court House is the hub of the county's governmental activities.
[bottom right]

SANTA BARBARA COUNTY COURT HOUSE
Santa Barbara, California, 1933
This magnificent County Court House is a glorious tribute to the early Spanish days. This structure is acclaimed by world travelers as one of the most magnificent public buildings of modern architecture in the world.

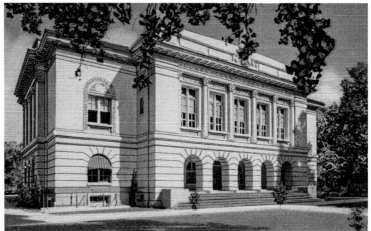

UNIVERSITY OF
SOUTHERN CALIFORNIA
Los Angeles, California, 1939
The University of Southern California
was founded July 29th, 1879.
The campus comprises 45 acres.
The university consists of 24 schools
and colleges, with a total enrollment
of over 7,500 students, and has
approximately 500 faculty members.

UNIVERSITY OF UTAH
Salt Lake City, Utah, 1940
The University of Utah, founded in
1850, is the oldest university west of
the Missouri River. It is a coeducational
institution offering complete college
courses to more than 3,000 students.
Situated on the brow of a hill
overlooking the city and valley.

MUDD HALL

COLLEGE OF
PHARMACY

SCIENCE BLDG.
AND
SCHOOL OF MEDICINE

BOVARD ADM.
BLDG.

STUDENT UNION
BLDG.

SCHOOL OF LAW

BRIDGE HALL

UNIVERSITY OF CALIFORNIA
Berkeley, California, 1935
Sather Gate is the principal entrance to the University of California Campus. A gift of Mrs. Jane K. Sather, along with the Sather Tower known as "The Campanile" (right background), which rises to a 300-foot height. From this tower, a view of the East Bay Cities and entire Bay area is obtainable.

UNIVERSITY OF SOUTHERN CALIFORNIA
Los Angeles, California, 1936
Edward L. Doheny Memorial Library, Southern California, was built at a cost of over $1,000,000, and has 300,000 volumes and many special libraries.

UNIVERSITY OF CALIFORNIA
Berkeley, California, 1935
Built from funds of a $2,000,000 State of California bond issue, the Life Sciences Building was completed in 1930. It is the largest academic structure of any American University. Dedicated to research, it houses over 500 laboratories.

SAN JOSE STATE UNIVERSITY
San Jose, California, 1943
The San Jose State Teachers College, oldest state public educational institution, which opened in 1862, occupies a series of modern buildings in architecture reminiscent of the Spanish Missions in a beautiful park of twenty-six acres. The college has a faculty ranging from 135 to 150 and a student body of approximately 3,000.

STANFORD UNIVERSITY
Palo Alto, California, 1940
Senator Leland Stanford and Mrs. Jane Lathrop Stanford founded Leland Stanford Junior University in 1887 as a memorial to their only son. Situated at Palo Alto on the spacious Stanford Farm of 8,800 acres, this world-famous university is picturesquely situated in delightful surroundings. Student attendance numbers over 4,000. The first class was held in 1891.

UNIVERSITY OF CALIFORNIA
Los Angeles, California, 1935
Located in West Angeles just five miles from the Pacific Ocean are a dozen imposing buildings on a campus of 384 acres, all development in the past ten years. Among its 14,000 enrollment are students from more than 50 other countries as well as from the Territories of Alaska and Hawaii.

STANFORD UNIVERSITY
Palo Alto, California, 1937
Memorial Church, Stanford University, is considered one of the most beautiful churches in America. The extensive use of art mosaics for mural decorations combine to make it a structure more than unique in character, worthy of visiting, and well-remembered.

UNIVERSITY OF WASHINGTON
Seattle, Washington, 1938
Library and physics hall, with vista of Mount Rainier. Just ten years after the city of Seattle was founded in 1861, the people of the then Territory of Washington started the University of Washington. From that day, the university has progressed to where it now boasts one of the most beautiful campuses in the United States. With an enrollment of 12,000 students, it ranks among the highest educational institutions in the country.

UNIVERSITY OF CALIFORNIA
Berkeley, California, 1935
This tall majestic campanile, with its four-sided clock and beautiful chimes of twelve bells housed in the belfry, times the students' daily activities morning, noon, and evening.

UNIVERSITY OF ARIZONA
Tucson, Arizona, 1939
The beautifully landscaped campus of the University of Arizona is studded with modern buildings and is conveniently located in Tucson's northeast residential section.

STANFORD UNIVERSITY
Palo Alto, California, 1940
Stanford University is located in the Santa Clara Valley at Palo Alto. The site consists of 8,000 acres, and was founded in 1887 by Senator and Mrs. Leland Stanford as a memorial to their son. Student attendance numbers over 4,000. The first class was held in 1891.

UNIVERSITY OF SANTA CLARA
Santa Clara, California, 1943
The University of Santa Clara is the oldest institution of higher learning in California. Founded as a college in 1851, Santa Clara's educational tradition is coexistent not only with the State of California.

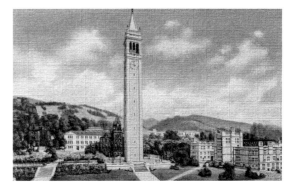

MOUNT WILSON OBSERVATORY
Los Angeles, California, 1938
The Carnegie Astronomical
Observatory of Washington, D.C.,
is located on the summit of Mount
Wilson, in the Sierra Madre Mountains,
6,000 feet above sea level. The view
from Mount Wilson is an impressive
sight. On a clear night, the lights of
more than 60 cities are visible, a sight
unequaled in all the world.

MOUNT WILSON OBSERVATORY
Los Angeles, California, 1938
The Carnegie Astronomical
Observatory of Washington, D.C.,
is located on the summit of Mount
Wilson, in the Sierra Madre Mountains,
6,000 feet above sea level. Day and
night, eight huge telescopes are
busy probing the mysteries of the
universe. The astronomical museum
is open to the public daily. Dome of
the 100-inch Hooker Reflector.

INFRASTRUCTURE

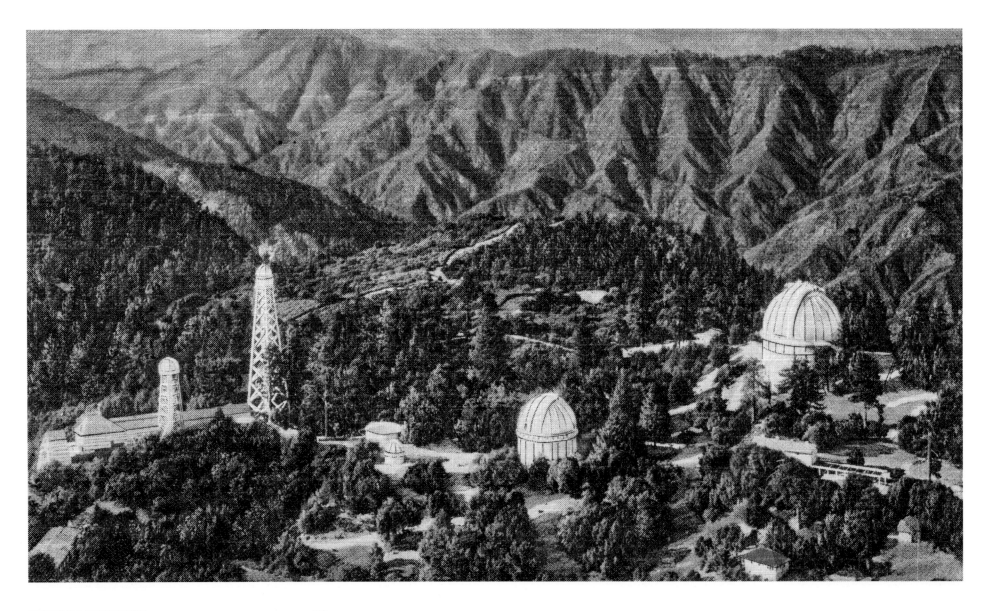

DISTRIBUTION

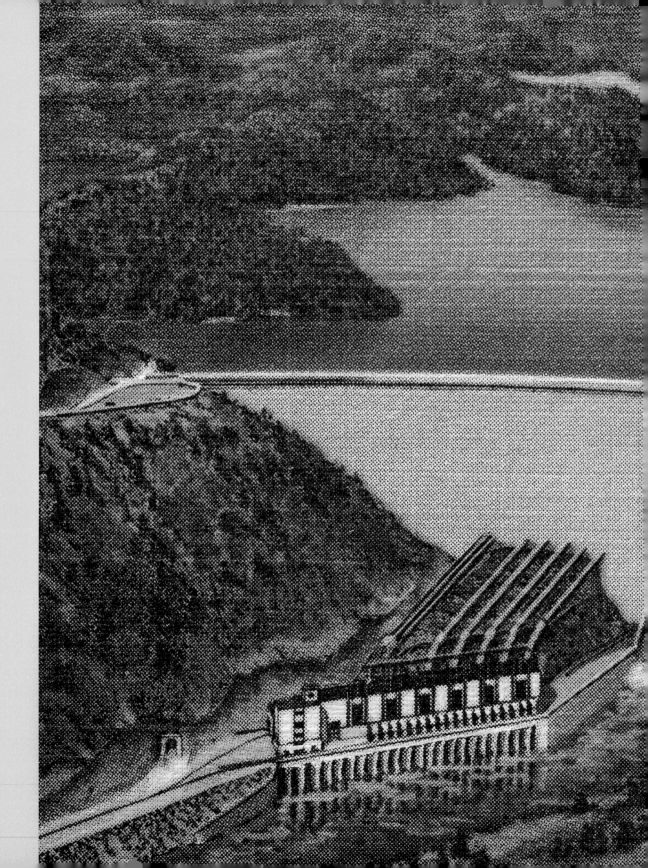

INFRASTRUCTURE IN THE AGE OF STEEL

Major heavy engineering infrastructures for water, power, and transportation emerged at the beginning of the twentieth century. They facilitated the distribution of services, goods, and people across ever larger areas of the challenging geography of the arid West. These federal investments had a profound impact on rapidly growing agriculture, industry, and city centers. The 1909 Theodor Roosevelt Dam near Phoenix, Arizona, kicked off the massive program of federal infrastructure developments. The New Deal triggered the "big dam" period of the 1930s–1950s, including the creation of such majestic projects as the Grand Coulee Dam in the Pacific Northwest, Hoover Dam in Nevada and Arizona, and the Central Valley Project in California.

It also triggered the "big bridge" period during the same era, with equally impressive concrete and steel structures to fill the gaps in the national transportation networks, culminating in the two largest bridges in the world at mid-century spanning San Francisco Bay. The San Francisco-Oakland Bay Bridge was the longest and largest span ever built, linking metropolitan San Francisco with Oakland and the Eastbay, and the majestic Golden Gate Bridge was the largest single-span suspension bridge in the world—creating the key link in the proposed All-Pacific Coast Highway System.

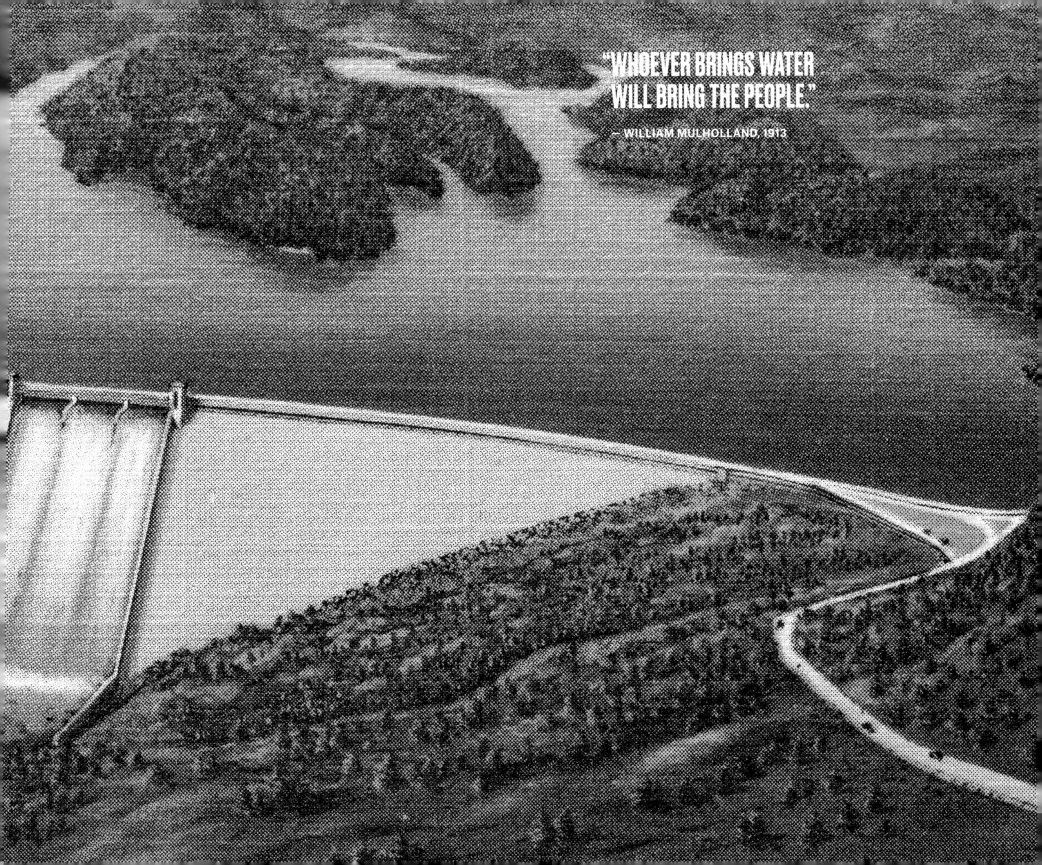

"WHOEVER BRINGS WATER
WILL BRING THE PEOPLE."

— WILLIAM MULHOLLAND, 1913

SHASTA DAM
Redding, California, 1940
Shasta Dam is the key unit of the
Central Valley Project being built by
the U.S. Bureau of Reclamation at
a cost of $170,000,000. It will be the
world's highest overflow-type dam
and is located near Redding, Northern
California. Height 560 feet—crest
length 3,500 feet. Thickness at top
37 feet. Base thickness 580 feet.
Length over reservoir 35 miles
[previous spread]

MULHOLLAND DAM
Hollywood, California, 1941
Within five minutes of the heart of
Hollywood, where beautiful Lake
Hollywood nestles in the hills.
Mulholland Drive skirts the shores
of the lake and from the dam, a
commanding view of Hollywood
and surroundings is revealed.

COOLIDGE DAM
San Carlos, Arizona, 1921
This picture shows the great Coolidge
Dam and the spillways and proposed
power plant under the center arch of
the Dam. The drive across the crest
of the dam is 880 feet in length and
16 feet wide. It is 250 feet above
bedrock, 300 feet at base of canyon
walls, will create a lake 25 miles long,
3 miles in width, capacity 1,200,000
acre feet, and will water 100,000 acres.

ROOSEVELT DAM
Roosevelt Lake, Arizona, 1936
One of the engineering wonders of
the West, a vast precipice of granite
masonry—299 feet high and 1,125 feet
long, set for all time in this gorge of
Salt River Canyon in a setting of wild
mountain grandeur. It is located on the
famed "Apache Trail" about 80 miles
east of Phoenix.

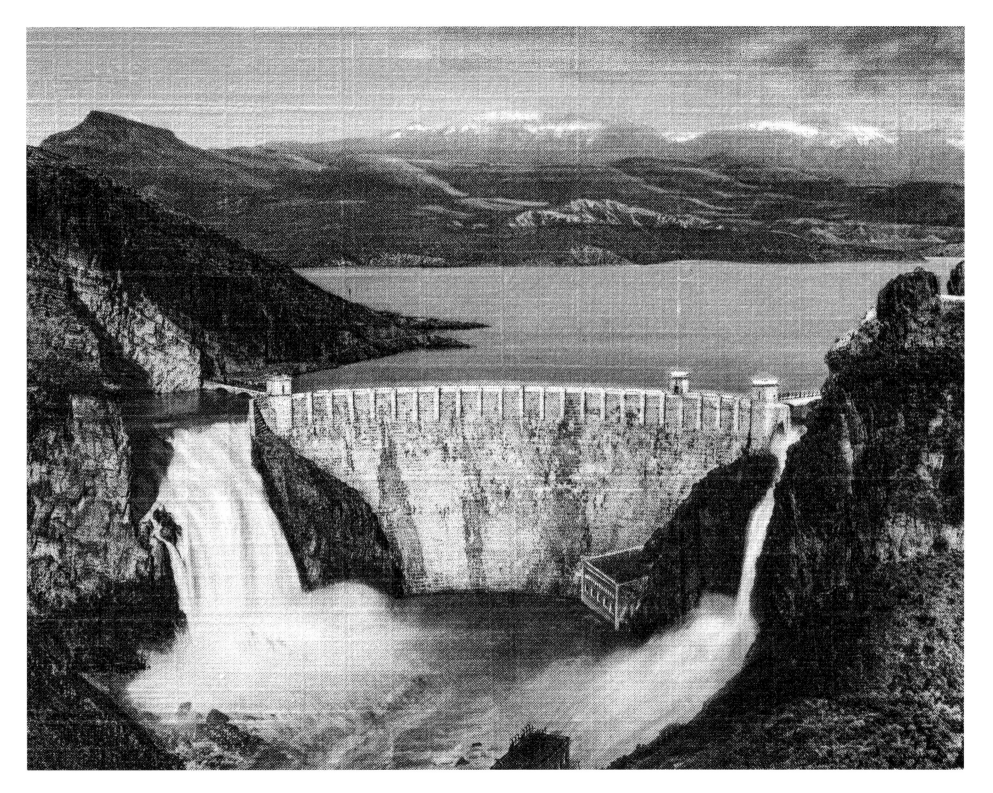

CONCRETE GRAVITY DAM
Grand Coulee Dam, Washington, 1942
Grand Coulee Dam is one of the largest in the world. It creates an artificial lake 354 feet deep and 2 to 10 miles wide and extends up the Columbia River 150 miles to the Canadian border. Across the top, there is a 24-foot roadway and enough room left to operate the massive gates of the spillway. Dam 4,100 feet long, 450 feet wide at bottom, and 36 feet at top.

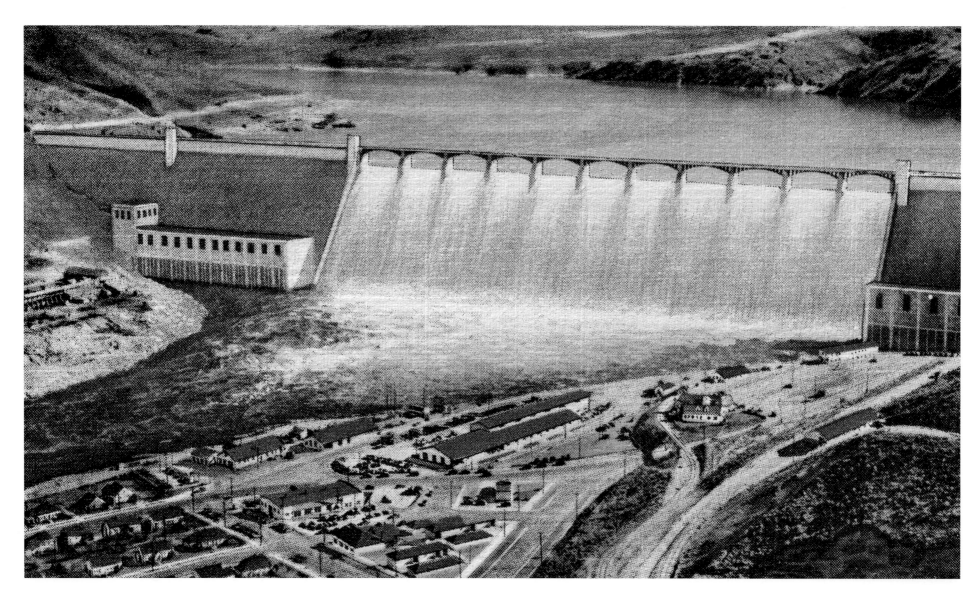

GLORY OF NIGHT
Grand Coulee Dam, Washington, 1948
A spectacular view of the world's
largest concrete dam creating a
falls twice as high as Niagara, as the
waters of the mighty Columbia plunge
in snowy whiteness—a fairyland of
brilliant and scintillating lights.

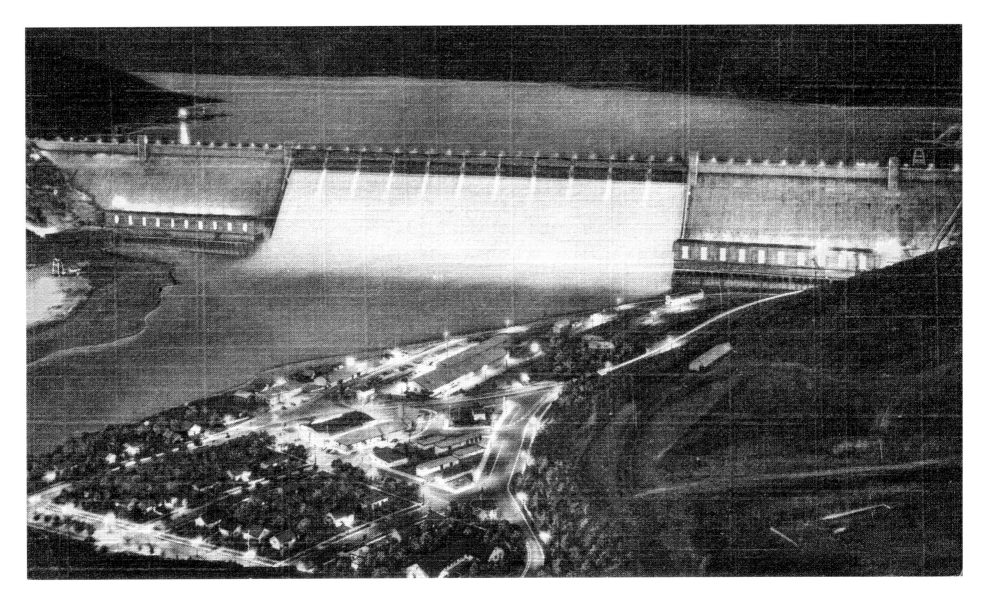

VISION OF ACHIEVEMENT
Boulder Dam, Arizona/Nevada, 1937
The dam, illuminated at night by batteries of floodlights, presents an inspiring scene. The cliffs of Black Canyon, darkened to unimportant dullness, retire into the shadows, for the dam to display, without competition from nature, the tremendous features that render it "Man's Greatest Engineering Achievement."
[top left]

CREST OF DAM
Boulder Dam, Arizona/Nevada, 1941
Today, Boulder Dam, spanning Black Canyon between Arizona and Nevada, serves as an artery for transcontinental traffic. Routed over the crest of the barrier are U.S. Highway 93 and 466, which provide easy access to an area which but two decades ago defied the most daring explorer.
[top right]

LAKE MEAD
Boulder Dam, Arizona/Nevada, 1941
Only a few feet of the 600-foot sheer upstream face of Boulder Dam remain visible, as the stored waters in the reservoir have risen and extended into the Grand Canyon to form the world's largest artificial lake, 115 miles in length.
[bottom left]

LAKE MEAD
Boulder Dam, Arizona/Nevada, 1935
Boulder Dam and Lake. The upstream face of Boulder Dam, showing four intake towers and roadway across the top of Dam. The new route, connecting Boulder City, Nevada, and Kingman, Arizona. View from the Arizona side looking towards Nevada.
[bottom right]

INTAKE TOWERS
Boulder Dam, Arizona/Nevada, 1936
The giant intake towers and the upstream face of the dam, with the highway across the top of the dam, and up the rocky slopes on the Arizona side. This is a main highway east, connecting at Kingman, Arizona, with U.S. 66.
[opposite page]

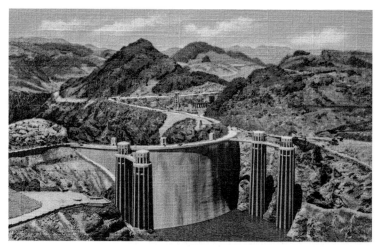

SAN FRANCISCO-OAKLAND BAY BRIDGE
San Francisco, California, 1937
Bridging the San Francisco Bay Metropolitan Area with a structure 58 feet wide, double deck, and eight and a half miles long over navigable water is an accomplished feat. The main spans are 2,320 feet long with a vertical clearance of 185 feet. Cost was $77,000,000. Auto speed limit of 45 miles is allowed.

COLORADO STREET BRIDGE
Pasadena, California, 1931
The Colorado Street Bridge spans 1,486 feet at a maximum height of 150 feet and is notable for its distinctive concrete beaux arts arches, light standards, and railings. The Vista del Arroyo Hotel and Bungalows, as well as the U.S. McCormack General Hospital as seen in distance.

SEVEN BRIDGES
Spokane, Washington, 1937
The Spokane River, with its turbulent five waterfalls, plunges through the heart of the business district of Spokane, Washington, furnishing abundant waterpower. It turns the wheels of industries. Highly important among these to this thriving, fast-developing capital of the Inland Northwest are lumbering, mining, and agriculture.

COLORADO STREET BRIDGE
Pasadena, California, 1931
The magnificent view across the Arroyo Seco through the concrete arches of the Colorado Street Bridge shows the Vista del Arroyo Hotel and Bungalows at the eastern end of the bridge.
[opposite page]

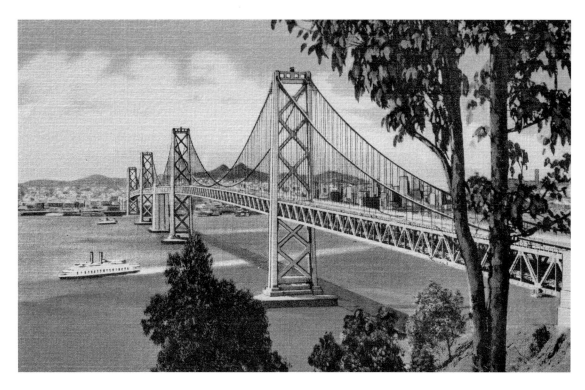

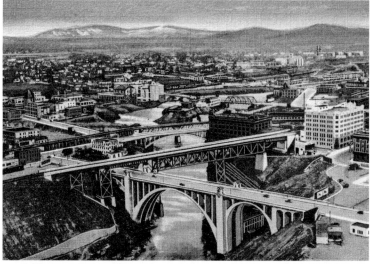

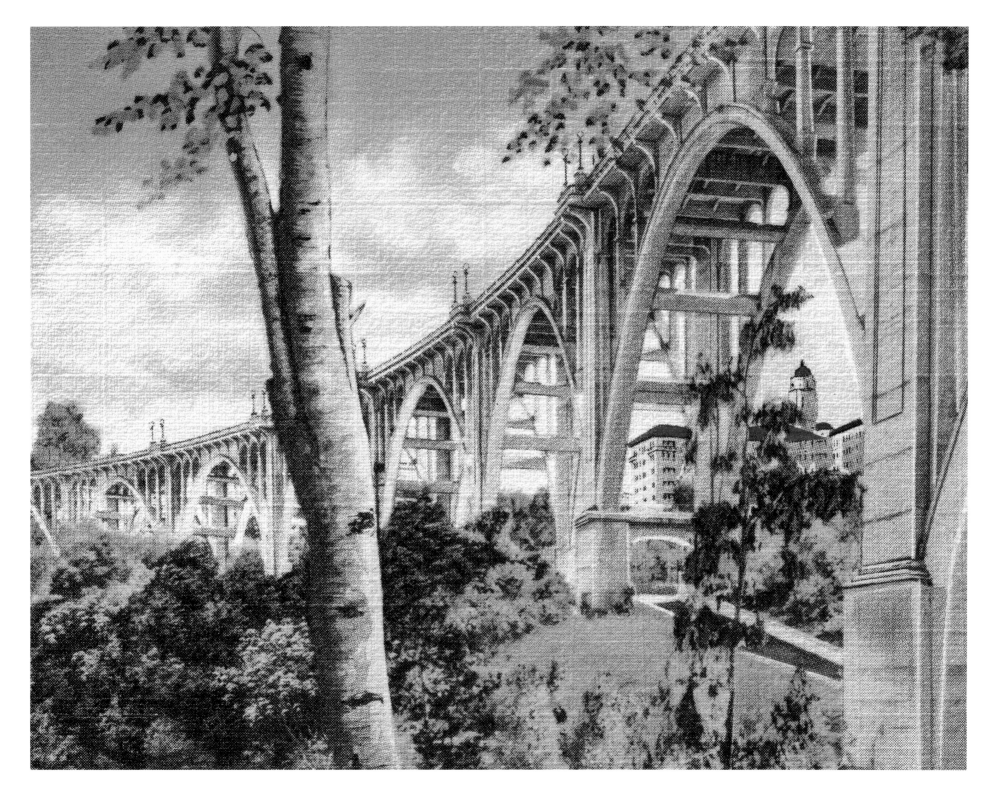

TRUSS BRIDGES
Yuma, Arizona, 1942
U.S. Highway 80 and Southern Pacific Railroad Bridges across Colorado River entering Yuma. Yuma is the business center of a fertile reclaimed-desert agricultural area lying along the east bank of the Colorado River and extending south to the Mexican Border. This picture was taken from the California side of the river. State line is the middle of the river. Time changes at this point; Yuma operating on mountain time while California has Pacific Coast time.

LIFT BRIDGE
Sacramento, California, 1943
The one-million-dollar lift bridge spans the Sacramento River at the western approach to the city, U.S. Highway 40. The lift span is 200 feet long, has a 100-foot clearance at flood stage, and is one of the highest in the world of its type.

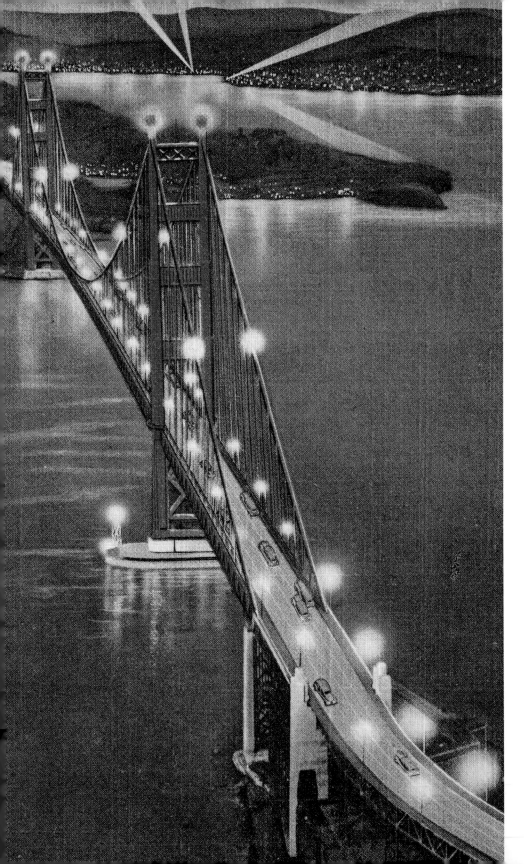

GOLDEN GATE BRIDGE
San Francisco, California, 1937
Probably nowhere else in the world is there such an impressive sight as the night view of the massive Golden Gate Bridge, which spans the world-renowned "Golden Gate" entrance to San Francisco Bay. Brilliantly illuminated, and with its mighty towers rising 746 feet above the waters of the bay, it greets the incoming ships and may be seen from many miles at sea.

BRIDGE TOWER
San Francisco, California, 1937
The length of the longest span of the San Francisco-Oakland Bay Bridge is 2,310 feet, and the highest tower is 519 above the water of the bay. Total length of bridge is 8½ miles; 4½ miles of this is over water. The total length of the suspender ropes is 43 miles, and the total length of the wire used in the cables is 70,815 miles.

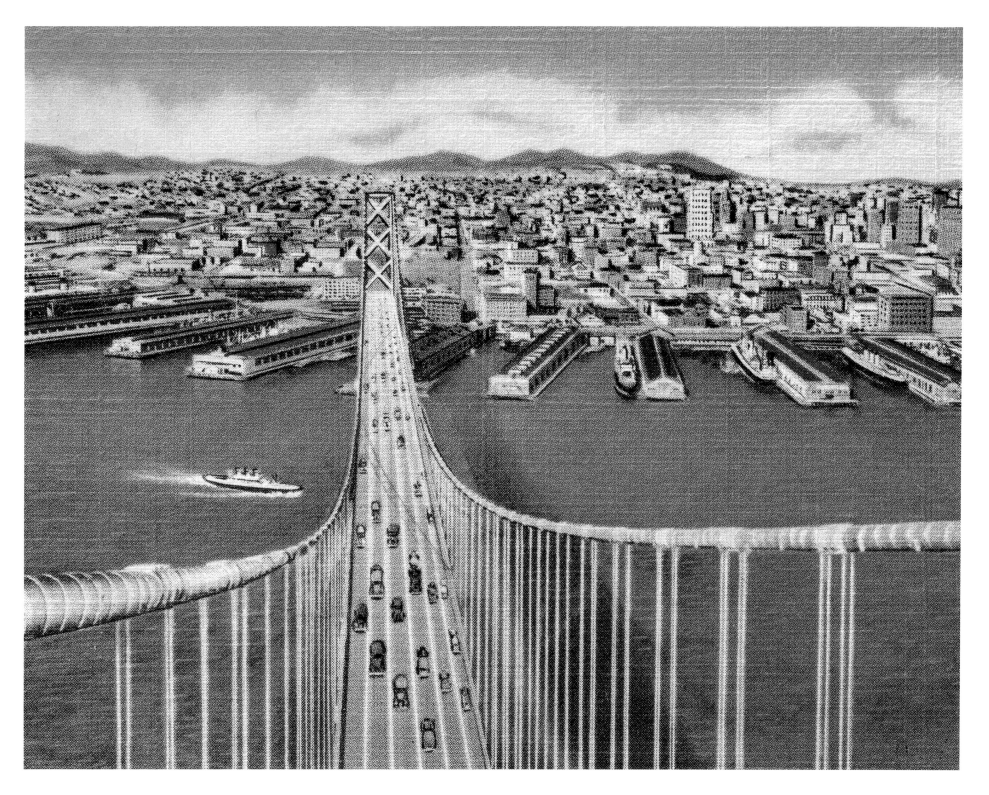

MOBILIZATION

INFRASTRUCTURE IN THE AGE OF OIL

Highway construction became of national importance during the first half of the twentieth century—in particular in the West, where travel distances were much greater than in the East. Federal investments into a national highway and defense network started with the Highway Act of 1916. Drivers for that demand were consumers embracing the automobile mass market created by Henry Ford and others, the economic benefits of trade, commerce, and travel, and improved national security through a motorized United States Army.

This was the first in a series of significant federal highway investments over a forty-year period, culminating in the National Interstate and Defense Highways Act of 1956. This bill created a 41,000-mile interstate highway system that would, according to President Dwight D. Eisenhower, eliminate unsafe roads, inefficient routes, traffic jams, and whatever else might get in the way of speedy, safe transcontinental travel. At the same time, highway advocates argued, that in case of an atomic attack on key American cities, the road network would permit quick evacuation of target areas. For all of these reasons, the 1956 law declared that the construction of an elaborate expressway system was essential to the national interest.

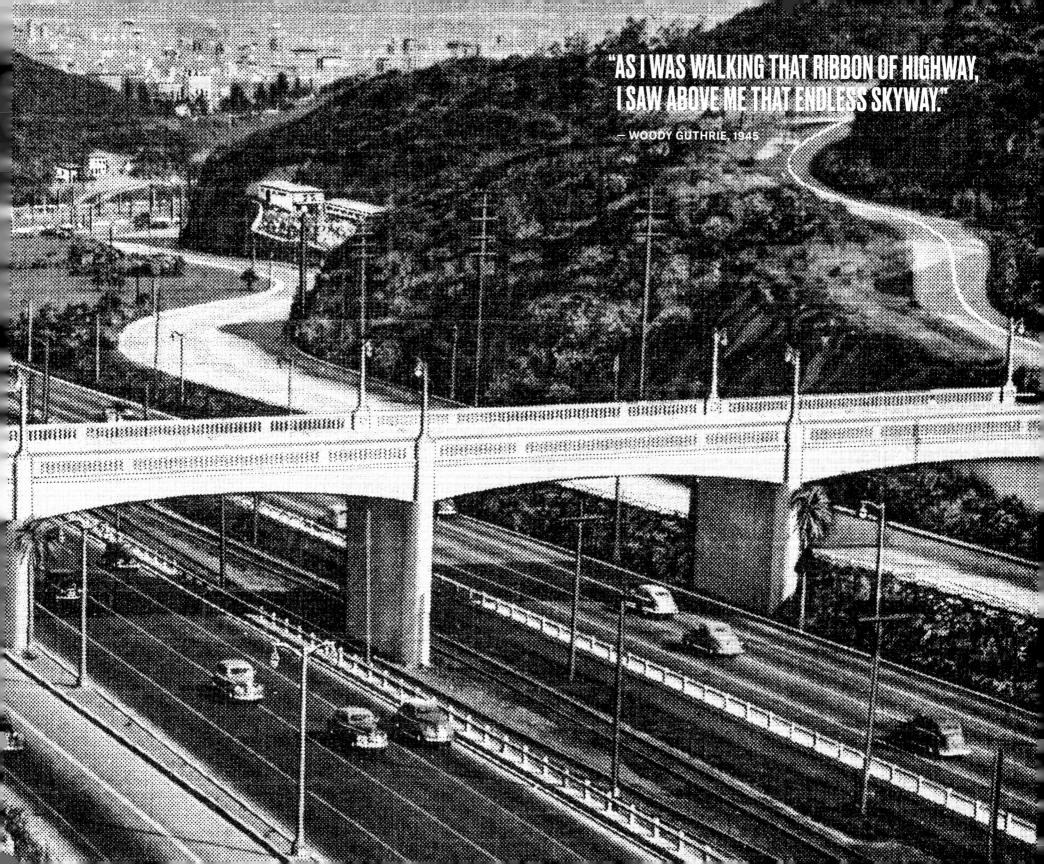

"AS I WAS WALKING THAT RIBBON OF HIGHWAY,
I SAW ABOVE ME THAT ENDLESS SKYWAY."

— WOODY GUTHRIE, 1945

CAHUENGA FREEWAY
Hollywood, California, 1947
Cahuenga Freeway is one of the major networks of the Los Angeles system of superhighways. This pass forms the Gateway to Hollywood from the famous San Fernando Valley and points north.*
[previous spread]

SPEEDWAY
Bonneville Salt Flats, Utah, 1950
These world-famous salt flats are known as Bonneville, left by the receding waters of Lake Bonneville. This salt deposit covers approximately 160 square miles of Western Utah. The salt is white, its aggregate crystalline, porous, hard and rigid; and supports heavy loads when dry. The timing poles in picture line the course of this world-famous automobile speedway.

SPEEDWAY
Bonneville Salt Flats, Utah, 1951
The square on black line is one end of the measured race course. Electric eyes, one setting far out on salt and one close up. There are two race courses of thirteen miles each, one circular and one straightaway. First tried out in 1912, became world-famous 1931 when Ab Jenkins with his Mormon Meteor broke all previous world's speed records.

SPEEDWAY
Bonneville Salt Flats, Utah, 1951
Roland R. Free, of Los Angeles, California, riding a British Vincent motorcycle in a prone position to cut down wind resistance approximately 2 miles, on September 11, 1950, established a new American speed record for 1 mile @ 156.71 miles per hour. Mr. Free's picture was taken from an automobile running parallel to the black line.

SPEEDWAY
Bonneville Salt Flats, Utah, 1938
In 1912 this area was tested as a racetrack and has since proved to be the greatest automobile speedway in the world. In 1931 Ab Jenkins of Salt Lake City broke all former world speed records. On August 26, 1939, John Cobb became the world's automobile speed king by driving his car 369.74 miles per hour.

ARIZONA HIGHWAY
Tucson, Arizona, 1939
Splendid modern highways, which pierce every part of the state of Arizona, make driving safe and all points of interest, both desert and mountains, accessible.

ROOSEVELT HIGHWAY
Malibu, California, 1938
The Roosevelt Highway, a 1,400-mile road, opened in the late 1920s. It is the first highway linking the Mexican and Canadian borders and was named after the famously internationalist U.S. president, Theodore Roosevelt. View of the adjacent Malibu Mountains north of Santa Monica.
[top left]

ROOSEVELT HIGHWAY
Santa Monica, California, 1939
A beautiful park of palms and flowers crowns the Palisades at Santa Monica. Before you lies the shining blue Pacific and the seaside homes of many of the stars. The pink moss-covered bluffs add to the beauty of this famous drive along U.S. Highway 101—the Roosevelt Highway.
[top right]

SHORELINE HIGHWAY
San Diego, California, 1939
A typical shoreline drive in Southern California.
[bottom left]

ARROYO SECO PARKWAY
Pasadena, California, 1941
A new modern motorway, divided three lanes each way, and intersection-free, serving the metropolitan area between Los Angeles and Pasadena.
[bottom right]

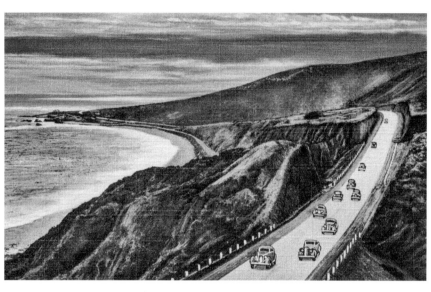

COAST HIGHWAY
Santa Monica, California, 1931
Castellammare is located along the Pacific Coast Highway on small bluffs much closer to sea level, just north of where Sunset Boulevard meets the Roosevelt Highway. The narrow, winding streets in this neighborhood have Italian names and ocean breezes.*
[top left]

CALIFORNIA HIGHWAY
Los Angeles, California, 1938
A California highway winding through the mountains on U.S. Highway 99. The scene depicted herein shows a portion of the Ridge Route, a stretch of highway unparalleled for engineering ingenuity and beauty.
[top right]

ARROYO SECO PARKWAY
Pasadena, California, 1955
Spanning the Arroyo Seco at the west entrance to Pasadena is the Pioneer Bridge, dedicated October 8, 1953, to all Pasadena Pioneers, especially the twenty-seven who founded the city near this spot on January 27, 1874.
[bottom left]

HOLLYWOOD FREEWAY
Los Angeles, California, 1952
The Hollywood Freeway is one of a vast network of major highways engineered and designed to provide unobstructed driving to and from the metropolitan area of Los Angeles. When completed, these freeways will constitute the finest and most modern motor connections with cities and towns throughout Southern California.
[bottom right]

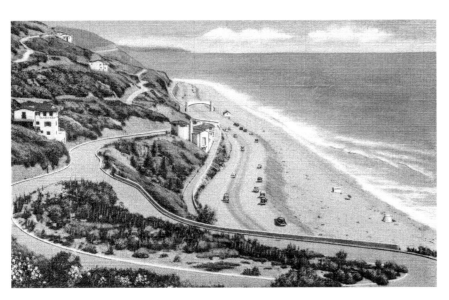

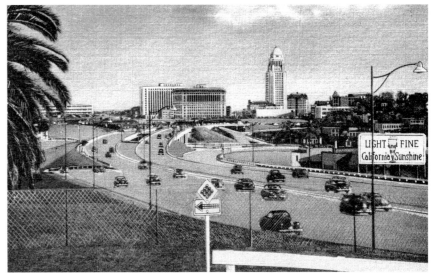

INFRASTRUCTURE

COLUMBIA RIVER HIGHWAY
Bonneville, Oregon, 1937
Illuminated Tunnel Near
Bonneville Dam.

TRANSCONTINENTAL HIGHWAY
Kingman, Arizona, 1937
Both Arizona and Nevada met the
demand of visitors for wider, finer
highways to Boulder Dam by building
modern surfaced roads with easy
grades and banked curves. Slashing
through the corrugated foothills
of northern Arizona, this highway
affords striking vistas of the rugged
Recreational Area below Boulder Dam.*

CUESTA GRADE HIGHWAY
San Luis Obispo, California, 1939
Winding through the beautiful Santa Margarita Mountains in San Luis Obispo County, this new wide-lane, high-speed highway, known as "Cuesta Grade," affords safety, speed, and scenic interest to travelers to and from San Francisco and Los Angeles.

CALIFORNIA HIGHWAY
Burlingame, California, 1940
In the early 1900s, elm and eucalyptus trees planted under the direction of the master gardener John McLaren, designer of San Francisco's Golden Gate Park, towered over the California Highway, known as El Camino Real, to provide shade.*

MOUNTAIN HIGHWAY
High Sierra, California, 1941
Winter traveling in the mountain areas is very delightful. Snowdrifts are cleared from main highways during the heaviest of snow storms through use of modern snow removal equipment.

REDWOOD HIGHWAY
Mendocino, California, 1936
Miles and miles of towering redwoods—undisputed monarchs of this scenic kingdom, many over 300 feet above the highway, and ranging in age from 3,000 to 4,000 years.

BIG SUR COAST HIGHWAY
Big Sur, California, 1933
The territory opened by the new
Big Sur Coast Highway south
from the Monterey Peninsula, the
connecting link of the Roosevelt
Highway between San Luis Obispo
and Monterey, opens a region of
unsurpassed mountain beauty and
coastal grandeur.

TWIN PEAKS HIGHWAY
San Francisco, California, 1934
A sight never to be forgotten is seeing
San Francisco spread out before you
from Twin Peaks, a centrally located
urban mountain rising 1,000 feet
above the city. You behold the broad
Pacific, the Golden Gate, the bay,
cities, mountains, temples, citadels,
and fleets.

INFRASTRUCTURE

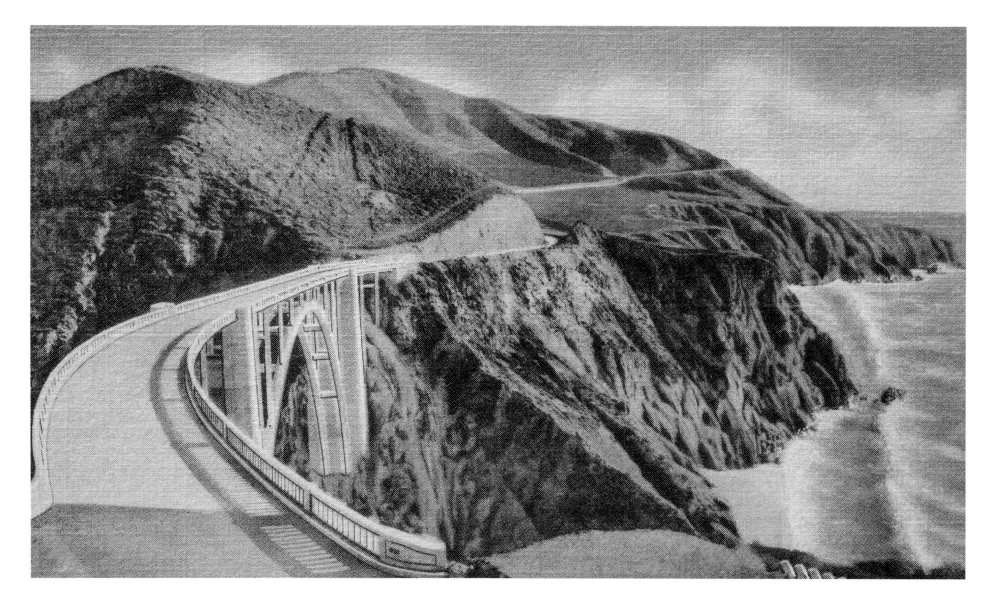

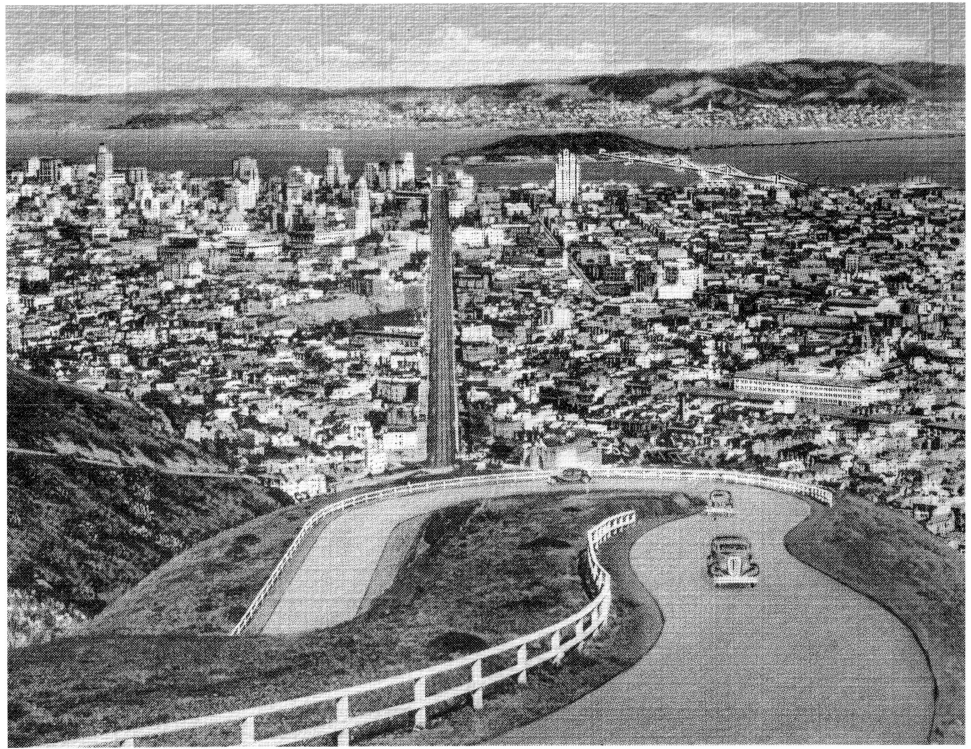

CONNECTION

INFRASTRUCTURE IN THE AGE OF INFORMATION
The military infrastructures to secure a sustained Pax Americana grew in parallel to the civil infrastructures. A vast network of permanent army, navy, and air force installations was established throughout the West, but particularly in California, Washington, Utah, Arizona, New Mexico, and Colorado.

The federal commitment to promote science in the interest of national security started with the Manhattan Project, which produced atomic weapons during World War II, specifically between 1942–1946. The government embraced entire science cities and clusters of laboratories dedicated to research and development in remote locations, such as the Atomic City of Los Alamos in New Mexico.

The fear of an atomic attack on American cities dominated the federal infrastructure development during the cold war in the second half of the twentieth century. The West was both the place where atomic weapons were created and tested, and where the infrastructure networks of the early twentieth century, serving dense, centralized cities, were transformed into resilient infrastructure networks that could withstand a nuclear attack. The urban result was distributed land use connected by highways, municipal airports, and global communication networks that converged into the Internet, created by research and development labs during the 1960s, also in the west.

"A COMMUNICATIONS SYSTEM THAT COULD WITHSTAND A NUCLEAR ATTACK WAS NEEDED."

— PAUL BARAN, 1962

UNION AIR TERMINAL
Burbank, California, 1936
This airport, in the northwest corner of Burbank, was built in 1930. By 1934, the airport had become Los Angeles' primary airport known as Union Air Terminal. Sixteen airline departures a day were scheduled out of Burbank in the 1930s: eight on United Airlines, five on Western Airlines, and three on TWA.
[previous spread]

ARMY TRAINING FIELD
Glendale, Arizona, 1943
In 1940, the U.S. Army sent a representative to Arizona to choose a site for an Army Air Corps training field for advanced training in conventional fighter aircraft. The city of Phoenix bought 1,440 acres of land, which they leased to the federal government at $1 a year.

NAVAL TRAINING STATION
San Diego, California, 1939
Recruits standing by for inspection at the Naval Training Station, San Diego, California, on Saturday morning. They are formed in a quadrangle known as Paul Jones Court, named after their illustrious predecessor, John Paul Jones. All recruits from the western part of the United States are sent to this station before being assigned to the fleet.

NAVAL AIR STATION
San Diego, California, 1931
North Island in San Diego is the first Naval Air Station in the American West. It was commissioned in 1917. Due to its proximity to Hollywood, it plays a unique role in the promotion of air power.

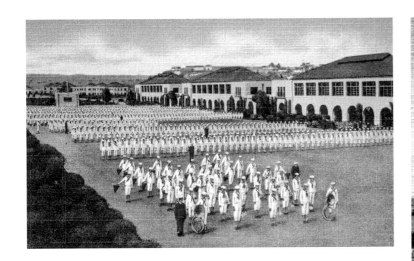

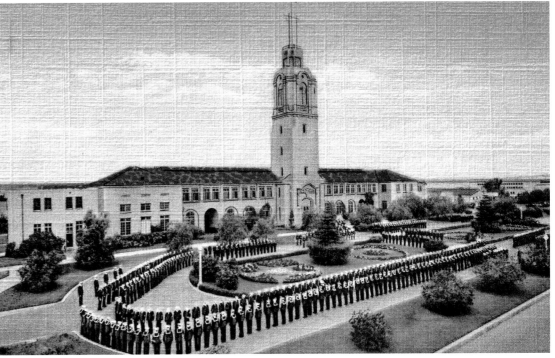

NAVY YARD
Bremerton, Washington, 1938
The Puget Sound Navy Yard at Bremerton, just across Elliott Bay from Seattle, was first established in 1891. Its area now composes 285 acres, and its present inventory value is about $60,000,000. There are three piers in the yard capable of berthing 12 battleships at the same time, and supplying each with necessary electricity, steam, air, and water.

NAVY PLANE CARRIER
San Diego, California, 1933
US Navy plane carrier at anchor, looking up Broadway.*

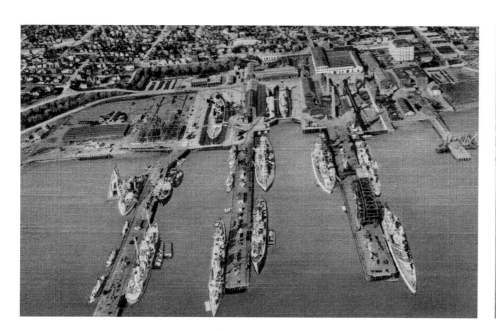

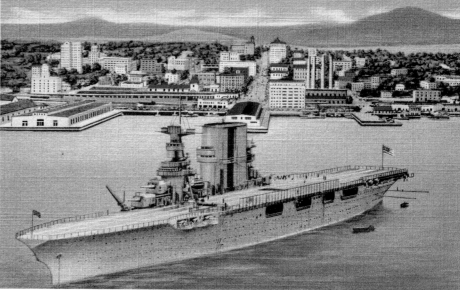

BATTLESHIP
Portland, Oregon, 1938
During Fleet Week each year, a score or more U.S. battleships, submarines, and torpedo boats pass through the several drawbridges to anchor. They also salute the famous *Oregon* of Spanish War fame, now moored in permanent Willamette River Harbor reserve.

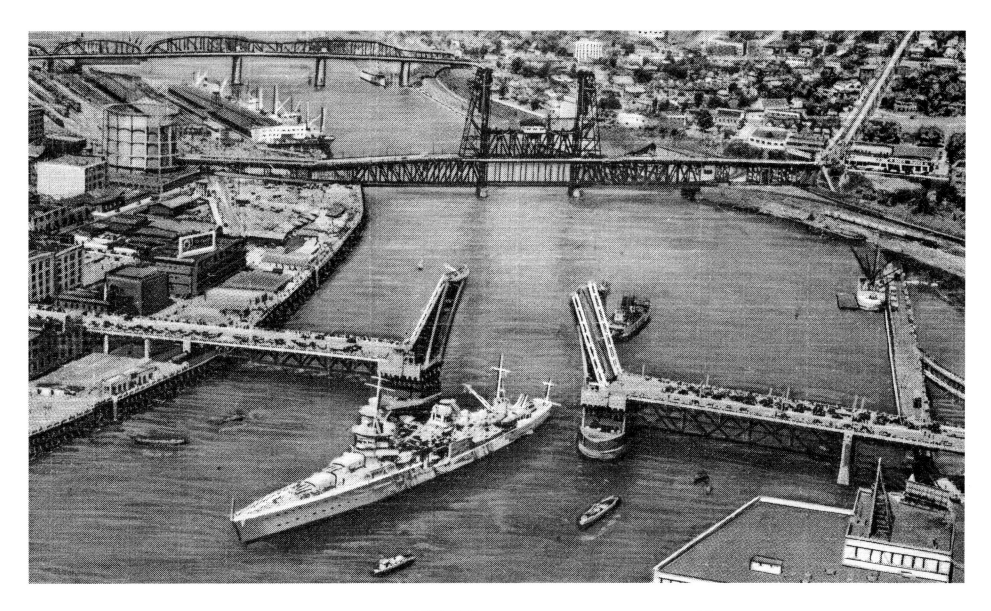

MATHER FIELD
Sacramento, California, 1943
In 1941 Mather Field became the site for advanced navigator training. The Army Air Forces Navigator School consisted of a rigorous 18-week course consisting of instruction in celestial navigation and dead reckoning.

CONSOLIDATED PB2-Y-2
San Diego, California, 1941
Consolidated PB2-Y-2 Navy plane in flight, showing City Hall and the San Diego Bay.

ARMY AIR FORCE
Glendale, Arizona, 1943
Wings over Grand Canyon. Flight of three T-6 Texans, an American single-engined advanced trainer aircraft used to train fighter pilots at Luke Field. During World War II, Luke Field was the largest fighter training base in the Army Air Forces, graduating more than 17,000 fighter pilots earning the nickname, "Home of the Fighter Pilot."*

CHINA CLIPPER
San Francisco, California, 1936
This luxurious flying ship is one of a
fleet of three "Clipper" Ships, *China*,
Hawaii, and *Philippine*, operated on
regular weekly trips between California
and the Orient by Pan-American
Airways System. Stops are made at
the Hawaiian, Midway, Wake, Guam,
and Philippine Islands en route,
reducing a month's sea voyage to five
and one-half days.

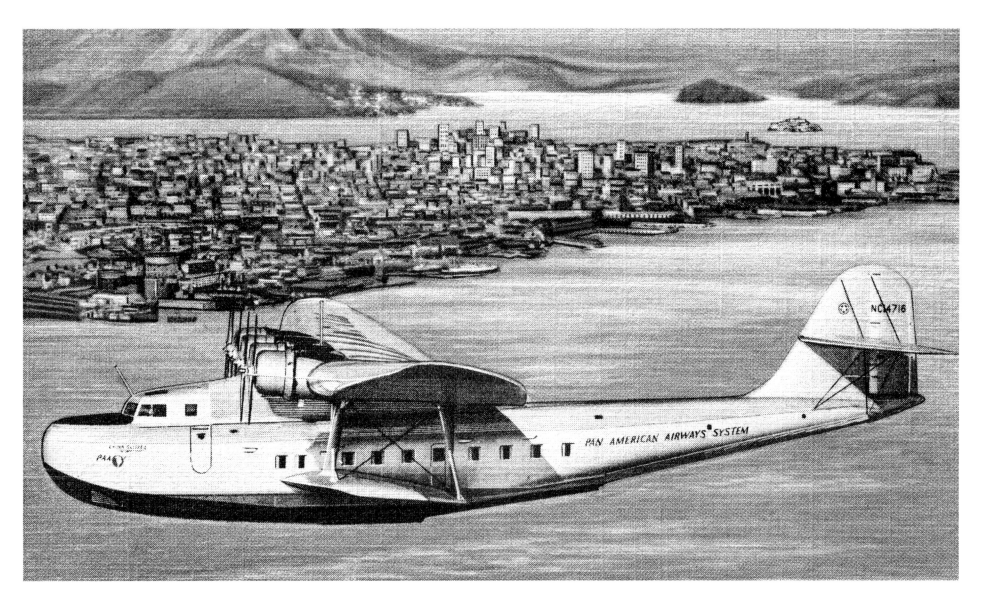

NAVAL AIR STATION
Moffett Field, California, 1943
In 1931, the city of Sunnyvale acquired
a 1,000-acre parcel of farmland
bordering San Francisco Bay as a home
base for the Navy airship U.S.S. *Macon*.
The location proved to be ideal for an
airport since the area is often clear
while other parts of the San Francisco
Bay are covered in fog.*

GIANT HANGAR
Moffett Field, California, 1943
Hangar One is one of the world's largest freestanding structures, covering 8 acres at the Moffett Field airship hangars site at Moffett Field, California, in Santa Clara County of the southern San Francisco Bay area. It was built in 1933 as a naval airship hangar for the U.S.S. *Macon.*

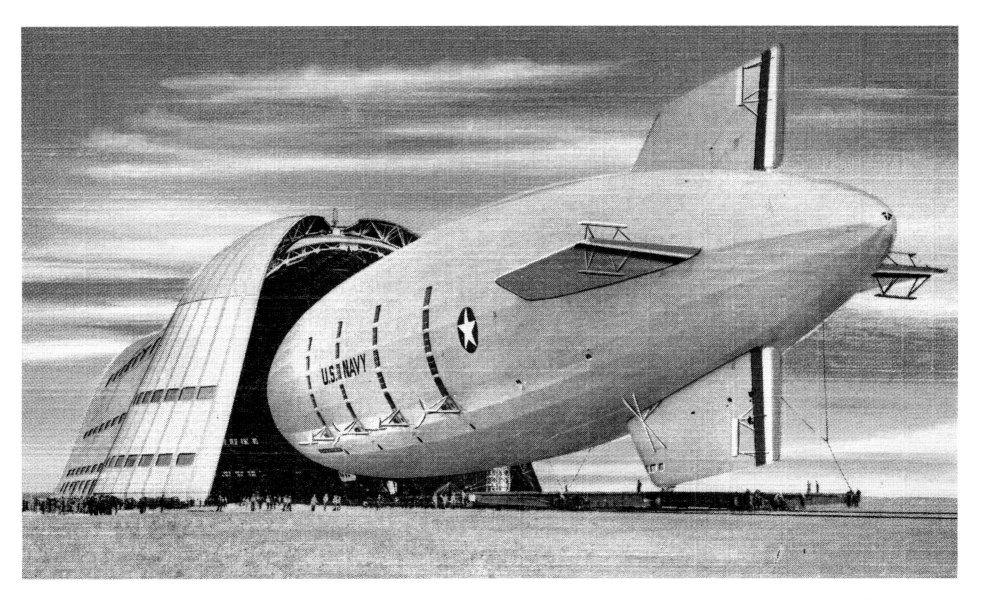

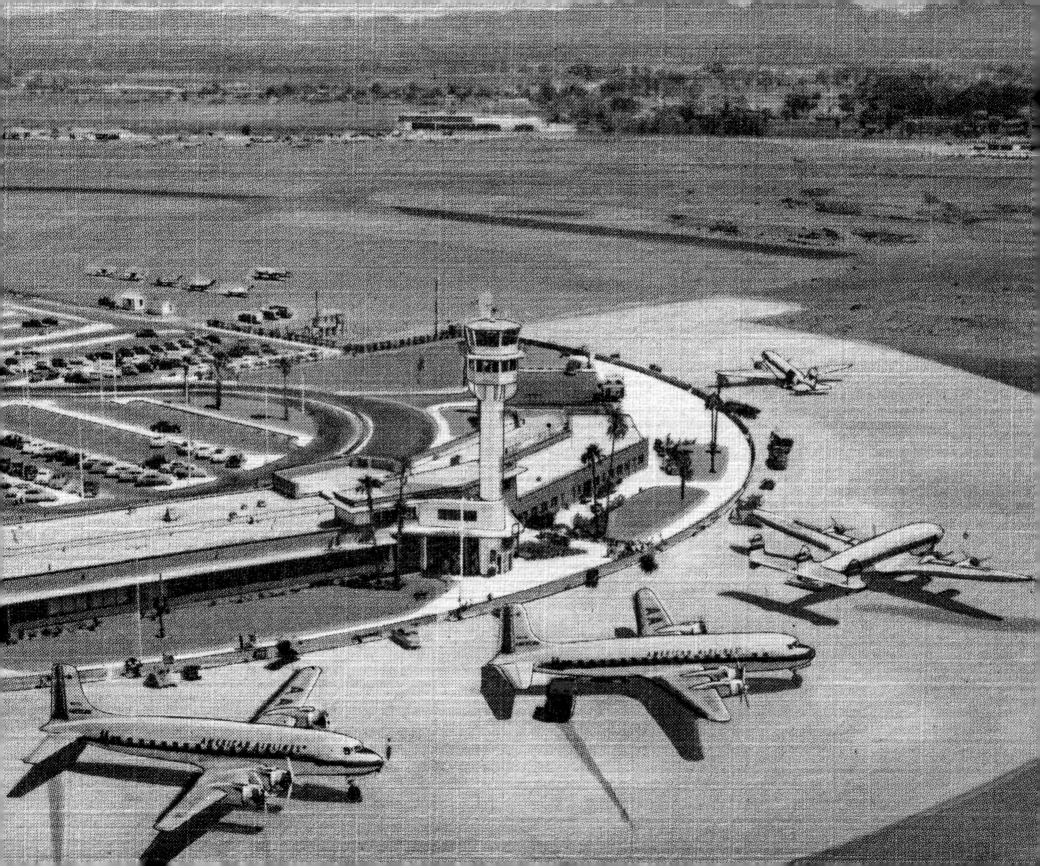

PHOENIX MUNICIPAL AIRPORT
Phoenix, Arizona, 1953
One of the nation's fastest growing
airports and one of the busiest.
Of 152 tower-controlled airports in
the US, it ranked 15th in all activities
in 1952. Its unique Control Tower,
one of the world's tallest, over 125 feet
in height and built of a steel tube 9 feet
in diameter, is the first of its kind in
the world.
[opposite page]

LINDBERGH FIELD
San Diego, California, 1937
San Diego's municipal airport was
named after Colonel Charles A.
Lindbergh, whose famous transatlantic
plane was *The Spirit of St. Louis*.
This airport is one of the finest in
the country and adjoining the harbor
has the double advantage of being
able to accommodate both land
and seaplanes.

OAKLAND MUNICIPAL AIRPORT
Oakland, California, 1935
With a U.S. Department of Commerce
rating of AA-1, the Oakland Municipal
Airport is considered one of the
finest and most modern in the world.
It is the terminus of all important
transcontinental and coastal
passenger lines. The port covers 845
acres and is accessible from water as
well as land.

SAN DIEGO MUNICIPAL AIRPORT
San Diego, California, 1928
Days after Lindbergh made his historic
solo flight from New York to Paris,
San Diego's Chamber of Commerce
named San Diego's new airport
after him. When it was dedicated in
1928, San Diego Municipal Triple-A
Airport—Lindbergh Field—was the
first federally-approved airport in the
United States.

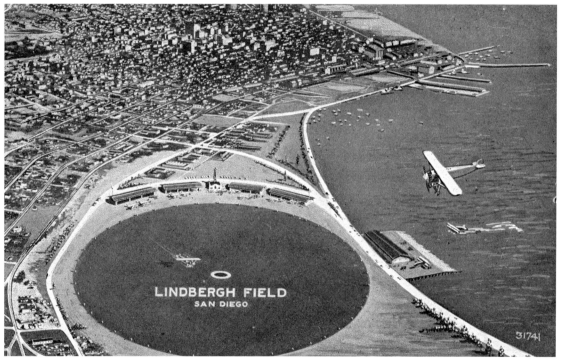

INFRASTRUCTURE

CRADLE OF THE ATOM BOMB
Berkeley, California, 1949
In the Berkeley Hills, overlooking
the campus, is the world-famous
radiation laboratory of the University
of California. In the distance lie the
cities of Berkeley, Oakland, and
San Francisco with the Golden Gate
to the extreme right.

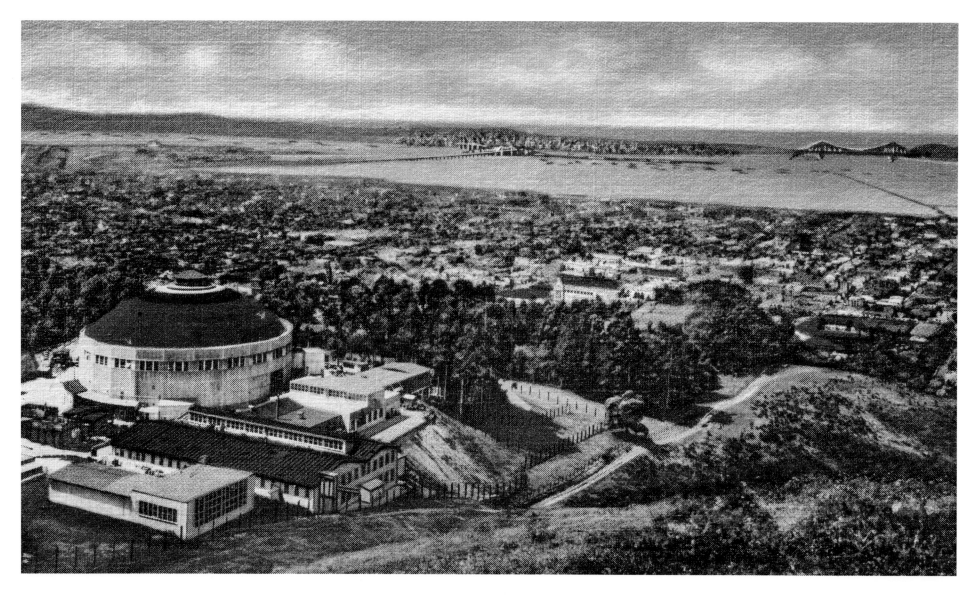

ATOMIC CENTER
Los Alamos, New Mexico, 1948
In the commercial heart of this atomic center are stores to meet every demand of the residents. The Western Housing Area is pictured in the background.

ARCHITECTURE

CIVILIZING THE CITY

by Wolfgang Wagener

"THE CITY STANDS AT THE POINT WHERE NATURE AND ARTIFICE MEET."

— CLAUDE LÉVI-STRAUSS, 1955

TOWN AND DESERT APARTMENTS
Palm Springs, California, 1948
The new Town and Desert is Palm Springs' apartments of tomorrow. Its quiet location offers a beautiful view of the foothills of San Jacinto, and its design provides for maximum advantages of the sun. It is air-conditioned throughout, and for cool nights, there are ample electric heating facilities. Its many and modern features include individual control of radio service in all units of the building. A notable feature is a distinctive and varied color theme. All furniture is custom-built, and particular care was taken in the purchase of the finest beds obtainable. The beautifully tiled and illuminated swimming pool is efficiently heated and of unusually large dimensions.*
[previous spread]

WHILE THE POLITICAL AND ECONOMIC framework of the American West has been the result of strategic, top-down planning by the federal government, cities take, by definition, the opposite approach. They are grassroots, bottom-up developments in local communities, which occur at a concrete place at a specific time for a unique group of citizens. From its very founding, the democratic ideals of the United States empowered civic self-government that secured the right of individuals and advanced their shared interests. Virtually every municipal charter begins with the premise that a city has the police power to protect the public health, safety, and welfare of its residents. The 1879 Constitution of California, for instance, states: "A city may make and enforce within its limits all local, police, sanitary, and other ordinances and regulations not in conflict with general laws." The constitution also placed significant restrictions on California's power to interfere with local city matters.

But what is a city? Less than 175 years ago, there was not a single city in the American West. This fact is particularly remarkable because the first cities emerged independently in the Middle East, India, China, and Middle America between 5,000 and 2,500 years ago during the Neolithic revolution. This global transition of many human cultures from a lifestyle of hunting and gathering to one of agriculture and settlement made increasingly larger populations possible. The agricultural model of cities as local, stable, and long-term settlements lasted until the industrial revolution. It is still reflected in the word "real estate" across many European countries: *l'immeuble* in France, *Immobilie* in Germany, *l'immobile* in Italy, and *el inmueble* in Spain. All are rooted in the Latin *immobilis*—best translated as "immovable property."

The few colonial settlements of the seventeenth- and eighteenth-century American West, beginning with Santa Fe in New Mexico in 1610, or San Jose, the first city in California, in 1777, can also not be seen as the origin for self-governed American cities. They were founded by European nations to integrate North America into the North Atlantic network of trade and commerce.

Today, there are more than 1,000 self-governing cities in the American West. And this number continues to grow. What human activities can take place within a city? Where can they be located? What services does a city provide for residents? How are these services paid for? How many people can live, work, learn, and play in a city? Who decides the physical form? Every single city in the American West represents an economic and

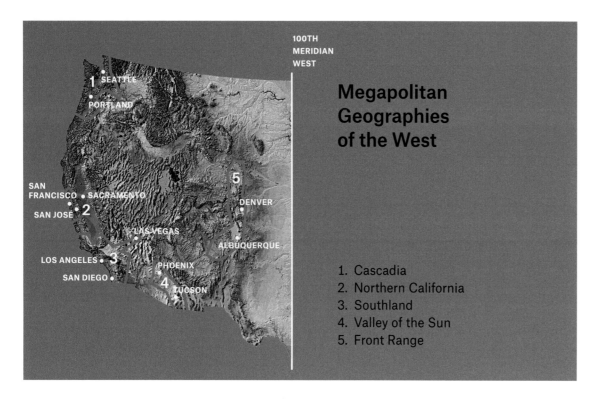

100TH MERIDIAN WEST

Megapolitan Geographies of the West

1. Cascadia
2. Northern California
3. Southland
4. Valley of the Sun
5. Front Range

a political fact. The architecture of these cities lets us know how cities are governed, and who defines, designs, develops, delivers, and manages them. We can read in every skyline and in any city map the representation of the controlling political and economic powers.

These controlling forces have evolved over the past two hundred years along the four ages of steam, steel, oil, and information. At the beginning of the twenty-first century, city development in the American West included ten thousand townsites, one thousand municipal corporations, ten metropolitan areas, and five megapolitan geographies.

Ten Thousand Townsites

Nearly all of the thousands of settlements in the American West were founded as townsites during the age of steam, railway, and mechanization within the federal survey township system, which established administrative boundaries for land ownership based on the 1785 United States Public Land Survey (with the few exceptions of the land grants of colonial cities with European roots). Townsite planning was mostly done by private developers. It was the first step to create legal subdivisions of land for the development of a community. Townsite plans show the layout of blocks with streets and alleys. Each block could show individual lots, usually for the purpose of selling or buying the land. This process became known as subdivision. Land-use regulations were limited to the public right of way for streets to access each land parcel, and the nuisance law, which entitled landowners and leaseholders to the quiet enjoyment of their properties.

Western city blocks differ in size, but typically they are square in shape with an area close

TOWNSITE AREA
Santa Barbara, California, 1877
Bird's eye view of Santa Barbara.
Looking north to the Santa Barbara
Mountains.

to 2.5 acres. The block sizes range from the largest western city block in Salt Lake City, Utah—660' × 660' with a street width of 120'—to one of the smallest western blocks in Portland, Oregon—200' × 200' with a street width of 60'—which is approximately ten-times different in size. Street grids were carefully numbered (First, Second, etc.), lettered (A, B, etc.), or arranged in alphabetical order in anticipation of future growth.

This uniquely American urban development approach was a radical departure from the urban traditions of agricultural Europe up to the founding of the United States. *Stadtluft macht frei*—"cities create liberty"—was, for instance, the principle of German town law. As Germans began establishing cities throughout northern Europe as early as the tenth century, they often received city privileges granting cities autonomy from the feudal lands of secular or religious rulers. Such privileges included economic autonomy, and the right to self-governance, including the ability to

maintain their own criminal courts and militia. A city resident was a free person after living one year and one day in a city. This law created city territories outside the feudal system.

The legal concept of "Life, Liberty and the pursuit of Happiness," one of the founding principles in the United States Declaration of Independence, lies in stark contrast. In fact, one could paraphrase this concept as "liberty creates cities." The biggest surprise in the urban evolution of the American West is the realization that private real estate developers, in exercising their decisive influence on the built environment, have to be considered the primary force for the development of communities in the New West. Basically, townsites are large-scale commercial real estate developments, whose plans were created by land surveyors, real estate developers, urban entrepreneurs, railway companies, and investors. The nineteenth-century age of steam, railway, and mechanization in the American West can be considered the golden age of land

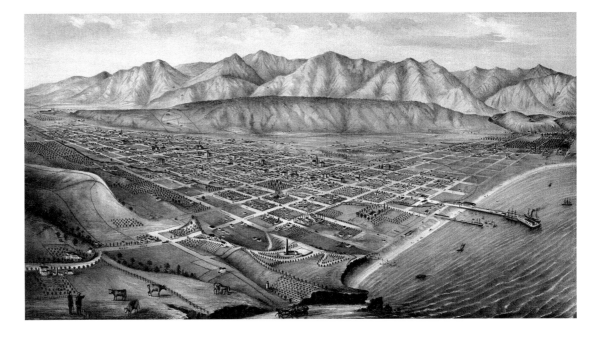

development—one of the biggest real estate developments in the history of mankind.

One Thousand Municipal Corporations

At the beginning of the age of steel, electricity, and heavy engineering, only small land areas of the western states were controlled by cities. With the rapid population growth, industrial activities, and the adoption of urban innovations at the turn of the twentieth century, for example, water, sanitation, and streetcars, more and more communities transformed into cities. Cities are municipal corporations that were granted self-governing powers by the western states. To establish a city as a municipal corporation requires the vote of the residents in the physical area that is seeking to incorporate. A minimum number of residents—1,500 people in California, for instance—is required to apply for a city incorporation plan with the state. Ultimately, a special election for residents must be held on the city's charter, which is like the constitution for the corporate municipality. It contains the framework for its local government, including community development, zoning, the ability to raise revenue by taxation, and the providing of local city services. A municipality must exercise ordinary and reasonable care in providing safe public places and services. As a result of municipal self-governance, land use, real estate development, and the function, form, and user experience of the built environment are under the outright control of each local community.

Municipal corporations had two choices to generate and control future growth and revenues. They could either increase the density within the boundaries of the original city incorporation or expand the city limits through the annexation of adjacent communities. Most cities tried to do both. Municipal corporations started to act as aggressive territorial powers to control land as quickly as possible. The cities of San Francisco and Los Angeles were the two largest and most rapidly growing western cities during this period. Both had strategic geographic disadvantages that they needed to overcome. San Francisco was space-constrained on the northern tip of the San Francisco Peninsula and had no direct access to the transcontinental railway; Los Angeles had no sufficient water supply and no direct access to a harbor at the Pacific. Although San Francisco failed with its annexation plans, it grew vertically. Los Angeles, on the other hand, succeeded with vast annexations and continued to grow horizontally.

While San Francisco established itself in the second half of the nineteenth century as the most powerful city in the American West, it was not able to expand the forty-nine square miles of footprint that the city and county of San Francisco occupied since its incorporation in 1850. A plan was developed by 1912 to consolidate the Bay Area under one municipality by annexing every city within a twenty-mile radius, including Oakland and its East Bay neighbors. This proposal failed to get the required two-thirds majority vote in the general election of November 1912. By 1930, the city and county of San Francisco found an alternative way to double the size of the land area that it controlled through the purchase of the Spring Valley Water company, which was a private company that held the monopoly on water rights in San Francisco from 1860 to 1930, including the almost two hundred miles of water-conveyance system from the Hetch Hetchy Reservoir to the city.

During the same period, the City of Los Angeles was able to increase its physical footprint twelve times, increasing the city-controlled land area from the original twenty-eight square

the grandeur of commercial central business districts and monumental civic centers in the City Beautiful tradition.

Ten Metropolitan Areas

Even with ambitious municipal corporations driving dense city developments, in the second half of the century—the age of oil, automobile, and mass-production—real estate development rapidly outpaced the expansion of physical borders of incorporated cities. The roots of this evolution are in Southern California in the 1920s. During the Jazz Age, Los Angeles was a laboratory of the future. A whole new society was in the making. Los Angeles was the first metropolitan region created to serve the needs of the automobile, and for a brief period of time, Southern California was the center of the world's oil production. A handful of major oil discoveries—at Huntington Beach in Orange County, at Signal Hill near Long Beach, and at Venice Beach near Marina del Rey—made Southern California the world's biggest oil producer for a time. An enormous amount of oil money was quickly made and spent in all kinds of high-rolling ways, including the funding of large-scale real estate developments, the construction of roads and highways for the automobiles that would use the oil, and mass-production of consumer goods. Alphonzo Bell, a farmer in Orange County, suddenly became rich when oil was discovered on his farmland. Among other things, Bell became a real estate developer, and the wealthy enclave of Bel Air was one of his early creations.

Accelerated by the population growth in the western United States after World War II and the rapid adoption of urban innovations—including new roads, highways, automobiles, communications, and climate control—land development expanded rapidly across all cities of the American West into increasingly

miles of the Spanish land grant, which was incorporated by 1850, to 340 square miles by 1916. This included the direct connection to the harbor in San Pedro and the 1915 annexation of the San Fernando Valley to ensure the water supply for the city through the Los Angeles aqueduct system running about three hundred miles from Mono Lake to the city.

The first half of the twentieth century—the age of steel, electricity, and heavy engineering in the American West—marks the coming-of-age period for the cities in the New West. Ambitious municipal corporations drove the bold development of compact, dense, and central cities, which were crowned by

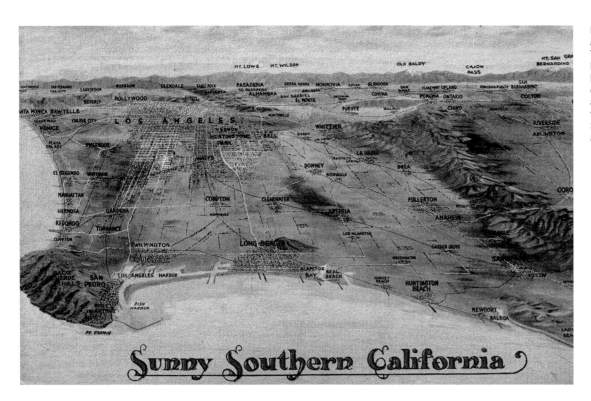

METROPOLITAN AREA
Los Angeles, California, 1932
Topographical view of Los Angeles Metropolitan Area. The Los Angeles Basin, in which more than 80 communities of Los Angeles County are located, is a region bounded on three sides by the Santa Monica, Santa Susana, San Gabriel, San Bernardino, and Santa Ana Mountains.*

remote locations. This development outgrew the control of a single city, but was influenced by a patchwork of many local municipal corporations, which could be reached via the automobile, and which shared industry, employment, infrastructure, housing, education, and recreation across an entire metropolitan region, such as Denver, Las Vegas, Los Angeles, Phoenix, Portland, Sacramento, San Diego, San Francisco, San Jose, and Seattle.

The unintended consequences of these organic, regional, and rapid development patterns were wasteful consumption of land and natural resources, and the pollution of air, water, and land. The scale of these environmental challenges affected entire natural systems and ecologies much larger than were controllable for a local municipality. The federal and state governments stepped in to regulate urban development on a regional scale by establishing environmental protection agencies as well as historic preservation and urban redevelopment organizations in the 1960s, and also by requiring that cities start to develop comprehensive plans to manage future growth in their local communities through proactive urban planning.

As result of the rapid expansion from municipal corporations to metropolitan regions, the second half of the twentieth century was a period of increasingly interconnected urban development with a focus on environmental sustainability, community participation, and functional integration.

Five Megapolitan Geographies

Successful cities are like magnets. The colonial grassroots expansion that real estate developers started 175 years ago in the American West congealed at the beginning of

METROPOLITAN AREA
San Francisco, California, 1934
Topographical view of San Francisco Metropolitan Bay Area. San Francisco Bay area and adjacent territory as it appears from the air. The great sweep of Bay covers 460 square miles. In the distance is "The Great Valley" and beyond the Sierra Mountain Range.

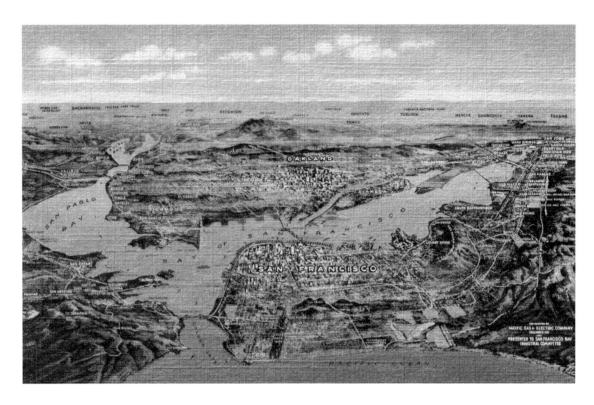

the twenty-first century into five megapolitan geographies. Each of the five megaregions—Cascadia, Northern California, Southland, Valley of the Sun, and Front Range—contains more than ten million people and has centralized global connections, infrastructure, and services. They are platforms for innovation, entrepreneurship, and economic growth. This is an evolution of the metropolitan structure away from the monocentric cities toward more dispersed, yet, at the same time, integrated networks of responsive and resilient cities with a focus on collaboration, user experience, health, quality of life, and a balance of city and nature. Due to the large scale of the megapolitan areas, regional cohesion is created less by functional relationships, such as mobility and infrastructure, than by the connecting forces of goods movement, business linkages, cultural commonality, and physical environment.

Human activities happen simultaneously in space and in time (space and time describe the human activity range, while the mobility of people, goods, and services extends the action radius). People may choose to live further away from the townsites of the age of steam, railways, and mechanization, further away from the municipal corporations of the age of steel, electricity, and heavy engineering, and further away from the metropolitan areas of the age of oil, automobile, and mass-production. This is because advances in mobility and connectivity in the age of information, communication, and big data allow people the abundance of space of smaller cities and towns, and access to nature in the spectacular setting of the American West, combined with many of the employment options, goods, and services once available only in central cities.

FORMATION

ARCHITECTURE IN THE AGE OF STEAM

The booming grassroots land development in the second half of the nineteenth century was characterized by two complementary architectural approaches: one, adding value to the land through commercial real estate development; and two, adding value to the scenery through federal national park development.

Urban entrepreneurs and railway companies started to develop the ubiquitous survey townships of the 1785 land survey system across the American West to meet the market-driven space needs of a rapidly growing population, industrial activities, commerce, and gateways to transportation. Design and construction had to be pragmatic: wood and brick were the first locally produced industrial construction materials, and buildings were built quickly.

The development of the national park architecture, on the other hand, was an approach that sought to make the scenery the main attraction rather than the buildings. Lodges, hotels, and supporting structures were developed for a particular site with the goal of blending the buildings with the spectacular natural surroundings through low silhouettes, the avoidance of severely straight lines, and the demarcation between the land and the structure. Natural materials and colors, hand-tooled finishes with logs and quarried stone, the adaptation of frontier construction methods, and vernacular architecture were used to reflect the spirit of a local place.

"BUY LAND. THEY'RE NOT MAKING IT ANYMORE."

MARK TWAIN, 1875

SURVEY TOWNSHIP
Palm Springs, California, 1940
As the place comes up through the desert from the east, a view is had which gives the real idea of the relation of Palm Springs to desert and mountain. The town nestles close to the mountain which affords it shelter. Tahquitz Canyon is seen on the left, Tachevah in the center, and Chino on the right.
[previous spread]

CITY GRID
Albuquerque, New Mexico, 1938
The village of Albuquerque—the present Old Town—was founded by Governor Cuervo in 1706. In 1885 the railroad arrived, building their depot 3 miles east. A new town sprang up around this and is now the largest city in the state.

WASHINGTON STREET
Phoenix, Arizona, 1943
Roll call of nation's chain stores. Phoenix is the trading center for approximately 200,000 people living in and adjacent to the Salt River Valley, "Valley of the Sun." The fact that most of our national chain store organizations are represented here is proof that business is good in Phoenix.

CITY GRID
Phoenix, Arizona, 1940
The 1940 census gave Phoenix a population of 65,434, but the large buildings in its downtown section make it look like a city twice that size; and actually, it is the shopping center for all of Maricopa County with a population of 185,539, as well as jobbing center for the entire state.

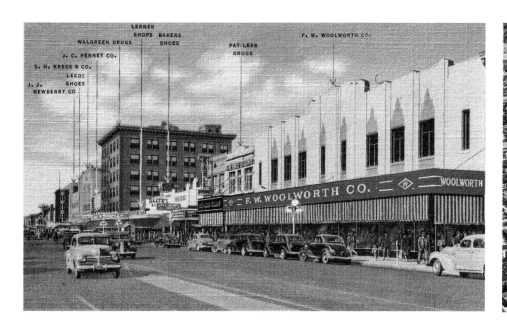

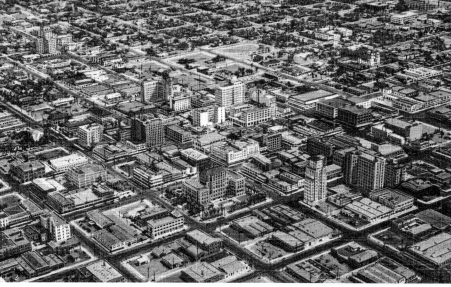

ARCHITECTURE

K STREET
Sacramento, California, 1943
K Street is Sacramento's major business thoroughfare and is the hub of retail shopping for the entire Golden Empire of California. Looking south from Eighth Street.
[top left]

HIGUERA STREET
San Luis Obispo, California, 1939
San Luis Obispo is one of the historic Mission towns of California—a thriving business community, midway on the Coast Highway between Los Angeles and San Francisco and in the heart of a large, rich dairy and cattle region.
[top right]

MAIN STREET
Salt Lake City, Utah, 1938
Main Street is one of the principal business thoroughfares of Salt Lake City, which is noted for its broad, straight streets. The standard width of a Salt Lake street is 132 feet, allowing ample room for parking on either side and six lanes for driving.
[bottom left]

WASHINGTON STREET
Phoenix, Arizona, 1943
Looking east from Phoenix's Washington Street, which leads past downtown hotels and on through residential districts and citrus groves into the mountain-fringed winter resort lands.
[bottom right]

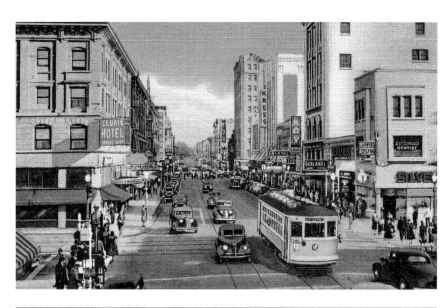

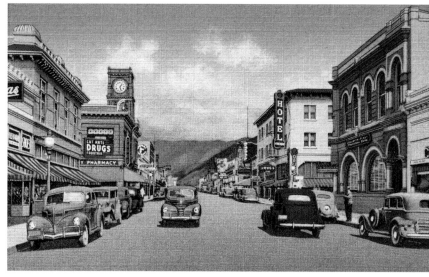

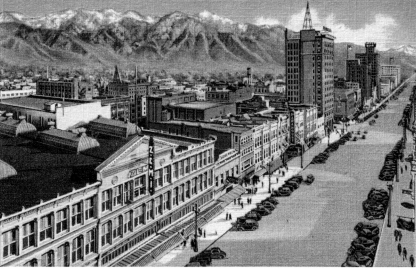

ARCHITECTURE

MAIN STREET
Fresno, California, 1939
The city of Fresno has a population of over 60,000. It is the thriving metropolis of the San Joaquin Valley, the great farming empire of Central California. Here are located packing and processing plants for the products of the farms. It is the home of the largest raisin packing plant in the world.
[top left]

D STREET
Marysville, California, 1943
Marysville, a thriving, active community often referred to as the "Hub City" acts as a gateway to the rich mining districts of the Sierras and Northern California. Centrally located in a rich farmland area where 75 varieties of crops abound as well as cattle, sheep, hogs, and dairying. The per capita buying power is exceedingly large.
[top right]

VIRGINIA STREET
Reno, Nevada, 1929
All roads lead to Reno's Virginia Street. The main business thoroughfare of Reno at night is transformed into a blaze of brilliant lights, featuring many of the city's famous nightspots and casinos.
[bottom left]

CONGRESS STREET
Tucson, Arizona, 1942
Congress Street is one of the city's most vibrant and well-used downtown commercial corridors. The view is looking west.*
[bottom right]

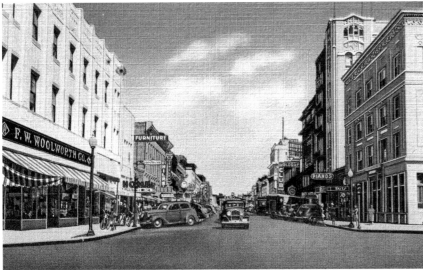

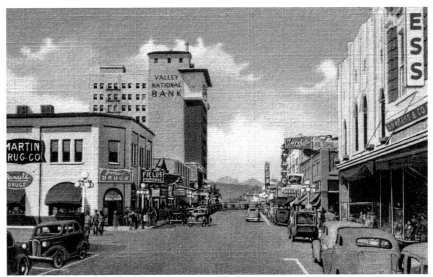

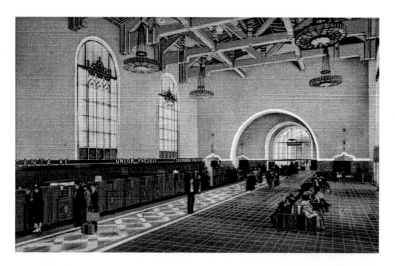

UNION STATION
Los Angeles, California, 1939
This spacious ticket concourse has been beautifully decorated in magnificent colors. The three great railroad systems which built and operate this fine passenger station have provided every convenience for the arriving or departing traveler.

UNION STATION
Los Angeles, California, 1940
Typically Californian in its spacious and beautiful Spanish architecture, the new Los Angeles Union Station, built at a cost of $11,000,000, provides a setting which typifies to visitors the charm and hospitality of Los Angeles and Southern California. The tropical plantings and beautiful drives, walkways, and shady patios add to the charm of this most modern terminal.

UNION STATION
Los Angeles, California, 1939
In keeping with the lavish appointments provided in the new Los Angeles Union Station, the glimpse of the waiting room shows the leather upholstered settees provided for the comfort of the passengers.

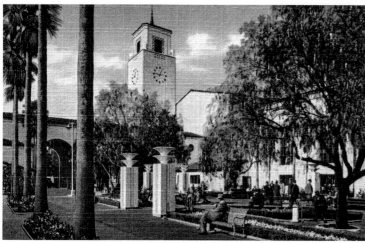

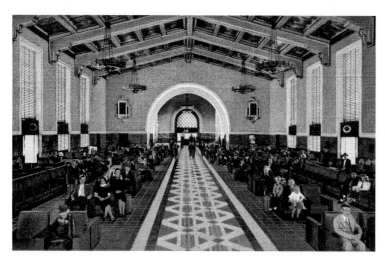

FERRY BUILDING
San Francisco, California, 1940
More than 55,000,000 people
pass through the portals of the
San Francisco Ferry Building each
year, where boat connections are
made for the East Bay cities and for
other rail connections in all directions.
The Ferry Building with its clock is
one of the landmarks of the city.

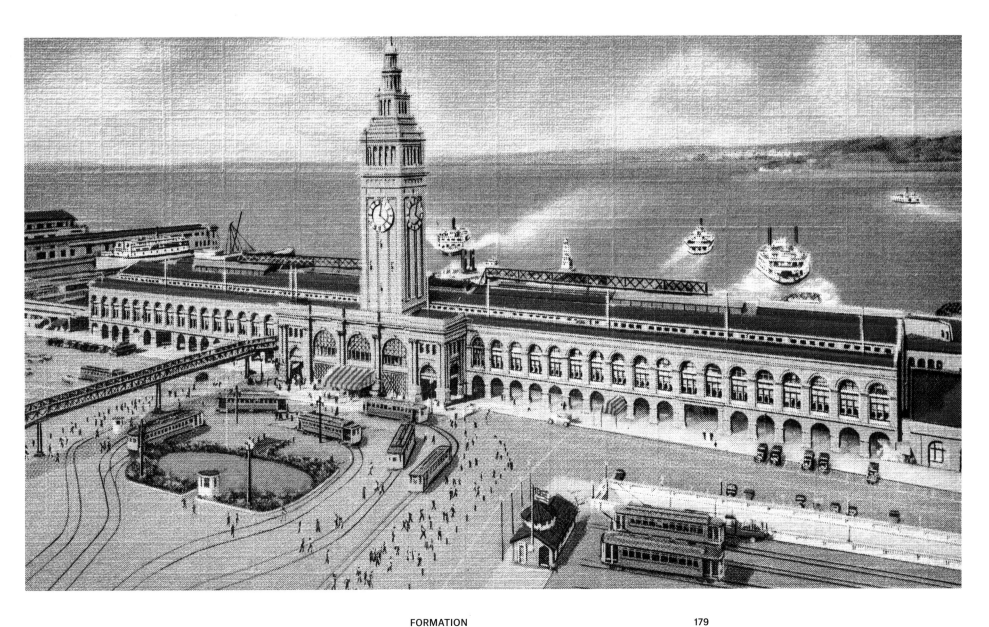

NAVAJO HOGAN
Monument Valley, Utah, 1939
The Navajo Indian house or home is still built in aboriginal style of sticks and mud with dirt floors. From ancient custom the door always faces the east. During the summer months, they move higher into the mountains and build a temporary hogan. In case of death of any member of the family while in the hogan, they immediately desert it and it is known as a "chin-dee hogan" or haunted house.
[top left]

SAW LOG HOUSE
Tacoma, Washington, 1925
Two natives of Washington: a bear den and dwelling in a Washington sawlog.*
[top right]

FIRST HOUSE
Salt Lake City, Utah, 1939
First House was erected in 1847, under the direction of Brigham Young, by the pioneers who reached Salt Lake Valley July 24th of that year. The material used was rough logs and slabs cut from same for the roof. The crevices between logs were filled with mud. Now under pergola on Temple Block.
[bottom left]

HOPI HOUSE
Grand Canyon National Park, Arizona, 1937
Near El Tovar Hotel is the Hopi House, an exact reproduction of a pueblo dwelling, with its interesting glimpses of Indian life.
[bottom right]

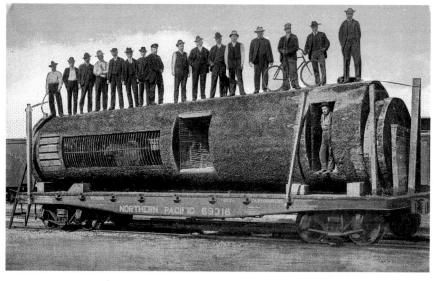

HOUSE OF ANTLERS
*Yellowstone National Park,
Wyoming, 1936*
In front of the Headquarters Museum
at Mammoth stands this unique house
of antlers, made principally of shed
wapiti antlers and some from moose
and deer. This is probably the most
frequently photographed "building" in
the park.

TIMBERLINE LODGE
Mount Hood, Oregon, 1937
This new lodge is located on the south slope of Mount Hood at Timberline, approximately 6,000 feet above sea level. In a setting of unusual beauty, it will afford delightful accommodations to the lovers of the great outdoors, and it is of particular interest to the enthusiasts of winter sports.

TIMBERLINE LODGE
Mount Hood, Oregon, 1937
Erected by the Federal Government at a cost of over $1,000,000 in Oregon's beautiful vacationland. Altitude of lodge: 6000 feet. Altitude of mountain: 11,245 feet.*

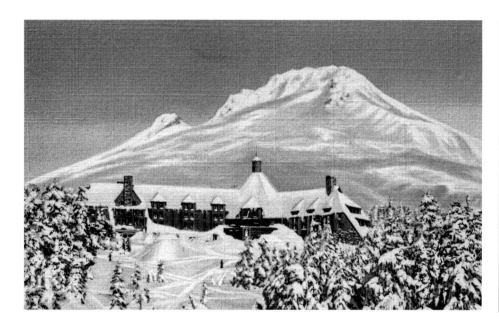

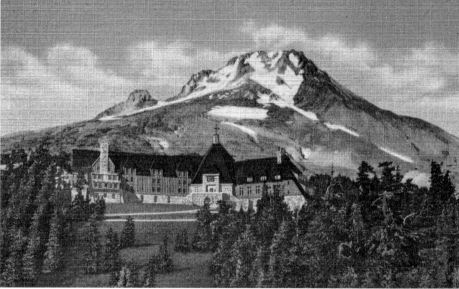

PARADISE INN
Rainer National Park, Washington, 1938
Mid-June scene. Clearing highway
to Paradise Inn by steam shovel. The
snow here ranges from 8 to 10 feet in
depth. Automobiles follow immediately
after the steam shovel is through.

OLD FAITHFUL INN
Yellowstone National Park,
Wyoming, 1935
Old Faithful Inn, in Upper Geyser Basin,
was so named because of its proximity
to Old Faithful Geyser. From the
veranda of this huge log structure,
there may be seen at close range the
hourly eruptions of Old Faithful Geyser,
as well as displays of many other
nearby geysers.

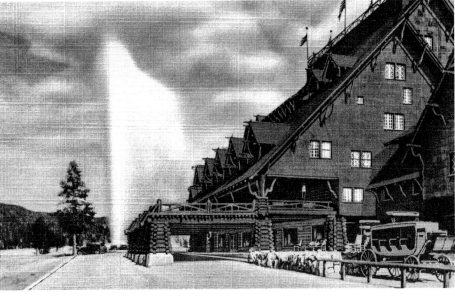

YOSEMITE LODGE
Yosemite National Park,
California, 1936
An excellent view of Yosemite Falls
from Yosemite Lodge. The Upper
Fall, 35 feet wide at the top, plunges
1,430 feet over a perpendicular granite
wall. The park and Yosemite Lodge
are open all year.*

GLACIER PARK HOTEL
Glacier National Park, Montana, 1941
Glacier Park Hotel, built by the Great
Northern Railway at the eastern
entrance of the park, at a cost of
$100,000, is the most prominent
structure of the park. It easily
accommodates 200 people and has
every convenience of the modern hotel.
The most important feature of the
hotel is its magnificent rustic lobby,
finished in fir wood and stained a
natural brown to bring out the beauty
of the wood.

CANYON HOTEL
Yellowstone National Park,
Wyoming, 1940
Canyon Hotel Lounge, one of the
showplaces of the park, is the front
wing of the hotel situated on the
north side of the Grand Canyon of the
Yellowstone. It has an elegant resort-
like air. The Canyon Hotel was built in
Yellowstone National Park in 1910 by
the Yellowstone Park Company. It was
built on a huge scale, with a perimeter
measurement of one mile.

EL TOVAR HOTEL
Grand Canyon National Park,
Arizona, 1937
El Tovar Hotel is situated on an
unparalleled site, 7,000 feet above
sea level, on the very rim of the
Grand Canyon. It was named for the
Spanish conquistador, Don Pedro
de Tovar, whose memory is linked with
the discovery of the Grand Canyon
by Coronado's soldiers in 1540.

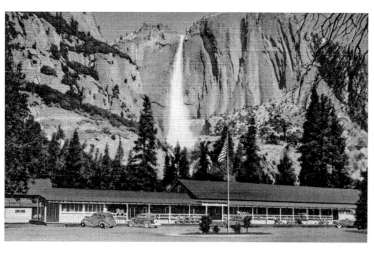

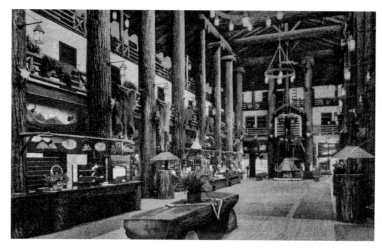

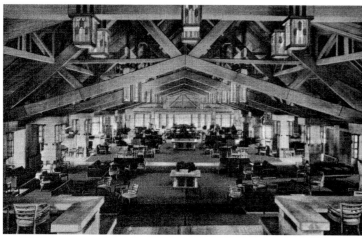

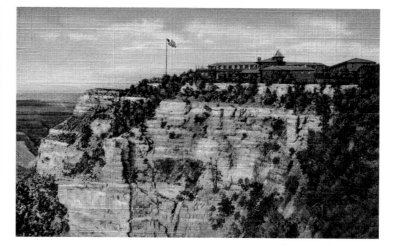

AHWAHNEE HOTEL
Yosemite National Park,
California, 1934
The Ahwahnee is Yosemite's famous
hotel. It is located in a beautiful
meadow on the north side of the valley
near the base of Royal Arches and
from its location commands all the
major views of the valley.*

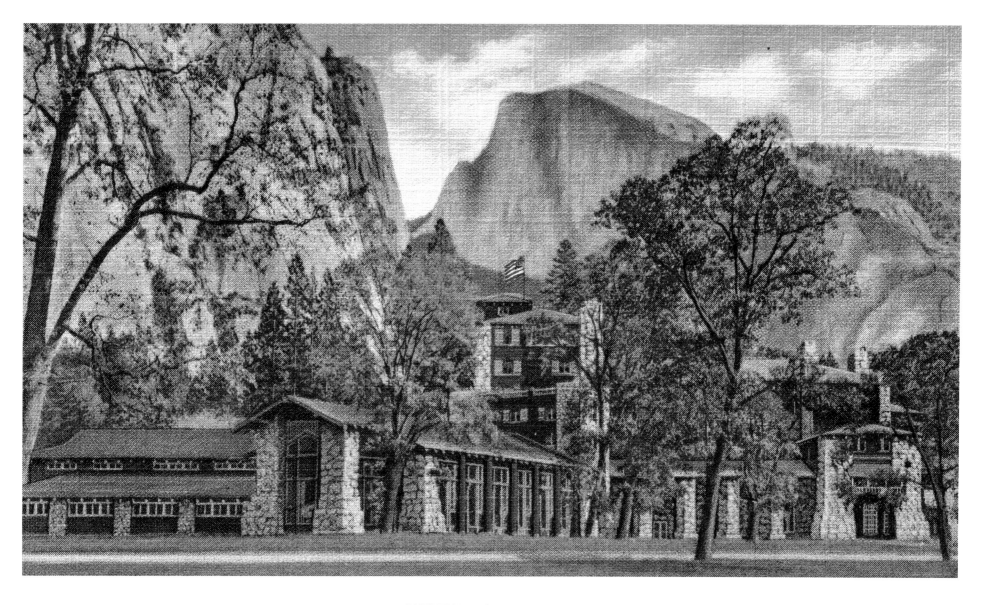

ARCHITECTURE

DENSITY

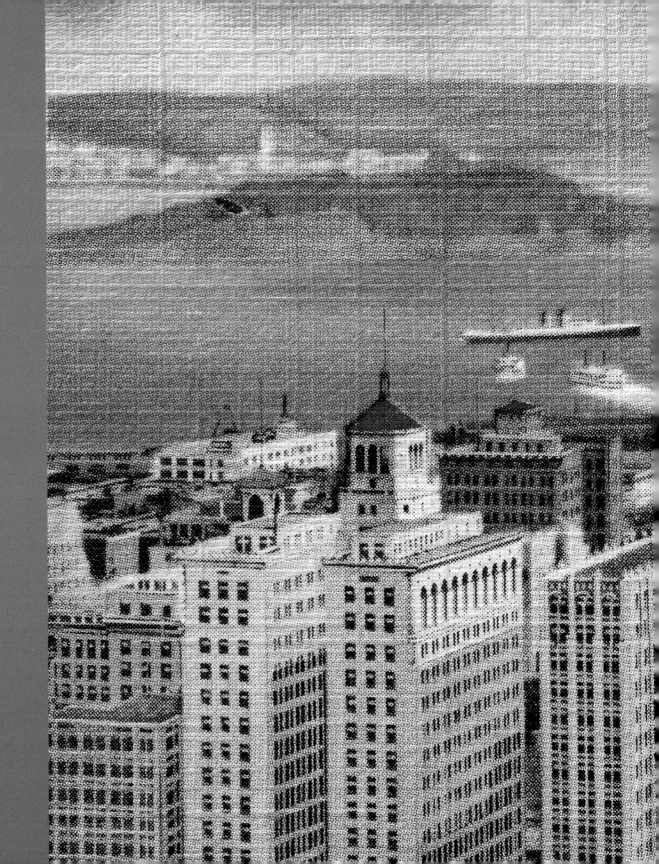

ARCHITECTURE IN THE AGE OF STEEL

Unprecedented population growth, industrial activity, and municipal corporations drove the rise of central cities at the beginning of the twentieth century. As both market-driven engineering marvels of commerce and planned centers of civic pride, the early twentieth-century cities increased urban densities with benefits for a vibrant street life, the efficient use of infrastructure, and access to employment, goods, and services.

Steel and concrete frames intensified land use by multiplying the footprint vertically for new types of commercial office, hotel, retail, and apartment buildings. The electrical and mechanical systems that were introduced in the nineteenth century became universal features, increasing real estate productivity, comfort, and safety. While San Francisco was the natural metropolis of the New West, the tallest building on the West Coast from 1914 to 1962 was the Smith Tower in Seattle.

The increasing heights and densities in the early twentieth-century city centers triggered the introduction of urban planning and zoning regulations. In 1904, Los Angeles was one of the first municipalities in the United States to enact a land use ordinance. The city also imposed a strict 150-foot height limitation for aesthetic and economic reasons, with one exception: Los Angeles City Hall itself. At three times this height, City Hall dominated the entire skyline from 1928 to 1964.

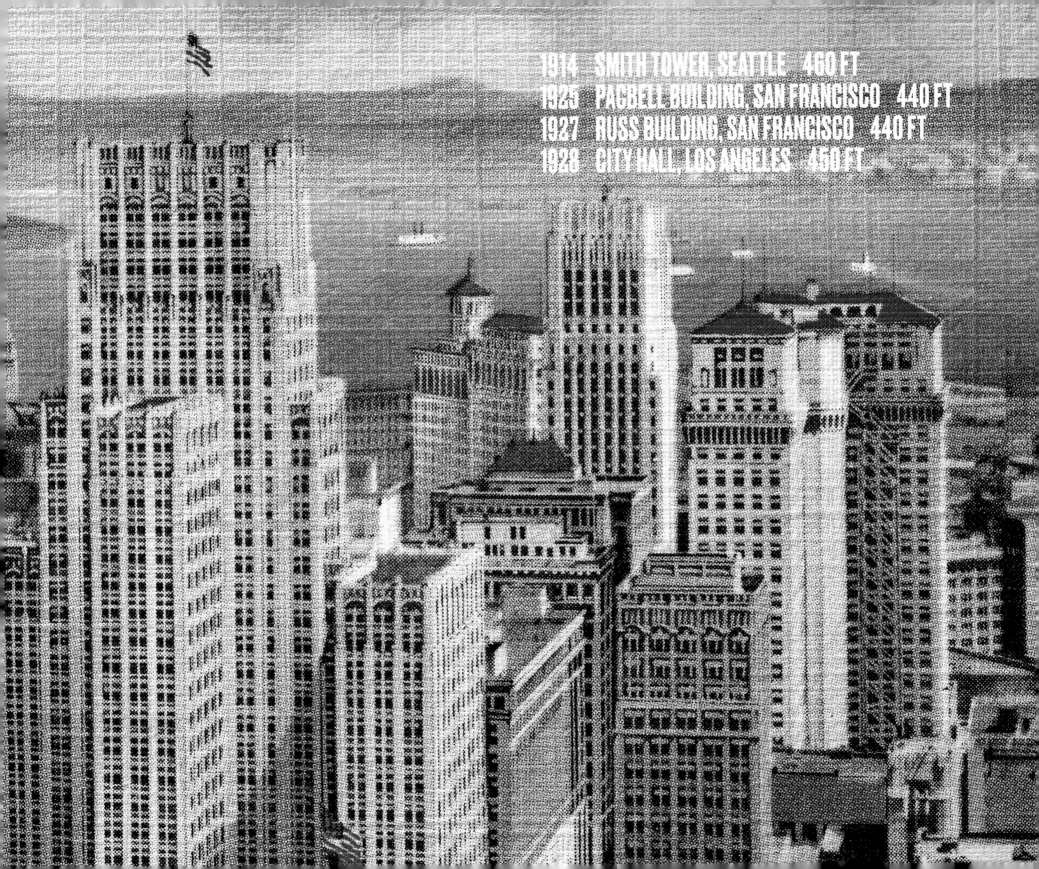

1914 SMITH TOWER, SEATTLE 460 FT
1925 PACBELL BUILDING, SAN FRANCISCO 440 FT
1927 RUSS BUILDING, SAN FRANCISCO 440 FT
1928 CITY HALL, LOS ANGELES 450 FT

SKYSCRAPERS

San Francisco, California, 1932
"Citadels of modern business" best describe the skyscrapers which tower above the busy streets of San Francisco. Unprecedented growth in population and industrial activity have brought architectural wonders of stone and steel into being—to vie with one of nature's wonders—San Francisco Bay and the Golden Gate.
[previous spread]

FISHERMAN'S WHARF

San Francisco, California, 1938
The outdoor fish markets and restaurants of San Francisco's Fisherman's Wharf largely supply her with abundance of various shell and freshly caught fish. Here you may also come to enjoy a fresh crab, shrimp, or lobster cocktail, or a full-course seafood dinner, under most interesting and picturesque Latin environment.

GOLDEN DRAGON PARADE

San Francisco, California, 1938
Parade "Golden Dragon" of good luck in Chinatown. The Golden Dragon "Gim Lung," signifying good luck, is one of four. The others: Heavenly Dragon, which guards the mansions of the gods; Spiritual Dragon, which controls winds and rain; and Earth Dragon, which guards secret places of wealth from mortals, are only paraded on special occasions.

PUBLIC MARKET
Portland, Oregon, 1934
One-million-dollar public market
on Portland Harbor.*

OLVERA STREET
Los Angeles, California, 1936
Olvera Street is located near the Plaza
and the new Union Station. The street
is typical of Old Mexico—an interesting
quarter of colorful bazaars, where
vendors display their quaint pottery,
candle, and basket novelties. The
oldest house in Los Angeles is located
on this historical street.

ARCHITECTURE

POWELL STREET AT MARKET
San Francisco, California, 1938
Powell Street, with unique hill-climbing cable cars, their resonant clanging bells, turntables, intriguing grip and cable propulsion arrangement, enhance the visitor's interest to this street of famous hotels, cafes, and many shops.

MARKET AND POST STREETS
San Francisco, California, 1932
Streets running at angles enter Market St., forming a gore. Many of the choice downtown locations occupy two streets.

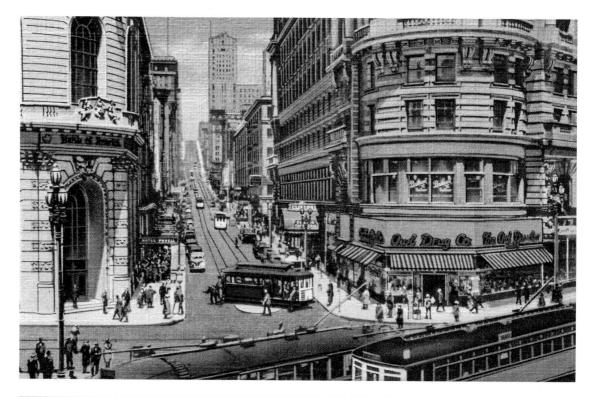

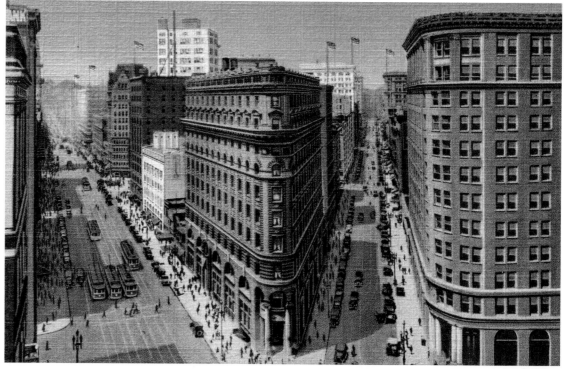

SEVENTH STREET AT HILL
Los Angeles, California, 1931
In the heart of the downtown shopping district. Its daily passing parade reflects a true cross section of population of this metropolis of the West.*

BROADWAY
San Diego, California, 1939
San Diego is a city of over 175,000 and is located in the Southwestern corner of the United States. This is a region diversified in agricultural and mineral resources, a superb vacationland, a beautiful residential area, and an important commercial center. San Diego is one of the outstanding naval operating bases in America, also United States Marine Base on the West Coast.

ARCHITECTURE

PERSHING SQUARE
Los Angeles, California, 1931
Pershing Square is located in the heart of the downtown shopping district, close to theatres, cafés, and leading hotels. It affords a delightful resting place for countless tourists and Southern Californians.*

UNION SQUARE
San Francisco, California, 1934
Union Square, one of the many small parks scattered throughout San Francisco, is surrounded by office buildings, hotels, and shops, in the center of which is a monument erected to Admiral Dewey. To the right is the Stockton Street tunnel under one of San Francisco's famous seven hills.

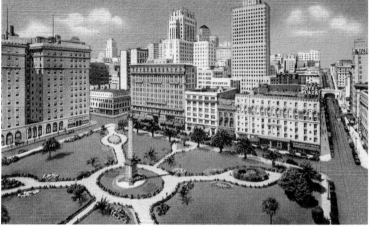

PORTSMOUTH SQUARE
San Francisco, California, 1934
Surrounded by tall buildings is
Portsmouth Square Park in the heart
of downtown San Francisco and
adjacent to the city's internationally
famous Chinatown. It was here that
the American flag was first raised
when the lands (now California) were
secured from Mexico July 9, 1846,
by Captain John B. Montgomery.*

DENSITY

CIVIC CENTER

San Francisco, California, 1932
San Francisco's $20,000,000 Civic Center includes the City Hall, whose dome is higher than that of the National Capitol; the Public Library; the Civic Auditorium; the State Building; the War Memorial and Opera House; and the Health Center. The Civic Center is one of the finest in the world.
[top left]

CIVIC CENTER

Los Angeles, California, 1939
Los Angeles' imposing New Federal Building is situated in the heart of the Civic Center, flanked on each side by the beautiful City Hall and massive Hall of Justice. It houses all Post Office and Federal Departments as well as all United States District and Bankruptcy Courts.
[top right]

CITY HALL PARK

Seattle, Washington, 1942
The City Hall Park is surrounded by the County-City Building, the forty-two-story Smith Tower, the tallest building west of the Mississippi, and Frye Hotel. When the park was laid out in 1916, the County-City Building housed both Seattle and King County governments.*
[bottom left]

CIVIC CENTER

Oakland, California, 1935
Oakland's $3,000,000 City Hall with Memorial Park in foreground is a splendid structure situated in the heart of downtown Oakland, from which the principal business district radiates. San Pablo Ave., Fourteenth Street, and Broadway, act as a hub. Plaza is a constantly changing view of flowers.
[bottom right]

CIVIC CENTER

Los Angeles, California, 1936
City Hall, State Building, Hall of Records, Hall of Justice, and Federal Post Office and Courthouse Building comprise the buildings in the Los Angeles Civic Center.

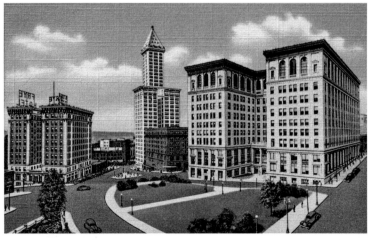

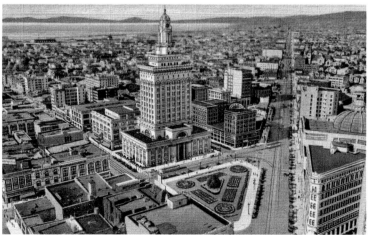

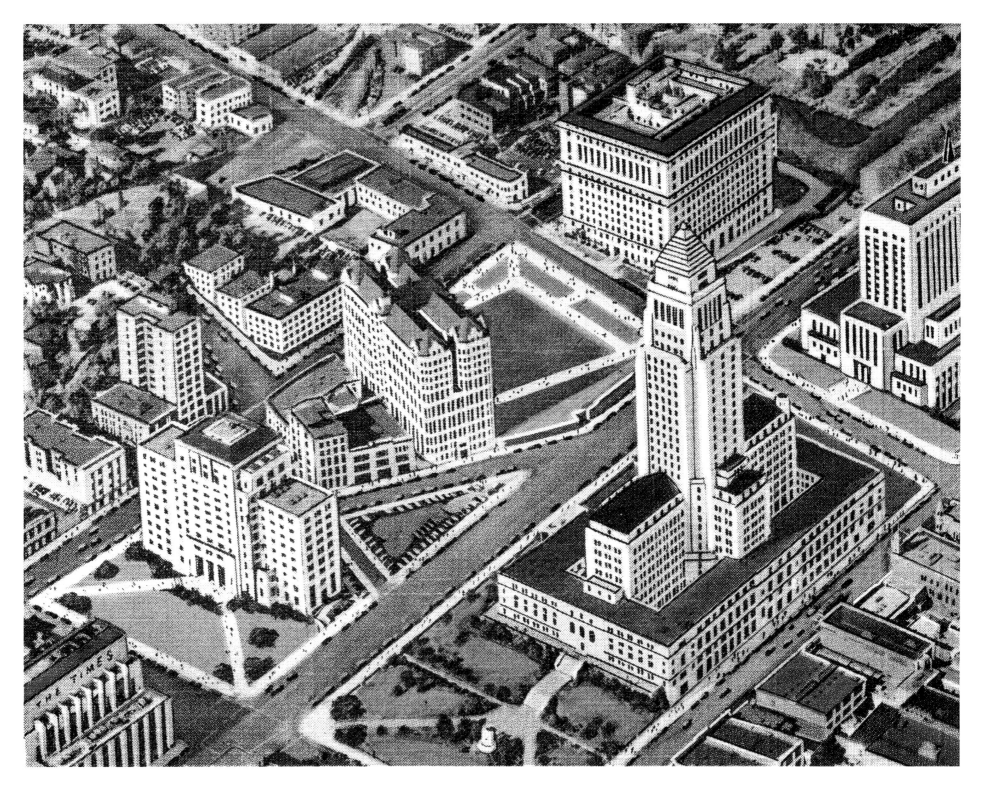

VILLA RIVIERA

Long Beach, California, 1941

Long Beach is justly proud of one of the finest and most popular bathing beaches on the California Coast. Many fine hotels, apartment houses, beach clubs, and homes front on this delightful shore, in full view to the resort activities.

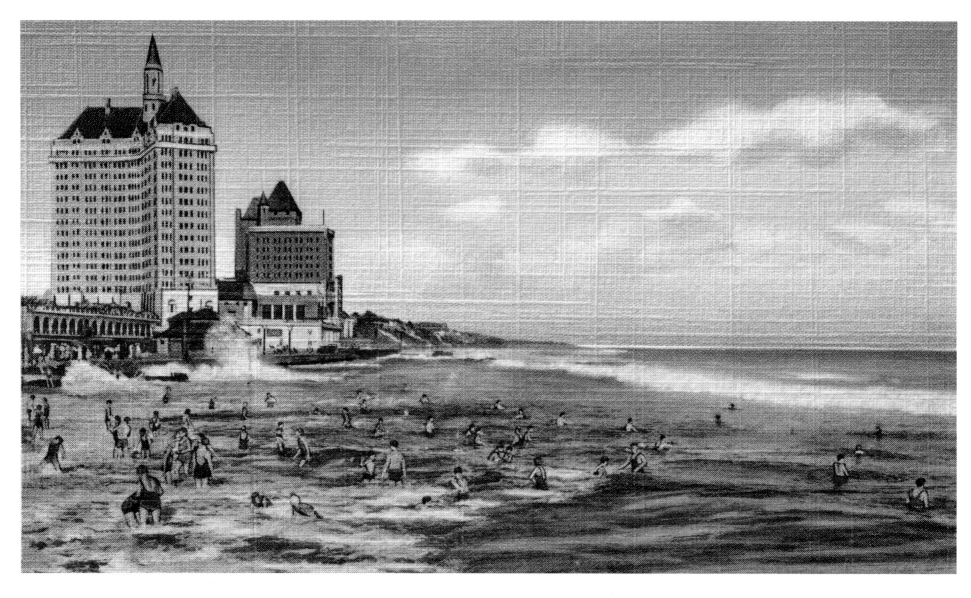

ARCHITECTURE

HOTEL ST. FRANCIS
San Francisco, California, 1945
The two twelve-story south wings
of the hotel were built in 1904,
and the double-width north wing
was completed in 1913, initially as
apartments for permanent guests.
During the 1920s, the St. Francis
became the fashionable place to stay
for celebrities and film actors coming
from Hollywood.
[top left]

LOS ANGELES BILTMORE
Los Angeles, California, 1936
The largest hotel in western America.
1,500 rooms, six restaurants,
including the Biltmore Bowl famous
supper club. Situated between two
tropical garden parks. It is the social
and business center of the southland.
[top right]

ROSSLYN HOTEL
Los Angeles, California, 1936
These twin buildings of the New
Rosslyn Hotel are connected by Marble
Subway. 1,100 rooms—800 baths—
popular rates. Free autobus meets
all trains. Automobile entrance direct
to hotel lobby. Descriptive folder with
rates sent upon request.
[bottom left]

U.S. GRANT HOTEL
San Diego, California, 1935
The Horton Plaza in downtown
San Diego has been the center of city
interest since 1870. Facing it is
the modern 500-room U.S. Grant
Hotel, famed throughout the country
for its excellent service.
[bottom right]

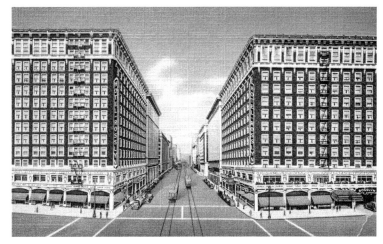

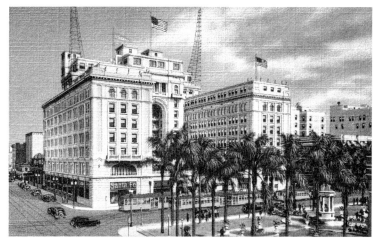

PACIFIC TELEPHONE BUILDING
San Francisco, California, 1932
Thirty-two stories with all the dignity, grace of line, and aspiring height of modern structures. 435 feet high with 210,000 square feet of office space. Cost approximately $5,000,000.

BUSINESS CENTER
San Francisco, California, 1932
Forty-three piers and terminals, comprising more than 17 miles of berthing space, now line San Francisco's waterfront. San Francisco has the finest natural harbor in the world and ranks second in value of water-borne commerce of all ports in the United States and is the port of departure for more than 112 steamship lines to all parts of the earth.

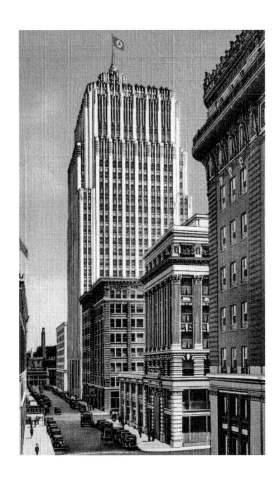

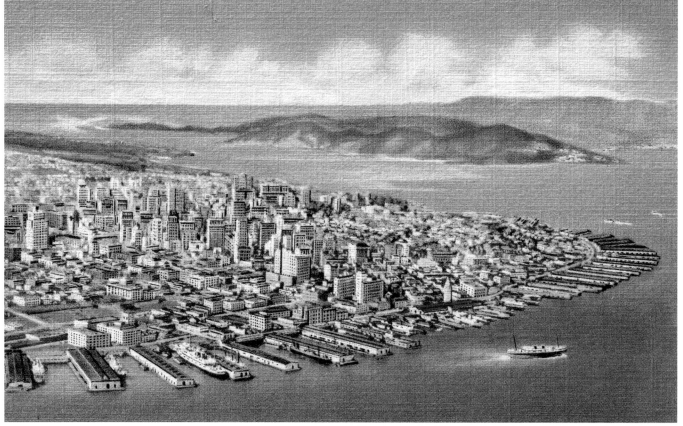

BUSINESS CENTER
Seattle, Washington, 1935
View of central business district. Ships depart from Seattle's waterfront to all parts of the world. Mount Rainier in the distance as it looks on a clear day, fifty miles away.*

FOUR-FIFTY SUTTER STREET
San Francisco, California, 1929
A twenty-six-floor, 344-foot skyscraper. The tower is known for its "Neo-Mayan" Art Deco design by architect Timothy L. Pflueger.*

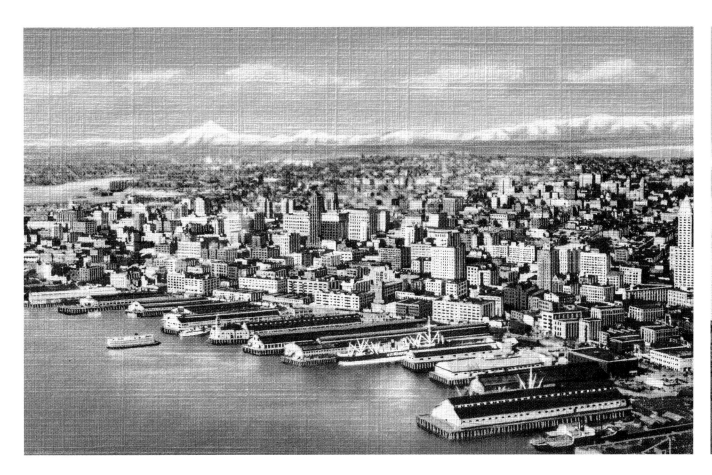

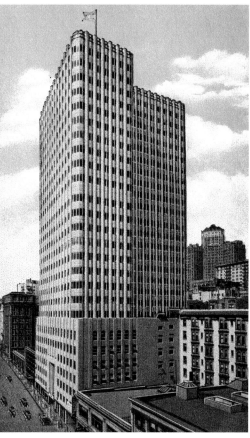

ARCHITECTURE

EXPANSION

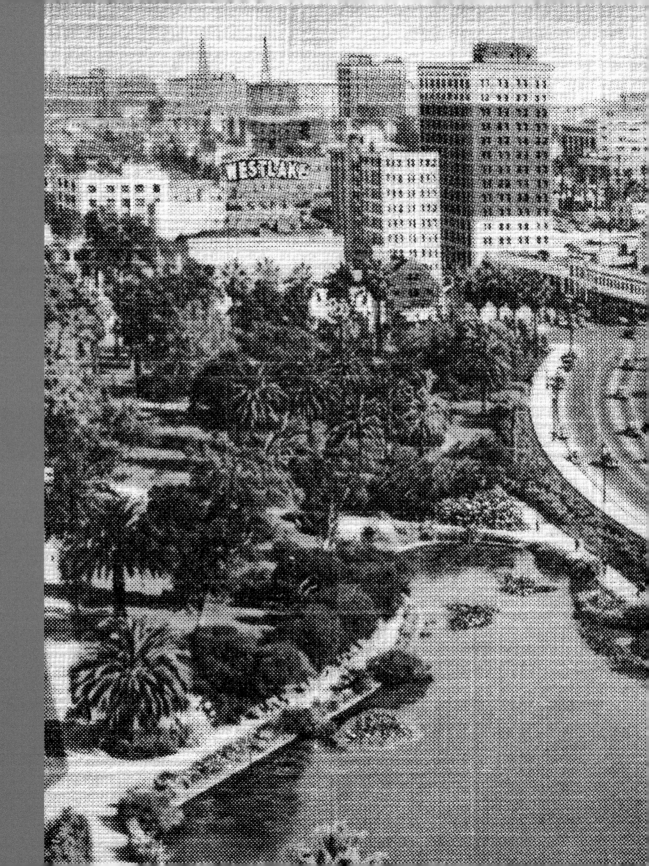

ARCHITECTURE IN THE AGE OF OIL

From the 1920s to the 1950s, Southern California was the laboratory of the future. Los Angeles was the first metropolitan area that had the space and the will of civic leaders, real estate developers, and architects to successfully integrate the new possibilities of the automobile. Employment options, goods, and services once available only in central cities started to be developed in new communities along major boulevards, creating linear downtowns such as the 1930s Miracle Mile at Wilshire Boulevard. Department stores, corporations, and other businesses expanded their operations and reorganized their buildings for convenient car access.

At the same time, the challenge of integrating automobiles and their storage in existing central cities began to be addressed as early as 1941 with the world's first underground parking structure in the heart of San Francisco's Union Square shopping district.

Dispersion was not only desired for an improved quality of life, it was also a necessity for national security, providing a higher degree of resilience in the case of military attacks during World War II. Buildings did not just need to be spread out, they also had to be blacked out. The world's first windowless, fully climate-controlled, blackout plant was established in Long Beach in 1941. Subsequently, climate-control integration improved the performance of office, retail, and apartment buildings in both new communities and existing central urban cores.

"WILSHIRE BOULEVARD IS ONE OF
THE FEW GREAT STREETS IN THE WORLD
WHERE DRIVING IS A PLEASURE."

— REYNER BANHAM, 1971

BULLOCK'S WILSHIRE
Los Angeles, California, 1937
It is one of the first department stores in Los Angeles to cater to the burgeoning automobile culture. It is located in a mostly residential district, its objective to attract shoppers who want a closer place to shop than downtown Los Angeles. Since most customers arrive by vehicle, the most appealing entrance is placed in the rear.*

OWL DRUGSTORE DRIVE-IN
Los Angeles, California, 1948
The world's largest and finest drugstore. World headquarters located at Beverly and La Cienega Boulevards for easy access by car near the border of West Hollywood and Beverly Hills.

WESTWOOD VILLAGE
Los Angeles, California, 1940
Westwood Village is ultra-modern, different in every respect, in a land of unusual communities. Smart shops, intimate restaurants, outdoor skating rink, and the college atmosphere all lend to make Westwood one of the most unusual and picturesque of California's newer cities.

WILSHIRE BOULEVARD
Los Angeles, California, 1941
Westlake Park is an interesting 20-acre sunken park, containing a large lake with boating facilities. Many varieties of tropical trees and flowers surround the lake. Wilshire Boulevard, one of the principal thoroughfares of the metropolitan area, passes through the park, a direct route to Beverly Hills and the beaches west of Los Angeles.
[previous spread]

RAINBOW PIER
Long Beach, California, 1937
A more distinctive pier never adorned the Southern California shore. Rainbow Pier was among the first of its kind designed explicitly for the automobile. Built atop a granite breakwater, the pier's roadway could easily support the weight of a motorcar. The road extended more than a quarter-mile into the Pacific before returning back to shore, which eliminated the need for awkward turnarounds.*

UNION SQUARE GARAGE
San Francisco, California, 1943
Union Square, one of the many parks scattered throughout San Francisco, is surrounded by office buildings, hotels, and shops, in the center of which is a monument erected to Admiral Dewey. Four levels of underground space, occupying the entire block, accommodating 1,700 autos, is operated as an ultramodern public garage, with entrances and exits on all four sides.

LINCOLN HIGHWAY TERMINUS
San Francisco, California, 1938
High on a promontory in Lincoln Park, San Francisco, the California Palace of the Legion of Honor stands. The famed Golden Gate is below, while across the strait are the Marin Hills and Mount Tamalpais, guardian of the Pacific. The flagpole in the foreground marks the western terminal of the Lincoln Highway.

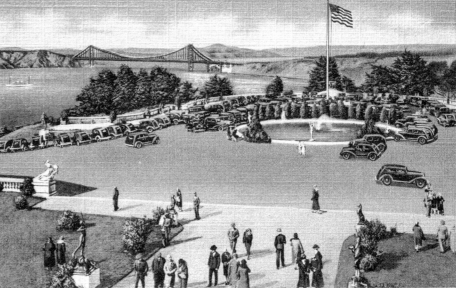

SCOTTY'S CASTLE
Death Valley National Monument, California, 1940
Scotty's Castle is the most impressive example of man's handiwork to be found in the Death Valley region. The palatial home of Death Valley Scotty, the mystery man of the desert.

ARIZONA BILTMORE
Phoenix, Arizona, 1939
The hotels in the "Valley of the Sun" are among the country's finest. The Arizona Biltmore is one of the most prominent, a luxurious hotel surrounded with well-appointed bungalows in spacious gardens, offering every convenience to its guests who have come to Arizona to rest and play, and above all to be in the sun.

BLACK-OUT PLANT
San Diego, California, 1941
San Diego is an important aircraft
construction center. Many of
the U.S. Army and Navy airships
are constructed here. New
developments are conceived
and experimented with in this
air-minded community. The
Consolidated Aircraft Corporation
is one of San Diego's largest
airplane plants.*

BLACK-OUT PLANT
Long Beach, California, 1941
One of the large units of the Douglas
Aircraft Corporation engaged in the
manufacture of planes for defense
purposes is located at Long Beach.
It is a most modern factory, and the
first black-out plant to be established
in the United States. Showing the giant
bomber B-19 in flight.

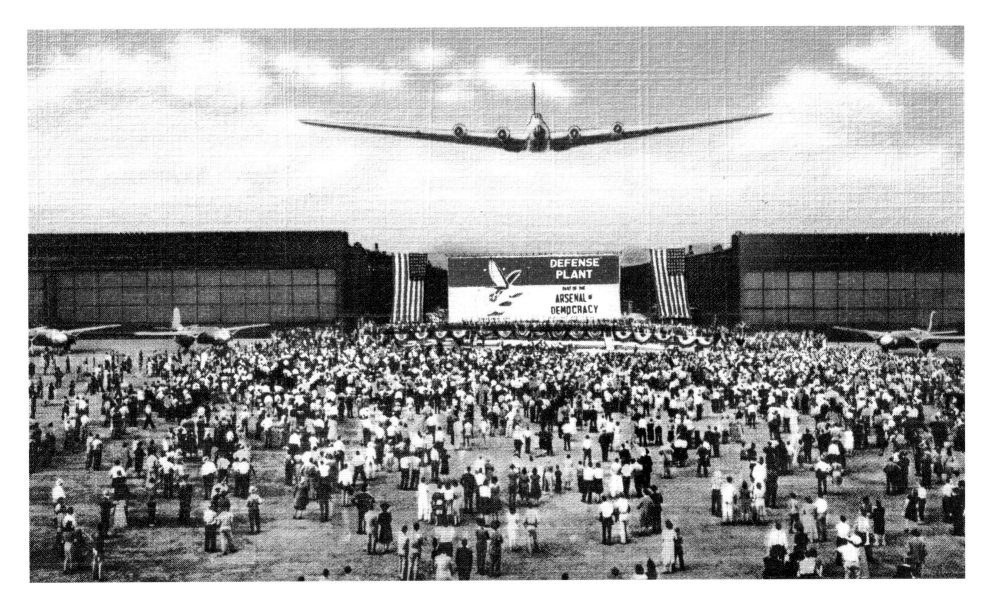

EQUITABLE BUILDING
Portland, Oregon, 1955

One of America's most modern office buildings with 39,500 square feet of double plate glass windows and sheet aluminum exterior. Completely air-conditioned by reverse cycle heating and cooling, using water from three wells under the building. Home Office of Equitable Savings and Loan Association, which was founded in 1890. Building completed in 1948.

HOTEL STATLER
Los Angeles, California, 1953

Statler Center in Los Angeles is the largest hotel project to be constructed in America in more than 20 years. The center, which occupies an entire city block, is comprised of a 1,300-room hotel, an office building with 150,000 square feet, shops and stores, and a semitropical garden pool area—in heart of the business district.

BULLOCK'S PASADENA
Pasadena, California, 1949
A department store of distinction, and
one of the most unusual and beautiful
establishments in the entire country.
The architecture is ultramodern,
outwardly having the appearance
of a fine hotel or an exclusive club.
Bullock's Pasadena is among the
first department stores in America
to be located outside of a downtown
area and is intended to appeal to the
emerging "carriage trade," or those
shoppers arriving by automobiles.*

PRUDENTIAL INSURANCE BUILDING
Los Angeles, California, 1950
Wilshire Boulevard is one of the main thoroughfares of the city, connecting downtown Los Angeles direct to the beach at Santa Monica. Many attractive suburban shopping districts are part of Los Angeles. The "Miracle Mile," so named because of its rapid development, is one of the most interesting. Many of the leading downtown retail and department stores have established beautiful and unique shops along this "Fifth Avenue of the West."

PARKLABREA TOWERS
Los Angeles, California, 1951
Parklabrea Towers and Residential Community occupies 176 acres in the heart of the Wilshire District of Los Angeles. The eighteen 13-story buildings and surrounding apartment dwellings establish a resident population of about 12,000 people. Parklabrea is conveniently situated near the famous "Miracle Mile" Wilshire Boulevard shopping district.

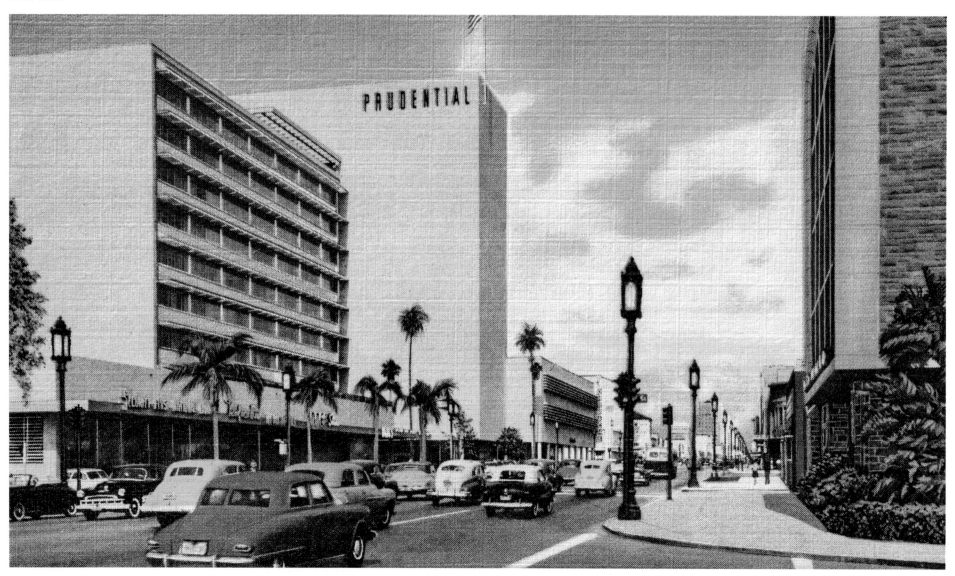

ARCHITECTURE

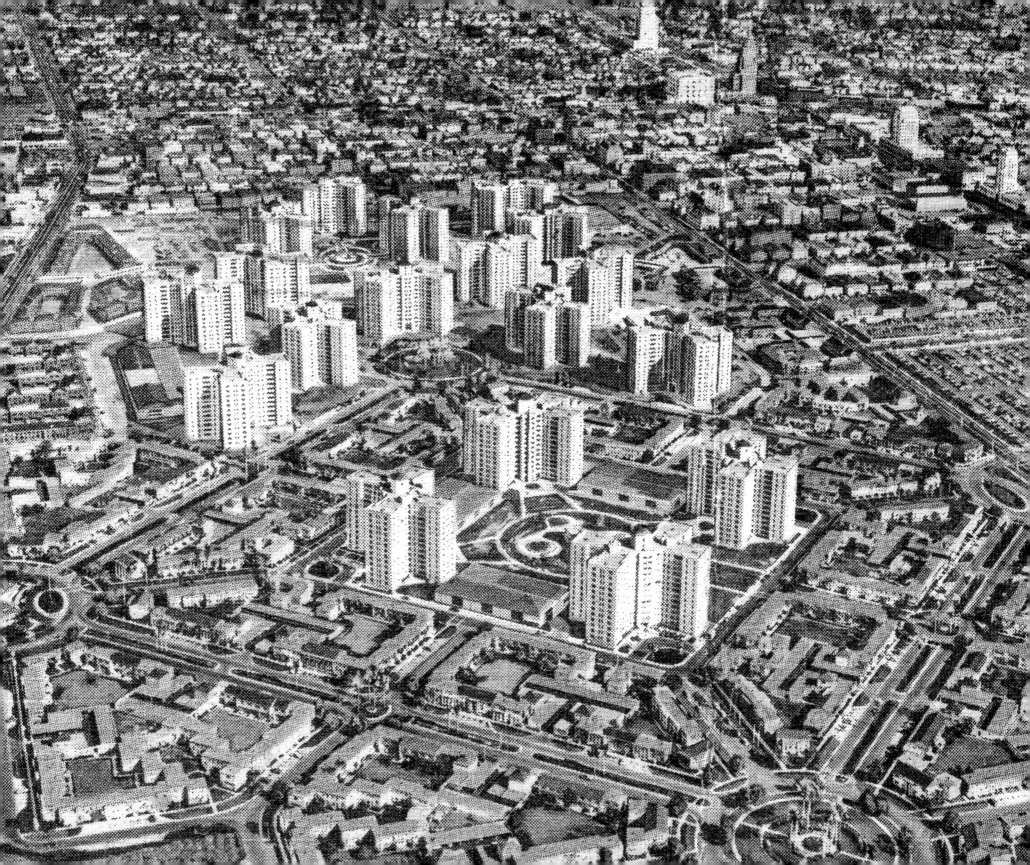

BALANCE

ARCHITECTURE IN THE AGE OF INFORMATION
Developed almost overnight during the 1930s, new communities with 5,000+ populations were created by the federal government outside central cities. They were manifestations of optimism, offering social and cultural amenities to recruit employees to remote locations. There was an emphasis on health and a high quality of life in the vast setting of the New West. Examples include Boulder City in Nevada, built to support the Boulder Dam construction, and Los Alamos in New Mexico, built to develop the atomic bomb for the Manhattan Project.

During the same period, private real estate investors began to drive the development of new communities of equal size outside city centers. These communities were typically affluent resorts in Southern California and the Rocky Mountains with seasonal use, such as the ocean resort city Newport Beach, the desert resort city Palm Springs, and the winter resort city Sun Valley.

Initially occupied during a limited annual period, all of these new communities turned out to be habitable year round thanks to advances in climate control, mobility, and communications in the second half of the twentieth century. Today, the twenty-first-century balance of city and nature provides many of the face-to-face contacts, employment options, goods, and services once available only in central cities with the abundance, beauty, and ecology of the American West.

"THE ONE AND ONLY REASON FOR CONGREGATION IN THE NEAR FUTURE IS FACE-TO-FACE CONTACT."

— JOEL GARREAU, 2010

SOUTH PALM SPRINGS
Palm Springs, California, 1938
Beyond the village is seen the Santa Rosa Mountains. View from above the Desert Inn.

PARKVIEW COURT
Cañon City, Colorado, 1945
West on Highway 50, "Home of the Royal Gorge," 40 strictly modern units, all steam-heated and air-conditioned.

RANGE VIEW COURT
Colorado Springs, Colorado, 1948
Located in the heart of the Pikes Peak Region, with a marvelous view of Pikes Peak, Garden of the Gods, Cheyenne Mountain, and Rampart Range. 18 units each with private bath and excellent beds. Approved by Chamber of Commerce. Three S Service, and AAA Reasonable Rates.

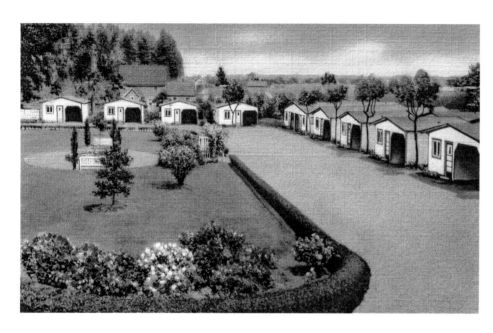

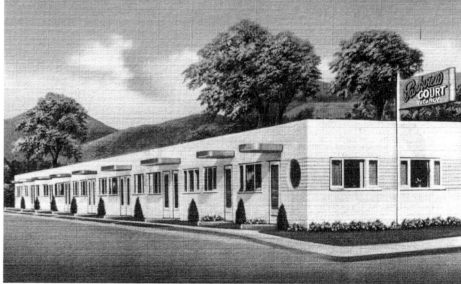

PARK CITY LODGE
Santa Cruz, California, 1933
2½ miles from Santa Cruz on the
Watsonville Highway. 20 modern
cabins. Reasonable rates, by the day,
week, or month. A delightful place
to stop.

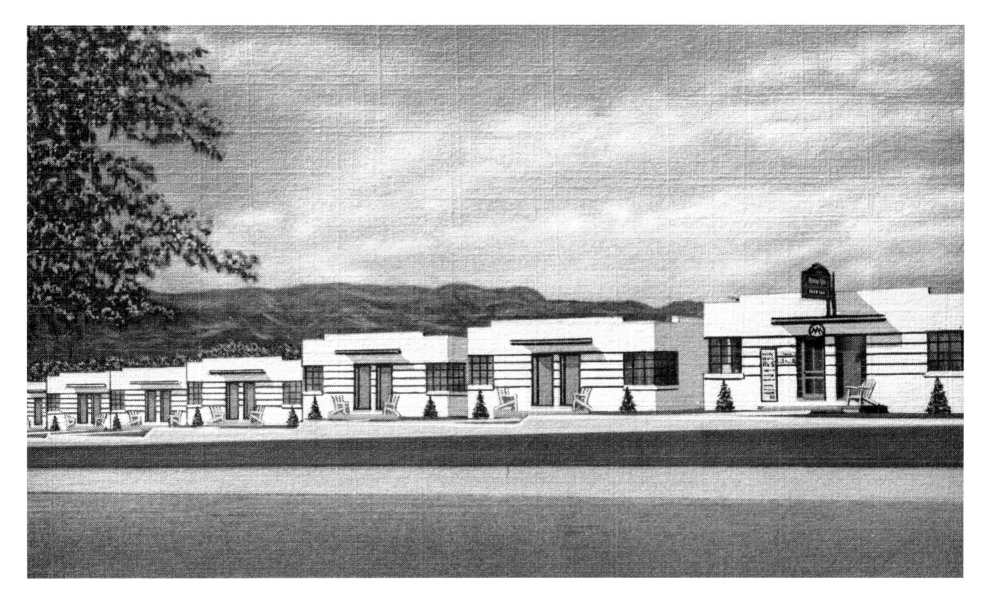

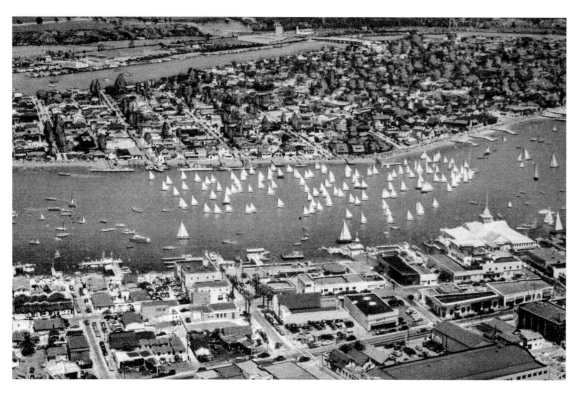

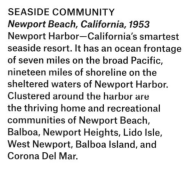

FLIGHT OF THE SNOWBIRDS
Newport Beach, California, 1953
Balboa and Balboa Island, popular south coast residential and recreational areas, face each other across a sail-dotted channel of Newport Harbor. Along the shores are many fine homes, private docks, and pleasure craft.

SEASIDE COMMUNITY
Newport Beach, California, 1953
Newport Harbor—California's smartest seaside resort. It has an ocean frontage of seven miles on the broad Pacific, nineteen miles of shoreline on the sheltered waters of Newport Harbor. Clustered around the harbor are the thriving home and recreational communities of Newport Beach, Balboa, Newport Heights, Lido Isle, West Newport, Balboa Island, and Corona Del Mar.

SEASIDE COMMUNITY
San Diego, California, 1936
Point Loma is a seaside community
within the city of San Diego, California.
It is historically important as the
landing place of the first European
expedition to come ashore in present-
day California. The peninsula has
been described as "where California
began."*

DESERT COMMUNITY
Boulder City, Nevada, 1949
Boulder City is 7½ miles from Boulder Dam, overlooking Lake Mead. A model city, built as the administrative center of the Boulder Canyon Project, Boulder City is controlled by the U.S. Bureau of Reclamation. It is a beautiful city of well-paved streets, modern homes, green lawns, and spacious parks.

DESERT COMMUNITY
Boulder City, Nevada, 1936
Boulder City is the administrative, home and touring center for Boulder Dam and the Boulder Dam Recreational Area. This planned community, designed by government architects and constructed in eighteen months, is located only seven miles from Boulder Dam and five miles from Lake Mead. It is aptly termed "The Modern Oasis of the West."*

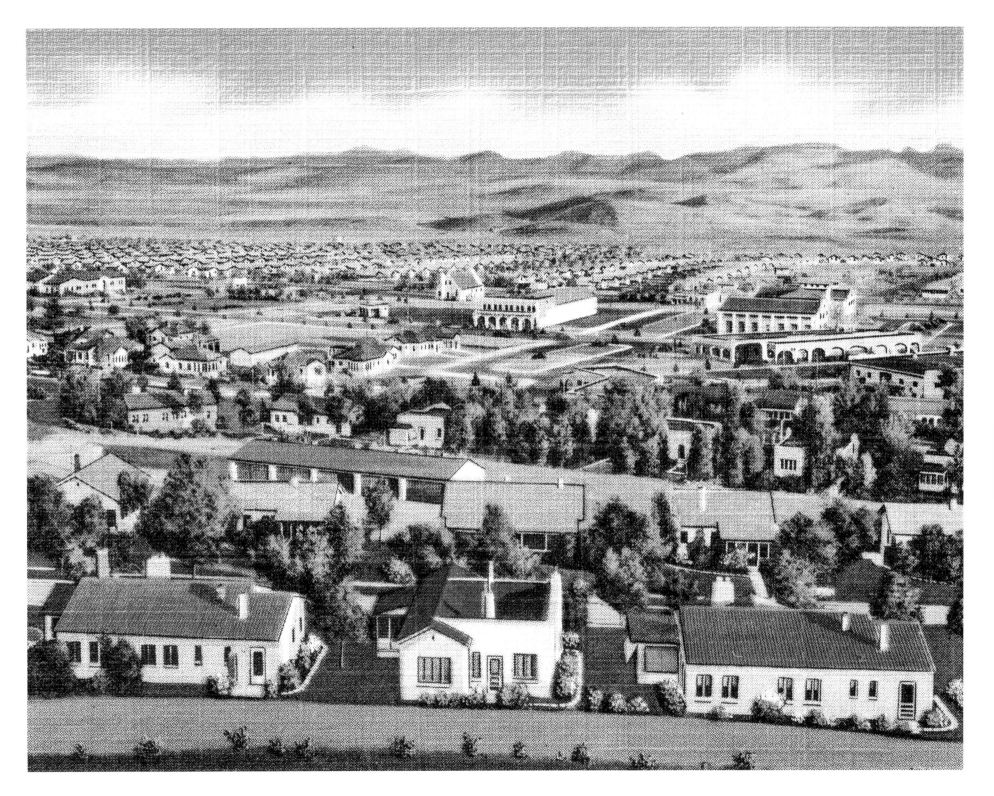

ENTERTAINMENT

IN PURSUIT
OF HAPPINESS

by Leslie Erganian

"WE HOLD THESE TRUTHS TO BE SELF-EVIDENT, THAT ALL MEN ARE CREATED EQUAL, THAT THEY ARE ENDOWED BY THEIR CREATOR WITH CERTAIN UNALIENABLE RIGHTS, THAT AMONG THESE ARE LIFE, LIBERTY AND THE PURSUIT OF HAPPINESS."

— UNITED STATES DECLARATION OF INDEPENDENCE, 1776

HOLLYWOOD BOULEVARD
Hollywood, California, 1931
The grand opening of a new feature movie gets a big "send-off" on the first showing. The attendance of featured movie stars, producers, and guests make this a "gala" event.*
[previous page]

THE UNITED STATES DECLARATION OF IN-dependence, penned by Thomas Jefferson and adopted by the Second Continental Congress on July 4, 1776, contained the following extraordinary words: "We hold these truths to be self-evident, that all men are created equal, that they are endowed by their Creator with certain unalienable Rights, that among these are Life, Liberty, and the pursuit of Happiness." The civic right to pursue happiness, and the governmental obligation to protect that right, was a uniquely American declaration.

Within the study of Greek classics, one finds two complementary ideas about what constitutes happiness. Aristotle promoted the concept of "eudaemonia," from the Greek "eu" for good, and "daimon," meaning spirit, referring to having a good indwelling spirit, or happiness derived from living a meaningful life through working towards the highest human good. Epicurus, on the other hand, promoted the addition of "hedonia," or pleasure derived from the senses and the absence of distress, to the meaning of happiness. While today we often think of hedonism as meaning sensual fulfillment to excess, its original meaning implied a limitation in indulgence, precisely because excess often leads to distress. Hedonia meant something closer to attaining a heightened awareness and awakening of the senses through stimulation and connection.

Through the ideas he embedded into the American Declaration of Independence, Jefferson, a self-proclaimed Epicurean, helped to charter a remarkable course for his young country's future, one that elevated the pursuit of happiness to a level equal to the importance of life and liberty. Jefferson's view of happiness placed sensual and spiritual happiness side by side and within the hands of the individual to explore, free from governmental oppression as long as it did not impinge upon the rights of others.

In the centuries subsequent to America's founding, the technological advances of the four waves of the industrial revolution and the blank canvas and wild extremes of the American West, in combination with this bold, balanced, and visionary roadmap, would create a blossoming of new ways in which to attain happiness in both forms, with entertainment pursuits like nowhere else on earth.

WONDER

If one thinks of types of entertainment along a line, ranging from simple sensory-stimulating kinetic experiences to those with greater complexity, deeper meaning, and more reliance on the mechanisms of storytelling, one can imagine the thrill of being an early passenger on the Great Transcontinental Railroad connecting Chicago with the Oakland Long Wharf in 1869.

Consider the experience of a train ride itself as a form of long-distance storytelling, with the landscape as the story, and the passenger's own wonder as the storyteller. The more curiosity, knowledge, and power of observation brought to the experience, the more engaging the story. The passengers as a whole, with their comings and goings to and from dining cars, sleeping cars, and observation cars, were the collective audience. With transcontinental travel suddenly reduced from months to days, with access expanded to the general populace through this new safe, comfortable, and affordable means of transportation through the sparsely settled territories, and with the raw beauty of this new world on view and in motion through a train window, cross-country travel transcended being a mere means of transportation and became its own unique form of entertainment. A train ride through the still-wild American West was inherently more seductive and more stimulating to the senses than anything else the continent had yet offered, and the desire to travel through it took off like a shot of lightning.

Private developers were quick to capitalize on the interest travelers had for exploring the American West. Fresh access to once remote and inaccessible destinations of interest, in close proximity to the main train line, meant that all an ambitious railway entrepreneur had to provide was a short connecting line to previous parts unknown.

Zalmon G. Simmons, founder of the Simmons Manufacturing Company of Wisconsin, maker of the Simmon's Beautyrest Mattress, built the Pike's Peak Cog Railway, the highest railway in North America, through the breathtakingly beautiful Rocky Mountains Rampart Range. The first car reached the summit in 1891, one year after Halfway House Hotel had opened to provide adventurous overlanders with

COG TRAIN
Timberline, Pike's Peak, Colorado, 1908
The trip to Pike's Peak by Cog Road is a continuous panorama of wonders with magnificent sweeping views of incredible sublimity. From the dwindling dwarf trees at timberline may be seen the boundless rock slopes leading up to the peak itself, towering in white majestic grandeur, while on the other side one may look over the green valleys to the verdant hills and back over sweeping hills and valleys to the plains.

GIANT ROLLER COASTER
Farmington, Utah, 1940
Lagoon, fun spot in Utah, opened
its doors on the banks of the Great
Salt Lake back in 1886. The lake then
receded, and what was then called
Lake Park was moved to Farmington,
Utah, just a few miles away.*

comfortable overnight accommodations at the halfway point. Over time, such hotels situated in remote locations dedicated solely to tourism proved to be more than just places to sleep and sup, but rather environments in which the traveler could both anticipate and assimilate their travel experiences. Often built with an eye towards integrating location-specific materials, these hotels, designed in harmony with the natural environment, became pleasurable extensions of the original travel experience, often becoming worthy and entertaining travel destinations in and of themselves.

In addition to the private development of ancillary railroad routes to and from such western inland destination locations as peaks

and caves, a pristine undeveloped Pacific Coast offered its own unique possibilities for exploration and exploitation. Charles I.D. Looff, America's first great carousel carver, having started his career on the East Coast in Coney Island and in Atlantic City, was one of the greatest contributors to the form of this new mechanized amusement. Transferring his talents to the West Coast in the early decades of the twentieth century, he quickly made his mark all along the sunset-facing shoreline, with carousels in Spokane, Washington, and up and down the California coast, in Santa Cruz, Santa Monica, Venice, Redondo Beach, and Long Beach. Established in 1902, The Pike in Long Beach, a Looff development, featured one of Looff's signature carousels along a boardwalk, the Long Beach Plunge; an indoor swimming and bathing destination, as well as photographers, taffy makers, and fortune-tellers among other vendors. Visitors could partake of the spectacle of lights, colors, music, and motion offered by a variety of innovative amusements, all while in a safe and happy environment throughout a long western evening as sunset settled into darkness. In 1930, the first-ever roller-coaster to be suspended out over an ocean, the Cyclone Racer, a Prior & Church and Harry Traver collaboration, was added to The Pike along with a growing number of amusements; these additions brought about the name change to Pike's Pier. Many of the amusement piers of the early 1900s proved to be so successful that they survived a century, and by their longevity and ability to continue to entertain an audience have become integral to the identities of the cities in which they still stand.

CELEBRATION
With the age of steam having propelled the development of safe and affordable means of travel throughout the western territories

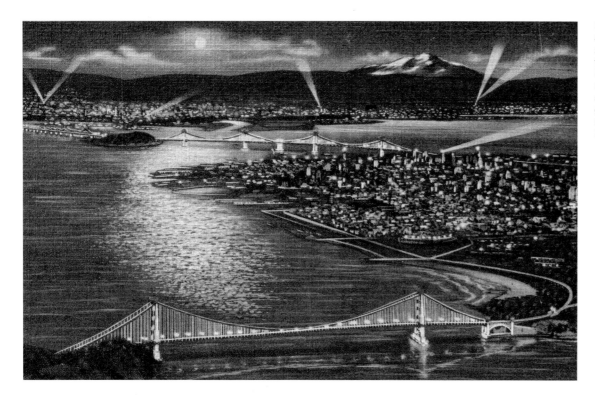

of the United States, the second wave of the industrial revolution brought western statehood and the innovations of steel, electricity, and heavy engineering. An eruption of bold building and infrastructure projects facilitated deeper connections across the continent and into the world, with affordable illumination to keep those connections flickering 24/7. World's fairs, which had heretofore belonged to Europe and to cities along the eastern seaboard of the United States, now had the physical and social support structures in the west to receive the honor and opportunity of hosting their own celebrations of industrial and civilized progress for an international audience.

The first half of the twentieth century saw numerous western cities stepping up to host international expositions. In 1905, Portland hosted the Lewis and Clark Centennial Exposition to celebrate the 100th anniversary of the Lewis and Clark Expedition, attracting 1.6 million visitors. In 1915, San Diego hosted the Panama-California Exposition to celebrate the opening of the Panama Canal in August of the previous year. San Francisco held its own Panama-Pacific International Exposition in 1915 to demonstrate its resilience in recovering from the Great Earthquake of 1906.

With the California-Pacific Exposition in 1935, San Diego ambitiously stepped up again in an attempt to claim the crown as the greatest western harbor city; San Diego had long contested this title with Seattle and San Francisco, yet the honor would eventually go to the bold and visionary upstart city of Los Angeles. In 1939, San Francisco, with two new bridges to celebrate, hosted the Golden Gate International Exposition—this was the same year that New York hosted

its own world's fair. An estimated twenty million people attended San Francisco's fair, while forty-four million attended its eastern counterpart.

President Franklin D. Roosevelt, in his "Message Opening the Golden Gate Exposition in San Francisco," perfectly summarized the ambition and function of these future-facing and heroically scaled celebrations: "I am quite open and unashamed in my liking for expositions. They perform a distinct service in acquainting people with our progress in many directions and with what other people are doing. They stimulate the travel that results inevitably in a larger degree of national unity by making Americans know their America and their fellow Americans."

Beyond that, Roosevelt recognized the part that government agencies had played in helping to build two of the "engineering marvels of the century," the Bay Bridge and the Golden Gate Bridge, as well as Treasure Island, the site of the fair itself. Originally, Treasure Island had been envisaged as the main airport for San Francisco but, owing to the abrupt commencement of World War II, became a vital military base instead.

The ability to light up the night with affordable electricity took the spirit of celebration directly to the city streets. Building facades were showcased with strategically positioned floodlights. High rooftops became natural points for beacons. Bridges and dams proved to be some of the finest structures to illuminate. Positioned near or over water, the effect of each light source became doubled through reflection. A spirit of play and not just function was evident in the use of colored and klieg lights and gave cities nocturnal life and vibrancy in what were formerly its dark and sleepy corners. The spirit of the era aroused by the innovations of the age precipitated a sense in the populace of not just being observers of civic life, but of being engaged contributors.

SPECTACLE

While the transcontinental train traveler during the age of steam focused on the elemental variations of texture, color, scale, line, and space outside their moving window, and the International Exhibition visitors during the age of steel and electricity directed their attention to the illuminated exhibitions celebrating and promoting progress, the age of oil saw audiences under their own agency, in their own cars, taking off as individuals to gather collectively in the same place, at the same time, and focusing their simultaneous attention on the singular spectacle before them. This era saw the flourishing of massive football stadiums, outdoor amphitheaters, and racetracks.

Within two years, four massively scaled outdoor athletic stadiums were built in California. In 1921, Stanford Stadium, capacity 85,000, was built in Palo Alto. 1922 saw the opening of the 90,000-seat Pasadena Rose Bowl. The bowl, a new typology, had originally been established in 1914 with the Yale Bowl on the East Coast. In 1923, the 85,000-seat California Memorial Stadium at Berkeley was built with public funds in honor of California veterans lost in World War I. The same year saw the opening of the Los Angeles Coliseum, built for 80,000 spectators. Games and tournaments held in such stadiums fostered friendly rivalries between colleges within states, across state lines, and between eastern and western leagues, while engendering team loyalties and building an ever-broadening fan base for American football.

Not only did the availability of space allow for the development of major stadiums throughout the West, but the naturally sculpted terrain in conjunction with a mild climate suggested additional opportunities for the development of entertainment venues. In the second quarter of the twentieth century, a number of natural amphitheaters were built throughout the West. Intended as venues in which to showcase the arts, their development was funded by universities as well as by private initiatives. These amphitheaters offered destinations for integrated day trips as well as evening getaways, often in close proximity to city centers. They featured integrated parking and bathroom facilities and dining options to keep patrons comfortable throughout an extended program.

In 1929, the Hollywood Bowl opened, offering 25,000 patrons a place to gather under the stars for a night of outdoor music nestled into the Hollywood Hills, and with the hum of the city just a mountain ridge away. In 1930, as part of the legacy of wealthy landowner Griffith J. Griffith, who had donated 3,000 acres to the city of Los Angeles for a permanent park, the Greek Theater, with an audience capacity for 6,000, was built within Griffith Park in a canyon site that had been chosen for its natural acoustics. The Frost Theater, an outdoor amphitheater with a capacity for 7,000, was built on the Stanford Campus in 1937, and in 1941, the Red Rocks Amphitheater, with a capacity for 10,000, opened in Denver.

The third entertainment typology that came of age during this period was the racetrack. While rodeos had been an ongoing form of western entertainment since the late 1800s in places such as Cheyenne Frontier Park in Wyoming and the Pendleton Round-Up in Oregon, and were capable of attracting

ENTERTAINMENT

SANTA ANITA PARK
Arcadia, California, 1940
Santa Anita Park is located on the famous and beautiful Lucky Baldwin "Santa Anita Ranch," fourteen miles east from downtown Los Angeles. It has become the world's winter racing center and is the scene of the famous Santa Anita Handicap—the turf's richest stake.

significant crowds, horse racing and betting remained south of the border. The Agua Caliente Racetrack in Tijuana, Mexico, opened in December of 1929, alongside a hotel and casino that had opened one year earlier, attracting up to 10,000 visitors per day. Large numbers of Southern Californians made the journey to participate in the excitement offered by a day at the races, an activity that was then illegal in their own state.

When a California constitutional amendment legalized pari-mutuel betting in 1933, it ushered in the modern age of horse racing. Within a year, Santa Anita Racetrack, with a capacity for 60,000, would open. At that time, the most luxurious racetracks in the world were in Paris, France, and developer Charles Strub was determined to create a California racing venue on par. It was to be sporting and imaginative and offer a real test of thoroughbred ability. It immediately attracted the attention of Hollywood, with stars in attendance including Cary Grant and Lana Turner, stockholders such as Bing Crosby, Al Jolson, and Harry Warner, and with luminaries including Spencer Tracy and Errol Flynn as track thoroughbred owners.

The Hollywood Turf Club, capacity 25,000, opened in 1938 in Inglewood. Jack L. Warner, of Warner Bros. film studio, was chairman, with shareholders including Walt Disney, Samuel Goldwyn, Darryl Zanuck, and Joan Blondell. Luxury, horses, fashion, gambling, and Hollywood converged in these exciting new sports venues.

IMMERSION
In the film *Broadway Melody of 1940*, which was the last of the great black-and-white American musicals, there's a scene in which

Fred Astaire and Eleanor Powell tap their hearts out to Cole Porter's "When They Begin the Beguine." It isn't just that Porter's music is fantastically light and energetic, and it isn't just that the scenic choices, from the liquid black stage and floor to the luminous white dress and suit worn by these two timelessly talented dancing phenomenons, provide a magical contrast suggestive more of heavenly bodies suspended in a starlit night than of mere mortals; it's that the directorial choice was simplicity itself: an unbroken, unedited two shot of these charismatic costars performing at the apex of their physical abilities—uncut, unembellished, and unequivocal talent. The scene does what cinema was first born to do—it captures a moment with light-exposed silver halide crystals and keeps it, like lightning in a bottle.

Film was the technology that allowed a performance that previously only a theater's worth of patrons could say they saw to be transmuted into an immortal form, with the ability to reach an international as well as a timeless audience wherever a print could be projected. Television was the innovation that allowed audiences of millions to view the same broadcast at the same time irrespective of their location.

Prior to 1945, there were fewer than 10,000 television sets in the United States. By 1950, that number had grown to six million, and by 1962, fifty-two million American households had their own TVs. Consider that the first national telecast of a college football game, which occurred in 1952 at the Rose Bowl with a stadium capacity of 90,000, had the ability to reach an audience of millions simultaneously, launching entertainment into new stratospheres of audience engagement at mid-century.

While television was busy touching more viewers, it was also rendering certain forms of entertainment more personal and less social by giving at-home audiences access to comedies, dramas, news, and sports from the comfort of their own armchairs. This may have shifted certain members of the populace away from live entertainment and the large-scale venues that hosted it, but farsighted individuals saw the opportunity to fill the desire gap to experience entertainment in person and in broad numbers.

Walt Disney was one such entrepreneur. Having already found a film audience for Mickey Mouse and Friends, and having staked out a space on television for their continuing adventures, he had the vision to create a complex, multisensory, educational, experiential destination that would bring entertainment into a new dimension. Utilizing the top technology of the time, from glistening monorail transportation to nascent robotics that brought parrots and past presidents to life for eager minds of all ages, he built Disneyland in the image of his imagination in the favorable climate of Anaheim, California, as an outdoor Adventureland, Frontierland, Main Street, Tomorrowland, and Fantasyland all rolled into one. Disneyland opened in 1955 to great fanfare and boldly declared a direction for the future of entertainment that had not been previously considered, an environment independent of natural constraints, built from the ground up with the intention of feeding the senses with every kind of visual, verbal, musical, edible, kinetic, and colorful delight, as well as telling stories that deepened visitors' understanding of American history, progress, and hope for the future. Disneyland had an ambition no higher than to be considered "The Happiest Place on Earth."

EARL CARROLL THEATRE
Hollywood, California, 1941
The Earl Carroll Theatre-Restaurant, in the heart of Hollywood on Sunset Boulevard near Vine, is a favorite nightspot in the film capital of the world. Seating arrangements are terraced so all guests may enjoy an unobstructed view of the lavish stage production with "Sixty of the Most Beautiful Girls in the World."

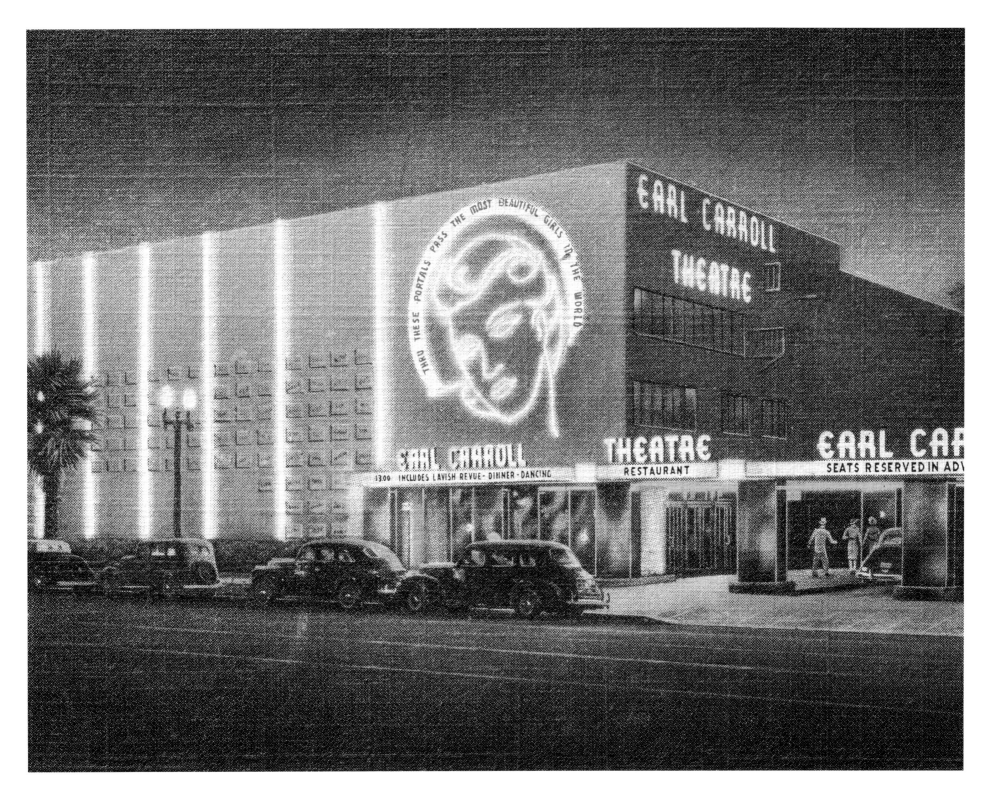

THRU THESE PORTALS PASS THE MOST BEAUTIFUL GIRLS IN THE WORLD

EARL CARROLL
THEATRE

EARL CARROLL
$3.00 INCLUDES LAVISH REVUE · DINNER · DANCING

THEATRE
RESTAURANT

EARL CAR
SEATS RESERVED IN ADV

WONDER

ENTERTAINMENT IN THE AGE OF STEAM
The completion of the transcontinental railway in 1869, beginning in Omaha, Nebraska, crossing the Rockies in Denver, traveling on through Salt Lake City, and with its terminus in Oakland on the bay of San Francisco, provided the first reliable link between the eastern and western continental United States for goods and people. The fate of this magnificent, open, and previously unspoiled land was irrevocably altered by this achievement, and its development was thrown into rapid acceleration. Beyond the potential for commerce and settlement, entrepreneurs were quick to recognize the added value of tourism to once remote locations all along the line. Modern and convenient access to this unique, bold, and grand landscape would provide entertainment for the masses, the likes of which had never been seen before. All a passenger was required to bring was a sense of wonder.

In rapid succession, other developers saw the potential for exploring and exploiting additional geographically extraordinary and once-remote locations. Peaks, piers, and caves, as well as newly established destination locations and development enticements for resort-style or amusement-based vacationing, became highly desirable and widely accessible travel stops, punctuating the natural highlights of the New West.

"WISDOM BEGINS IN WONDER."

— SOCRATES, 350 B.C.

SUBMARINE GARDENS
Santa Catalina Island, California, 1931
The famous Submarine Gardens are seen from glass-bottom boats, whose windows reveal myriads of fish, colored undersea vegetation, and give a never-to-be-forgotten picture of life at the bottom of the ocean.
[previous page]

ROYAL GORGE INCLINE
Cañon City, Colorado, 1931
A new sensation is available for visitors to the Royal Gorge in the new incline railway running up and down Telephone Gulch from the Hanging Bridge to the top of the Suspension Bridge. This incline will carry two steel cars of 21-passenger capacity and will allow travelers on the railroad who stop over an easy but thrilling trip to the wonderful scenes at the rim of the gorge.

PIKES PEAK SUMMIT
Pikes Peak, Colorado, 1937
At the summit of Pikes Peak, altitude 14,110 feet. Showing the famous old Summit House, Observation Tower, and the Cog Train.

MOUNT LOWE INCLINE
Pasadena, California, 1933
Earth's grandest mountain ride. The Great Incline was about 3,000 feet long and rose 1,238 feet in elevation from 1,954 feet at Rubio Canyon to 3,192 feet at Echo Mountain. The incline started out at a slope of 57 percent and increased to almost 62 percent before dropping back to 52 percent and finished at 39 percent at the top.*

PIKES PEAK COG RAILWAY
Manitou Springs, Colorado, 1912
Pikes Peak, America's most famous mountain, once thought to be unconquerable is now ascended by the famous Manitou Cog Railway as well as by an auto highway. Thousands travel to its summit each summer and see remarkable panoramas of distant peaks and plains; sometimes when the peak is above them to experience the remarkable spectacle of looking down upon the clouds.

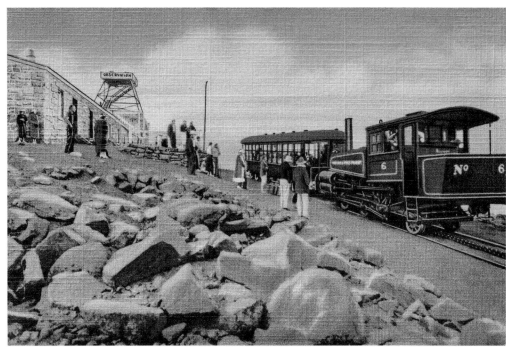
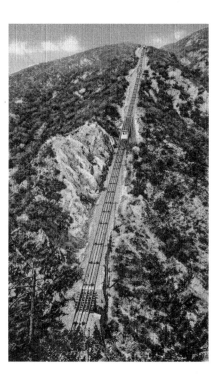

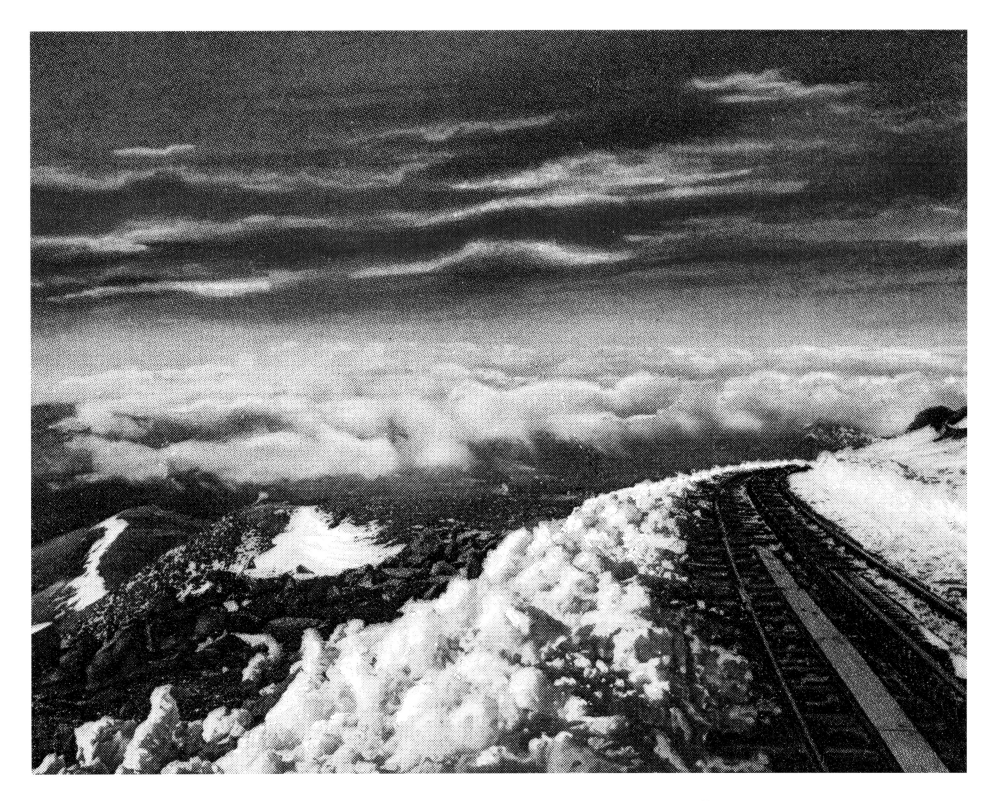

WONDER

VISTA HOUSE
Corbett, Oregon, 1937

A state-owned viewpoint affording a magnificent view from one of the highest points reached by the Columbia River Highway. With sheer walls below a panoramic view presented, reaching far down and up the river.

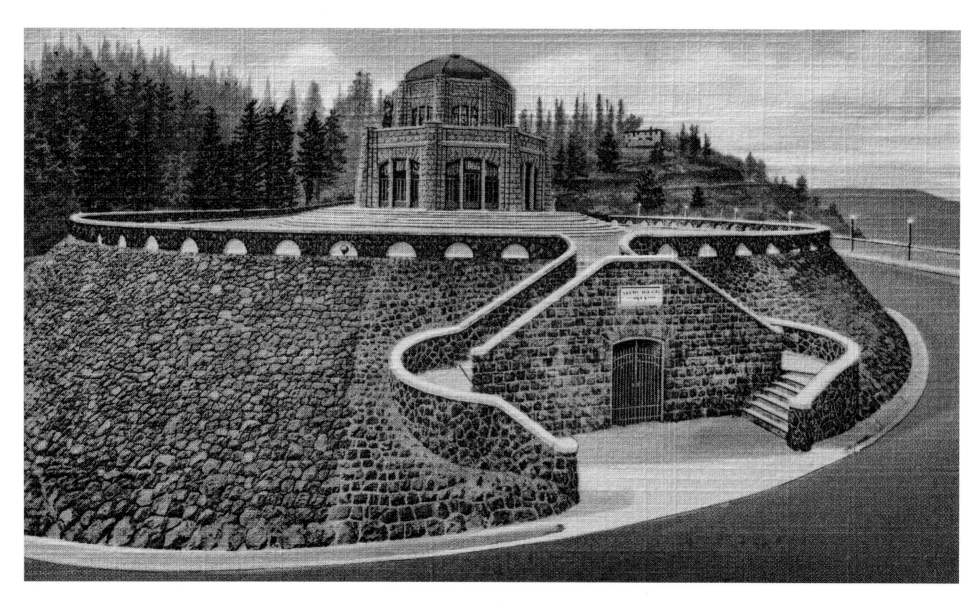

PIKES PEAK SUMMIT
Pikes Peak, Colorado, 1941
Streamline Cog Train at summit of
Pikes Peak, 14,110 feet above the sea.
This scene shows the massive old
stone Summit House visited by
travelers for over 40 years. Located
at the extreme eastern edge of the
summit, it overlooks Colorado Springs,
Manitou Springs, and the plains.

WILL ROGERS SHRINE
Colorado Springs, Colorado, 1937
Will Rogers Shrine of the Sun is located
high up on Cheyenne Mountain,
Broadmoor–Cheyenne Mountain
Highway.

ARROWHEAD SPRINGS HOTEL
San Bernardino, California, 1943
Nestled at the foot of the San Bernardino Mountains in an enchanting playground, and overlooking the beautiful San Bernardino Valley is Arrowhead Springs Hotel and one of America's finest spas. The world's hottest mineral spring of 202 degrees is located here. According to a legend, the strange natural formation—void of vegetation—of a giant arrowhead on the mountainside, guided the Indians to these curative springs.
[top left]

HOTEL DEL MONTE
Monterey, California, 1927
Situated in the midst of a splendid floral park of great pines, ancient oaks, and velvety lawns. Del Monte is on the Monterey Peninsula, the cradle of California's history, and for extraordinary scenic beauty is world-famous.
[top right]

CLAREMONT HOTEL
Berkeley, California, 1949
High atop the Berkeley Hills overlooking San Francisco Bay. In foreground, courts of Berkeley Tennis Club, where tennis stars Helen Wills, Helen Jacobs, and Don Budge started their careers.
[bottom left]

HUNTINGTON HOTEL
Pasadena, California, 1938
Situated in the beautiful Oak Knoll residential section of Pasadena, the Huntington commands an unsurpassed view of the San Gabriel Valley. Surrounding the hotel are many attractive bungalows, where one may enjoy every convenience of home without its cares. The Huntington, of absolute fireproof construction, is open all the year and is convenient to the many famous golf courses of Southern California.*
[bottom right]

MISSION INN
Riverside, California, 1932
In the cloister have been reproduced many architectural bits of the old missions. The massive buttresses are copied from those of San Gabriel Mission.*
[top left]

BEVERLY HILLS HOTEL
Beverly Hills, California, 1934
Screenland congregates and mingles in the spacious lobby of this beautiful hotel and bungalows.
[top right]

AMBASSADOR HOTEL
Los Angeles, California, 1938
The spacious grounds of The Ambassador are a riot of flower-filled beauty at all times of the year. Nature smiles during cool summers and balmy winters. U.S. government statistics show that children raised in California are stronger and healthier than others. The little folk literally "laugh and grow fat" in the happy atmosphere of this charming hotel.*
[bottom left]

HOTEL DEL CORONADO
Coronado, California, 1936
For 55 years, this internationally famous hotel has been known for its charm, its hospitality, its service, and its beauty. Here are found the Turquoise Pool, the Rainbow Fleet, and a host of other modern facilities for making life more enjoyable.*
[bottom right]

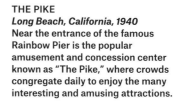

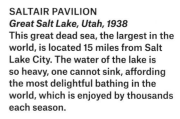

SANTA MONICA PIER
Santa Monica, California, 1936
The La Monica Ballroom, opened on July 23, 1924. Designed by T. H. Eslick, with a Spanish façade and French Renaissance interior, it was the largest dance hall on the West Coast, accommodating 5,000 dancers on its 15,000-square-foot hard maple floor.*

THE PIKE
Long Beach, California, 1940
Near the entrance of the famous Rainbow Pier is the popular amusement and concession center known as "The Pike," where crowds congregate daily to enjoy the many interesting and amusing attractions.

SALTAIR PAVILION
Great Salt Lake, Utah, 1938
This great dead sea, the largest in the world, is located 15 miles from Salt Lake City. The water of the lake is so heavy, one cannot sink, affording the most delightful bathing in the world, which is enjoyed by thousands each season.

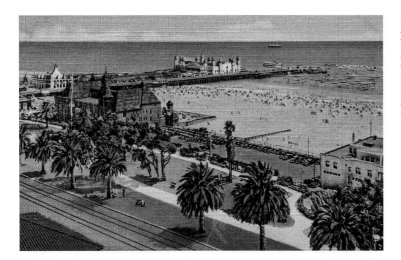

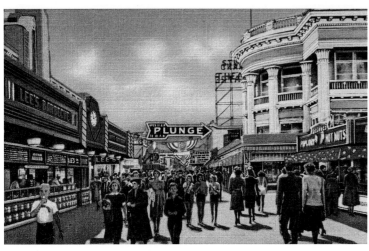

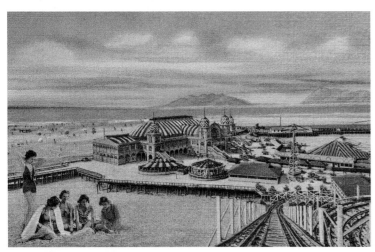

LONG BEACH PIER
Long Beach, California, 1936
The Cyclone Racer is a large wooden
dual-track roller-coaster, built out
on pilings over the water.*

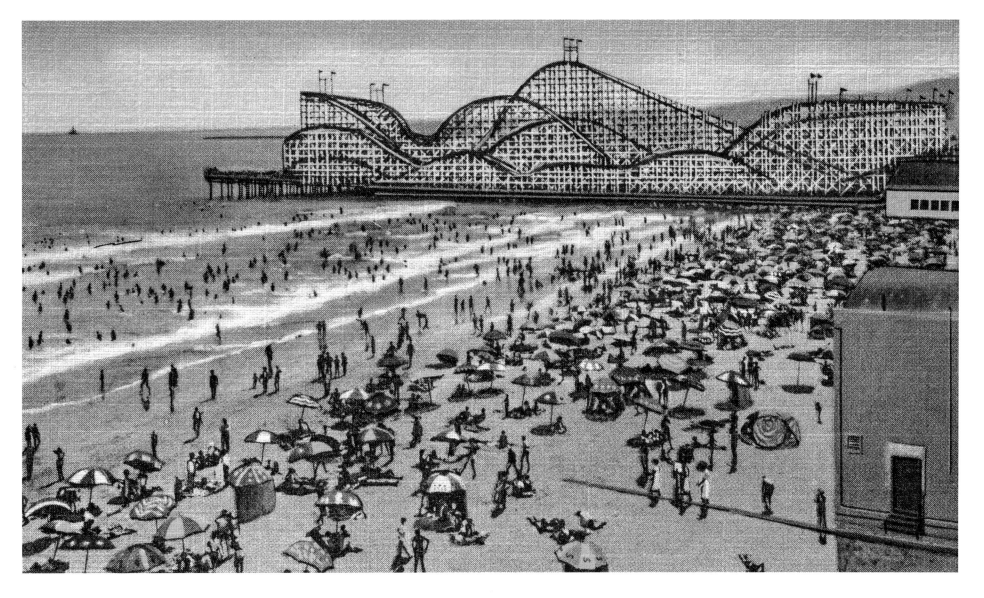

CARLSBAD CAVERNS
Carlsbad Caverns National Park,
New Mexico, 1936
The Shrine of the Sun God, before
which range numerous coralline
stalagmites. The stalactites form
an onyx drapery above.

ENTERTAINMENT

CARLSBAD CAVERNS
Carlsbad Caverns National Park,
New Mexico, 1950
From mid-May to early October, bats
emerge from the mouth of Carlsbad
Cavern and fly off in a southwesterly
direction nine times out of ten. Their
return begins around midnight and
lasts until daybreak. The remarkable
sight of an estimated 3,000,000 bats
making their nightly sojourn led to
the discovery and exploration of these
magnificent caverns by Jim White.

OREGON CAVES
Grants Pass, Oregon, 1937
In 1922, a group of businessmen in
Grants Pass, Oregon, came up with
a novel way of promoting tourism
along the Redwood Highway from
San Francisco, California, to Grants
Pass, Oregon. Dressing up as
cavemen, the Oregon Caves Cavemen
and Women, pretending to be
descendants of the Neanderthals, bring
thousands of additional tourists to visit
the Oregon Caves with their antics
and attire.*

CARLSBAD CAVERNS
**Carlsbad Caverns National Park,
New Mexico, 1941**
Based on the real-life experiences of
Jim White, the discoverer and explorer
of Carlsbad Caverns, New Mexico,
Jim White's Own Story, a thirty-two-
page book with 30 illustrations, of
which 16 are in beautiful color, details
the thrilling experiences of a lone
cowboy three days under the world in
Carlsbad Caverns.

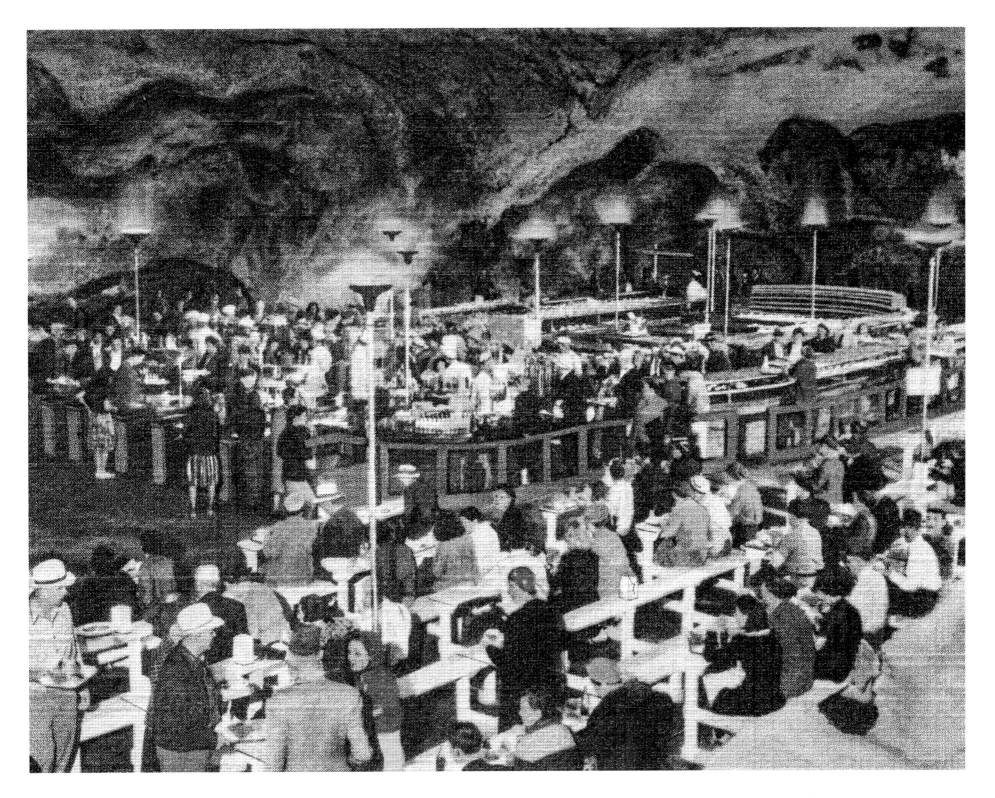

CELEBRATION

ENTERTAINMENT IN THE AGE OF STEEL

In the nineteenth century, London hosted what is now considered to be the first World's Fair, the Great Exhibition of 1851, which showcased the industrial achievements of the steam age. By 1889, the Paris Exposition had the new innovations of electricity and inexpensive steel to celebrate, which came together in the world's tallest man-made structure, the Eiffel Tower, constructed as the exposition entrance and illuminated throughout. But while the Old World led the industrial advances of the nineteenth century, the advances of the twentieth century were driven by the New World, with no region more rapidly transformed than the American West

The Golden Gate International Exposition and World's Fair of 1939 was held on Treasure Island, in the Bay of San Francisco, and marked the completion of two engineering marvels, the Bay Bridge and the Golden Gate Bridge. Franklin D. Roosevelt, in a radio address to the nation, lauded this "Pageant of the Pacific" for illuminating "giant strides of trade and travel" between bordering nations and underscored the importance of understanding and celebrating the related destiny of disparate nations by showcasing their goods as well as traditions. With an estimated attendance of twenty million visitors to a city with only 600,000 inhabitants, an entertained populace would seem to have agreed with their president.

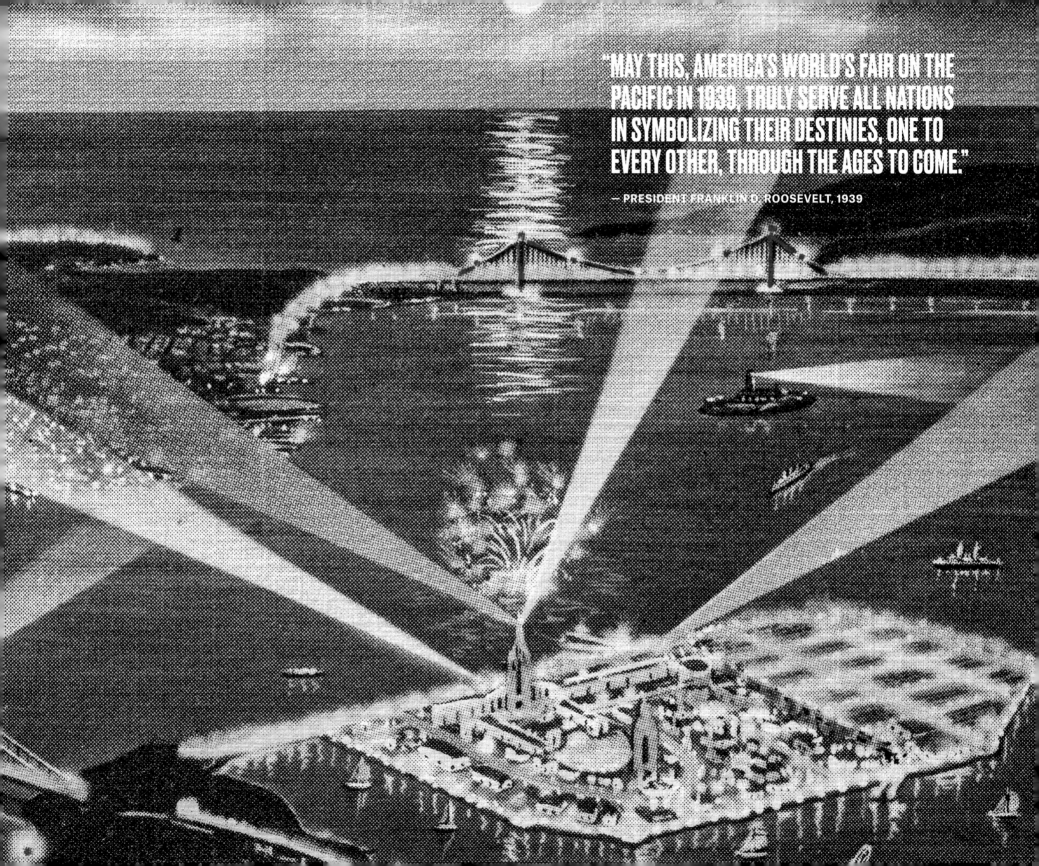

"MAY THIS, AMERICA'S WORLD'S FAIR ON THE PACIFIC IN 1939, TRULY SERVE ALL NATIONS IN SYMBOLIZING THEIR DESTINIES, ONE TO EVERY OTHER, THROUGH THE AGES TO COME."

— PRESIDENT FRANKLIN D. ROOSEVELT, 1939

PAGEANT OF THE PACIFIC

World's Fair on San Francisco Bay, 1937

The metropolitan area cities around San Francisco Bay will celebrate the completion of the world's two largest bridges in 1939 with a fifty-million-dollar International Exposition. A most unique and picturesque site—the participation of foreign countries, especially those around "The Pacific," promises to make this the greatest "World's Fair" and finest exposition of all time.

[previous spread]

TREASURE ISLAND

World's Fair on San Francisco Bay, 1938

Magic city of the Golden Gate International Exposition, rises in a setting unrivaled in the history of great World's Fairs. Approached by giant ferries from San Francisco and the East Bay or by motor across the mighty Bay Bridge, this World's Fair commemorates the completion of the World's two greatest bridges—the San Francisco Oakland Bay Bridge and the Golden Gate Bridge.

ENTERTAINMENT

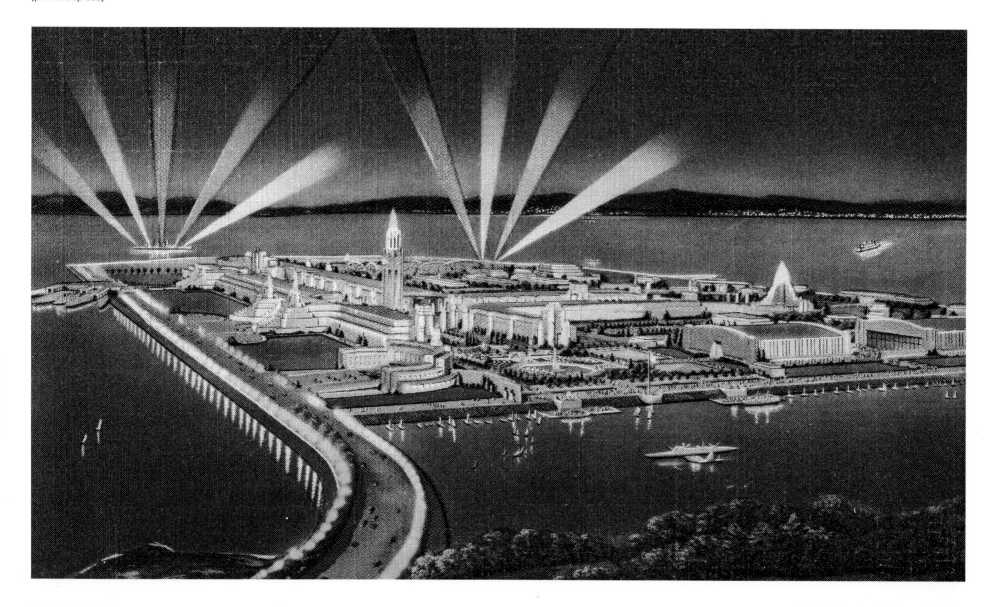

PRESIDENTIAL MESSAGE OPENING THE GOLDEN GATE EXPOSITION IN SAN FRANCISCO

— PRESIDENT FRANKLIN D. ROOSEVELT, 18 FEBRUARY 1939

"Commissioner Creel, President Cutler, Friends of the Golden Gate International Exposition:

Although I have commissioned Mr. Roper to act and speak for me in the ceremonies that mark the opening of the Golden Gate International Exposition, I cannot forego this further and more personal expression of my deep interest. From what I saw with my own eyes last July, I can well imagine the beauty of the completed undertaking, and I look forward with real eagerness to the visit this coming summer that I have promised myself.

Were the West and things Western less close to my heart, I would still be constrained to wish the Exposition a success even beyond the hopes of its builders, for the federal government is in close partnership with this national enterprise.

One government agency has helped financially to build the Bay Bridge and the Golden Gate Bridge—both of them engineering marvels of the century; another agency has helped with men and funds to raise this new island from the ocean bed; and still another has assisted in the construction of the hangars and other buildings that will remain when the Exposition ends, and the site reverts to its intended purpose—a great permanent airport immeasurably helpful to the commerce of the Pacific Coast, and a vital and integral part of our national defense.

Treasure Island, with an area of more than four hundred acres, is America's newest insular possession. It is an outstanding example of territorial expansion without aggression.

I am quite open and unashamed in my liking for expositions. They perform a distinct service in acquainting people with our progress in many directions and with what other people are doing. They stimulate the travel that results inevitably in a larger degree of national unity by making Americans know their America and their fellow Americans.

I have never thought it unfortunate that New York and San Francisco picked the same year for their World's Fairs. Instead of one incentive, people have two, and it is my sincere hope that 1939 will witness a swing around the whole American circle that will give some realization of our resources and our blessings, and more important, emphasize the essential unity of American interests. Getting acquainted with the United States is about as good a habit as I know.

Furthermore, the San Francisco and New York World's Fairs do not in any way duplicate each other. Their themes and their exhibits cover different fields and make different appeals. Most decidedly, if you have seen one, you have not, in effect, seen the other also. The eleven western states which are partners in this Exposition constitute a great area which is of incalculable importance to the prosperity of the United States. The vigor and boldness of these states—a direct inheritance from path finding forbears—are equally helpful in the social pioneering that has been commanded by today's necessities.

Many times, in the elaboration of what I call the Good Neighbor policy, I have stressed the point that the maintenance of peace in the Western hemisphere must be the first concern of all Americans—North Americans, South Americans and Central Americans—for nothing is more true than that we here in the New World carry the hopes of millions of human beings in other less fortunate lands. By setting an example of international solidarity, cooperation, mutual trust, and joint helpfulness, we may keep faith alive in the heart of anxious and troubled humanity, and at the same time, lift democracy high above the ugly truculence of autocracy.

And so, when I wish the Golden Gate International Exposition all possible success, it is as an instrument of international good will as well as an expression of the material and cultural progress of our own West and of our Pacific Ocean neighbors."

COURT OF THE MOON
World's Fair on San Francisco Bay, 1939
The beautiful Court of the Moon and its sweeping vista showing the Palace of Mines, Metals, and Machinery on the left and the Place of Foods and Beverages on the right—and beyond the Tower of the Sun, together with languid pools and high-shooting fountains, is exceptionally inspiring.

COURT OF THE SEVEN SEAS
World's Fair on San Francisco Bay, 1939
The Court of the Seven Seas, looking toward the Court of the Pacific, as seen from the Court of Honor—is a beautiful sight by day—brilliant and magnificent at night. Large murals, depicting man's conquest over the seas, grace the facades of the palace walls fronting upon this court.

COURT OF THE SEVEN SEAS
World's Fair on San Francisco Bay, 1939
Court of the Seven Seas looking toward the Court of the Pacifica as seen from the Court of Honor—is a beautiful sight by day—brilliant at night. Large murals, depicting man's conquest over the seas, grace the facades of the palace walls fronting upon this court.

COURT OF PACIFICA
World's Fair on San Francisco Bay, 1939
In the Court of Pacifica is the statue-dotted Fountain of Western Waters. The small statues symbolize the races of the Pacific Basin. In the background is the great carved mural—"Peacemakers," flanked by the names of the world's boldest explorers.

COURT OF REFLECTIONS
World's Fair on San Francisco Bay, 1939
In the tranquil Court of Reflections are two large rectangular pools reflecting the soft coral walls with trailing vines from the parapets. The magnificent Arch of Triumph, brilliantly lighted and mirrored in the pools, is an awe-inspiring sight. Thru the arch can be seen the statue of the Rainbow Girl.

COURT OF THE MOON
World's Fair on San Francisco Bay, 1939
The beautiful Court of the Moon and its sweeping vista showing the Exhibit Palace—and the Tower of the Sun, together with languid pools and high-shooting fountains, are exceptionally inspiring.

LAKE OF THE NATIONS
World's Fair on San Francisco Bay, 1939
Breathtaking are the night reflections of the Towers of the East and Tower to the Sun, as reflected in the Lakes of the Nations. The facades, with their bright Oriental hues and golden base reliefs, burst into augmented glory when flooded with uncolored streams of light.

COURT OF PACIFICA
World's Fair on San Francisco Bay, 1939
Pacifica—calm and stupendous—reigns over the court of that name. This 80-foot figure symbolizes the very essence of the Fair—that of peace and unity.

COURT OF THE SEVEN SEAS
World's Fair on San Francisco Bay, 1939
The Court of the Seven Seas looking toward the Tower of the Sun—is a beautiful sight by day—brilliant and magnificent at night. Large murals, depicting man's conquest over the seas, grace the facades of the palace walls fronting upon this court.

ELEPHANT TOWERS
World's Fair on San Francisco Bay, 1939
Two massive Elephant Towers flank the Portals of the Pacific—the main entrance to the Fair. The towers are 120 feet high and are surmounted by three elephant motives—age-old symbols of pageantry.

FOUNTAIN OF WESTERN WATERS
World's Fair on San Francisco Bay, 1939
The Fountain of Western Waters in the Court of Pacifica is one of the many symbolizing the races of the Pacific Basin. The Court of the Seven Seas, with soft harmonizing colors, delicate tints, make the buildings, pools, and gardens glow in a sea of iridescence. In the distance, looms the brilliantly lighted 400-foot Tower of the Sun.

CHINESE VILLAGE
World's Fair on San Francisco Bay, 1938
The "Good Earth Village," costing $1,250,000, is one of the Fair's largest concessions. It is a reproduction of an ancient Chinese walled city, with shops, dwellings, cafés, shrine, theatre, temple, and gardens. Native farmers are seen working in rice paddies and soya bean patches—artisans carving ivory, jade, silver, mother of pearl, and porcelain—festivals and plays abound. Fortune-telling by trained Chinese larks is very interesting.

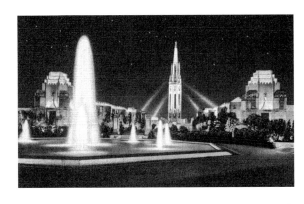
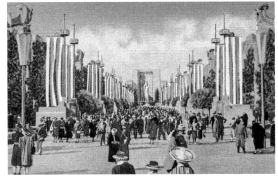
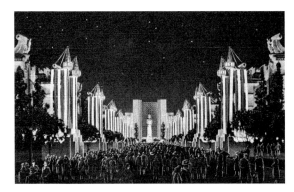
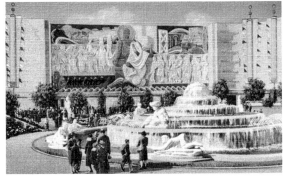
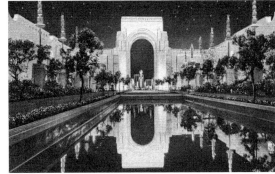

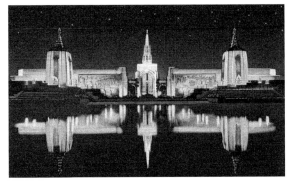

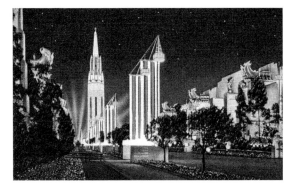
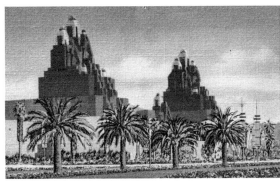
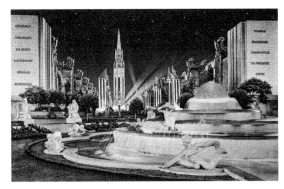
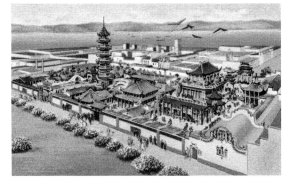

CELEBRATION

TOWER OF SUN
World's Fair on San Francisco Bay, 1939
Soft harmonizing colors painted with light of delicate tints, and reflected in the pools, glow in a sea of iridescence. The gleaming Spire of the Sun, as mirrored in shimmering waters of the Fountain and Pool of the Phantom Arches in the Court of the Moon, complete the "Glory of Night" at the Fair.

FORD EXPOSITION BUILDING
San Diego, California, 1935
At the south end of the Plaza de America is the Ford Motor Company's permanent steel and concrete building—located in a natural spot of beauty with the Firestone Singing Fountain in the foreground.

SANTA CATALINA ISLAND
Avalon, California, 1937
The Art Deco-style structure of the Catalina Casino was built to house an acoustically sophisticated movie theater on the ground floor and was topped off by the world's largest circular ballroom. The yacht club sits beside the casino on this magical twinkling island shore.*

FERRY BUILDING
San Francisco, California, 1938
More than 55,000,000 people pass through the portals of this building each year, where boat connections are made for the East Bay cities and for other rail connections in all directions. The Ferry Building with its clock is one of the landmarks of the city.

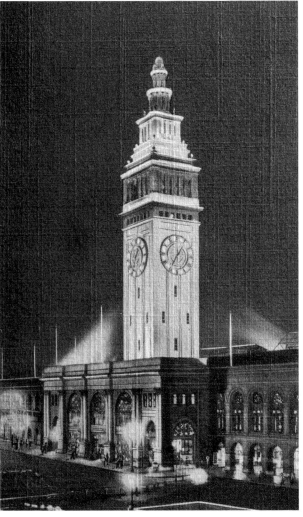

LIGHTS OF DENVER
Denver, Colorado, 1943
Lookout Mountain, overlooking Golden, is about 16 miles from Denver. At night, from many spots, the millions of lights of Denver fill up the entire horizon and present a beautiful spectacle.

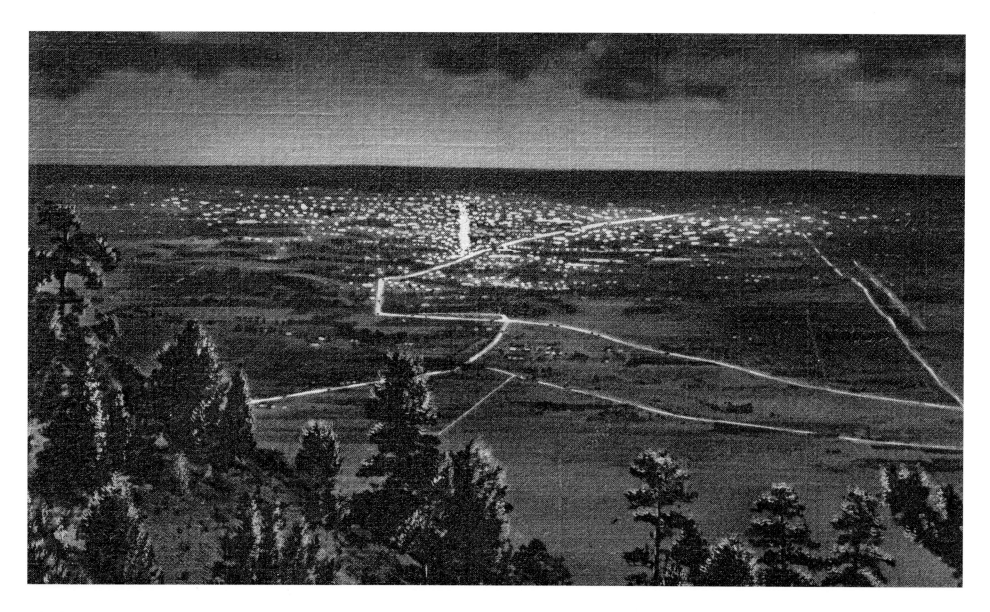

LIGHTS OF HOLLYWOOD
Hollywood, California, 1929
The glory of night in the Hills of
Hollywoodland with Lake Hollywood in
foreground, overlooking Los Angeles.*

LIGHTS OF OAKLAND
Oakland, California, 1944
Lights of Oakland's downtown district
shine across Lake Merritt, the only
tidal lake located in the heart of
an American city.*

BOULDER DAM
Boulder City, Nevada, 1939
The graceful curve of the highway
across Boulder Dam becomes at night
a star-studded crescent of light rivaling
the natural beauty of the dark desert
sky, while the light-flooded intake
towers are reflected in the still waters
of the lake.

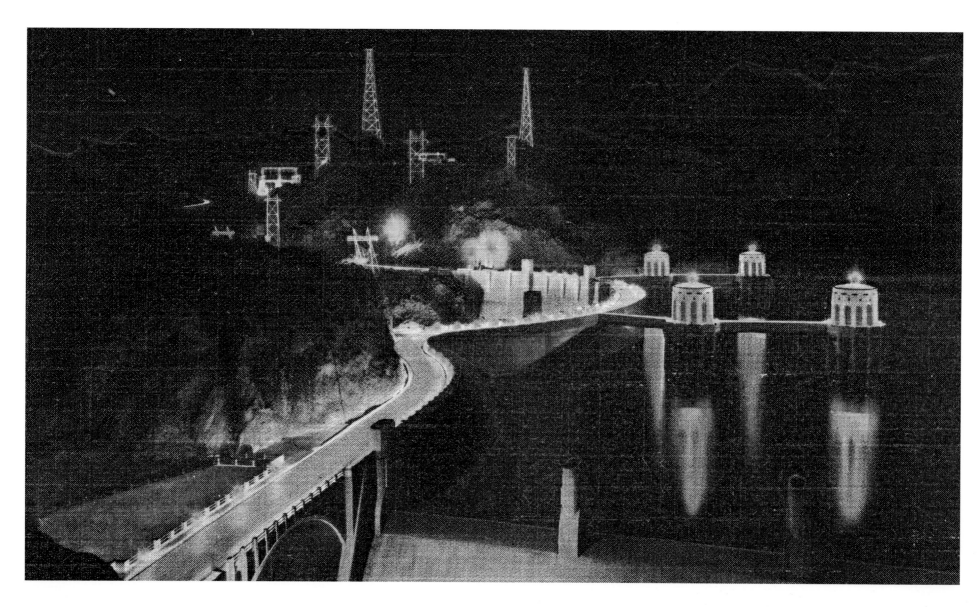

ENTERTAINMENT

OIL FIELD
Los Angeles, California, 1943
The discovery and exploitation of
oil played a vital part in the early
settlement of California. At present,
oil wells pumping by day and night
produce 225 million barrels of
"black gold" annually.*

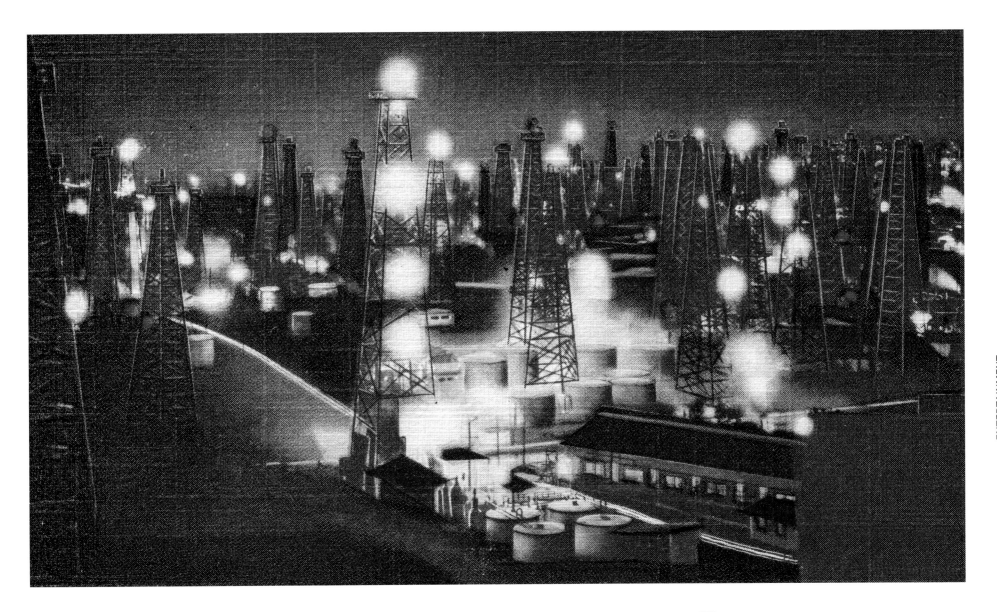

ELECTRIC FOUNTAIN
Beverly Hills, California, 1931
The Electric Fountain, located on the busy corner of Santa Monica and Wilshire Boulevards, is the centerpiece of Beverly Gardens Park. Illuminated by striking special effects, including a changing pattern of neon-colored lights at night, the fountain consists of two basins, with the upper basin containing a ring of varied height nozzles.*
[top left]

STATE CAPITOL BUILDING
Salt Lake City, Utah, 1935
Utah is justly proud of its Capitol Building. From its commanding situation on Capitol Hill, one is afforded a most wonderful view of Salt Lake Valley surrounded by the lofty, snow-capped mountains of the Wasatch Range. The building itself is very beautiful. When illuminated at night it is most attractive.
[top right]

HOLLYWOOD BOULEVARD
Hollywood, California, 1940
World-famed Hollywood Boulevard, with its fascinating shops, cafés, and theatres, is the main thoroughfare of the motion-picture capital. Brilliant at night with colorful lights and blazing searchlights, it is a never-ending pageant of celebrated characters of stage, screen, and radio.
[bottom left]

ELLIOTT BAY
Seattle, Washington, 1938
Searchlights off the battleships on Elliott Bay with Seattle in background.*
[bottom right]

SAN FRANCISCO
San Francisco, California, 1938
Brilliant and dazzling are the searchlight displays on San Francisco Bay from the battleships of the Pacific Fleet. These radiant night shafts of light accentuate the lights of Market Street, "The Path of Gold," and the East Bay Shore.

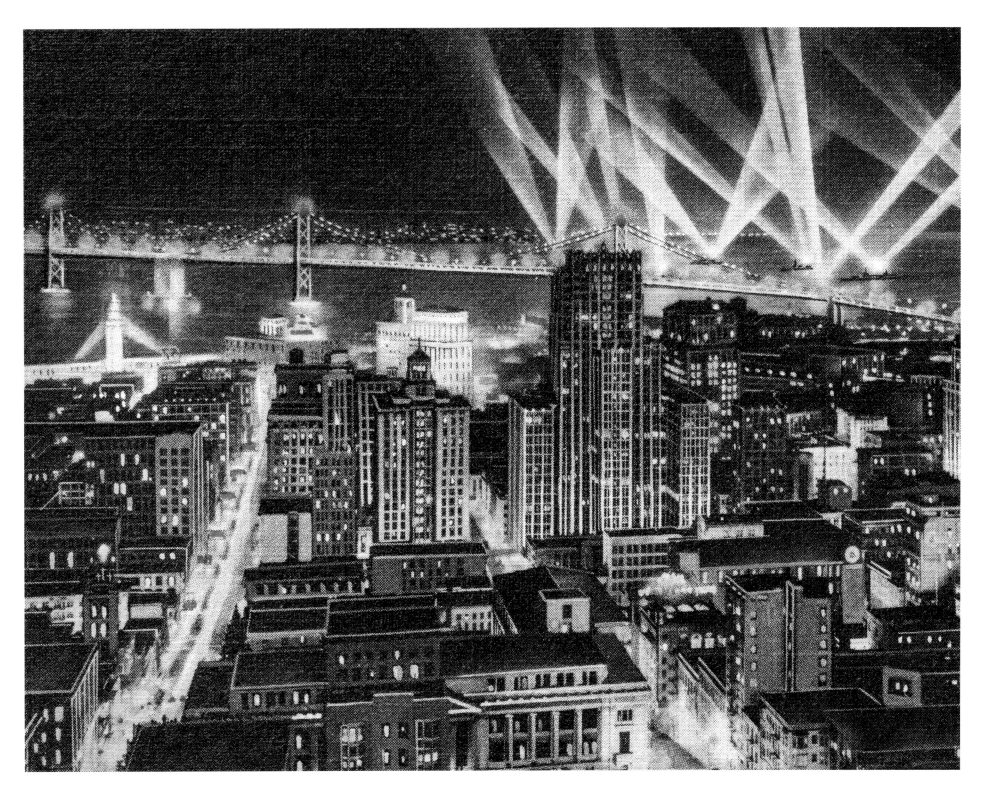

SPECTACLE

ENTERTAINMENT IN THE AGE OF OIL

By 1929, the perfection of a reliable gasoline engine, increased availability of oil, and momentous strides in mass production had facilitated the widespread adoption of yet another transformative innovation, the automobile. By this year, one out of every two U.S. households owned a car, and with affordable personal transportation at their 24/7 disposal, they had the means not only to streamline the execution of daily life and work tasks, but to explore new opportunities for play. Under their own propulsion, large numbers of people could now assemble in places and for events that during previous ages would have required advanced and strategic travel planning, and, for most, an overnight stay.

Rodeos, racetracks, college football stadiums, and outdoor performing arts amphitheaters took the lead in large-scale entertainment venues of the west. The region's mild climate and available land provided ideal settings for developers, from Hollywood celebrities and West Coast entrepreneurs to universities and local governments.

Between 25,000 and 200,000 day-trippers, sport spectators, and performing arts aficionados could now conveniently drive, convene, and partake in a shared outdoor experience under temperate skies and in view of hazy mountains, before returning home to their own beds.

1921　STANFORD STADIUM　85,000
1922　PASADENA ROSE BOWL　90,000
1923　BERKELEY STADIUM　85,000
1923　LOS ANGELES COLISEUM　80,000

CIVIC STADIUM
Portland, Oregon, 1930
The stadium was built in 1926 for $502,000 by the Multnomah Athletic Club, who named it Multnomah Civic Stadium. The site is used for college football, cricket matches, and greyhound racing.*
[previous spread]

PLAZA DE TOROS
Tijuana, Mexico, 1950
"Plaza de Toros," on 5th and 6th Streets, became the center of Tijuana's bullfighting activities in the 1920s and 1930s. It was officially inaugurated as Plaza El Toreo de Tijuana on July 3, 1938. Practically every great torero of the era performed in the historic "Plaza de Toros."*

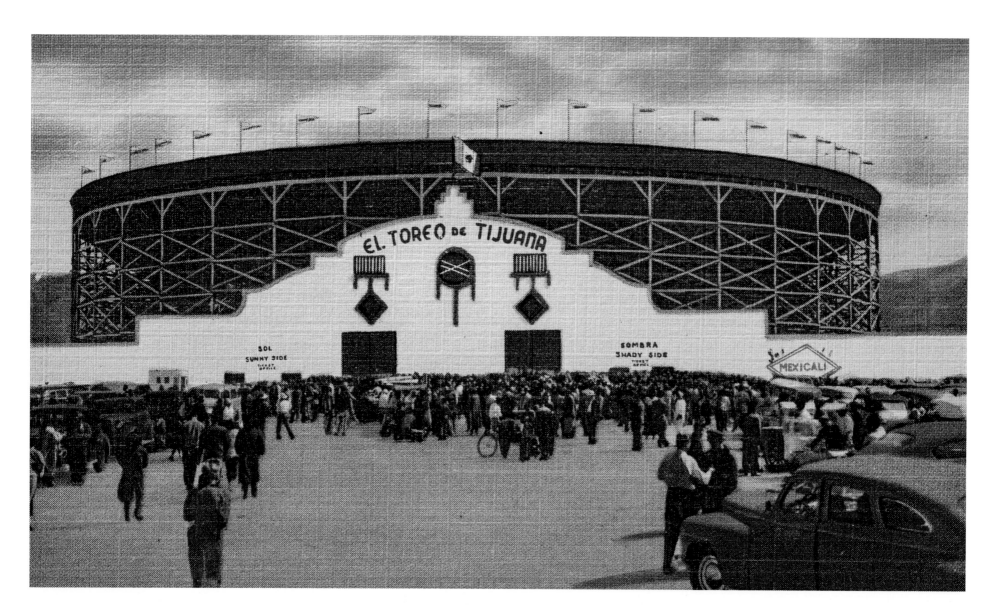

ENTERTAINMENT

PLAZA DE TOROS
Tijuana, Mexico, 1939
The matador has the sword in his hand waiting to give the final thrust, which puts the finis to the bull.*

AGUA CALIENTE RACE TRACK
Tijuana, Mexico, 1935
Agua Caliente Race Track, thought to be the finest race course in the world, opened in December of 1929, and was built at a cost of 2.5 million dollars.*

AGUA CALIENTE RACETRACK
Tijuana, Mexico, 1931
The shaded veranda at the world's finest racecourse from which guests may watch the racing from their luncheon tables at the Agua Caliente Jockey Club.*

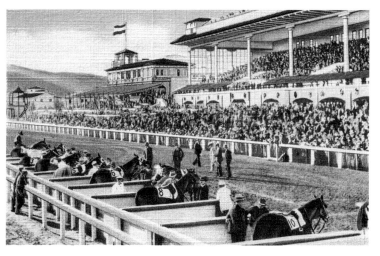

ENTERTAINMENT

RODEO COWBOY
Pendleton, Oregon, 1939
Ed Scholtz on Bob Cat.

RODEO COWBOY
Pendleton, Oregon, 1939
Chester Byers roping steer.

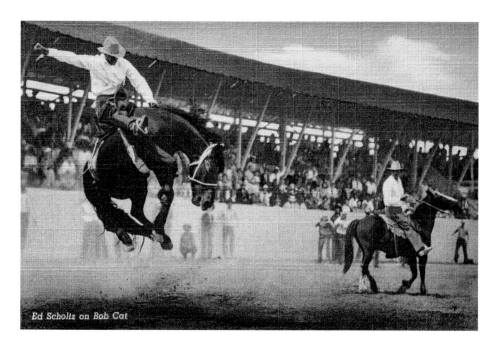

Ed Scholtz on Bob Cat

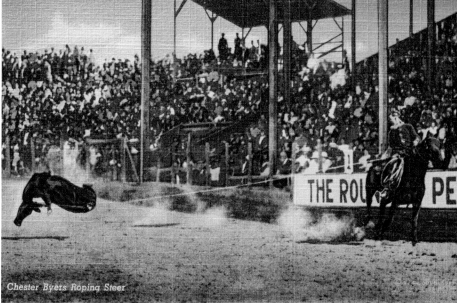

Chester Byers Roping Steer

RODEO COWBOY
Cheyenne, Wyoming, 1939
Bob Boden leaving Mexico.

RODEO COWBOY
Livingston, Montana, 1939
Earl West thrown from Bluebonnet.

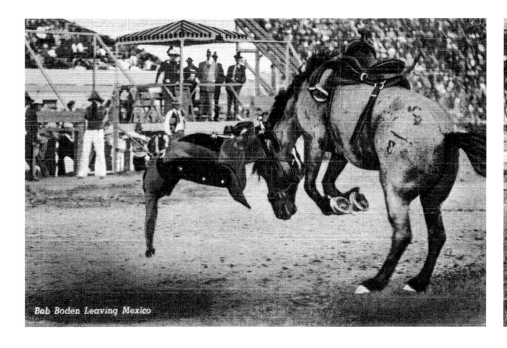

Bob Boden Leaving Mexico

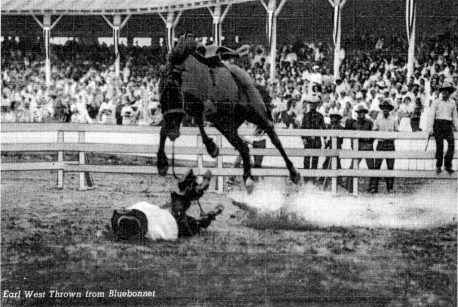

Earl West Thrown from Bluebonnet

HOLLYWOOD PARK
Inglewood, California, 1940
Hollywood Park, one of America's most beautiful race tracks, is situated in Inglewood, California, a short distance from Los Angeles. Here, the summer visitor to Southern California may experience the double thrill of viewing the "Sport of Kings" and mingle with Movieland's most glamorous personalities.
[top left]

SANTA ANITA PARK
Arcadia, California, 1935
Southern California's million-dollar race track is located on the famous and beautiful Lucky Baldwin "Santa Anita Rancho" in Arcadia. The Los Angeles Turf Club House and Grand Stand present a daily fashion show of filmland notables and society folk during the racing season.
[top right]

FRONTIER PARK
Cheyenne, Wyoming, 1937
Frontier Days are famous throughout the nation; the most noted rodeo event in the world. It is held each year late in July, attracting the most noted performers and contestants in the country and drawing visitors from all over the nation.
[bottom left]

SUN VALLEY RODEO
Sun Valley, Idaho, 1938
The first professional rodeo documented in North America was in Cheyenne, Wyoming, in 1872. Since then, the sport and its traditions have been passed down through generations, especially here in Idaho, where cattle, horse, and ranch work have a rich history.*
[bottom right]

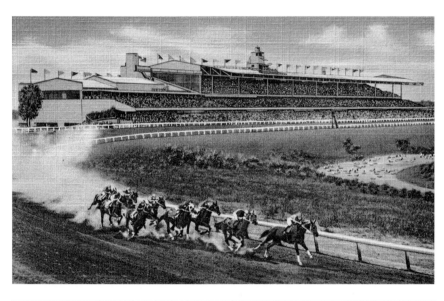

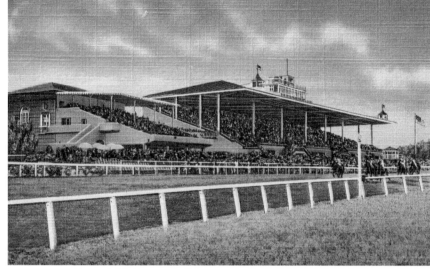

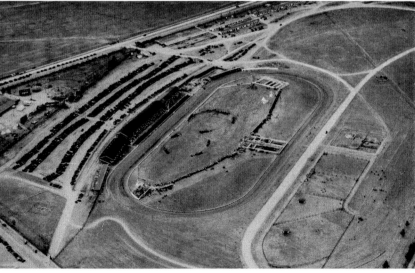

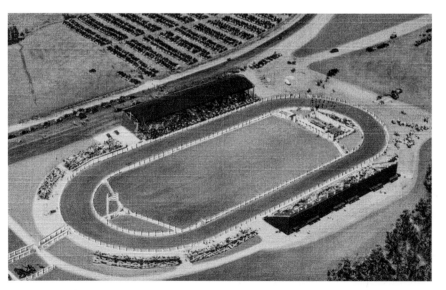

SANTA ANITA PARK
Arcadia, California, 1939
Southern California's two-million-dollar race track, located on the famous and beautiful Lucky Baldwin "Santa Anita Rancho" in Arcadia, fourteen miles from downtown Los Angeles, has been established as the world's winter horse racing center. The Club House and Grand Stand present a daily fashion show of filmland notables and society folk during the racing season.
[top left]

SANTA ANITA PARK
Arcadia, California, 1939
Santa Anita Park is located at the base of the beautiful Sierra Madres on the famous Lucky Baldwin "Rancho Santa Anita," fourteen miles east from downtown Los Angeles. The world's winter horse racing center, it is also the scene of the famous "Santa Anita Handicap."*
[top right]

PENDLETON ROUND-UP
Pendleton, Oregon, 1939
The Pendleton Round-Up at the Pendleton Round-Up Stadium is a major annual rodeo in Pendleton, Oregon. Held during the second full week of September each year since 1910, the rodeo brings roughly 50,000 people every year to the city of Pendleton.*
[bottom left]

SANTA ANITA PARK
Arcadia, California, 1939
Santa Anita Park, Southern California's two-million-dollar race track, located on the famous Lucky Baldwin's "Santa Anita Rancho" in Arcadia, fourteen miles from downtown Los Angeles, has been established as the world's winter horse racing center. This view shows the beautiful paddock, saddling barns, and a small portion of the 100-acre parking area.
[bottom right]

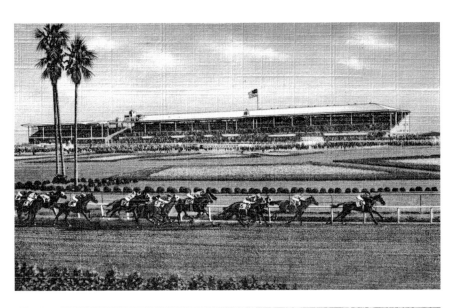

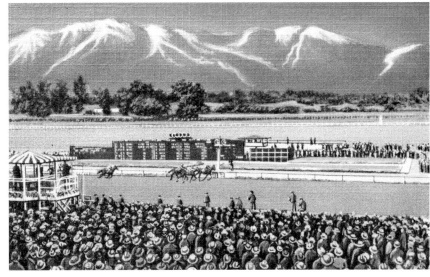

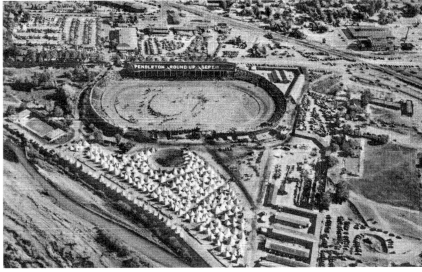

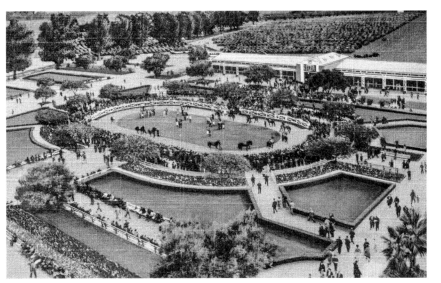

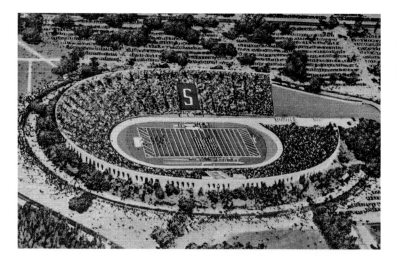

STANFORD STADIUM
Palo Alto, California, 1940
Situated on Stanford University Campus, amid attractive and quiet surroundings, Stanford Stadium, the nation's second-largest, will accommodate 100,000 people.

ROSE BOWL
Pasadena, California, 1936
The scene of the annual East-West football championship, which is played on New Year's Day. Each year the Tournament of Roses Association invites the western university whose team has made the most outstanding record during its season. The university, in turn, invites its opponent of similar standing from the East. This game has become a national classic. Over 100,000 football enthusiasts crowd this immense stadium.

MEMORIAL STADIUM
Berkeley, California, 1935
The Memorial Stadium was built in 1923 at a cost of $1,025,000 from funds secured by sale of ticket scrip for seats covering games 10 years in advance; can seat in excess of 80,000 people. It is a memorial to the sons of the University of California who fell during the World War. From the upper portion, an excellent view is had over San Francisco Bay, the Golden Gate, and surrounding East Bay territory.

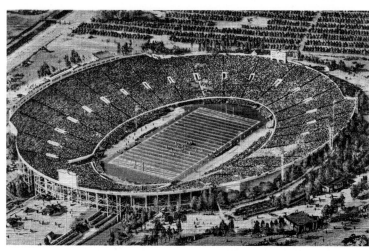

ENTERTAINMENT

LOS ANGELES COLISEUM
Los Angeles, California, 1941
The Los Angeles Coliseum, located
in Exposition Park, is one of the largest
and finest stadiums in the world,
with a seating capacity of over 110,000.
It has been the scene of many famous
and spectacular events, including
motion picture pageants, several
Eucharistic Congresses, and the 1932
Olympic Games.

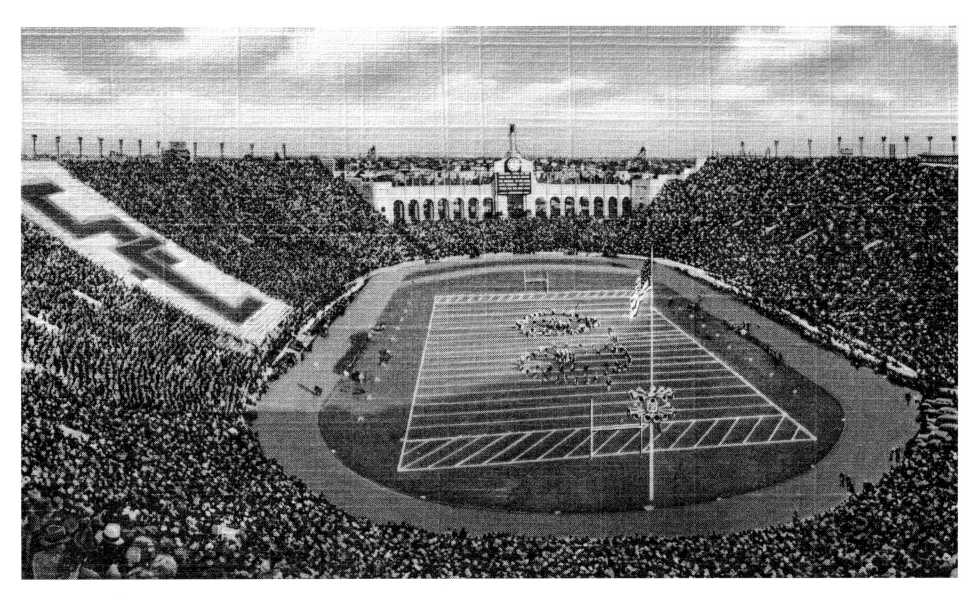

FROST AMPHITHEATER
Palo Alto, California, 1940
The Laurence Frost Amphitheater is a prominent amphitheater at Stanford University. It first opened in 1937 and is the site of the commencement ceremonies for the university, holding about 7,000 people.*
[top left]

MOUNT RUBIDOUX AMPHITHEATRE
Riverside, California, 1932
Easter Sunrise Service near Riverside, in the midst of the Orange Belt, east of Los Angeles, rises Mount Rubidoux, a famous landmark surmounted by a cross dedicated to Padre Junipero Serra, founder of the old Franciscan Missions. Riverside lies in the beautiful Santa Ana Valley, set about by mountains. The auto drive to the top of Mount Rubidoux should not be missed.*
[top right]

GREEK THEATRE
Berkeley, California, 1935
The Greek Theater at Berkeley is an open-air structure built of concrete and situated in a natural hillside amphitheater on the University of California Campus. It has a seating capacity of approximately 10,000. Presented to the University by the Hearst family, it is sometimes called Hearst Greek Theatre.
[bottom left]

GREEK THEATRE
Los Angeles, California, 1933
Greek Theatre, the world's most beautiful outdoor theater, is located in Griffith Park, where each summer a season of ballet, opera, and other forms of outstanding musical theater is presented.*
[bottom right]

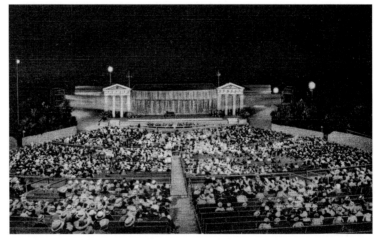

HOLLYWOOD BOWL
Hollywood, California, 1934
The Hollywood Bowl is a large, natural, outdoor amphitheater in the Hollywood foothills, where, during the summer months, "Symphonies Under the Stars" are given under the baton of nationally-known directors. Easter sunrise services are observed here each year. Seating capacity 20,000.

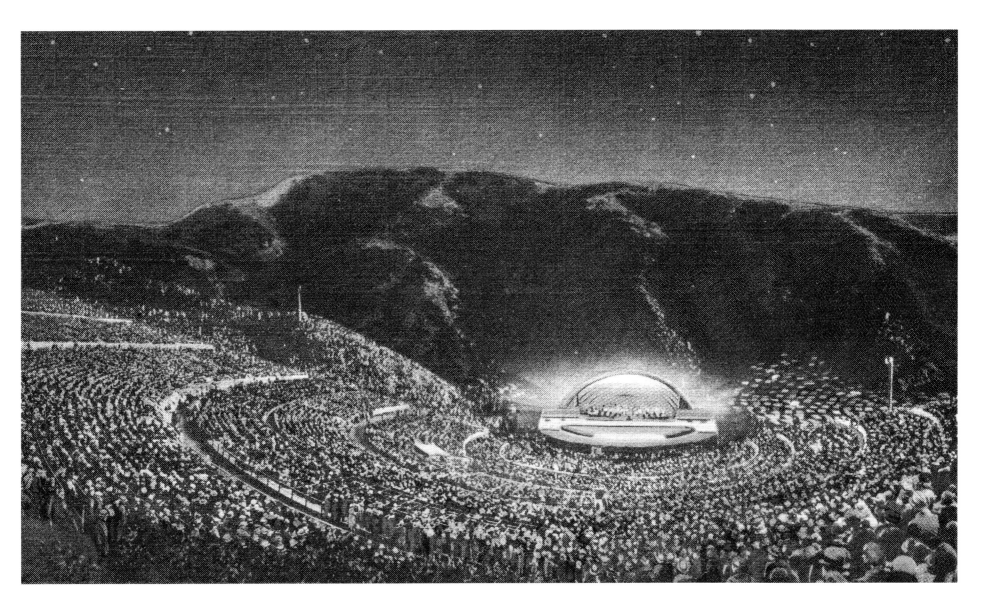

HOLLYWOOD BOWL
Hollywood, California, 1938
The world's largest natural amphi-
theater, nestled in the Hollywood Hills
where thousands thrill to glorious
music under the stars, seats 20,000.*

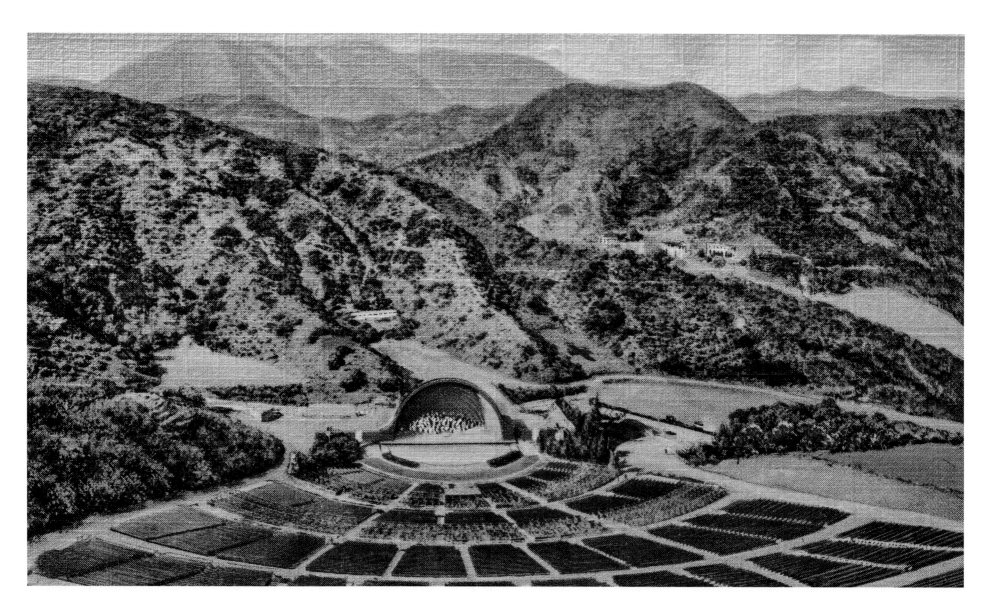

RED ROCKS THEATRE
Denver, Colorado, 1941
The great open-air amphitheater at the Park of the Red Rocks was opened in 1941. This great bowl seating 12,000 or more people is flanked on each side with huge red sandstone cliffs and the stage is at the foot of another great block of stone. These great rocks form natural sounding boards offering splendid acoustics as well as a marvelous setting.

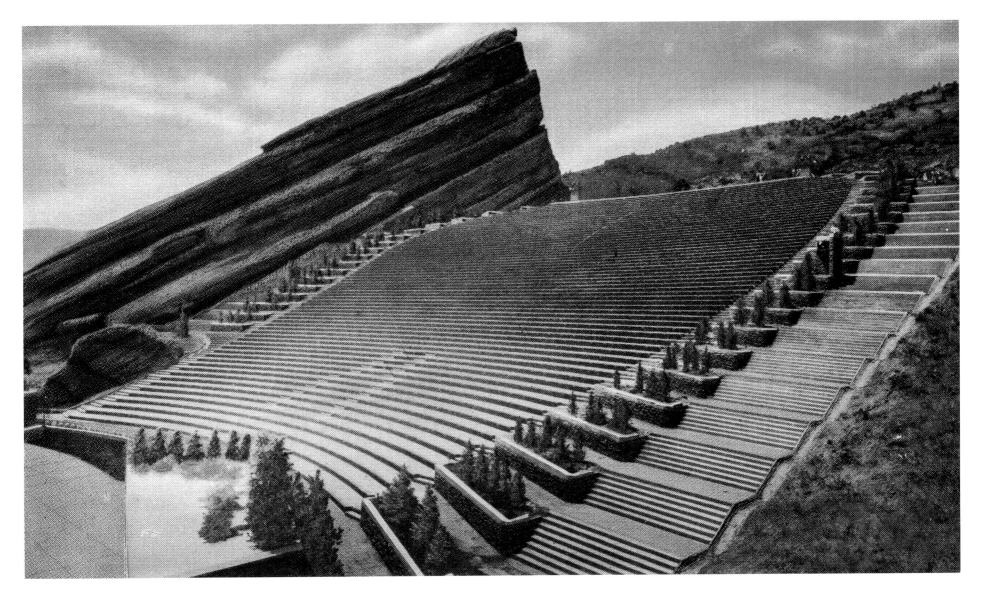

IMMERSION

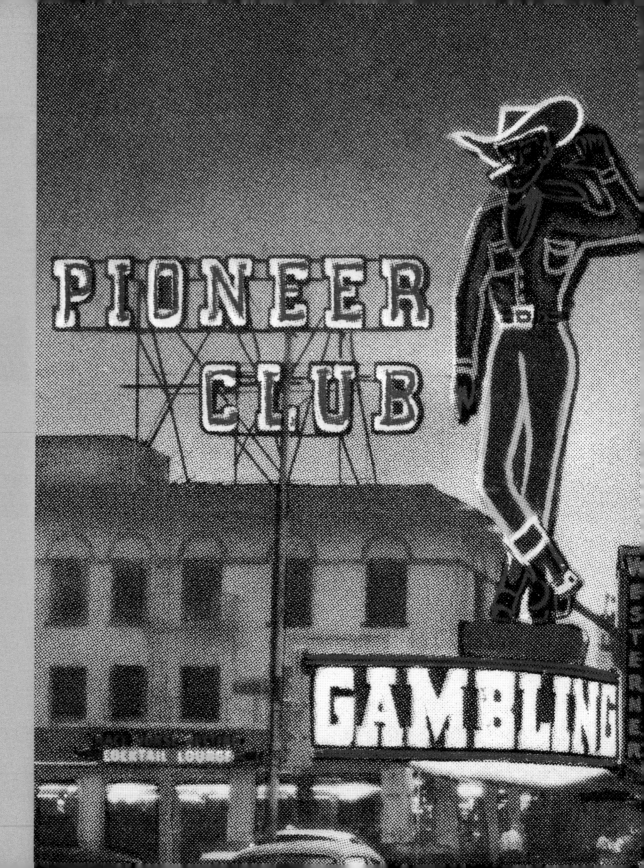

ENTERTAINMENT IN THE AGE OF INFORMATION

No field had more potential for rapid transformation in the age of information than that of entertainment, which was dependent in the main upon ideas, emotions, and their transmission from storyteller to audience. New technology, with the capacity to free this exchange from space and time constraints, was certain to explode the field and send its hurtling energized pieces into a multiplicity of new directions.

Whereas live performance and film projection depended upon the physical presence of a limited audience, radio and television broadcasting technology facilitated the simultaneous transmission of a performance to a far-flung audience of millions. New York became the initial epicenter for both radio and television production and distribution, but by mid-century, television shifted west with ABC, NBC, and CBS all establishing new Hollywood head-quarters in rapid succession.

Simultaneously, entire entertainment oases were being built from the ground up, creating instant cities in such unlikely destinations as Anaheim and Las Vegas. Driven by imagination and designed to feed the senses, new experiential models for entertainment, from Disneyland to the Las Vegas Strip, broke free of naturalistic constraints to create wholly immersive entertainment environments and possibilities for children as well as adults in the spacious and temperate West.

HERE IT IS!
The Famous
PIONEER
CLUB

LAS VEGAS CLUB

"BUY THE TICKET. TAKE THE RIDE."
— HUNTER S. THOMPSON, 1968

FREMONT STREET
Las Vegas, Nevada, 1954
The world's largest casinos are all in
two blocks on fabulous Fremont Street.
Wine, dine, or play twenty-four hours
a day, every day of the year. Atomic
detonation shown was 65 miles
distant. From the "Up and Atom" city.*
[previous spread]

GRAUMAN'S CHINESE THEATRE
Hollywood, California, 1931
Premiere Night at Grauman's
Chinese Theatre.*

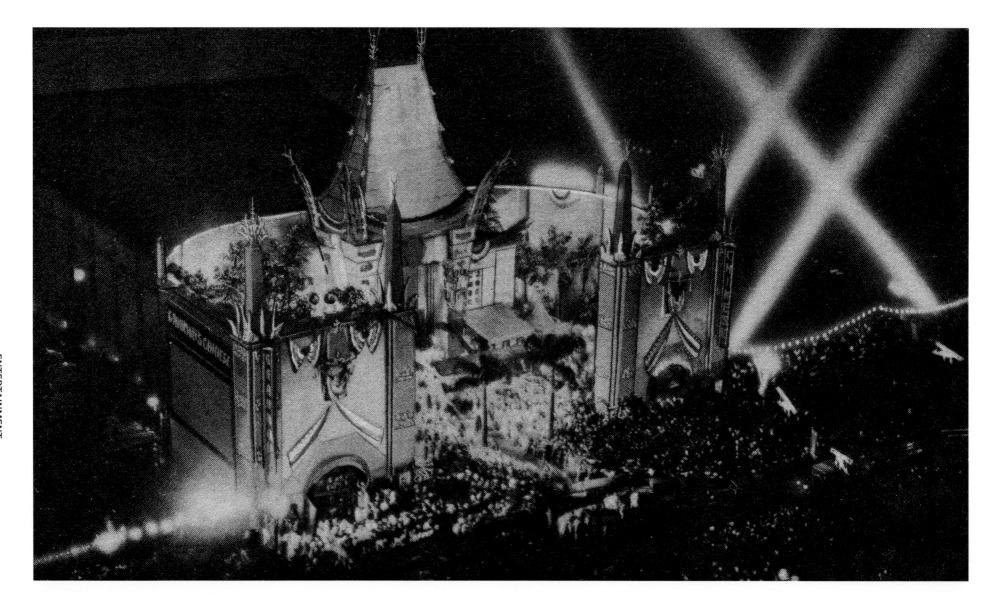

ENTERTAINMENT

GRAUMAN'S CHINESE THEATRE
Hollywood, California, 1941
The "Floor of Fame" is one of the most frequented and interesting places in Hollywood. Inscribed into the cement blocks on the floor of the forecourt of Grauman's Chinese Theatre are the handprints, footprints, and signatures of some of the most famous of filmland's celebrities, inviting visitors of all ages to step into the shoes of their favorite stars.

BROWN DERBY
Hollywood, California, 1941
The famous Brown Derby on Vine Street, Hollywood, with its adjacent distinctive Bamboo Room, is the acknowledged center of the smart social life of the Movie Colony.

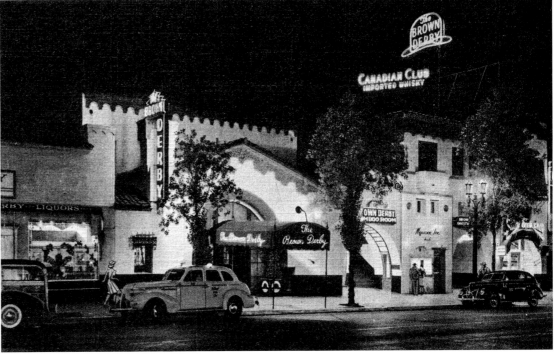

AMERICAN BROADCASTING COMPANY

Hollywood, California, 1952
On this famous thoroughfare in the heart of glamorous Hollywood are located the Pacific Coast headquarters of three of the major networks, broadcasting and televising coast-to-coast, affording daily entertainment and pleasure to thousands of visitors to Hollywood.
[top left]

COLUMBIA BROADCASTING SYSTEM

Hollywood, California, 1941
The new West Coast home of Columbia Broadcasting System's broadcasting station. The ultramodern architecture and equipment make the guided inspection tours an interesting attraction.*
[top right]

COLUMBIA BROADCASTING SYSTEM

Hollywood, California, 1941
Built around a verdant forecourt, these Columbia Broadcasting System studios are the spot where the majority of the West Coast broadcasts originate.*
[bottom left]

NATIONAL BROADCASTING COMPANY

Hollywood, California, 1941
Many of the most popular broadcasts originate at this new studio. Spacious, air-conditioned studios provide accommodations for large audiences to see and hear firsthand radio broadcasts.*
[bottom right]

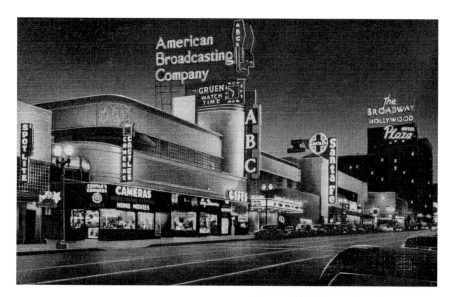

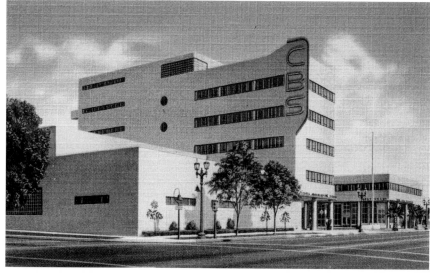

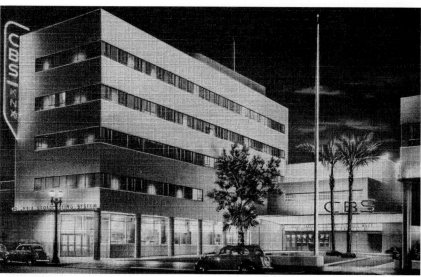

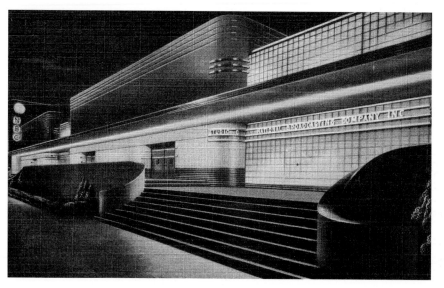

RADIO CITY

Hollywood, California, 1940

Radio Center on Sunset Boulevard is in the heart of glamorous Hollywood. On this romantic palm-fringed boulevard are located the Pacific Coast headquarters of two national broadcasting networks—motion picture studios and offices, and nearby famous nightspots, where one may dine and dance to the music of nationally famous orchestras and mingle with the film colony's celebrities.

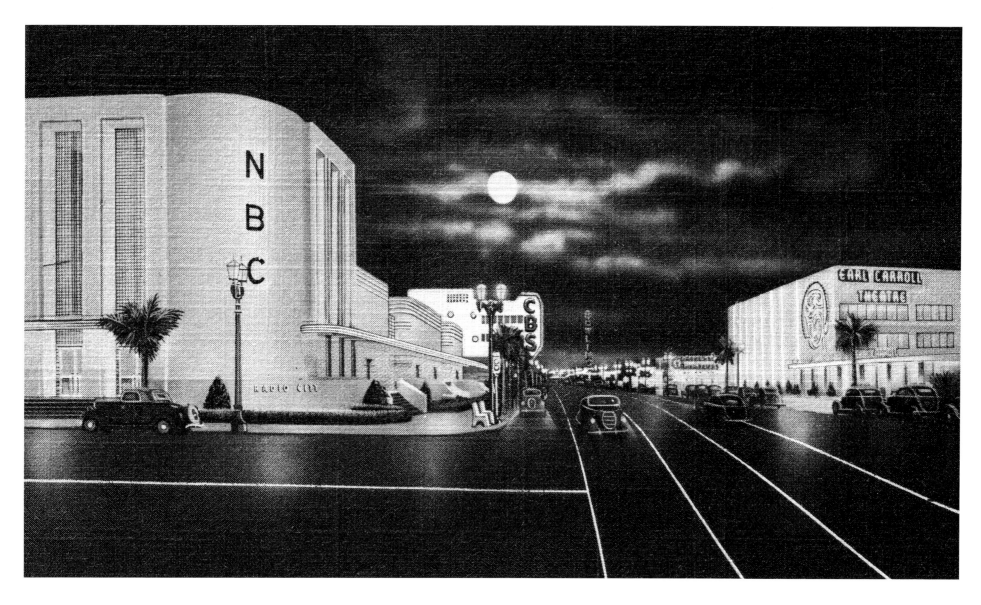

HAROLD'S CLUB
Reno, Nevada, 1939
The most advertised club on earth draws an average of 5,000 customers every day in the year. Roadside signs arouse motorists' curiosity over the entire US. Adorning the front of the club is the world's largest and finest ceramic mural: 35 × 70 feet.

THE SANDS
Las Vegas, Nevada, 1953
A Place in the Sun. The newest luxury hotel in Las Vegas world renowned for its headline entertainment, luxurious living accommodations, and complete shopping and amusement.

HOLLYWOOD PALLADIUM
Hollywood, California, 1938
Located on Sunset Boulevard, one of the principal traffic ribbons threading its way through the entertainment capital of the world is the famed Palladium, popular Hollywood ballroom, featuring big-name bands. Adjoining is the Pacific Coast headquarters of the Columbia Broadcasting System.

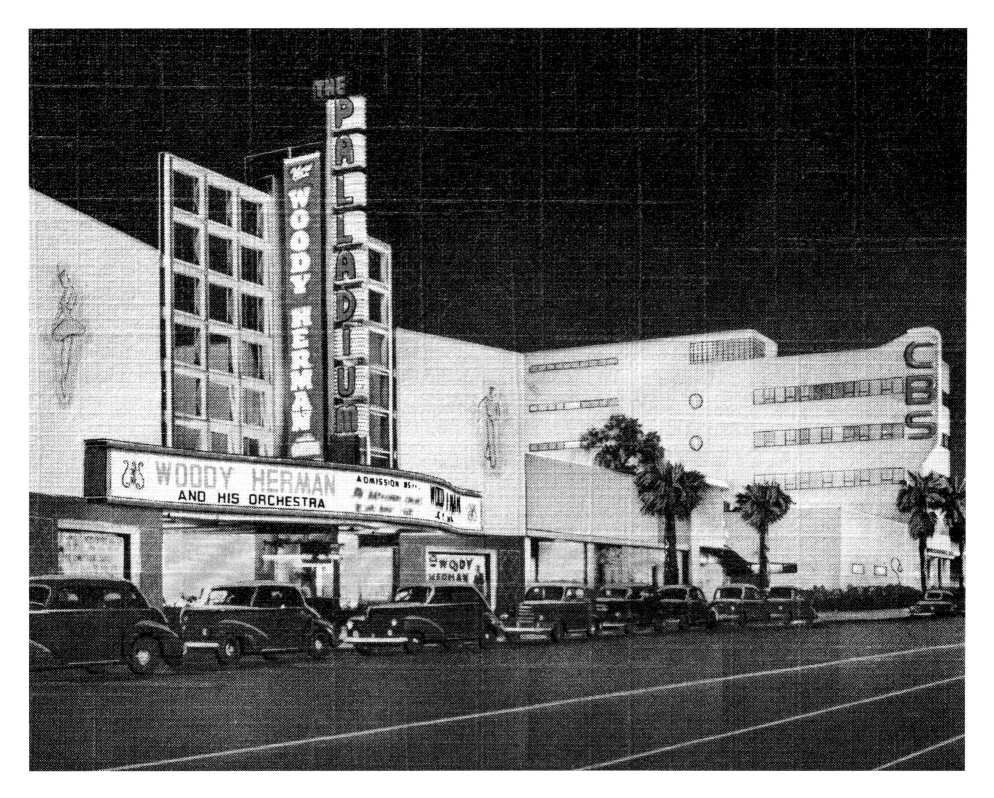

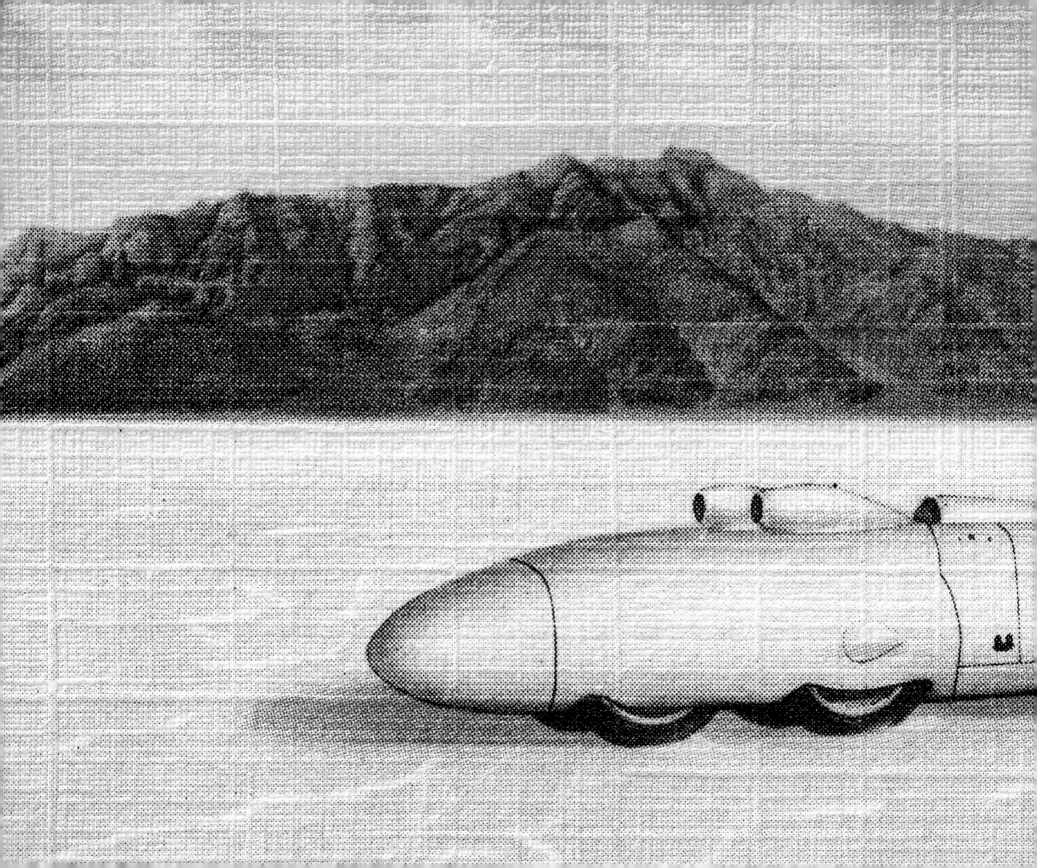

FANFARE FOR THE COMMON MAN

by Leslie Erganian

"I'VE ALWAYS HAD A WEAKNESS FOR HEROIC IMAGERY."

— EDWARD RUSCHA, 2008

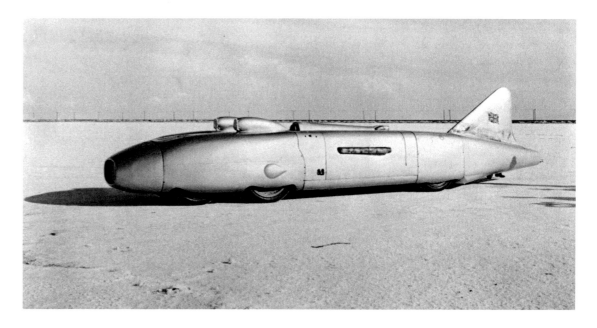

THUNDERBOLT
Bonneville Salt Flats, Utah, 1938
The car was driven by two Rolls-Royce V-12 'R' engines, as used on Schneider Trophy seaplanes, and reached 312 mph in November 1937, 346 mph in August 1938, and 358 mph in September 1938.

SPEEDWAY
Bonneville Salt Flats, Utah, 1938
In 1912 this area was tested as a racetrack and has since proved to be the greatest automobile speedway in the world.
[previous spread]

ON FEBRUARY 27, 1861, THE UNITED STATES Congress passed an act that allowed privately printed cards weighing one ounce or less to be sent through the U.S. mail. The first post card to receive a copyright was issued the same year. Over the coming decades, facilitated by a series of acts passed by Congress limiting, expanding, and ultimately defining the form, the post card evolved with the features of an image with or without caption, printed on one side of a small piece of card stock paper, and on the reverse, a short description, room for writing a message and address, and a defined position reserved for a postage stamp.

The year 1931 saw the emergence of the linen post card, so called because of the fabric-textured, high rag-content paper of the card itself, which allowed for the ink to grab hold of the surface with a great degree of saturation. The linen post card, which came to dominate the American post card market, was developed by Curt Teich & Co. of Chicago. Teich was a German émigré from a multi-generational line of printers, who employed his vision and skills to create a wholly new iteration of the already well-established post card. Teich also had the moxie to enlist a cadre of collaborators, including photographers,

MCM MEDIUM

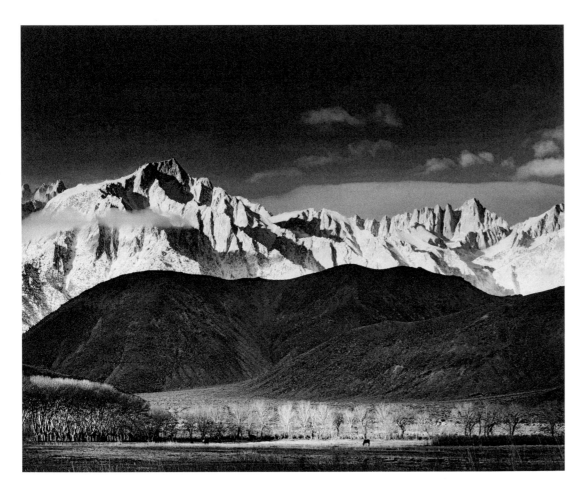

producers, and artists, to help him bring his vision to life. His company oversaw the creation of 10,000 distinct views of the American West. With print runs averaging 20,000 per view, Curt Teich & Co. printed nearly 200 million western-view linen post cards across nearly three decades, with the last card printed in 1959.

PHOTOGRAPHIC DOCUMENT

In 1932, eleven San Francisco Bay Area photographers, including Ansel Adams, Edward Weston, and Imogen Cunningham established themselves as Group f/64. They chose to reject the soft focus of Pictorialism, which had characterized art photography during the first few decades of the twentieth century, in favor of the sharp detail and extensive depth of field afforded by utilizing the smallest aperture on a large-format camera. At a time when the American West was still in its unspoiled youth, these photographers applied their individual artistry with technological acuity to create work that communicated specificity of place with poetry.

In 1975, the exhibition *New Topographics, Photographs of a Man-Altered Landscape* was held at the International Museum of Photography at the George Eastman House in Rochester, New York. Curated by William Jenkins, it featured the work

of ten photographers, including Robert Adams, Lewis Baltz, and Joe Deal. Jenkins recognized in the work of these photographers a shared interest in documenting a changing landscape—such changes not always being for the better. These photographers collectively rejected the notion that anything aesthetically displeasing should be cropped out of a landscape photograph. With a focus as sharp as the work of their seminal western predecessors, they framed man's changes to the landscape front and center. Directing their lenses towards roads, factories, motels, roadside eateries, and tract-home developments, they found virtue in truth and value in documenting the world as it was.

Seven decades earlier, in 1905, Curt Teich himself had pointed his camera at ordinary main-street businesses all along the route of a solo cross-country train trip. Starting off in Chicago, Teich traveled on to St. Petersburg, Florida, and then headed out to the West Coast. Racking up $30,000 worth of orders for large print runs of post cards based upon

his initial exploratory catalog of images, Teich returned to Chicago determined to enter the post card printing business. With the addition of the talents of more than a thousand employees at the height of his business, and the ongoing interests of dozens of partners throughout a national network to commission new work, Teich rose to the top of his field with his signature-style hand-colored linen post cards that reigned supreme until the slick-surfaced photochromes supplanted them in popularity by the mid-1950s. Teich became one of the most prolific post card printers in America during the first half of the twentieth century, with 250 million or more cards per year issuing from his business.

ARTISTIC HYBRID

Color photography was not yet widely available or affordable when the five-color Curt Teich Art-Colortone process began in 1931. The process built upon a black-and-white photographic image, which, based upon direct feedback from the customer, was extensively altered and enhanced to form a constructed, refined, and idealized view. A skilled craftsman had the ability to eliminate an offending phone line or add an as-yet-unbuilt bridge. They could soften a shadow or sharpen a skyline with brush in hand. In a time when film speeds were still not fast enough to capture detail without grain at low light levels, Teich's in-house artists could even paint day into night.

Teich's sales team played an integral part in the production of his post cards. Not only did they work directly with customers to propose and commission specific views, but they remained engaged throughout the back-and-forth process of crafting each image through numerous stages. After a photo had been retouched in the Chicago studio to a certain

MCM MEDIUM

degree, it headed back to the customer with a tissue overlay and a numbered chart of up to seventy-five custom colors. The customer would be asked to write in a corresponding number on the tissue to best approximate the color of the scene as he or she desired it. The overall tendency leaned towards the selection of colors more vivid than true to life, which, over time, resulted in the signature color-saturated look that became associated with Curt Teich's linen post cards. Teich praised his company's final products as "beautiful miniature paintings." They proved remarkable enough to give birth to the phrase "pretty as a post card."

Curt Teich & Co. of Chicago was the first post card printer to introduce certain specific innovations to the printing process, affecting both style and economy. He was the first to print color post cards on a large offset press, which brought down the per-card printing cost. He was the first to make the addition of a white border surround for each image, which reduced paper waste by eliminating the need to trim down to the image border. He also developed his own lithographic process that utilized black halftone plates and a series of color applications onto linen-textured card stock—a process so unique that he was able to obtain a "C.T. Art-Colortone" patent for it.

One of Teich's most productive post card collaborators was photographer, publisher, and entrepreneur Stanley A. Pilz of San Francisco. Pilz went all-in on Teich's C.T. Art-Colortone printing method with his own branded "Pictorial Wonderland Art Tone" series, which included heroicized images of dams, bridges, roads, buildings, cities, agriculture, and national parks located throughout Northern California, and including the San Francisco World's Fair of 1939. Tichnor Brothers Inc. of Boston, which was

SAN FRANCISCO-OAKLAND BAY BRIDGE

San Francisco, California, 1937
Each individual tower of the bridge, standing more than 700 feet high from the base of its pier on the floor of the bay to its tip, represents a construction job comparable to that of a great skyscraper 60 stories high. The two suspension bridges have 2,310-foot main spans.
The lower deck carries two tracks for interurban electric cars and three lanes for heavy trucks, and the upper deck carries a 58-foot highway for six lanes of automobiles.

SAN FRANCISCO-OAKLAND BAY BRIDGE

San Francisco, California, 1937
A continuous traffic flow in both directions on the San Francisco-Oakland Bay Bridge has proven the wisdom of this $77,000,000 structure. The eight-and-one-half-mile distance across the Bay is now covered in ten to fifteen minutes, traffic speed of 45 miles is allowed. Six lanes of autos can traverse the upper deck, while the lower will carry three truck lanes and two train tracks. Width of bridge is 58 feet. Main spans 2,320 feet long with a vertical clearance of 185 feet.

SAN FRANCISCO-OAKLAND BAY BRIDGE

San Francisco, California, 1945
Night travel on the San Francisco-Oakland Bay Bridge is a real pleasure. The vapor sodium lighting system diffuses a soft nonglare light and lends an effective brilliance to the night. The massive towers silhouetted against the sky and reflected in the water create a lasting impression.

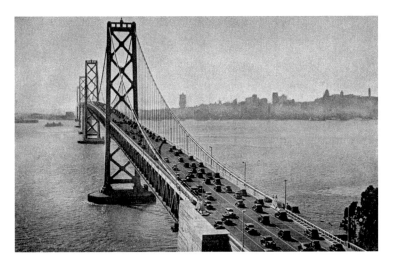

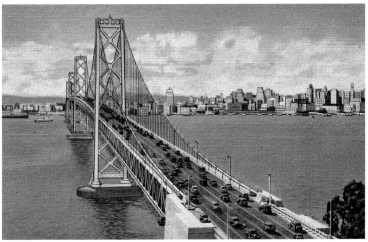

run by a number of ex-Curt Teich & Co. employees, was another major linen-era post card printer and contributor to the art form.

SOCIAL MEDIA

It is easy to attribute the ubiquity of communication in the age of Internet social media to the ease of the platform itself, a platform free from the requirement of any physical objects—no typewriter, camera, film negatives, or photo paper are necessary. All that is required is a communications network and device, and a combination of text and image the sender deems worthy of sharing. Today's Pony Express is everyone's index finger, and its delivery time is almost immediate.

It is remarkable, then, to consider that the overall annual production numbers for American post cards throughout the first half of the twentieth century were staggeringly high. From 250 million to over a billion cards were printed annually, an adoption rate in excess of two to three times the existing U.S. population. The success of the post card was aided by the patterns of delivery employed by the United States Post Office Department, which began what was known as "City Delivery" in 1863. Home delivery occurred twice daily in larger cities, with business delivery occurring up to four times per day. This practice was phased out in 1950, but it was during this period of multiple daily deliveries that the post card took off. Curt Teich's entry into the printing field in 1931, with his colorful modern interpretation of the form, reinvigorated and extended the reign of the post card for decades to come.

At a time when not everyone had access to an affordable camera, nor the ability to travel to all the distant places represented on post cards, these compact correspondences were as inspirational as they were practical. Not only did they express the sentiment "wish you were here," but the accomplishment "I was here." Almost from the beginning of the picture post card, they were purchased to keep as often as to send, becoming something by which to remember a place visited as much as to share it. Post cards made the sender's job easy by offering themselves up as souvenirs with at least half the message taken care of before pen was ever set to paper.

Part personal communication, part proof of travel, part business promotion, these small pieces of paper ephemera at a penny a pop were a convergence of art and advertising born directly from the technology of the times. Curt Teich's views, which were captured in silver through light, hand-colored with paint, and pressed by platen onto paper, helped to create hope after the devastation of World War I and the Great Depression and inspired new ways of seeing and appreciating the breadth of beauty to be found even in the ordinary.

HISTORIC ARTIFACT

Every artifact is a secret keeper. It means little until someone with a passion for observation and the discipline for inquiry comes along to examine it and to ask questions of it and, through the process of observation and inquiry, begins to explore its origins, context, meaning, and materiality. The longer an artifact lives, the more opportunities it has to reveal its secrets in an evolving historical context. As an object increases in age, what it has captured or embodied from its own time becomes ever more precious, simply for having survived beyond it. Time also provides the possibility that more and more viewers will see an artifact. By bringing their own

WESTERN STATES AS SUBJECTS DURING THE MCM LINEN POSTCARD ERA, 1931–1959
38% California, 12% Arizona, 11% New Mexico, 10% Colorado, 7% Wyoming, 6% Utah, 5% Washington, 4% Nevada, 4% Oregon, 3% Montana, 1% Idaho

MCM MEDIUM

MCM MEDIUM

experiences and understanding to it, viewers can unlock its secrets and discover deeper and deeper layers of meaning.

As an artifact, the post card presents a unique opportunity for examination. While high cost is a barrier to collectors of many other objects of historic significance—in that most areas of collectibles represent objects that have a value commensurate with their scarcity—the opposite is true of the post card. These small paper objects of desire remain, with few exceptions, affordable owing to their ubiquity.

The sheer diversity of imagery and broad availability gives the post card collector, also known as a deltiologist, the complete freedom to pursue his or her individual interests, be they directed by time, place, maker, subject, printer, style, or simply by an attraction to a particular image. Ubiquity and affordability also give post card collectors the ability to collect in quantity, which often leads to sequencing and storytelling. The advent of the Internet seller has allowed the collector to bring together pieces flung far and wide throughout the prior century and attach them to developing story lines that are very often either personal, local, or in alignment with their professional field of study and practice. Through souvenir images, these citizen historians are deeply and seriously engaged in historic reconstruction at a ground level.

Deltiology is the third-largest hobby in the United States, behind coin collecting and stamp collecting. While many collectors are satisfied to collect on their own, there are post card clubs throughout most metropolitan areas of the country, where members meet regularly to buy and sell from and to fellow collectors. More importantly, they share information about and enthusiasm for this

miniature art form rich in historic significance with like-minded individuals. It was at one such event, given by the San Francisco Bay Area Post Card Club, that we heard a club member enthusiastically describe the overall compendium of post cards as encompassing "the history of everything." It is an apt description of this vastly published and circulated art form, which only recently has begun to be recognized by museums and scholars as a working field unto itself—with multiple avenues for exploration as art, artistic inspiration, and as artifact.

Much as we have come to understand the value of oral history in recent years for having the ability to capture personal and emotionally grounding historic details that help bring an experience or place back to life in multiple dimensions, contemporary access to a catalog of images that exceeds the sources for existing imagery in any other medium during the same period, has unlimited potential to reveal new layers of whatever intimate and universal history has been captured and hidden in those images.

COLOR CHART

CURT TEICH & COMPANY, CHICAGO

THIS APPLIES FOR PHOTO-COLORIT AND ART-COLORTONE PROCESSES ONLY

DESIGNATE COLORS DESIRED BY NUMBERS

1	2	3	4	5	6	7	8
9	10	11	12	13	14	15	16
17	18	19	20	21	22	23	
	26	27		29	30		

2A-H341

BIBLIOGRAPHY

Abbott, Carl. *How Cities Won the West: Four Centuries of Urban Change in Western North America*. Histories of the American Frontier Series. Albuquerque: University of New Mexico Press, 2008.

Abbott, Carl. *The Metropolitan Frontier: Cities in the Modern American West*. Tucson: University of Arizona Press, 1993.

Acker, Emma, Sue Canterbury, Lauren Palmor, Adrian Daub, M. H. de Young Memorial Museum, and Dallas Museum of Art. *Cult of the Machine: Precisionism and American Art*. San Francisco: Fine Arts Museums of San Francisco de Young, in association with Yale University Press, 2018.

Adams, Robert. *The New West: Landscapes along the Colorado Front Range*. Boulder, CO: Colorado Associated University Press, 1974.

Adams, Robert, and International Museum of Photography at George Eastman House. *New Topographics: Photographs of a Man-Altered Landscape*. Rochester, NY: International Museum of Photography at George Eastman House, 1975.

Aldige, Alyce. *Vintage Postcards of New York*. Edited by Silvia and Stefano Lucchini, The Stefano and Silvia Lucchini Collection. New York: Rizzoli International Publications, 2015.

Angel, Shlomo. *Atlas of Urban Expansion*. Cambridge, MA: Lincoln Institute of Land Policy, 2012.

Angel, Shlomo. *Making Room for a Planet of Cities*. Cambridge, MA: Lincoln Institute of Land Policy, 2011.

Angel, Shlomo. *Planet of Cities*. Cambridge, MA: Lincoln Institute of Land Policy, 2012.

Banham, Reyner. *The Architecture of the Well-Tempered Environment*. London: Architectural Press, 1969.

Banham, Reyner. *Los Angeles: The Architecture of Four Ecologies*. London: Allen Lane, 1971.

Barford, Paul, Ramakrishnan Durairajan, Joel Sommers, and Walter Willinger. "InterTubes: A Study of the US Long-haul Fiber-optic Infrastructure." 2015.

Bayer, Patricia. *Art Deco Postcards*. London: Thames & Hudson, 2011.

Berger, Alan, Joel Kotkin, and Celina Balderas-Guzmán. *Infinite Suburbia*. 1st ed. New York: Princeton Architectural Press, 2017.

Braunfels, Wolfgang. *Abendländische Stadtbaukunst: Herrschaftsform u. Baugestalt*. DuMont Dokumente: Reihe Kunstgeschichte, Wissenschaft. Cologne: DuMont Schauberg, 1976.

Braunfels, Wolfgang. *Urban Design in Western Europe: Regime and Architecture, 900–1900*. Chicago: University of Chicago Press, 1988.

Brooks, David. *Bobos in Paradise: The New Upper Class and How They Got There*. New York: Simon & Schuster, 2000.

Brooks, David. *On Paradise Drive: How We Live Now (And Always Have) in the Future Tense*. New York: Simon & Schuster, 2004.

Bruegmann, Robert. *Sprawl: A Compact History*. Chicago: University of Chicago Press, 2005.

Burri, Monika. *Die Welt im Taschenformat: die Postkartensammlung Adolf Feller*. The World in Pocket-Size Format: The Adolf Feller Postcard Collection. Zurich: Scheidegger & Spiess, 2011.

Clark, W. C., and John Lyndhurst Kingston. *The Skyscraper: A Study in the Economic Height of Modern Office Buildings*. New York: American Institute of Steel Construction, 1930.

Corbett, Michael R. *Building California: Technology and the Landscape*. San Francisco: Published on behalf of the California Historical Society by William Stout Publishers, 1998.

Cranz, Galen. *The Politics of Park Design: A History of Urban Parks in America*. Cambridge, MA: MIT Press, 1982.

Cronon, William. *Nature's Metropolis: Chicago and the Great West*. 1st ed. New York: W. W. Norton, 1991.

Daily, Gretchen C., and Katherine Ellison. *The New Economy of Nature: The Quest to Make Conservation Profitable*. Washington, DC: Island Press, Shearwater Books, 2002.

Didion, Joan. *The White Album*. New York: Simon & Schuster, 1979.

Dixon, Timothy J. *Real Estate & the New Economy: The Impact of Information and Communications Technology*. Real Estate Issues. Oxford, UK: Blackwell Publishing, 2005.

Federal Writers' Project (Idaho). *Idaho: A Guide in Word and Picture*. The Library ed. The American Guide Series. Caldwell, ID: The Caxton Printers Ltd., 1937.

Federal Writers' Project (Montana). *Montana, A State Guide Book*. American Guide Series. New York: Hastings House, 1946.

Federal Writers' Project (New Mexico). *New Mexico, A Guide to the Colorful State*. New York: Hastings House, 1940.

Federal Writers' Project of the Works Progress Administration of Northern California. *California: A Guide to the Golden State*. American Guide Series. New York: Hastings House, 1939.

Federal Writers' Project of the Works Progress Administration of Northern California. *Death Valley: A Guide*. American Guide Series. Boston: Houghton Mifflin, 1939.

Federal Writers' Project (Oregon), and Howard McKinley Corning. *Oregon, End of the Trail*. Rev. ed. American Guide Series. Portland: Binfords & Mort, 1951.

Federal Writers' Project (San Diego, California). *San Diego, A California City*. San Diego: San Diego Historical Society, 1937.

Fischel, William A. *Zoning Rules! The Economics of Land Use Regulation*. Cambridge, MA: Lincoln Institute of Land Policy, 2015.

Fortune, Editors of. *The Exploding Metropolis*. 1st ed. Garden City, NY: Doubleday, 1958.

Garreau, Joel. *Edge City: Life on the New Frontier*. 1st ed. New York: Doubleday, 1991.

Getty, J. Paul. *The History of the Oil Business of George F. and J. Paul Getty from 1903 to 1939*. Los Angeles [?]: Getty, 1941.

Giedion, Sigfried. *Mechanization Takes Command, a Contribution to Anonymous History*. New York: Oxford University Press, 1948.

Graham, Stephen, and Simon Marvin. *Splintering Urbanism: Networked Infrastructures, Technological Mobilities and the Urban Condition*. London: Routledge, 2001.

Grübler, Arnulf. "The Rise and Fall of Infrastructures: Dynamics of Evolution and Technological Change in Transport." Diss., Technical University Vienna, 1988.

Gutfreund, Owen D. *Twentieth-Century Sprawl: Highways and the Reshaping of the American Landscape*. New York: Oxford University Press, 2004.

Guthrie, Woody. "This land is your land," notated music, 1956.

Hitchcock, Henry-Russell, and William Seale. *Temples of Democracy: The State Capitols of the U.S.A.* 1st ed. New York: Harcourt Brace Jovanovich, 1976.

Jackson, Kenneth T. *Crabgrass Frontier: The Suburbanization of the United States*. New York: Oxford University Press, 1985.

Jozefacka, Anna. *The Propaganda Front: Postcards from the Era of World Wars*. Boston: MFA Publications, Museum of Fine Arts, Boston, 2017.

Kaufmann, Obi, and William Kaufmann. *The California Field Atlas*. Berkeley: Heyday, 2017.

Kerouac, Jack. *On the Road*. New York: Viking Press, 1957.

Khan, Omar. *Paper Jewels: Postcards from the Raj*. Ahmedabad, India: Mapin Publishing Pvt. Ltd, 2018.

Klamkin, Marian. *Picture Postcards*. Newton Abbot, UK: David & Charles, 1974.

Knight, Oliver. "Toward an Understanding of the Western Town." *The Western Historical Quarterly* (Utah State University). Vol. 4, no. 1 (1973): 27–42.

Koenig, Gloria. *Iconic LA: Stories of LA's Most Memorable Buildings*. Glendale, CA: Balcony Press, 2000.

Kostof, Spiro. *America by Design*. New York: Oxford University Press, 1987.

Kostof, Spiro. *The City Assembled: The Elements of Urban Form Through History*. 1st North American ed. Boston: Little, Brown, 1992.

Kostof, Spiro. *The City Shaped: Urban Patterns and Meanings Through History*. Boston: Little, Brown, 1991.

Kotkin, Joel. *The New Geography: How the Digital Revolution is Reshaping the American Landscape*. 1st ed. New York: Random House, 2000.

Kotkin, Joel. *The Next Hundred Million: America in 2050*. New York: Penguin Press, 2010.

Kotkin, Joel. *The Human City: Urbanism for the Rest of Us*. Chicago: Agate B2, 2016.

Kotkin, Joel, Wendell Cox. "The Great Train Robbery: Urban Transportation in the 21st Century." In *Center for Demographics & Policy Research Brief*. Orange: Chapman University, 2017.

Lévi-Strauss, Claude. *Tristes tropiques* (*Terre humaine*). Paris: Plon, 1955.

Limerick, Patricia Nelson. *The Legacy of Conquest: The Unbroken Past of the American West*. 1st ed. New York: Norton, 1987.

Lopes, Shana. "Curt Otto Teich." German Historical Institute, last modified July 24, 2015, accessed August 25, 2017, http://www.immigrantentrepreneurship.org/entry.php?rec=245.

Meikle, Jeffrey L., and Curt Teich Postcard Collection (Lake County Museum). *Postcard America: Curt Teich and the Imaging of a Nation, 1931–1950*. 1st ed. Austin: University of Texas Press, 2015.

Miller, Char, ed. *Cities and Nature in the American West*. The Urban West Series. Reno: University of Nevada Press, 2010.

Milner, Clyde A., Carol A. O'Connor, and Martha A. Sandweiss. *The Oxford History of the American West*. New York: Oxford University Press, 1994.

Mozingo, Louise A. *Pastoral Capitalism: A History of Suburban Corporate Landscapes*. Urban and Industrial Environments. Cambridge, MA: MIT Press, 2011.

Muir, John. 1911. *My First Summer in the Sierra*. Boston: Houghton Mifflin Company, 1911.

Muir, John. 1901. *Our National Parks*. Boston: Houghton Mifflin Company, 1901.

Museum of Fine Arts Boston, Anne Nishimura Morse, J. Thomas Rimer, and Kendall H. Brown. *Art of the Japanese Postcard: The Leonard A. Lauder Collection at the Museum of Fine Arts, Boston*. Boston: MFA Publications, a division of the Museum of Fine Arts, Boston, 2004.

Museum of Fine Arts Boston, Lynda Klich, Leonard A. Lauder, and Benjamin Weiss. *The Postcard Age: Selections from the Leonard A. Lauder Collection*. 1st ed. Boston: MFA Publications, Museum of Fine Arts, distributed by ARTBOOK/ D.A.P, 2012.

Nadeau, Remi A. *The Water Seekers*. 1st ed. Garden City, NY: Doubleday, 1950.

Nash, Gerald D. *The American West in the Twentieth Century: A Short History of an Urban Oasis*. Englewood Cliffs, NJ: Prentice Hall, 1973.

Nash, Gerald D. *The American West Transformed: The Impact of the Second World War*. Bloomington: Indiana University Press, 1985.

Nash, Gerald D. *A Brief History of the American West since 1945*. Harbrace Books on America since 1945. Fort Worth: Harcourt College Publishers, 2001

Nash, Gerald D. *Creating the West: Historical Interpretations, 1890–1990*. 1st ed. The Calvin P Horn Lectures in Western History and Culture. Albuquerque: University of New Mexico Press, 1991.

Nash, Gerald D. *The Federal Landscape: An Economic History of the Twentieth-Century West*. The Modern American West. Tucson: University of Arizona Press, 1999.

Neff, Emily Ballew, Museum of Fine Arts Houston, and Los Angeles County Museum of Art. *The Modern West: American Landscapes, 1890–1950*. New Haven: Yale University Press, Museum of Fine Arts, 2006.

Neue Galerie New York, Elisabeth Schmuttermeier, and Christian Witt-Dörring. *Postcards of the Wiener Werkstätte: A Catalogue Raisonné: Selections from the Leonard A. Lauder Collection*. New York and Ostfildern, Germany: Neue Galerie, Hatje Cantz, 2010.

Northrup, JoAnne. *Unsettled*. Reno, NV: Hirmer Verlag, 2007.

Nye, David E. *American Illuminations: Urban Lighting, 1800–1920*. Cambridge, MA: MIT Press, 2018.

Nye, David E. *Electrifying America: Social Meanings of a New Technology, 1880–1940*. Cambridge, MA: MIT Press, 1990.

O'Mara, Margaret Pugh. *Cities of Knowledge: Cold War Science and the Search for the Next Silicon Valley*. Politics and Society in Twentieth-Century America. Princeton, NJ: Princeton University Press, 2005

Perez, Carlota. *Technological Revolutions and Financial Capital: The Dynamics of Bubbles and Golden Ages*. Cheltenham, UK: Edward Elgar Publishing, 2002.

Pitt, Leonard. *Paris Postcards: The Golden Age*. Berkeley: Counterpoint, 2009.

Plato. *Theaetetus*. The Little Library of Liberal Arts. New York: Liberal Arts Press, 1949.

Powell, John Wesley. *Report on the Lands of the Arid Region of the United States*. 1 vol. n.p., 1878.

Rabinowitch, Eugene, Donald and Astrid Monson, Robert E. Merriam, Ralph E. Lapp, Goodhue Livingston, and William L.C. Wheaton. "Defense through Decentralization: A Symposium on Dispersal." *Bulletin of the Atomic Scientists* VII, no. 9, (1951): 241–288.

Reps, John William. *Cities of the American West: A History of Frontier Urban Planning*. Princeton, NJ: Princeton University Press, 1979.

Reps, John William. *The Forgotten Frontier: Urban Planning in the American West before 1890*. Columbia: University of Missouri Press, 1981.

Rockwell, David, and Bruce Mau. *Spectacle*. London: Phaidon, 2006.

Roderick, Kevin. *The San Fernando Valley: America's Suburb*. Los Angeles: Los Angeles Times Books, 2001.

Roderick, Kevin, and J. Eric Lynxwiler. *Wilshire Boulevard: Grand Concourse of Los Angeles*. 1st ed. Santa Monica: Angel City Press, 2005.

Rose, Jonathan F. P. *The Well-Tempered City: What Modern Science, Ancient Civilizations, and*

Human Nature Teach Us about the Future of Urban Life. New York: Harper Wave, 2016.

Rosenheim, Jeff, and Walker Evans. *Walker Evans and the Picture Postcard*. Göttingen: Steidl, 2009.

Rossi, Aldo, Peter Eisenman, Graham Foundation for Advanced Studies in the Fine Arts, and Institute for Architecture and Urban Studies. *The Architecture of the City*. Oppositions Books. Cambridge, MA: MIT Press, 1992.

Rowe, Peter G. *Making a Middle Landscape*. Cambridge, MA: MIT Press, 1991.

Ruchelman, Leonard I. *Cities in the Third Wave: The Technological Transformation of Urban America*. Chicago: Burnham, 2000.

Rydell, Robert W. *World of Fairs: The Century-of-Progress Expositions*. Chicago: University of Chicago Press, 1993.

Sandweiss, Martha A. *Print the Legend: Photography and the American West*. Yale Western Americana series. New Haven: Yale University Press, 2002.

Schindler, Bruno, and Nikolaus Kuhnert. *Schauplätze der Macht: Zum Baugedanken nach 1945*. Vol. 89. Aachen: Arch+ Verlag, 1987.

Schivelbusch, Wolfgang. *Lichtblicke zur Geschichte der künstlichen Helligkeit im 19. Jahrhundert*. Hanser Anthropologie. Munich: Hanser, 1983.

Schivelbusch, Wolfgang. *Geschichte der Eisenbahnreise zur Industrialisierung von Raum und Zeit im 19. Jahrhundert*. Hanser Anthropologie. Munich: Hanser, 1977.

Schivelbusch, Wolfgang. *Licht, Schein und Wahn: Auftritte der elektrischen Beleuchtung im 20. Jahrhundert*. Lüdenscheid: ERCO, 1992.

Schivelbusch, Wolfgang. *The Railway Journey: The Industrialization of Time and Space in the 19th Century*. Berkeley: University of California Press, 1986.

Schivelbusch, Wolfgang. *The Railway Journey: Trains and Travel in the Nineteenth Century*. New York: Urizen Books, 1979.

Schivelbusch, Wolfgang. *Das verzehrende Leben der Dinge: Versuch über die Konsumtion*. Munich: Hanser, 2015.

Soullière, Laura E. *Architecture in the Parks, National Historic Landmark Theme Study*. Washington, DC: Dept. of the Interior National Park Service: for sale by Supt. of Docs., U.S. G.P.O, 1986.

Spectorsky, Auguste C. *The Exurbanites*. 1st ed. Philadelphia: Lippincott, 1955.

Standage, Tom. *The Victorian Internet: The Remarkable Story of the Telegraph and the Nineteenth Century's On-line Pioneers*. New York: Walker and Co, 1998.

Stanilov, Kiril, and Brenda Case Scheer. *Suburban Form: An International Perspective*. New York: Routledge, 2004.

Starr, Kevin. *Americans and the California Dream, 1850–1915*. Americans and the California Dream. New York: Oxford University Press, 1973.

Starr, Kevin. *Coast of Dreams: California on the Edge, 1990–2003*. New York: Knopf: distributed by Random House, 2004.

Starr, Kevin. *The Dream Endures: California enters the 1940s*. Americans and the California Dream. New York: Oxford University Press, 1997.

Starr, Kevin. *Embattled Dreams: California in War and Peace, 1940–1950*. Americans and the California Dream. Oxford: Oxford University Press, 2002.

Starr, Kevin. *Endangered Dreams: The Great Depression in California*. Americans and the California Dream. New York: Oxford University Press, 1996.

Starr, Kevin. *Golden Dreams: California in an Age of Abundance, 1950–1963*. Americans and the California Dream. Oxford: Oxford University Press, 2009.

Starr, Kevin. *Inventing the Dream: California through the Progressive Era*. Americans and the California Dream. New York: Oxford University Press, 1985.

Starr, Kevin. *Material Dreams: Southern California through the 1920s*. Americans and the California Dream. New York: Oxford University Press, 1990.

Steiner, Frederick R., George F. Thompson, and Armando Carbonell. *Nature and Cities: The Ecological Imperative in Urban Design and Planning*. Cambridge, MA: The Lincoln Institute of Land Policy, 2016.

Stoll, Steven. *The Fruits of Natural Advantage: Making the Industrial Countryside in California*. Berkeley: University of California Press, 1998.

Suisman, Douglas R. *Los Angeles Boulevard: Eight X-rays of the Body Public*. Santa Monica: Hennessey + Ingalls, 2013.

Swift, Earl. *The Big Roads: The Untold Story of the Engineers, Visionaries, and Trailblazers Who Created the American Superhighways*. Boston: Houghton Mifflin Harcourt, 2011.

Tarr, Joel A., and Gabriel Dupuy. *Technology and the Rise of the Networked City in Europe and*

America. Technology and Urban Growth. Philadelphia: Temple University Press, 1988.

Thompson, Hunter S. *Fear and Loathing in Las Vegas: A Savage Journey to the Heart of the American Dream*. New York: Random House, 1971.

Toffler, Alvin. *Future Shock*. New York: Random House, 1970.

Toffler, Alvin. *The Third Wave*. 1st ed. New York: Morrow, 1980.

Travis, William R. *New Geographies of the American West: Land Use and the Changing Patterns of Place*. Orton Innovation in Place Series. Washington, DC: Island Press, 2007.

Turner, Paul Venable. *Campus: An American Planning Tradition*. The Architectural History Foundation/MIT Press series. New York, Cambridge, MA: Architectural History Foundation, MIT Press, 1984.

Twain, Mark, and A. Grove Day. *Mark Twain's Letters from Hawaii*. Pacific Classics. Honolulu: University Press of Hawaii, 1975.

Vure, Sarah, Robert Bruegmann, and Orange County Museum of Art (Calif.). *Cities of Promise: Imaging Urban California*. Newport Beach, CA: Orange County Museum of Art, in cooperation with the Automobile Club of Southern California, 2004.

Wagner, Anton. *Los Angeles: Werden, Leben und Gestalt der Zweimillionenstadt in Südkalifornien*. Leipzig: Bibliographisches Institut, 1935.

Walter, Marc, Sabine Arqué, and Detroit Photographic Co. *An American Odyssey: Photos from the Detroit Photographic Company 1888–1924*. Cologne: Taschen, 2014.

Walter, Marc, Sabine Arqué, and Karin Lelonek. *Deutschland um 1900: Ein Porträt in Farbe*. Cologne: Taschen, 2015.

Wells, H. G. *Anticipations of the Reaction of Mechanical and Scientific Progress upon Human Life and Thought*. New York: Harper & Brothers, 1902.

Willes, Burl, and Anthony Bruce. *Picturing Berkeley: A Postcard History*. 1st ed. Layton, UT: Gibbs Smith Publisher, 2005.

Willis, Carol. *Form Follows Finance: Skyscrapers and Skylines in New York and Chicago*. 1st ed. New York: Princeton Architectural Press, 1995.

Wilson, William H. *The City Beautiful Movement*. Creating the North American Landscape. Baltimore: Johns Hopkins University Press, 1989.

Writers' Program (Calif.). *San Francisco: The Bay and its Cities*. American Guide Series. New York: Hastings House, 1940.

Writers' Program (Nev.). *Nevada: A Guide to the Silver State*. American Guide Series. Portland: Binfords & Mort, 1940.

Writers' Program (U.S.). California. *Los Angeles: A Guide to the City and its Environs*. American Guide Series. New York: Hastings House, 1941.

Writers' Program (U.S.). California. *Santa Barbara: A Guide to the Channel City and its Environs*. American Guide Series. New York: Hastings House, 1941.

Writers' Program (U.S.). California, and California Department of Education. *The Central Valley Project*. Sacramento: California State Dept. of Education, 1942.

Writers' Program (Utah). *Utah: A Guide to the State*. American Guide Series. New York: Hastings House, 1954.

Writers' Program (Wash.). *Washington: A Guide to the Evergreen State*. American Guide Series. Portland: Binfords & Mort, 1941.

Writers' Program of the Work Projects Administration in the State of Arizona. *Arizona: A State Guide*. American Guide Series. New York: Hastings House, 1940.

Writers' Program of the Work Projects Administration in the State of Colorado. *Colorado: A Guide to the Highest State*. American Guide Series. New York: Hastings House, 1941.

Writers' Program of the Work Projects Administration in the State of Wyoming. *Wyoming: A Guide to its History, Highways, and People*. Lincoln: University of Nebraska Press, 1981.

Writers' Program, California. *Monterey Peninsula*. Stanford University: J. L. Delkin, 1941.

Wrobel, David M., and Patrick T. Long. *Seeing and Being Seen: Tourism in the American West*. Lawrence: Published for the Center of the American West, University of Colorado at Boulder by the University Press of Kansas, 2001.

IMAGE CREDITS

All images are courtesy of the Wagener-Erganian Collection, except:

U.S. Geological Survey, Department of the Interior: 13, 32, 166
Library of Congress Geography and Map Division, Washington, DC: 167
Dunlop Archive Collection, courtesy Upper Hutt City Library Heritage Collections: 287
Collection Center for Creative Photography, University of Arizona: 288
The Estate of Joe Deal, courtesy Robert Mann Gallery, New York: 289

All captions are the original image description located on the back of each linen post card, except when absent. In such exceptions, indicated with the symbol *, text has been derived from approximate image.

The year indicated in the captions, represents the year of publication for each linen post card.

INFOGRAPHIC SOURCES

U.S. Population: U.S. Census Bureau. 2018
U.S. Urbanization: U.S. Census Bureau. 2018
U.S. Territory: Steven Manson, Jonathan Schroeder, David Van Riper, and Steven Ruggles. IPUMS National Historical Geographic Information System: Version 13.0 [Database]. Minneapolis: University of Minnesota. 2018
U.S. Waterways: Encyclopedia Britannica, U.S. Army Corps of Engineers. 2018
U.S. Railways: *American Railroads: Their Growth and Development*. The Association of American Railroads. January, 1951. Central Pacific Railroad Photographic History Museum. 2018
U.S. Dams: U.S. Energy Information Administration. 2018
U.S. Highways: U.S. Department of Transportation, Federal Highway Administration. 2018
U.S. Airports: Federal Aviation Administration. 2018
U.S. Internet: Ramakrishnan Durairajan (University of Wisconsin–Madison), Paul Barford (University of Wisconsin–Madison and comScore, Inc.), Joel Sommers (Colgate University), Walter Willinger (NIKSUN, Inc.): "InterTubes: A Study of the US Long-haul Fiber-optic Infrastructure." 2015

AUTHORS' BIOGRAPHIES

WOLFGANG WAGENER is an international architect and real estate development adviser. His previous publications include the architectural monograph *Raphael Soriano* and *Connected Real Estate: Essays from Innovators in Real Estate, Design, and Construction*. He graduated with a PhD in Engineering from RWTH Aachen University in Germany and obtained an Advanced Management Degree in Real Estate from Harvard University. He is a member of the Urban Land Institute, the American Institute of Architects, the Royal Institute of British Architects, and is a lifetime member of the Society of Architectural Historians, Southern California Chapter, having followed his passion for mid-century modernism from Western Europe to the western coast of California.

LESLIE ERGANIAN is an American artist and writer. Her hand-colored photographs are in the permanent collections of the California Museum of Photography and the Xerox Corporation. She contributed her design talents to the production of feature film projects for MGM, DreamWorks, Warner Bros., and Showtime. She has been a writer and television correspondent for NBC, Discovery, and Hallmark. She graduated with a Master of Fine Arts in Art and Design from the University of Illinois at Urbana-Champaign and obtained a Master of Fine Arts in film production from the University of California, Los Angeles. Her undergraduate studies under *New Topographics* photographer Joe Deal cultivated an egalitarian eye and a twin interest in the practice and history of photography. She is a member of the Screen Actors Guild.

ACKNOWLEDGMENTS

NEW WEST is a project directed in equal parts by love for and interest in the place we as coauthors have come to call home, the American West. As natives of other climates and countries, we have been fortunate to have received thoughtful guidance by numerous individuals and institutions towards exploring and understanding the assets and challenges of this unique region.

To Alice Forbes and Alex Erganian, who introduced their daughter to California's breadth of beauty at an impressionable age.

To Elke and Dr.-Ing. Horst Wagener for encouraging their son to become a citizen of the world.

To one another, for expanding our horizons into what was once unchartered territory, and helping make the whole our own.

With sincere gratitude to the following for helping make this book possible:

Sarah Gephart, Sarah Mohammadi, MGMT. design, for their vision, direction, and generosity.
Rainer Arnold, Gunnar Musan, Owen Connors, Andreas Achter, HIRMER Publishers, for their steady and collaborative hand.
Laurie Olin and Skip Graffam, OLIN, for sharing their knowledge regarding the symbiosis of cities and nature.
Robert Adams, whose essays on photography and the art of observation were an inspiration.
Jack H. Knott, Kristina Raspe, and Christian Redfearn, University of Southern California, Sol Price School of Public Policy, for the invitation to teach a real estate and innovation class, which formed the thesis for this book.
Eric Morley, The Morley Bros., for his early and ongoing support.
Tom Dioro, Accurate Public Relations, for his belief in and encouragement of the project.
Lew Baer, Philip Feldman, and the late Joseph Jaynes, San Francisco Bay Area Post Card Club, for fostering a deeper understanding of the linen post card as art form and historic artifact.

Image licensing and research:
Claudia Rice, Ansel Adams Publishing Rights Trust
Heather Johnson, Curt Teich Postcard Archives at the Lake County Discovery Museum
Juan Molina Hernández, Curt Teich Postcard Archives Collection at The Newberry
Madeline Cornell, Robert Mann Gallery
Shandi Wagner, Center for Creative Photography

NEW WEST Instagram community @newwestthebook, whose participatory viewing helped shape the image selection for the book.

COLOPHON

Hirmer Publishers
Bayerstrasse 57–59
80335 Munich
Germany
hirmerpublishers.com

WOWA WEST
555 Bryant Street, #140
Palo Alto, California 94301
United States
wowawest.com

Art Direction by MGMT. design
Information Graphics by MGMT. design

Copy Editing by Owen Connors
Typesetting by Academic Publishing Service Gunnar Musan
Project Management by Hirmer Publishers: Rainer Arnold
Prepress by Reproline mediateam GmbH & Co. KG, Unterföhring
Paper: LuxoArt Samt 150 g/sqm
Printer & binder: Westermann Druck Zwickau GmbH
Printed in Germany

This book was printed on acid-free paper.

Library of Congress Control Number: 2019903458

The Deutsche Nationalbibliothek lists this publication in the
Deutsche Nationalbibliografie; detailed bibliographic data are
available on the Internet at dnb.de.

ISBN 978-3-7774-3189-5

MIX
Paper from
responsible sources
FSC® C110508
FSC www.fsc.org